ANGEL IN THE SUN

© McGill-Queen's University Press 1999
ISBN 0-7735-1747-2

Legal deposit first quarter 1999
Bibliothèque nationale du Québec

Printed in Canada on acid-free paper

This book has been published with the help of a grant from the Humanities and Social Sciences Federation of Canada, using funds provided by the Social Sciences and Humanities Research Council of Canada.

McGill-Queen's University Press acknowledges the financial support of the Government of Canada through the Book Publishing Industry Development Program for its activities. We also acknowledge the support of the Canada Council for the Arts for our publishing program.

Canadian Cataloguing in Publication Data

Finley, Gerald, 1931–
Angel in the sun: Turner's vision of history

Includes bibliographical references and index.
ISBN 0-7735-1747-2

1. Turner, J.M.W. (Joseph Mallord William), 1775–1851 – Criticism and interpretation. 2. History in art. 1. Title.

ND497.T8F54 1999 759.2 C98-900899-1

Designed by Miriam Bloom, Expression Communications

This book was typeset by Typo Litho Composition Inc. in 10/13 Baskerville.

For Christopher, Elizabeth, Heath, and Johanna

Contents

Figures

Paintings in oil are on canvas unless otherwise indicated.

The following abbreviations are used in the captions of the illustrations to indicate catalogue references:

Preface

THIS BOOK IS ABOUT Joseph Mallord William Turner's vision of history. That this romantic painter's art has much to reveal has been indicated by published researches of recent years, which have shown that previously undetected meanings linger beneath the surface of his art, even though there is little documentation to corroborate the presence of these meanings. While Turner's lecture notes and book marginalia provide some valuable insights into his art, his published correspondence has not really aided us in this respect. Although it presents some indication of the structure of his thought, fills out the list of his acquaintances and clients, and furnishes glimpses of events and activities that we should not otherwise possess, the letters are lamentably lacking in information concerning his art.[1]

For this reason, the period in which Turner lived (1775–1851) should be scrutinized still more closely. And so should his paintings. Though we cannot always, and certainly will never completely, comprehend the meanings of his art, the works included in this book tend to be those that reflect more than the subjects they depict and, in consequence, those that afford perhaps the greatest insights into his concept of history. Though a selection of other works would have given further impressions, these impressions would probably not have been noticeably different. In this study I have introduced discussions from articles that I have published previously; many of my earlier discussions have been elaborated, and all have been woven into the broader fabric of this study, which encompasses a range of art that is greater than that found in the articles. In consequence, this book has required a theme that embraces and unites these works: the artist's view of history, a view that is exceedingly rich and remarkably complex.

However, not all the works considered in this book are history paintings. Turner's ideas about history are often reflected in his illustrations and other pictures that sometimes contain signifi-

cant political, social, scientific, technical, or personal allusions characteristic of his history paintings; some of these works are examined here, including those that reveal his dedicated interest in capturing in paint nature's effects of light and colour, an interest (indeed, one might say a passion) that had particular significance for him as a painter of history.

The approach adopted in this thematic and largely chronological study of Turner's view of history is, in many respects, unconventional. It involves the analysis and explication of paintings, illustrations, and watercolours and a consideration of relationships existing between them. Because of the paucity of documents associated with his art, one is often left to consider these pictures as the primary evidence and to draw inferences from them. This approach is necessary, though it is fraught with difficulty and danger.

There are two points to be briefly made in this preface. First, it is worth noting that while this study is not biographical, biography radiates through many of its chapters. Biography is illuminating when discussing individual works of art or when scrutinizing the influences or conditions that have shaped or determined them. Second, because of developments in some art-historical methodologies over the past two decades, I have to state what I have *not* attempted in this book. I have not undertaken to give a neotheoretical or poststructuralist analysis of Turner's life and times. My interest here is not with his social, political, and cultural context but rather with the way his vision of history interacts with and interprets that context.

Acknowledgments

I AM GRATEFUL TO THE Social Sciences and Humanities Research Council of Canada and to the Queen's University Advisory Research Committee for support over the years. Both contributed funds for the initial research that resulted in published articles that I have made use of here. The Advisory Research Committee funded a final research trip especially for this study. I am indebted as well to Queen's University and to the Davies Charitable Foundation for its generous support of this book.

In this book I have drawn on a number of my published articles (listed in the selective bibliography). For allowing me to quote extensively from "Turner, the Apocalypse and History: The 'Angel' and 'Undine,'" I wish to thank *The Burlington Magazine*. I am grateful to the *Gazette des Beaux-Arts* for permission to include substantial segments from "The Theatre of Light: J.M.W. Turner's 'Vision of Medea' and 'Regulus,'" "J.M.W. Turner and the Legacy of Greece," and "Turner and the Steam Revolution." I am also indebted to the *Zeitschrift für Kunstgeschichte* for allowing me to include, in modified form, "Love and Duty: J.M.W. Turner and the Aeneas Legend." The *Queen's Quarterly* is to be thanked for allowing me to use material from "Heaven and Earth: J.M.W. Turner's Artistic Response to Astronomy and Geology," a paper prepared for a Royal Society of Canada symposium in 1992 and published with other symposium papers under the title *Muse and Reason* (1994). The contents of the last chapter concerning Turner's late Deluge pictures are heavily indebted to the article "Pigment into Light: Turner, and Goethe's Theory of Colours," which Frederick Burwick, long ago, encouraged me to write and which first appeared in the *European Romantic Review* in 1991; it was reprinted in 1996 in a collection of studies edited by Frederick Burwick and Jürgen Klein, *The Romantic Imagination: Literature and Art in England and Germany* (Rodopi). The material of this article also provided the basis for a substantial part of a second, more detailed study published in 1997 in the *Zeitschrift für Kunstgeschichte* entitled "The Deluge Pictures: Reflections on Goethe, J.M.W. Turner, and Early Nineteenth-Century Science," parts of which have inevitably found their way into different chapters. Much of the previously published work that I have included here has been revised in consequence of my own assessment or reassessment of the pictures and documents, and in response to the published research of others.

My fulsome thanks go to the many students of Turner and to colleagues, friends, and family for their aid. Without them my task would have been much more difficult. I have benefited from the assistance given to me by the late Dr Marinell Ash, who kindly directed me to material on Sir Daniel Wilson. Mark Antliffe, Boris Castel, Trevor Levere, Fred Lock, Evelyn Joll, Ross Kilpatrick, and many others – including members of the Geology Department at Queen's – went out of their way to be helpful. My son Heath took time from his busy life in Glasgow to search out nineteenth-century journal articles that I needed to consult. Judith Dundas and Douglas Stewart found time on numerous occasions over the years to answer difficult questions and to give advice about a study that, at that point, had hardly resolved itself in the author's mind. Judith Dundas also kindly read the first draft of what was to become the introductory chapter and made valuable suggestions for its improvement.

But the more difficult task of reading the manuscript fell to my wife, Helen, and then to Douglas Stewart. My wife bore the brunt of the initial completed draft, which benefited enormously from her acuity, common sense, and sensibility. I also owe much to the broad art-historical knowledge and critical acumen of Douglas Stewart, who took on the reading of the second draft and who, in the end, provided me with the book's title.

Finally, I wish to extend special thanks to the editors of the Press, Professor Donald Akenson, Dr Roger Martin, and the members of staff, for their encouragement and support of this project.

PHOTOGRAPHIC ACKNOWLEDGMENTS

Numbers in italic refer to colour plates

Alinari/Art Resource, NY: 89; By Permission of the British Library: 20, 43, 48, 100, 107, 110–12; © The British Museum: Frontispiece, 2, 32, 49, 55; The Trustees, Cecil Higgins Art Gallery, Bedford, England: 11; Derby Museum and Art Gallery: 76; Collection of the Duke of Northumberland, photograph Courtauld Institute of Art: 8; Glasgow Museums, Art Gallery & Museum, Kelvingrove: 22; Ironbridge Gorge Museum Trust, Elton Collection: 83, 84; Indianapolis Museum of Art: 62 (Gift in memory of Evan F. Lilley; photograph © 1997 Indianapolis Museum of Art); Kimbell Art Museum, Fort Worth, Texas: 27; National Gallery of Art, Washington: 17, 18, 70, 99, 101; © National Gallery, London: 34, 38, 80, 81, 85; *6, 7*; National Gallery of Scotland: 94; By courtesy of the National Portrait Gallery, London: 115; Royal Academy of Arts, London: 26; The Royal Collection © Her Majesty The Queen: 53; Trustees of the Tate Gallery: 3–7, 9, 10, 13–16, 19, 21, 24, 28–31, 33, 35–7, 39–42, 44, 45, 47, 50 (Lord Egremont collection [Petworth House]), 51, 52, 54, 56–61, 63–69, 71–5, 82, 86, 87, 90–2, 96–8, 104–6, 108, 109, 113, 114, 116–19; *1–5, 8, 9, 11–16*; Reproduced with the kind permission of the Trustees of the Ulster Museum, Belfast: 102, 103; *10*; Victoria and Albert Museum, London: 1; Vouros-Eutaxias Museum of the City of Athens, photograph Thomas Agnew and Sons: 12; Yale Center for British Art, Paul Mellon Collection: 46, 77–9, 88, 93; *23* B1977·14·8048 WILLMORE, James T (1800–1863), after Turner, J.M.W. "Ovid Banished from Rome," from *Ancient Italy* (1838–1852), c. 1842, etching and engraving touched with graphite, plate: 20 $\frac{1}{8}$ × 26 $\frac{1}{8}$ in (51.1 × 66.4 cm), Yale Center for British Art, Paul Mellon Collection; *46* B1977·14·78 TURNER, Joseph Mallord William (1755–1851), *Lake Avernus: Aeneas and the Cumaean Sybil,* c. 1813–1815, oil on canvas 28 $\frac{1}{4}$ × 38 $\frac{1}{4}$ in (72 × 97 cm), Yale Center for British Art, Paul Mellon Collection; *77* B1981·25·636 TURNER, Joseph Mallord William (1775–1851), *A Lime kiln at Coalbrookdale,* c. 1797, oil on panel, 11 $\frac{3}{8}$ × 15 $\frac{7}{8}$ (29.0 × 40.3 cm), Yale Center for British Art, Paul Mellon Collection; *78* B1981·25·2704 TURNER, Joseph Mallord William (1775–1851), *Leeds,* 1816, Watercolor heightened with bodycolor over pencil, 11 $\frac{1}{2}$ × 16 $\frac{3}{4}$ (29.0 × 42.5 cm), Yale Center for British Art, Paul Mellon Collection; *79* B1977·14·13436 WALLIS, R. (1794–1848) after Turner, J.M.W., *Dudley, Worcestershire,* 1835, subject: 6 $\frac{7}{16}$ × 9 $\frac{7}{16}$ (163 × 240 cm), plate: 9 $\frac{7}{8}$ × 11 $\frac{15}{16}$ in (251 × 304 cm), Yale Center for British Art, Paul Mellon Collection; *88* B1977·14·7925 BRANDARD, Robert after Turner, J.M.W., *Mustering of Warrior Angels,* engraving in India proof paper laid down on heavy wove paper, plate: 8 $\frac{5}{8}$ × 17 $\frac{1}{4}$ in (21.8 × 29.8 cm), sheet: 17 $\frac{3}{16}$ × 11 $\frac{3}{4}$ in (43.7 × 29.8 cm), Yale Center for British Art, Paul Mellon Collection; *93* B1978·43·14 TURNER, Joseph Mallord William (1775–1851), *Staffa, Fingal's Cave,* signed 1832, oil on canvas, 35 $\frac{3}{4}$ × 47 $\frac{3}{4}$ in (90.0 × 121.4 cm), Yale Center for British Art, Paul Mellon Collection.

Colour Plates

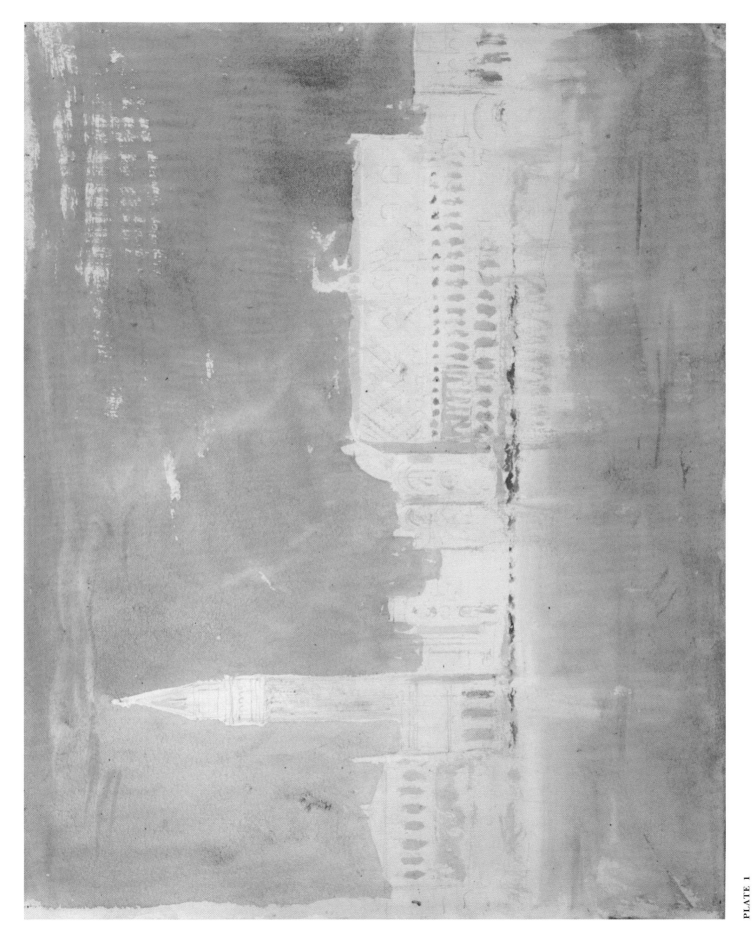

PLATE 1
Venice: The Campanile of St Mark's and the Doge's Palace. Watercolour, 1819. London, Clore Gallery for the Turner Collection. See fig. 14

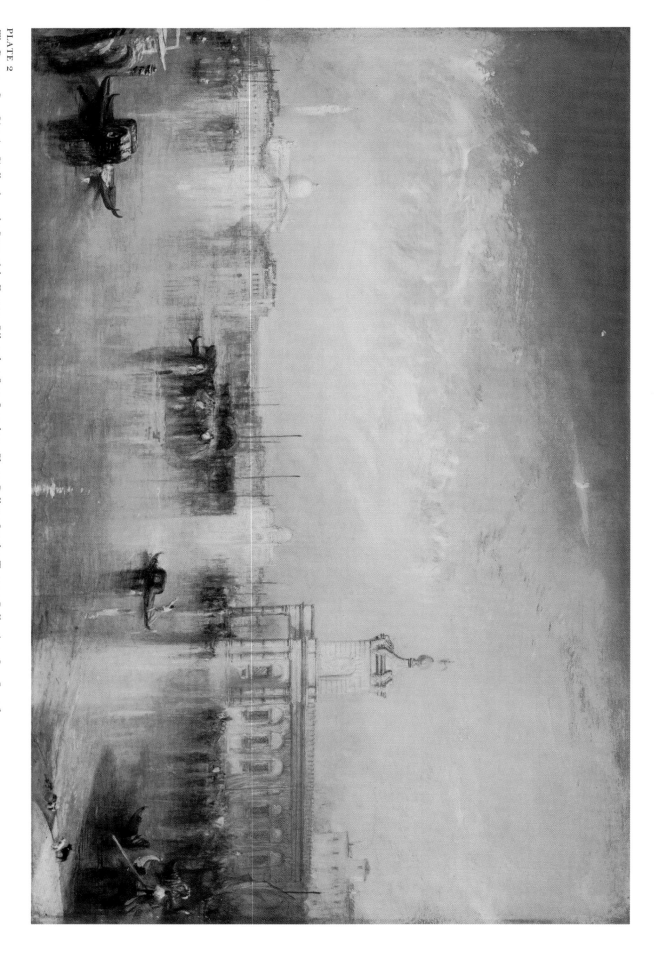

PLATE 2
The Dogana, San Giorgio, Citella, from the Steps of the Europa. Oil, exh. 1842. London, Clore Gallery for the Turner Collection. See fig. 16

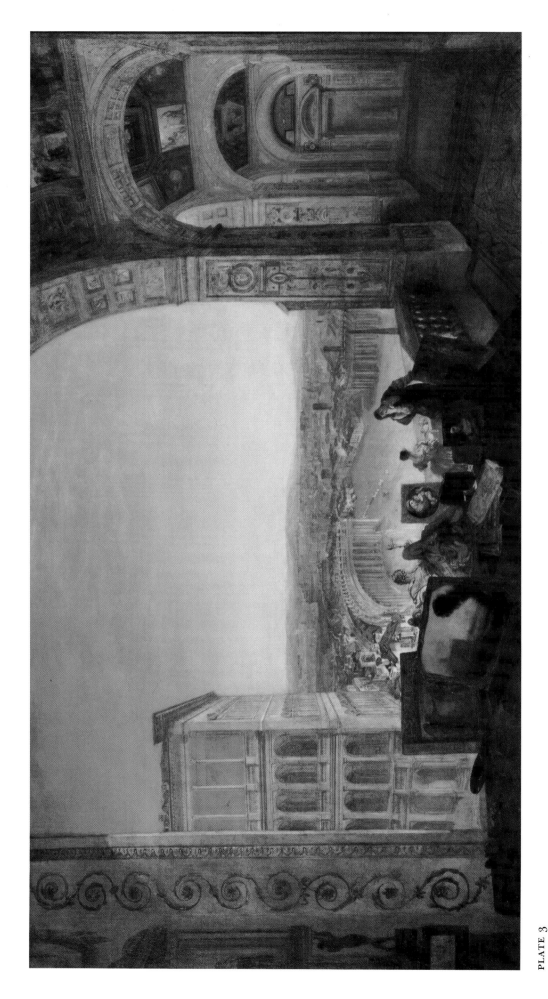

PLATE 3

Rome from the Vatican, Raffaelle, Accompanied by La Fornarina, Preparing His Pictures for the Decoration of the Loggia. Oil, exh. 1820. London, Clore Gallery for the Turner Collection. See fig. 19

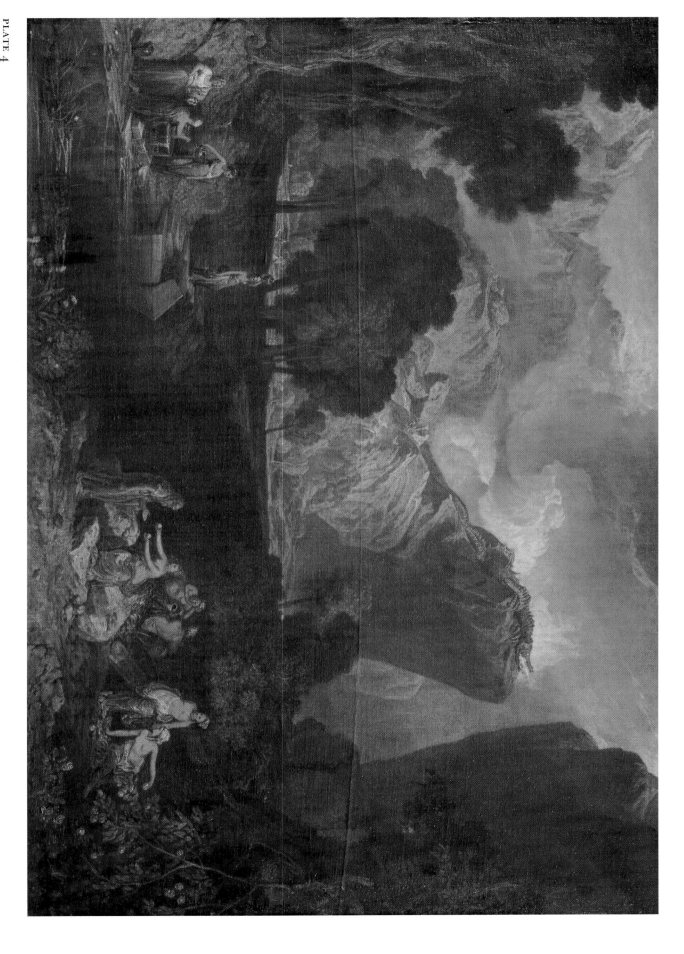

PLATE 4
The Goddess of Discord Choosing the Apple of Contention in the Garden of the Hesperides. Oil, exh. 1806. London, Clore Gallery for the Turner Collection. See fig. 31

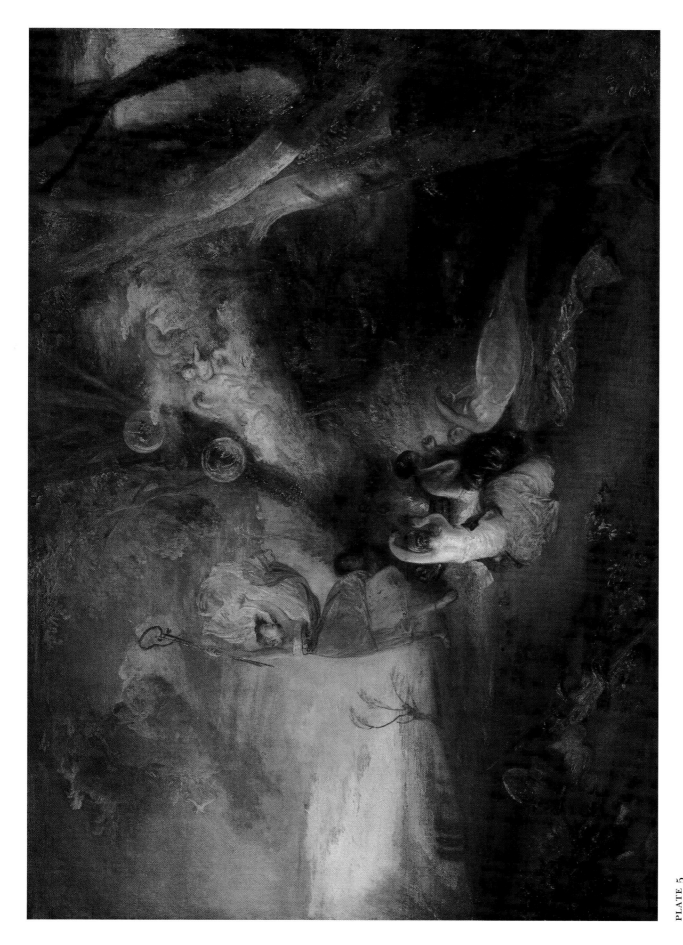

PLATE 5
Vision of Medea. Oil, 1828. London, Clore Gallery for the Turner Collection. See fig. 33

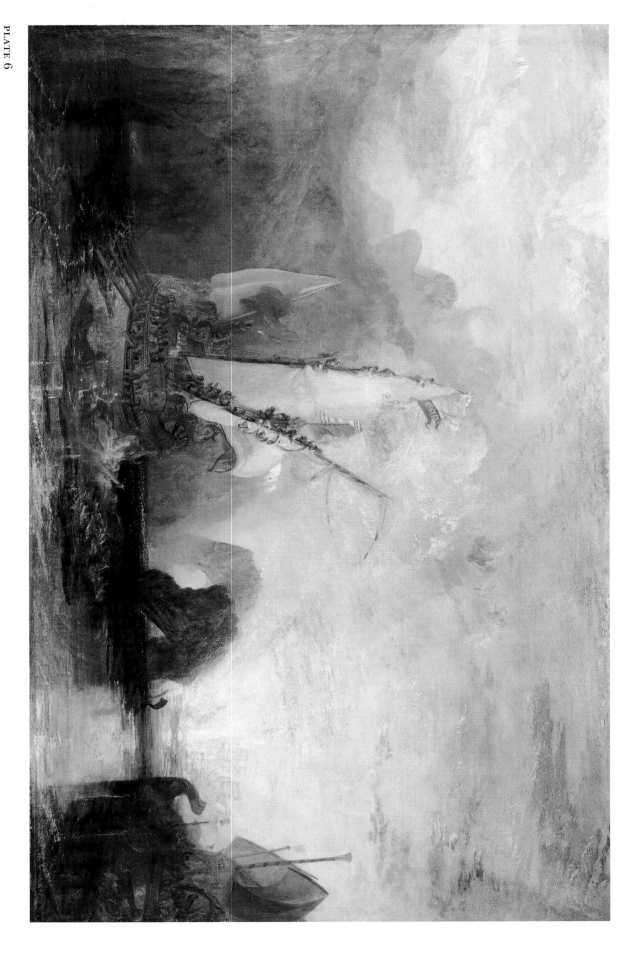

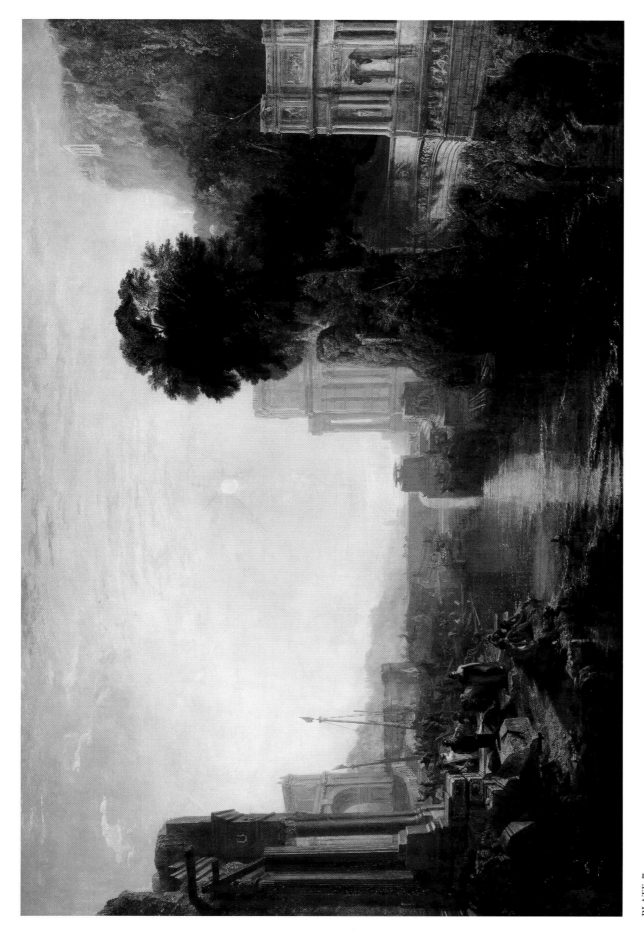

PLATE 7
J.M.W. Turner, *Dido Building Carthage; or the Rise of the Carthaginian Empire*. Oil, exh. 1815. © National Gallery, London. See fig. 38

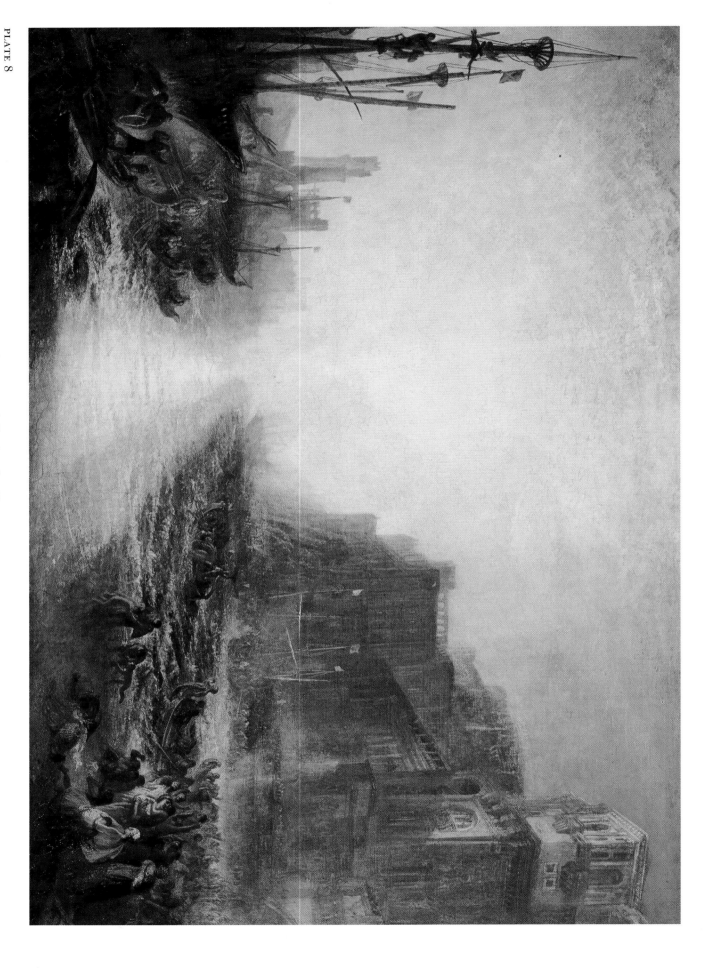

PLATE 8

Regulus. Oil, 1828; reworked 1837. London, Clore Gallery for the Turner Collection. See Fig. 57

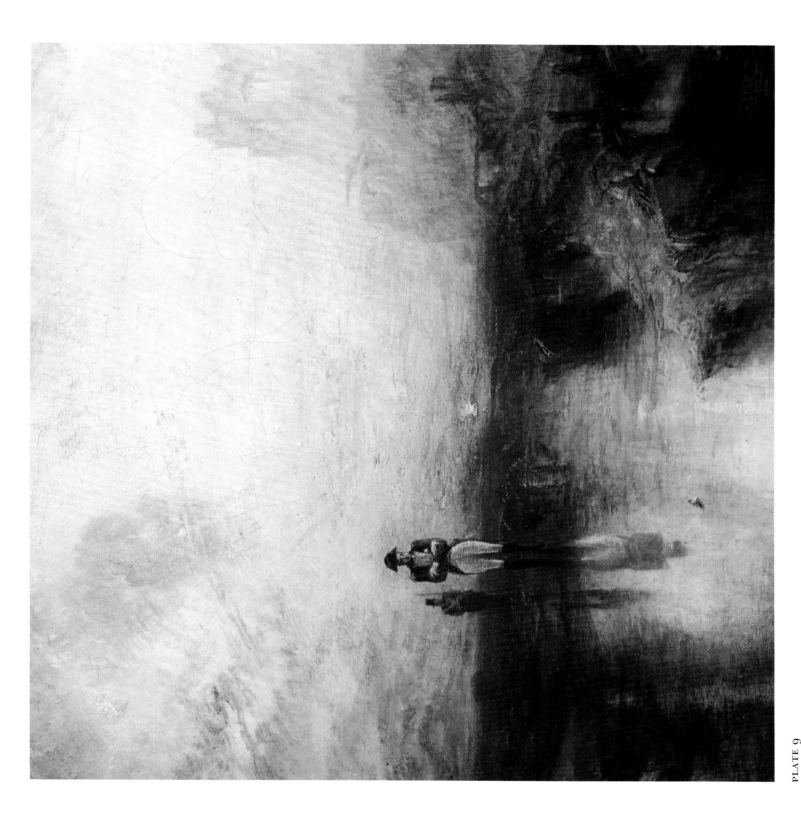

PLATE 9
War. The Exile and the Rock Limpet. Oil, exh. 1842. London, Clore Gallery for the Turner Collection. See fig. 64

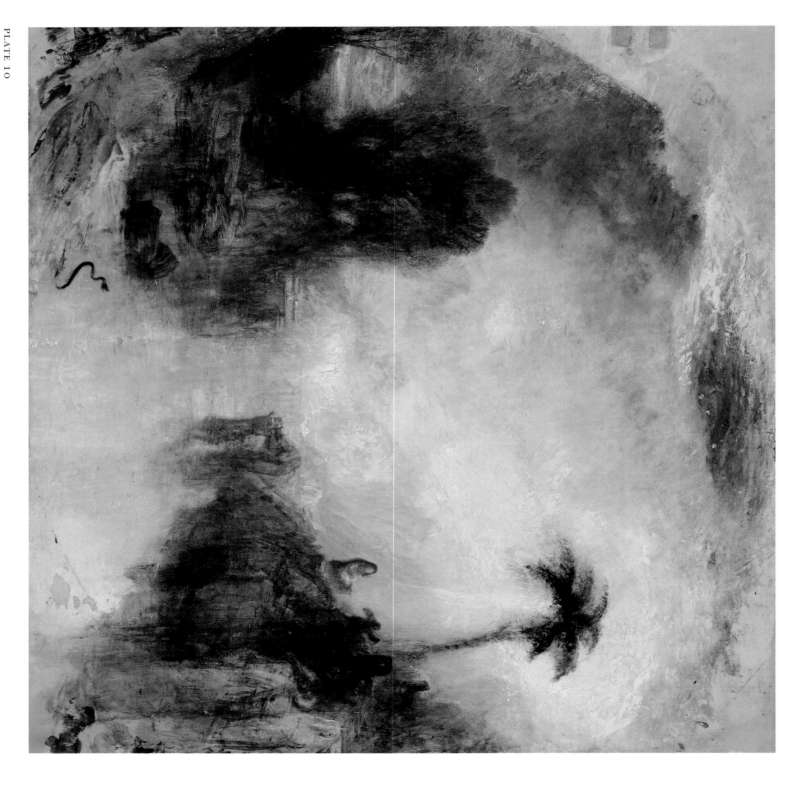

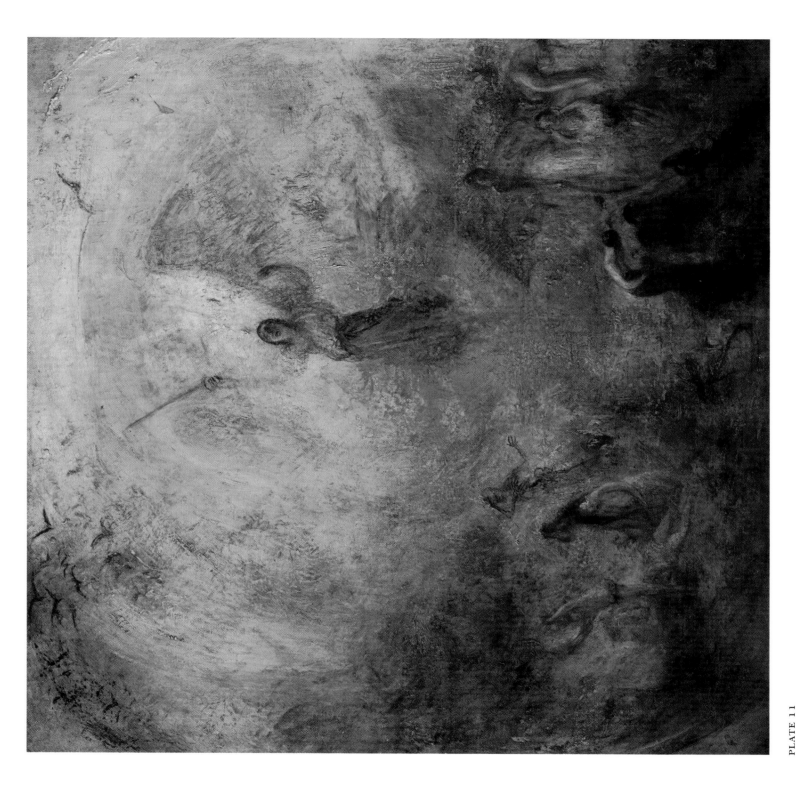

PLATE 11
The Angel Standing in the Sun. Oil, exh. 1846. London, Clore Gallery for the Turner Collection. See fig. 104

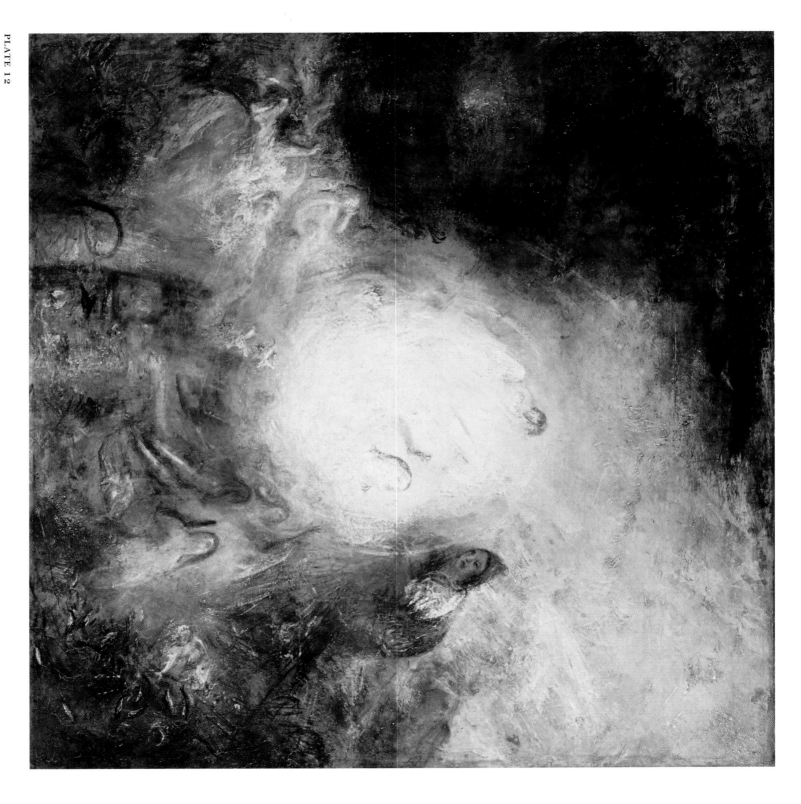

PLATE 12
Undine Giving the Ring to Masaniello, Fisherman of Naples. Oil, exh. 1846. London, Clore Gallery for the Turner Collection. See fig. 108

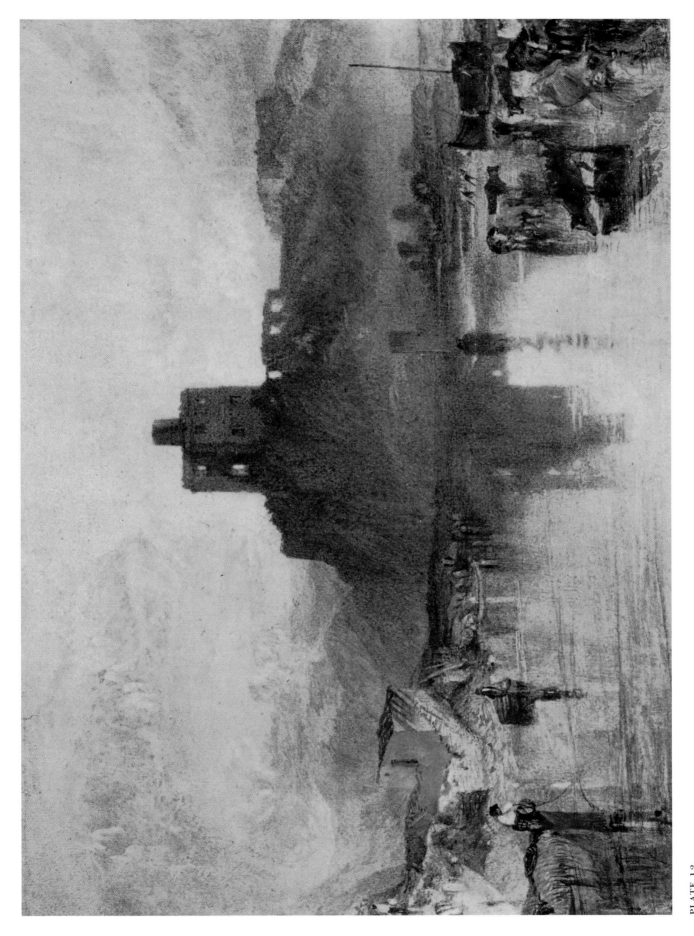

PLATE 13
Norham Castle, on the River Tweed. Watercolour, c. 1823. London, Clore Gallery for the Turner Collection. See fig. 114

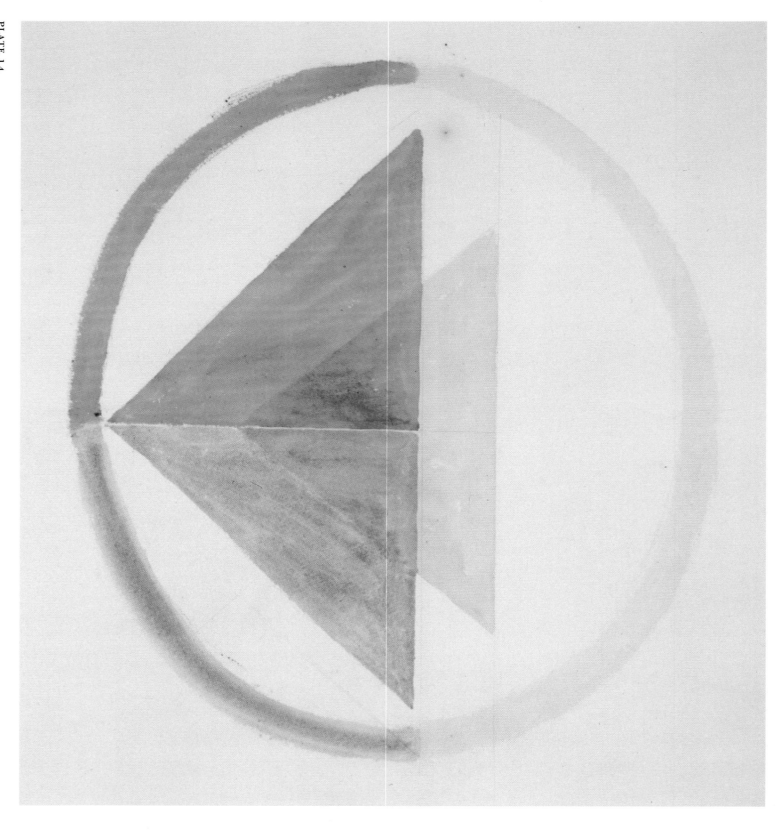

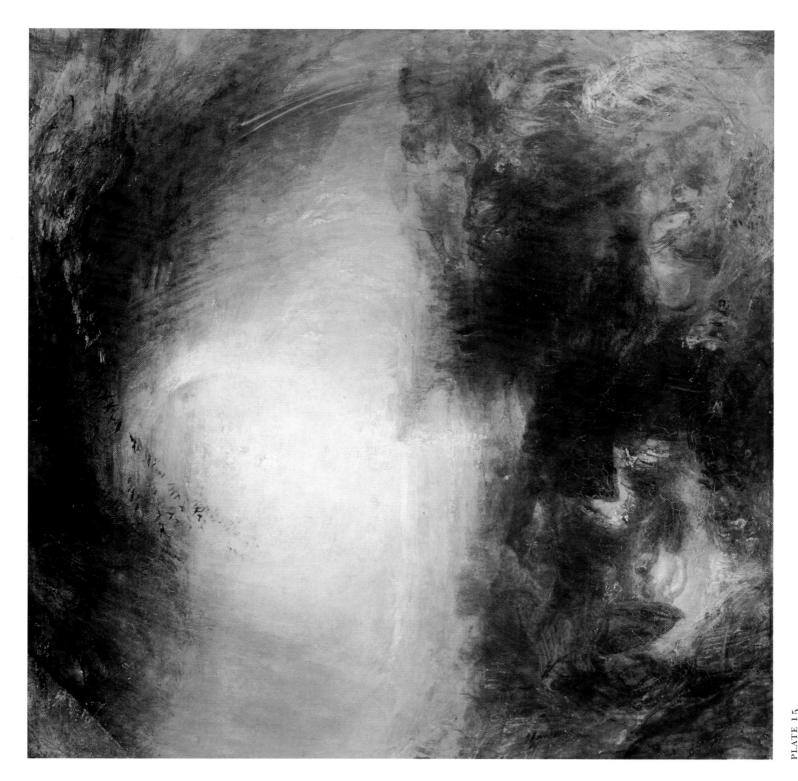

PLATE 15
Shade and Darkness – The Evening of the Deluge. Oil, exh. 1843. London, Clore Gallery for the Turner Collection. See fig. 118

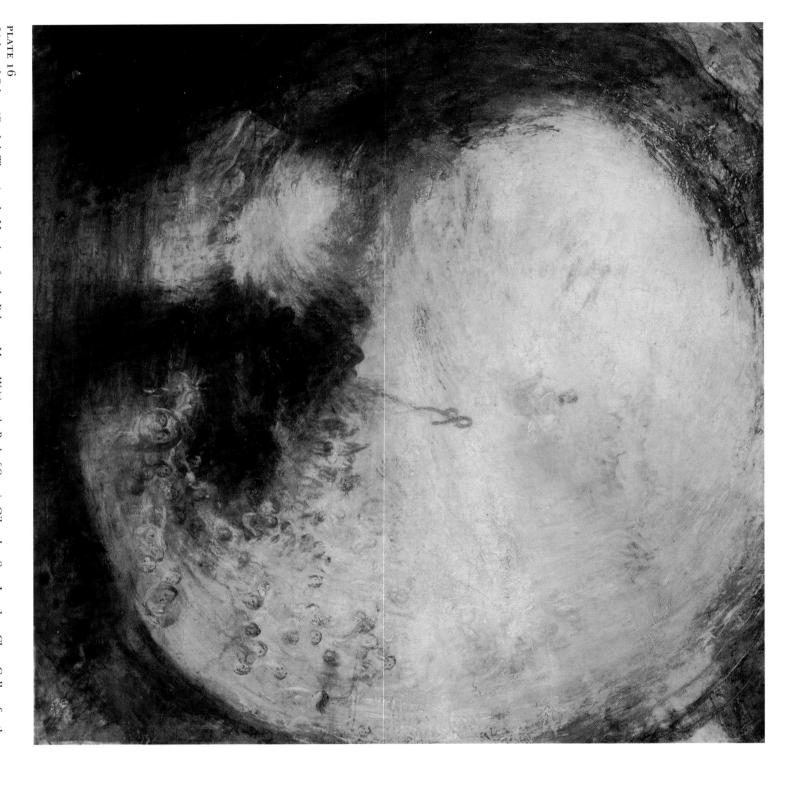

ANGEL IN THE SUN

1 Turner and History: A Brief Introduction

J. M.W. TURNER (1775–1851), the celebrated English painter of historical landscapes, was born into an age of political and intellectual ferment, an age galvanized by revolution – by the American Revolution, the French Revolution, and the Industrial Revolution. The dramatic changes that resulted had raised and sharpened Britain's consciousness of the present, heightened its awareness of the passage of time, and made it responsive to perceived relationships between events and conditions of past and present, relationships that are implicit in much historical writing of the first half of the nineteenth century. Turner, not unexpectedly, shared this awareness and was conscious of these discerned relationships.

The Industrial Revolution in eighteenth-century Britain presented new challenges and opportunities for humankind and resulted in tremendous social, economic, and physical changes. From a relatively stable agricultural economy, the country was gradually and irrevocably transformed into a dynamic, modern, industrialized society in which standardization "made the replacement of wood by iron increasingly necessary," in which machinery gradually replaced hand implements, and specialization was substituted for more general knowledge.[1] A part of the change was the shifting of populations and the growth of new social classes that led to repeated agitation for reform.

Science, from which technology developed, was also part of the change. The vigour of scientific enquiry during the late eigh-

teenth and early nineteenth centuries profoundly widened and deepened human understanding and control of the physical environment. Allegiance to ancient texts, especially the Bible, that had previously explained the world was now considered inadequate or wrong, as scientists depended increasingly on observation. Scientific investigations into the nature of the world had been stimulated not only by the new emphasis on empirical evidence but by the ordering and categorization of collected organic and inorganic specimens. Further, more precise calculations and the advent of increasingly refined apparatus provided the means for more successful penetration and accurate recording, measuring, deciphering, and interpreting of the phenomena of the heavens and earth.

Offshore events precipitated further change in Britain. The loss of the colonies in America as a consequence of the War of Independence had been a heavy blow. Then came the repercussions of the French Revolution and of Britain's wars with France, a struggle that lasted more than twenty years. This period saw Napoleon's remarkable rise to power and his determined expansionist ambitions that resulted in the rapid conquest of Europe. While Napoleon's policies nourished British fears of invasion, they also strengthened the country's sense of national pride and resolve to overcome this foe. With a smaller population than France but with superior technology, Britain was able to conquer Napoleon at sea and, with the aid of its allies, on land.

That Britain was attracted by, indeed obsessed with, Napoleon during this period is well established. Opinions of him differed and were sometimes ambivalent; he was considered evil by some, by others, good and great; more were perplexed by him, but almost all considered him captivating. Whatever the reaction, there was invariably agreement that he had secured for himself a prominent place on the world stage and in history. After his defeat, Britons continued to be fascinated with France, with its culture and its politics.

These are examples of some of the many striking contemporary developments, events, and personalities that through geography and circumstance impressed themselves on the British public's consciousness during the epoch in which Turner lived. Many of them found their way, directly or obliquely, into his art,

enriching, expanding, and reshaping its subject matter. His broad awareness of the current social, scientific, technological, and political events that were transforming his world led him to acknowledge, object to, or support pictorially certain of the changes, while at the same time venerating even more fervently aspects of the past.

Traditionally, landscape painting in Britain had occupied an insignificant place in the academic scheme of things, well below *istoria* (history painting), the most elevated category of painting. Its defining subjects, traditionally drawn from history and literature (including mythology and the Bible), were often concerned with heroic endeavours and actions, whether by gods, goddesses, or nymphs or by humankind.

Turner was particularly attracted to the subjects of *istoria*. He had developed from an architectural draughtsman and topographer into a landscape artist who began to realize that a landscape's importance lies not simply in its forms but in the meanings those forms can evoke. Awareness of the power of literature, especially poetry, and associationism marked the awakening of his metonymic and metaphorical consciousness, an awareness of correspondences between and among things that contributed to the underlying harmony of his pictures. This awareness led to the confident creation of distinctive landscapes whose historical subject matter, enriched with symbolism and allegory, set him apart from his artist contemporaries and often puzzled his audiences. He believed that historical landscape painting, which often dealt with the same or similar themes as *istoria*, was the latter's equal and, because of this conviction, endeavoured to improve the status of historical landscape by specializing in it. His early education prepared him for this role. His training as a topographical draughtsman was soon supplemented by the experience of drawing from casts and from the human model at the Royal Academy. He was also involved in independent learning: in addition to reading literature and history, he began to show an interest in science and studied old master paintings, their mainly historical subject matter, and their techniques.

Throughout his career, Turner was brilliantly resourceful. Indeed, he explored ideas that were well beyond those accepted and practised by his landscape-artist contemporaries. Many of

these artists were highly talented, but few painted historical themes, and of those that did, none was as perceptive or as innovative. From about 1820, his pictorial interpretation of history became increasingly imaginative and resistant to the maxims that had traditionally guided the depiction of history. He subscribed to the notion that the artist, like the poet (and he considered himself to have a poetical gift), has freedom of interpretation. As one of his contemporaries observed, the artist is independent; he is not bound by the historian's facts and events, which "have no dominion over the poet or painter ... history is made to bend and conform to the great idea of art."[2]

But poetic freedom had its cost in the limited ability of the viewers of his art to understand it. Turner's contemporaries and those who later wrote about his art were often bemused and baffled by it. Though they applauded his genius, they often failed to perceive many of his paintings' deeper meanings. Even the most supportive of the first writers on Turner did not appreciate important aspects of the content of his work, since he had almost nothing to say about it. Walter Thornbury believed that Turner's reticence was an expression of his secretiveness, which he adjudged a notable characteristic of both the man and his art:

All his life he had the peculiar love of mystification which is the result of suspicious reserve, when accompanied by humour. As a youth he concealed his processes of water colours from all but special friends with the narrow distrust of a petty tradesman guarding trade secrets ... As for his "Fallacies of Hope," that imaginary and unwritten poem was the standing joke of his life. Latterly in the names and even the subjects of his pictures he sought to puzzle and tease the public. His charitable intentions were mysteries; his residence was a mystery; where he had been to, where he was going to, and what he intended to do, were all mysteries; and so powerful was this habit of reserve that I have no doubt he died absolutely rejoicing in the fact that even his best friends knew not where he lay hid.[3]

During the earlier years of this century, one of Turner's ablest and most eloquent defenders, A. J. Finberg, had remarkably little understanding of the meaning of his paintings. He rebuked the artist's dedicated supporter John Ruskin, who, he asserted, read into his paintings "his own passions for botany, geology, and other

branches of natural history ... things utterly abhorrent to the imaginative artist."[4] Further, Finberg considered some of the oil paintings that Turner executed between 1815 and 1830 "disappointing," although they are unquestionably some of his finest. "It is no doubt regrettable," he observed, "that a man of his talents should have to waste his time ... in the manufacture of puerile and pretentious specimens of Academic 'high art.'"[5] Finally, Finberg maintained that Turner's paintings after 1830, produced during a period of "mental and physical decay," expressed a weakness and poverty of content.[6] Though the broad style of his later years sometimes renders forms in his paintings vague and difficult to interpret, most will agree that these particular assessments now have little or no validity.

Judging from the evidence of his art, Turner possessed no single, overarching concept of history or of the historical process. While pictorially he sometimes embraced the belief that history is linear, composed of unique, immutable events linked sequentially in time, on other occasions – or even in the same picture – he considered history to be cyclical, suggesting that history, in certain respects, is discontinuous. On this conception, as Stephen Jay Gould puts it, "Apparent motions are part of repeating cycles, and differences of the past will be realities of the future." Events "have no meaning as distinct episodes with causal impact upon a contingent history."[7] Examples of historical typology in Turner's pictures create or reinforce these repetitions. They are occasionally aided by conscious anachronisms that furnish a further means of enriching the meaning of his art and assist in elevating his work to what could be considered a plane of poetical truth. But if for the artist these devices were the means of attaining this goal, for the viewer they are often an obstacle to understanding.

The content of Turner's historical pictures is further thickened by the way in which layers of history interact in them. These layers may be present in the paintings themselves, in pictorial metaphors and symbols, or they may be supplemented externally by the paintings' titles or their attached verses. While this layered interaction can be between different national or public and private histories and between real or imagined events, the paintings invariably involve relationships that confront past and present. For example, in chapter 3 ("Greece and Italy"), paintings that concern the cultural legacy of Greece and Rome allude to national histories stimulated by the Napoleonic wars. In chapter 5 ("Rural Retreats") different regions and localities in England are discussed where private histories intersect with public ones. Chapter 7 ("Let my words / Out live the maker") examines histories that involve Turner's confrontation with artists of both past and present. In chapter 10 ("Biblical History: Fall to Apocalypse"), a particularly dense interaction of histories occurs: biblical history, intertwined with political history, is wrapped in distinctive strands of personal history. Finally, the interaction and yet discreteness of the conflicting histories of science and religion are subjects discussed in chapter 9 ("'The Terrible Muses': Astronomy and Geology") and in chapter 12 ("'The dark'ning Deluge' – *Shade and Darkness* and *Light and Colour*: The Late Deluge Pictures").

2 The Louvre and the Royal Academy Lectures

WHILE STILL AN ADOLESCENT, J.M.W. Turner, whose father was a barber and wigmaker, contemplated a future more ambitious than that of limning topographical views. This precocious youth, who had been working with architectural and landscape draughtsmen, was granted admission to the Plaister Academy of the Royal Academy Schools in 1789 and to the Academy's life classes in 1792. Although the mandate of the Royal Academy was to advance *istoria* and although students were instructed in its virtues, the Academy provided little assistance to this ambitious young artist who was determined to become a painter of landscape and, toward the end of the 1790s, a painter of historical landscapes. Nevertheless, while a student there, Turner studied under the Irish history painter James Barry (1741–1806), who was then professor of painting. Barry's lectures may have captured his interest, as has been suggested,[1] but possibly more important was the influence of his paintings. Their symbolical and allegorical qualities are sometimes reminiscent of those qualities that would come to characterize Turner's historical landscapes.

However, Turner's development as a landscape artist – and particularly as a painter of historical landscape – was still largely contingent upon his own independent effort. The Royal Academy's first president, Sir Joshua Reynolds, in his annual discourses delivered to students (1769–90), had urged his charges to adopt the "great style" characteristic of history painting through a study of the works of eminent masters from the past, mainly the Italians. He asserted that the task of the young artist was not to copy these old masters, only their conceptions – their general principles. This, Reynolds believed, would help students to forge their independent styles and make British art the equal of the best that Europe had produced.[2] The young Turner, determined to become a painter of landscapes, seems to have taken heed of this advice. While conscious of the rapid changes taking place in his world, in his early education this artist trod, in many respects, an essentially traditional path by seeking knowledge and inspiration in the culture of the past. He was apparently anxious that he should have the advantage of the solid education that a study of the excellent qualities of paintings by the great masters could provide, an education that would, in fact, prepare him to paint many types of landscapes. But he did develop other interests. Indeed, before 1800, before he was twenty-five years of age, there is ample evidence that his curiosity, interests, and intentions had broadened. Not only had he begun to study closely old master paintings, he had developed an interest in science and had consciously begun to court a wider celebrity by creating more ambitious landscapes of varied content and mood in both watercolour and oil. These included works of dramatic scenery, sea pieces, industrial themes and, most significantly, landscapes with historical subjects. Some of these paintings and watercolours were accompanied, when exhibited, with poetic lines. Poetry would play a significant role in the meanings of his historical canvasses.[3]

Reynolds had recommended in his sixth discourse that the young artist examine as broad a range as possible of examples of the work of the great masters, since a mind so enriched "will be more elevated and fruitful in proportion to the number of ideas which have been carefully collected and thoroughly digested. There can be no doubt but that the who has the most materials has the greatest means of invention." One does not know whether or not Turner was aware of Reynolds' counsel. However, he did seek a more extensive and deeper knowledge of the paintings of old masters and, partly for this reason, made his first trip to the continent, which occurred only months after he had been elected to full membership in the Royal Academy in 1802. During his trip

Turner studied the old masters in Paris, in the Louvre. Only five years later this talented and ambitious young painter would use the knowledge acquired there when elected as the Royal Academy's professor of perspective, a position that involved annual lectures. His knowledge of the art of the old masters, greatly augmented by this Paris visit, his conversations with colleagues, friends and patrons, and his wide reading undertaken both as a student and teacher, were to have profound implications for his own painting, especially his paintings of history.

The other reason for his continental visit was to see and sketch the French and Swiss Alps, most recently associated with the Italian campaigns of Bonaparte in 1796 and 1800. Turner visited Mont Blanc, Chamonix, and the Great St Bernard, going as far as the Val d'Aosta.[4] The landscapes that are the fruits of this visit are striking, uncompromising records: they reveal a remarkable sensitivity to the geology, spatial existence, and grandeur of the mountainous landscapes that confronted him. In them Turner attempted to suggest the intensity of a direct encounter with nature and the inherent threat that this encounter generates when the viewer seems to be transformed from observer to participant.[5]

THE LOUVRE

Turner's continental trip would not have been possible had it not been for the signing of the Treaty of Amiens, which temporarily halted the war between France and Britain. After almost ten years, tourists once more could visit Europe. The beginning of his sojourn was not without incident. His passage across the Channel from Dover to Calais was rough, and the boat that conveyed him to the pier almost sank. Possibly because he believed this trip was of signal importance for him and his art, he later painted a marine subject to commemorate it, *Calais Pier, with French Poissards Preparing for Sea: An English Packet Arriving* (exh. 1803; London, National Gallery). Its turbulent setting, indebted to seventeenth-century Dutch marine painting, not only demonstrates his thorough knowledge of sailing and the nature of the sea but also alludes to his difficult landing, about which he pithily noted in his sketchbook, "Nearly swampt."[6] From there he went to Switzerland

by way of Paris and on his return journey stopped again in the French capital, where he toured the studios of the renowned contemporary neoclassical painters, Pierre Narcisse Guérin and Jacques-Louis David. In David's studio he viewed that master's equestrian portrait, *Napoleon Crossing the St Bernard* (fig. 1). However, more important was his visit to the Louvre. He examined its collection of paintings, especially the celebrated canvasses that the conquering Bonaparte had brought back as booty. There, Turner's acute powers of observation and critical acumen were put to the test. He scrupulously studied works mainly by Flemish, Dutch, French, and Italian masters, particularly those from the periods of the renaissance and baroque. He was tireless in his pursuit of the information that these pictures could divulge. He was especially attracted to history paintings. In his sketchbooks he described and analysed their subjects, their structure, styles, techniques, and particularly their colour. He occasionally sketched their compositions, a few of them in watercolour. He was not uncritical of some of these paintings; he even suggested how they might have been improved![7]

Turner was assiduous in making notes on the art of the north Italian painters, especially the Venetians. He had a particular sympathy for the work of Titian and was struck by the dramatic effects of that artist's celebrated historical painting, *St Peter Martyr* (fig. 2): "This picture is an instance of his great power as to conception and sublimity of intellect – the characters are finely contrived, the composition is beyond all system, the landscape tho' natural is heroic, the figure wonderfully expressive of surprize and concomitate [concomitant] fear. The sanguinary assassin [is] striding over the prostrate martyr who with uplifted arm exults in being acknowledged by Heaven. The affrighted Saint has a dignity even in his fear (and tho' Idea might have been borrow'd) yet is here his own. The force with which he appears to bound towards you is an effort of the highest powers."[8]

However, it was the technique of Venetian painting that mainly attracted him; it was responsible for the school's characteristic effects of breadth, depth of tone, and colour. For that reason he made notes on what he considered historical colouring in Sebastiano del Piombo's *Resurrection of Lazarus*: "The colour so unites with the subject as to impress it forcibly and anticipates the

1 A. Gilbert, after Jacques-Louis David. *Napoleon on the Great St Bernard.* Engraving. London, Victoria and Albert Museum

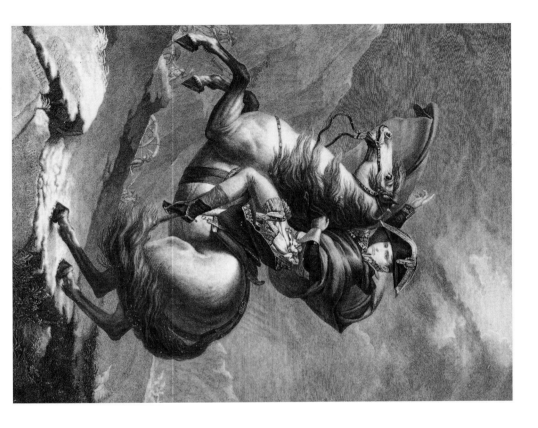

characters, which are here rather feeble ... the sombre tint which reigns thro' out acts forcibly and enforces the value of this mode of treatment, that may surely be deem'd Historical colouring; which in my idea only can be applied where nature is not violated but contributes by a high or low tone to demand sympathetical ideas."[9]

It was therefore often the means that the Venetian artists employed to achieve colour effects, as well as the descriptions of the colours themselves, that he recorded. In his analyses, for example, it was the layering of colour and the effects created by the reflection of light from the underpainting through transparent or translucent coloured over-glazes that captured his attention. He also considered the relationship between the dark ground colour and opaque and translucent whites scumbled over the ground. He noted that these whites produced a range of (optical) greys that established a tonal framework for subsequent colour glazes and touches of impasto. He was aware that the intensity of hue is heightened when a pure white or nearly pure white (as for example, in a highlight) is given a wash or glaze of colour.[10]

When examining the technique of Titian's *Christ Being Crowned with Thorns,* after making acute observations concerning the picture's psychological dynamics, he observed that it possesses a green-brown ground. This, he believed, was composed of "Spanish Brown and Umber" that show through the picture's background, the painting's "Broadest Shadow." The figure in the right foreground, "in Mail in Black with lights," functions, he observed, to relieve the monotony of the background brown.[11] He also noted that the drapery worn by Christ appeared to have the effect of crimson, though in fact it "is only a wash [of] V[ermilion] R[ed])."[12]

Turner completed a still more penetrating technical analysis in his sketchbook of another historical painting by Titian, the *Entombment of Christ.* Like *Christ Being Crowned with Thorns,* this painting possesses, he observed, a brown ground. Though the ground shows through the glazes in some areas, it does not in others, where opaque paint ("solid coloring") is applied to harmonize with it, in both hue and value.[13] In this picture Turner, conscious of the warm and cool nature of colours, remarked on the power of glazing to modify them and their relationships. He noted how Titian was able to balance the warm brown of the

2 M. Rota, after Titian. *The Martyrdom of St Peter Martyr.* Engraving. London, British Museum

ground in areas of flesh tone by applying a glaze of "a cold color" over it, "so that it is neither purple or green ... If he [the artist] wanted to colour them higher [? warmer, he could apply] ... a [further] glaze. Thus his brown figures lose in a great measure the grey colour which in fact is produced by the [? interaction of the glazed cold hue with the] ground."[14] Turner understood the role of the ground as a pictorially unifying element, whether showing through the transparent or semiopaque glazing or having opaque colour mixed into it in order to harmonize the overall effect. He also observed the breadth of effect created by the three primitive colours – red, yellow, and blue – interacting.[15]

Unity of effect in Titian's paintings was also assisted, Turner noted, by the introduction of the final "neutralizing" glaze. Turner considered this glaze several times when referring to *St Peter Martyr.* He adjudged the sky too vividly blue, which he attributed to the loss of its glaze; it was his opinion that this glaze was also missing from strategic areas of the figure of St Peter, specifically, from the saint's right hand and leg.[17] Such acute technical comments by Turner are important, not only because they indicate his careful observation but because they reveal his particular interest in, and understanding of, the various functions of glazes and the manner in which glazing colour responds to, controls, or is controlled by the hues and values of pigments over which it is applied. Though it was Claude Lorrain, the seventeenth-century French painter, whose pictorial effects of illumination were strongly to influence his work, aspects of the glazing technique of the Venetians aided him in achieving in his paintings, and especially in his historical canvasses, similar and indeed even more efficacious light and colour effects.

In consequence of his analyses of paintings in the Louvre, Turner came to appreciate the complexity of the Venetian technique, a technique that had fascinated many of his English colleagues, who recently had been intrigued by the proclaimed discovery of the so-called "Venetian Secret." As Finberg noted, before the opening of the Royal Academy exhibition of 1797 John Hoppner, the portrait painter, called upon Joseph Farington "to congratulate him on the success of his picture painted according to the newly discovered 'Venetian process.'"[18] This "discovery," which had been divulged by a Miss Purvis "to those who chose to

pay a fee of ten guineas for the secret," would allow the modern artist to emulate the remarkable richness of colour found in the paintings of the old Venetian masters.[19] It was satirized in a print by James Gillray, *Titianus Redivivus; or the Seven Wise Men Consulting the New Venetian Oracle*, in which allusion is made to the young Turner as being clear-minded and not duped as were many other more established and illustrious senior artists by this declared painterly nostrum.[20]

Turner's notations in the Louvre sketchbooks suggest that he believed the only way to learn of the Venetian technique was to study it at first hand. He was able to demonstrate, through his analyses, the interaction of colour when applied in varied combinations of impasto and glaze. Judging from his technical notes, he would seem to have agreed with the poet James Thomson, who noted in his poem "Liberty" that the Venetians had discovered "the magic art of colours melting into colours."[21]

LECTURES

Turner's notes on paintings in the Louvre sketchbooks document his growing fascination with colour, which found fuller expression in the notes he prepared for lectures when he became professor of perspective in the Royal Academy. He had become an artist to be reckoned with. His election in 1807, even though he was the only candidate, must be seen as acknowledgment of his considerable talent. He may have envisaged himself, in some respects, as heir to the academic mantle that had been Reynolds'. His new position, of which he was immensely proud, particularly considering his humble background, entailed an annual series of six lectures. While the watercolour illustrations accompanying his lectures were admired, the lectures themselves were criticized for their lack of comprehensibility. Also, the first lectures were not given until 1811 and, henceforward, were presented irregularly. Even though his lectures were not a success and were not delivered annually, he clung to his position for a period of thirty years, until 1837.

Turner, though a man of unrivalled artistic skills and quick, fertile intelligence, was not ideally suited to the task of lecturing. He laboured diligently in preparing his lectures, but he experienced difficulty in writing, organizing, and delivering them.[22] He was often, though not always, crippled by his inadequate command of language, by an inability to give clear expression to the complexities of his subject matter, the subtleties of his thought, and the brilliance of his intuition.[23] Turner's lectures, peppered with quotations, some from poetry, are nonetheless rich in content, as has been admirably demonstrated.[24] He was remarkably omnivorous in his reading and assiduous in his note-making. He assembled his own library and consulted the libraries of others, including that of the Royal Academy. He devoured texts, ancient and modern, that would aid him by providing information on perspective and on the wider context of art. He sought information that would aid in clarifying and confirming ideas he had already reached through "self-found" knowledge. This knowledge had resulted from his own experience as a former architectural draughtsman, as an amateur architect,[25] and as a thoughtful working landscape artist whose aim was to further his reputation as a painter of history. The lecture notes and comments that he pencilled in books he consulted when preparing his lectures form the principal repositories of his reflections on art. Indeed, as has been rightly observed, the lectures "are central to Turner's conception of his role as an artist."[26]

From his lecture notes it is evident that Turner intended to present the "practical theory" of perspective. Perspective was highly technical, and its intricacies not easily conveyed. Indeed, he rejected its theoretical complexities.[27] While he believed that the artist should master the rules of perspective, since they were useful and should be learned at an early age,[28] it was his passionate conviction that they should not fetter him.[29] With the aid of often relatively simple diagrams and highly attractive drawings he hoped to make the material of the lectures interesting and accessible.[30]

The subjects that he covered, however, were not limited to the technical refinements of perspective systems. His aim was more ambitious. The books he consulted concerned with the theory and application of perspective led him inevitably to undertake more exhaustive research into the nature of form and light and colour. Though initially he considered that light and colour should perhaps more properly belong to the professor of painting than to him, this subject was introduced in his lecture series of

1811 and became increasingly important to him during the latter part of the decade and the early 1820s.[31] The content of these lectures was broadened still further, since perspective was important to all subjects of painting;[32] He even introduced topics in the history of art, touching, if only briefly, on the art of the ancients[33] but discussing in detail paintings of the renaissance and baroque and considering his own particular specialty, landscapes. Sir Joshua Reynolds before him had elevated portraiture by marrying it with *istoria*. In his lectures, Turner achieved the same for landscape since, as already noted, he believed that historical landscape painting was the equal of history painting.[34] In enlarging the scope of these lectures, Turner wished not only to indicate the applications of perspective to many aspects of art but, in emulation of Reynolds, to present himself as a "learned painter."[35]

In Turner's lecture notes, form, light, and colour are discussed because of their intimate relationship with linear and aerial perspective. Forms that he believed provided nature's elemental structures were pictorially considered according to rules that established reciprocal relationships between the representation in drawing or painting of forms and the shapes of the corresponding solid objects existing in the world. He observed that "the pure forms of Triangle or Circle, Cube or Cone" underlie the appearances of nature.[36] Turner suggested that the permanent forms of nature support the appearances of nature – its "effects" – and he described the appearances of nature in terms of the "mutability of Time and Seasons," which "are our materials and offered daily as our patterns of imitation."[37] These materials involve the transient qualities – colour, light, and shade – that clothe and act on the permanent forms and, indeed, even overcome them. For Turner, these "pure" underlying structures perform pictorial functions similar to the serpentine *line of beauty* discussed in Hogarth's *Analysis of Beauty* (1753), with which he was familiar.[38] The line of beauty, like Turner's elemental structures, had an existence in both two- and three-dimensional space. Hence, Turner's triangle and circle are shapes that establish two-dimensional structures in a picture,[39] while the cube and cone provide structures in three dimensions.

When preparing notes for his lectures, Turner also considered light and colour in relation to science. Light was colour, and Turner, like most artists of his time and earlier – and like Newton – believed that light colour and material colour possessed qualities in common. Though artists might concur with Newton on this point, many disagreed with his assertion that white light could be refracted into seven primary colours; these artists affirmed from their own practical experience that the basic colours in nature, the "building blocks," were three, from which all colours derived. They believed that the fundamental colours in nature, from which the secondaries were produced, were red, yellow, and blue. Red and yellow mixed, produced orange; red and blue together, created purple; yellow and blue mixed, resulted in green. Turner concurred with these beliefs. In his notes, he recorded comments concerning the dispersal and mixing of rays of light: "Every body participates of the color of the light by which it is illuminated, for [the] Blue ray shows upon yellow, producing a green, red rays upon Blue[,] purple."[40] Yet Turner, like others, was aware of the limitation of theory when it came to mixing pigments[41]: "If we mix two [of the three primitives], we reduce the purity of the first; a third impairs that purity still more; and all beyond [is] monotony, discord and mud, or as Sir Joshua says practise [*sic*] must in some case[s] precede theory."[42] Although he intended these thoughts for the audience at his lectures, they had a more personal significance. It was his private wish to find a way to maintain the brilliance of pigment colour so that it could approximate certain effects of sunlight, and as the next chapter will show, in his oil paintings he exploited certain technical qualities of watercolour, using a white ground and glazes that he developed from his knowledge of the Venetian technique.

Turner's notes made earlier in the Louvre provide evidence of his interest in the nature and function of pictorial colour, especially the intimate relationship between colour, light, and shade that proved of assistance when he was shaping his lectures. In them he observed that "Color is universal gradation, of color to color, from the simple pastoral to the most energetic and sublime conceptions of form, combined with chiaroscuro."[43] The relation and interaction between hue and tone were historically established and well known to artists, as the layout of their palettes often attests, with the lightest colours leading through a series of descending values to the darkest; this scale of colours was often

parenthetically enclosed by white and black. Turner's palette indicates that he followed this arrangement. Such a traditional tonal sequence or relationship of pigments was determined by the dominance of tone over colour characteristic of chiaroscuro painting.[44] These interests, particularly the relationships between pigment and light emerge from Turner's lecture notes, where he considered the "substitute of light" to be white pigment[45] and discussed the active role of light in modelling and providing reflections in shaded areas. Reflections, he averred, are efficacious not only because they bring out colours but because they enrich these hues with "the matchless power of chiaroscuro."[46]

Pictorial reflections that Turner had studied in paintings in the Louvre deeply interested him, and they were to have a profound effect on the character of his art. He considered light to be powerful, to possess a number of different qualities deriving from different sources and resulting from light striking planes at different angles.[47] He observed that "Darkness or total shade cannot take place while any angle of the light reflected or refracted can reach an opposite plane."[48] He considered several kinds of reflections, those of solid bodies, those of polished bodies, and those that are transparent.[49] He was especially interested in the variety of reflected effects in water, not only because of its transparent nature but because of water's susceptibility to motion and its ability to refract light.[50]

As a painter, Turner was conscious of the close and necessary connection between value and hue. As he not only prepared works of art to be engraved but was an engraver himself, he understood how intimate that relationship must be. "Lines," he observed in his lecture notes, "become the language of colors."[51] However, he understood that the scale of tones between painting and print is necessarily different. The tonal range of engraving, as a result of the often reduced size of the translated design, the medium, and the technique employed, is more limited. The engraver is forced to compensate. Turner observed that "White scarcely exists in a Painter's scale but is the only means the Engraver has of making his lights."[52] The painter can attract the eye, not by the tonal lightness of a colour (which is the only means available to the engraver) but by means of pigment saturation. "Red [is] the strongest ray that call[s] the Eye wherever placed,"

and holds it to the exclusion of yellow."[53] Yellow may have a lighter value than red, but it lacks its strength of hue. An engraver, because he must see a colour in terms of value rather than hue, may be inclined to translate a red, however brilliant in appearance, in terms of its place in the tonal scale, since it is lower on that scale than either yellow or white. Still, because of its high saturation, in the touched-proof stage of the print the artist might wish the engraver to recognize that particular quality of the red by shifting its position in the tonal scale either towards white or black. The artist is normally more concerned that the engraving should capture the "effect" of the original work of art rather than its precise sequence of values. Turner realized, as did other painters who prepared art for engraving, that the print possessed an existence independent of the original work on which it was based.[54]

In his lectures Turner discussed light, shade, and colour not only with respect to theory but also as they functioned in old master paintings, and he referred largely to the Dutch, Flemish, French, and Italian schools. His experience in the Louvre was of specific assistance to him. The light and shade effects of Rembrandt he found beguiling,[55] and north Italian painters again (notably in the revision of his fifth lecture in 1818)[56] had a particular attraction for him. He discussed, often with great sensitivity, their subject matter and was perceptive when analyzing their colour and light and shade effects. He carefully described the character of the paintings of Correggio and Titian, whose reputations as colourists were well established. In the eighteenth century, Daniel Webb, in his *Inquiry into the Beauties of Painting* (a copy of which was in Turner's possession), had observed that Rubens "has painted in imitation of the rainbow; all the colours co-operate; the effect is good but accidental but, in Titian and Correggio, this arrangement is the result of science [read 'system'], it is a harmony which springs from a judicious and happy union of consenting colours."[57] Reynolds believed that Correggio and Titian were "two great colourists." He admired the particular effects of Correggio's art: "his breadth of light and colour" and "management of uniting light to light."[58] Turner's analysis of Correggio's art differs from that of Reynolds, though it is of the same order. He speaks of Correggio's "concentration of lights" but is more spe-

cific than Reynolds.[59] Because Turner believed that colour plays an especially complex role in painting, he transmuted Reynolds' account of chiaroscuro into one essentially of chromatics, since it was not only the value relationships but the dynamic of hues that fascinated him. In considering Correggio's "concentration of lights," he referred to white pigment as being related tonally with other colours.[60] Yellow, he believed, functions next to white; it is the next lower tone, followed by red, then brown and blue. However, the tonal sequence does not conclude with blue but with black, sometimes modified with colour: "These midnight shadows become toned or tinged with other primitives, or admitted pure as means of contrast."[61]

Light and shade, as it articulates form, establishes, Turner stated, the character of the paintings of each master, and colour, that of different schools,[62] although in his discussions he did not always acknowledge that distinction. He undertook to compare the light and colour effects of Venetian pictures with those of the Bolognese. He considered that "In … [the Venetian school], light by breadth appears *spread over the whole*."[63] What he seems to say is that luminous, colouristic effects triumph over strictly tonal modulations. Turner stresses especially the dynamic role of colour in the shadows of their paintings. The approach of the Bolognese school he considered to be different. He followed Reynolds in remarking that in their paintings colour functions as light and shade.[64] He referred to their characteristic "chiaroscuro" and "depth [of tone]."[65] The primitive colours (red, yellow, and blue) are deployed primarily for their value relationships,[66] which are aided by "half tone" created in shadows by reflected lights.[67]

Like Reynolds in his *Discourses*, Turner analysed Veronese's monumental history painting, the *Marriage at Cana*, and remarked on its light and shadow effects. Reynolds spoke generally of the "great light in the sky."[68] However, Turner, again more concerned with particulars than Reynolds, considered its tonal effects exemplary; he referred to the picture's "breadths of … half-tints and the lights" created by its "white, greys and a faint medium of the yellow … with a Blue Sky."[69] Both artists considered the painting's shadowed figures. Reynolds remarked that "the figures are for the most part in half shadow"; Turner, however, thinking more specifically in terms of hue rather than simply of tone, com-

mented that the "colors of the figures are its Shadows by contrast."[70] More generally, Turner discussed the complexities of the pictorial effects of colour in light and shade and spoke of the success of some colour combinations and the relative failure of others.

Turner also considered, as he did in the Louvre, historic colour, or historic tone. For historical subjects there are, he declared, "Historic or Poetic colours."[71] He believed that there were two types of historic colour in a picture. First, he claimed that it was a final overall glaze that provides a unifying tone for local colours.[72] Second, and more significantly, he considered historic colour to be the vehicle for symbolic, expressive qualities that requires "the busy power [of] memory."[73] Though appropriate colour tones should be employed to express particular subjects, Turner considered that their specific application cannot be codified. Hence, he rejected the idea of a fixed relationship between colour and subject in the work of Poussin.[74] Turner observed:

were we to follow the musical distinctions offered to designate style [or] the tones of colour, of grave, soft, magnificent, as have been ascribed to Poussin, with Qualifications of colours innate, as those of fury and anger for Phyrrus, gracious and delicate in the Picture of Rebecca; Langor and Misery in the Gathering of Manna … every tone must be Dorian, Lesbian, Lydian, Ionic, Bacchanal, all would be Historical Theory and practically confining depriving those tones of explicable commixture that appall by gloom and drag the mind into contemplation of the past [as] in his Picture of the Deluge distracting Theory by the uniformity with which he has buried the whole Picture, under the deep toned horrid interval of approaching gloom, defying definition, yet looking alluvial, calling upon those mysterious ties which appear wholly to depend upon the association of ideas.[75]

Though Turner considered the category of "Historic or Poetic colours" as suitable for sublime subjects, he asserted, with a negative allusion to Reynolds' "Rules of Art," that in such "elevated branches of Art, Rules, my young friends, languish … the higher qualities of sentiment or application of intellectual feeling, forming the poetic, Historic, or perceptions gained from nature and her works, are far beyond dictation."[76]

While art might in its most elevated form become "poetical," the traditional analogy established between painting and poetry (*ut pictura poesis*) had its limitations. Turner was familiar with the concept. Though painting and poetry both imitate nature and have the power to affect, these sister arts are fundamentally different. Poetry is a "speaking picture"; painting is "mute poetry." "The one operates in time, the other in space; the medium of the one is sound, of the other colour; and the force of one is successive and cumulative, of the other collected and instantaneous."[77] Poetry is dynamic and discloses its meaning as it is read. Pictorial art is static; its subject embraces the "immediately present moment."[78]

Though Turner was convinced that "good Painters" cannot be produced "without some aid from Poesy,"[79] he offered, nonetheless, apposite examples of the obstacles confronting the artist who attempts to imitate certain poetical effects. Using verses from Thomson's *Seasons* and Milton's *Paradise Lost*, he first pointed to their fundamental differences. The first lines, from Thomson, describe "Morning," the second, from Milton, "Evening," and they "depend, notwithstand[ing] the beauty of the diction, on color, one active, the other passive; [the one] possessing the utmost purity of glowing color, and [the other] the last solemnity of chiaroscuro, by color."[80] The lines by Thomson illustrate the difficulty faced by the artist when attempting to imitate temporal effect in poetry:

But yonder comes the powerful King of Day,
Rejoicing in the East; the lessening cloud,
The kindling azure, and the mountain's brow
Illumin'd with fluid gold, his near approach
Betoken, glad.

Turner savours these poetic lines: "The lessening cloud displays the most elevated power of delineation; and the kindling azure resembling Shakespeare's beautiful ... ballad that fancy, when established, dies."[81] The sense of movement and transition conveyed by this powerful imagery is both the poetry's strength and, as he seems to have believed at that time, what has made it inaccessible to the artist.[82] As Turner stated, "The difficulty is the poetic truth."[83]

In the "passive" imagery of the second lines, from Milton's *Paradise Lost*, Turner isolated a different difficulty encountered by the painter, that of the translation of described tones: "Now comes still Evening on and twilight grey, / Had in her silvery [sc., sober] livery all thing[s] clad: / Silence accompanied. "Grey" in the context of the poetic lines assumes, Turner suggested, the idea of "purity."[84] Yet, in painting, such tones "often fail." It is hopeless, he observed, to define "that tone which cautious Nature throws round for [a] mantle at evanescent twilight." In terms of painting, he asked rhetorically, how can it be introduced "without producing monotony of colour? Here then, Rules surely cease."[85]

Although the lectures indicate Turner's abiding belief that rules and theory have limited value for the artist, he respected the authority of science and was convinced that it offered the artist opportunities.[86] The aim of science was, after all, human understanding and hence control of the physical world. It was to science and nature that Turner turned when he discussed, as had others, the materiality of light as presented originally by Newton: "Every body," Turner observed, "emits or reflects numerous inconceivably small particles of matter from each point and plane of its surface, continually and in all directions."[87] Wherever light penetrates, there is colour, since "Light is ... color" and is responsible for the variations of natural light effects. "The grey [crimson struck] Dawn. The yellow morning / Golden Sunrise and red departing ray, in every changing combination ... are constantly found to be by subduction or inversion [?] of [the] rays or their tangents."[88] Turner was fully aware that colour was part of dynamic natural processes that the artist must come to understand. Probably echoing the ideas of Roger de Piles, Turner wrote, "The Science of Art and her Combinations [is] Coloring, not color."[89] Many of the ideas contained in the various versions of the Royal Academy lectures will assist us in understanding Turner's approach to his own art and particularly to his historical landscapes.

Turner perceived the Royal Academy, where he was now ensconced as professor of perspective, not only as a means of conveying his ideas on art but as the bulwark against the attacks of the nonprofessionals, the amateurs and connoisseurs who considered themselves arbiters of taste.[90] In his annotations in Shee's *Elements*

of Art (1809) he echoes a passage in Reynolds' fifteenth and final discourse, where the latter observed that "one short essay written by a Painter, will contribute more to advance the theory of our art than a thousand volumes such as we sometimes see; the purpose of which appears to be rather to display the refinement of the Author's own conceptions of impossible practice, than to convey useful knowledge or instruction of any kind whatever."[91] Turner stated that "The Painters ideas of practical knowledge would, if encouraged to give their thoughts, be useful to the student but the connoisseurs liberality makes him undertake to instruct the Painter the Student and correct the public taste and [in] the words of Johnson has encouraged every vain man to set the worst of idols, Vanity to betray the students eager early zeal by asserting, 'He that amends the public taste is a benefactor.'"[92]

There is a connection, it would seem, between these words and Turner's compositions. In 1809, he prepared two watercolours, *The Amateur Artist* (fig. 4) and its companion, *The Garretteer's Petition*; the latter, likely influenced by Hogarth's *Distressed Poet*,[93] he developed into a painting that he exhibited at the Royal Academy in this same year (fig. 3). These works, directly or indirectly, reflect the genre styles of Dutch and Flemish painting that can be identified in some of his other exhibited paintings of this period. He was influenced to a degree by Rembrandt and by the subject matter of the Brouwer- and Teniers-inspired canvasses of the young Scots painter, David Wilkie, who was largely, though not entirely, responsible for making genre painting academically acceptable in Britain.

The subjects of both compositions transcend their function as mere genre pieces and approach, if not reach, the realm of history, being concerned with ironic aspects of inspiration. The starving poet with the print of Mount Parnassus on the wall of his tiny room who calls on his reluctant Muse[94] is wittily contrasted with the well-fed, self-satisfied amateur painter who has the egoism and arrogance of one who possesses and requires no inspiration, since he makes use of the artistic ideas of others: on this drawing there is reference to "stolen hints from celebrated pictures." The pictures referred to possess historical subjects, the Judgment of Paris and Forbidden Fruit,[95] subjects that are related to themes in Turner's own history painting, the *Garden of the Hes-*

perides, which he had exhibited in 1806 at the newly formed British Institution. This rival to the Royal Academy was run largely by a group of aristocratic collectors, connoisseurs, and amateurs of conservative taste, amongst whom was Sir George Beaumont. In *The Amateur Artist* there is also a reference to "mysterious varnish." As has rightly been observed, Turner could be making allusion to "technical nostrums"[96] and to "Filchings from [Richard] Wilson" that appeared in Gillray's famous print, *Titianus Redivivus* (1797),[97] in which reference is also made to Turner.

Since connoisseurs and amateurs as arbiters of taste were anathema to Turner, in *The Amateur Artist* he was almost certainly mocking them. It is probably significant that he created this work only two years after being elected professor of perspective (in 1807, as we have seen). As an academician, his disparagement of and annoyance with amateurs and connoisseurs was perhaps fed by his specific, abiding dislike of the arch and imperious Sir George Beaumont, who had been intriguing incessantly against him.

That Beaumont felt pangs of jealousy and envy due to the artistic successes of this still relatively young man seems likely. Beaumont was a conservative amateur and studied landscape painting under the tutelage of the doyen of eighteenth-century British landscape artists, Richard Wilson, whose classic style he had consciously emulated. Widely admired and supported by the nobility, Beaumont was considered by them to be *the* outstanding landscape painter of the day.[98] As a connoisseur and collector, as well as a painter, he had arrogated to himself the role of arbiter of taste. Outspoken in his criticisms, in 1803 he had stated that the water in Turner's *Calais Pier* was like "the veins on a marble Slab."[99] When Turner opened a gallery in Queen Anne Street in 1804, Beaumont visited it and boldly criticized his pictures. Two years later when Turner exhibited two pictures in the gallery of the British Institution, the *Echo and Narcissus* and the *Garden of the Hesperides*, Beaumont indicated a particular distaste for them, saying that they "appeared to Him to be like the works of an *old man* who had ideas but had lost his power of execution."[100] In 1806, Beaumont and a group of seasoned artists had a dinner at the home of Joseph Farington, who had been friendly with the young Turner. Farington confided to his diary on that occasion that "the Vicious

3 *The Amateur Artist*. Pen and watercolour, c. 1809. 19.3 × 13.7 cm. London, Clore Gallery for the Turner Collection (TB CXXI, B)

4 *The Garreter's Petition*. Oil on mahogany, exh. 1809. Painted surface 20 ⅞ × 30 ¾ in. (53 × 78 cm). London, Clore Gallery for the Turner Collection (BJ 100)

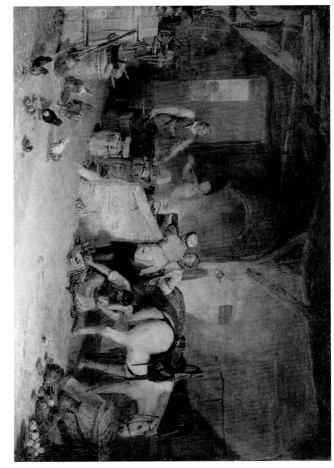

5 *A Country Blacksmith Disputing upon the Price of Iron, and the Price Charged to the Butcher for Shoeing His Pony.* Oil, on pine panel, exh. 1807. 21 ⅝ × 30 ⅝ in. (57.5 × 80.5 cm). London, Clore Gallery for the Turner Collection (BJ 68)

practise [*sic*] of Turner & His followers was warmly exposed."[101] In 1807, when Turner exhibited at the Royal Academy his *Sun Rising through Vapour* and the genre subject *A Country Blacksmith Disputing upon the Price of Iron* (fig. 5), which was in rivalry with Wilkie, Beaumont complained of Turner's lack of "execution" and observed that "*Loutherbergh* [*sic*] was superior to Him."[102]

Despite Beaumont's constant criticisms, it would seem he was not entirely opposed to the work of this young artist, since he at-tempted to purchase one of his pictures, *Fishing upon the Blythe-Sand, Tide Setting In* (RA 1809, 1815; Tate Gallery). Thornbury states that Turner "had the proud pleasure of refusing to sell [it] to his old enemy."[103] The artist would have been apprised at an early date of the hostility that Beaumont felt toward him, and he appears to have resented and grown impatient of it. Though Beaumont may have believed that he was immune from retalia-tion, he was not. It seems likely that the baronet is the specific butt of Turner's ridicule in *The Amateur Artist.*[104] However, Turner seems to have confronted his foe once more. And it would be in a quite remarkable history painting discussed in chapter 4.

3 Greece and Italy

THE SCOPE OF TURNER'S READING for his perspective lectures is an affirmation of the overriding importance of study to this maturing artist. One of the subjects that had fascinated him was the classics. From a relatively early age, concerned with his development as a painter of history, he probably heeded Reynolds' recommendation that universal themes from classical fable and history be selected as subjects for painting in the "great style."[1] He would have been receptive to such advice. Intellectually and emotionally he and his contemporaries still considered themselves close to the Greco-Roman world, nurtured as they were on its cultural heritage. Certainly classical history, legend, and myth taken from secondary sources form many of the subjects of Turner's art. Turner never visited Greece though had circumstances been favourable, no doubt he would have. He did, however, visit Italy on a number of occasions.

During the second decade of the nineteenth century Turner's interest in Greece and Italy had been strengthened by his encounter with Byron's poem *Childe Harold's Pilgrimage* (cantos 1 and 2, 1812; canto 3, 1816; canto 4, 1818), a panoramic poem concerned with distant lands that has been referred to as the first English travel poem. It seems probable that it came to Turner's attention before it was completed. He certainly knew it by 1818. This was a critical time for the artist – a time when his concepts of art and the world were changing. The poem's influence on him,

though often indirect, proved to be profound. As an inveterate tourist, Turner would especially have enjoyed its travelogue aspect. He would also have been attracted by its synoptic sweep and the energy and immediacy of its language.

Childe Harold's Pilgrimage establishes relationships between different times by finding resemblances and parallels between events in history and those of the present or near present. Byron considered liberty, tyranny, and slavery subjects of great interest to a civilization disillusioned by the French Revolution and, more recently, by the Napoleonic wars. In his engaging recapitulations Byron suggests that history is in some respects recreative, and so, by discovering pattern in history, the poet is able to provide insights concerning the future.[2] The historical allusions that thicken the texture of *Childe Harold's Pilgrimage* would have stimulated Turner's interest, since the artist seems to have discovered that he and Byron shared many convictions. This probably accounts for the poem's sustained influence on his pictures, almost to the close of his career.

This chapter deals with some of the different aspects of the classical world that stimulated Turner's romantic enthusiasms and became the subjects of his art. The first part of the chapter examines paintings and watercolours that reflect his familiarity with Greek architecture and sculpture and considers his knowledge of the history and myth that informs them. As in many of his paintings that through their subjects reclaim the past, he makes allusions to the present. He, like Byron, was attracted to the connection between past and present. The second part of this chapter investigates his pictorial responses to Italy, specifically, Venice and Rome, as well as his burgeoning fascination with colour, already mentioned, which his Italian visits helped to stimulate and focus.

GREECE

Fair Greece! Sad relic of departed worth.

The upsurge of British interest in and knowledge of Greek culture during the second half of the eighteenth century was stimulated by archaeological discoveries. The Greek revival, the culmination of the neoclassical movement, began to challenge attitudes that had been shaped by knowledge of the Romans. Archaeological publica-

tions that included measured drawings attracted attention. The publication of Sir William Hamilton's collections of Greek vases, for example, generated widespread interest, and Stuart and Revett's *Antiquities of Athens*, in three folios (1762, 1787, and 1794) followed by two posthumous volumes, edited largely by the architect and archaeologist Charles Robert Cockerell (1788–1863) in 1816 and 1830, also had a notable influence. However, the fascination of the British extended beyond the study of the ancient art and architecture of the Greeks. The British attempted, in the visual arts, to imbibe aspects of this culture and make it their own. British architecture adopted the Grecian manner; John Flaxman's sculpture reflected its influence, and his drawing style is indebted to Greek vase decoration. Popular enthusiasm for ancient Greek art was also reflected in designs created for pottery manufactured by Josiah Wedgwood, who believed that Greek ideas could be modified and mass-produced for a growing English middle-class market. The avowed English Romanist, architect Sir William Chambers, noted in the 1790s that "the Gusto Greco has again ventured to peep forth, and once more threatens an invasion."[3]

However, during the late eighteenth and early nineteenth centuries, familiarity with the Greek inheritance also stimulated Britons (and Europeans) to consider more seriously the plight of the modern Greeks under Turkish domination, especially with the beginning, in 1821, of the Greek War of Independence. Tourists and the books they published drew comparisons between the free citizens of ancient Athens and their modern counterparts enchained by the Turks.

Modern Greeks were considered to be the true descendants of the ancients. Because the French and American Revolutions had spread ideas of political freedom, thoughts were stimulated of a return to the golden age of Greek independence. The artistic imagination of the romantic age was certainly attuned to and enlivened by ideas of liberty associated with either Greece's heroic era or the Athenian commonwealth. Byron wrote with feeling of the difference between the glory of ancient Greece and its present ignominious state:

Fair Greece! sad relic of departed worth!
Immortal, though no more; though fallen, great!

Who now shall lead thy scatter'd children forth,
And long accustom'd bondage uncreate?[4]

Turner acknowledged the importance of the legacy of ancient Greece in his Royal Academy lectures, in the selection of poetic lines accompanying his exhibited paintings, and in the form and content of his art. His reverent interest had been stimulated in part by his education at the Royal Academy schools. Though his formal education was limited, he had a voracious appetite for knowledge. He studied ancient Greek literature and history from translated Roman sources and English critical commentaries. By the late 1790s he possessed a small library that contained many classical authors.[5] And his interest was sufficiently strong for him to have attempted, unsuccessfully, to master the Greek language.[6]

Greek authors that Turner read in translation included Apollonius Rhodius, Callimachus, Musaeus, and Homer. The subjects of their myth and legend were important for his art, and so was their history; also of interest were the lives of its eminent citizens and the society in which they lived, their weapons and costumes, their furniture, their ships, and the nature of their paintings. As has been mentioned, knowledge of their civilization had been enriched by archaeological discoveries. Turner's acquaintance with objects and images from this Mediterranean culture is suggested in many of his history paintings; for example, in *Apollo and Python* (RA 1811) (fig. 6) the design of Apollo's bow exhibits an awareness of ancient bows, which consisted of two horns of an antelope (or two tree branches of equal length shaped like them) bound together. In his *Ulysses Deriding Polyphemus – Homer's Odyssey* (RA 1829) (fig. 34) Ulysses' ships show the typical curved, swan-necked prows of ancient galleys.[7] Indeed, the extent of his knowledge of Mediterranean cultural history was quite remarkable. The son of the Reverend Henry Scott Trimmer recounted that Turner had represented the *equi effrenati* without bridles in his picture of *Dido and Aeneas* (RA 1814) (fig. 37, discussed in detail in chap. 4, below). His (Trimmer's) father had observed that "Libyan horses had no bridles, and Turner said he knew it."[8]

Turner's most intimate contact with Greek art, however, was through its sculpture. Casts and copies of Greek sculpture were at the Plaister Academy of the Royal Academy schools, where he was

6 *Apollo and Python.* Oil, exh. 1811. 57 ¼ × 93 ½ in. (145.5 × 237.5 cm). London, Clore Gallery for the Turner Collection (BJ 115)

a student from 1789 to 1792. This early experience was later fortified by his knowledge of the sculptures collected by his early patron, Charles Townley, by his long and close association with the sculptor Francis Chantrey, and by his particular interest in the collection of one of his most important patrons, the Third Earl of Egremont, a collection that the artist himself helped to supplement in 1828.[9]

A rare opportunity to study Greek sculpture and architecture had occurred in 1799, the year in which Turner was elected associate of the Royal Academy. Thomas Bruce, Seventh Earl of Elgin, wished to engage an artist to make drawings of the architecture and sculpture of Athens, especially of the Parthenon. For this project Elgin had required and received permission from Greece's rulers, the Turks. Turner was among several artists considered for the post. Then twenty-four years of age, with a considerable reputation as a draughtsman, Turner must initially have been flattered as well as attracted by the idea. Going to Greece would have been an opportunity to record in situ the remains of the great monuments of the classical past. By this time his experience and his constant travelling to record specific topography had persuaded him that visiting a site was important. He had developed an unusually strong sense of locale – of his personal response to the site, to the physical relationships between monument and landscape or simply between natural features, and often of the importance, in this interaction, of history.[10] This may help to explain, as Thornbury first noted, the "attachment of Turner to place, the debt of gratitude he felt for special localities [which] was a very marked feature of his character."[11]

If Turner had hopes of making a visit to Greece, they were soon to be dashed, however. Despite Elgin's offer, Turner reluctantly decided not to accept the position because of the conditions that were attached to it. For instance, Elgin's proposal was to take possession of every drawing and sketch executed by Turner. Turner, in his spare time, would also be responsible for giving Lady Elgin drawing lessons. Further, he considered the salary offered inadequate.[12] Still, his fascination with Greece and its archaeology did not fade, and one soon finds letters from the Greek alphabet inscribed on a monument(?) in the upper left corner of the Poussinesque *Tenth Plague of Egypt* (fig. 7), exhibited in 1802.

When Lord Elgin arrived in Athens he was confronted with the vandalized Parthenon. It had become a gunpowder magazine and had taken a direct hit, causing devastating damage and loss. A considerable number of the ancient buildings of Greece had provided the Turks with material for their own building projects, and the Parthenon was no exception. However, they did recognize the particular significance of the Parthenon, and no one had been given official permission to remove what still remained.[13] Yet Lord Elgin did receive permission. He removed the sculptures that he shipped back to England, though not without difficulty. A vessel carrying many of the marbles sank and was salvaged only after great personal expense. From 1807 to 1811 the marbles were publicly exhibited in Elgin's house in Park Lane, London. Eventually, in 1816, they were acquired for the nation and housed in the British Museum, where they remain to this day.

Many responded favourably to their acquisition. The eminent Italian sculptor Canova (who visited Turner's gallery in 1815 and who met Turner in Rome in 1819)[14] praised them and was pleased that they were in British hands, since he believed that they were important for the development of British art. Benjamin West was similarly enthusiastic. The youthful artist John Sell Cotman, who could have seen the metopes at Elgin's exhibition, prepared a landscape watercolour of a *Centaur Fighting a Lapith* clearly derived from them.[15] When Benjamin Robert Haydon visited the sculptures with his fellow art student David Wilkie, he was overcome: "The combination of nature and idea which I had felt was so much wanting for high art was here displayed … My heart beat! If I had seen nothing else I had beheld sufficient to keep me to nature for the rest of my life … Oh, how I inwardly thanked God that I was prepared to understand all this … I went home in perfect excitement. Wilkie trying to moderate my enthusiasm with his national [i.e., Scottish] caution." But Haydon was too stimulated by the experience and returned with Henry Fuseli, the artist, who on seeing the marbles, "strode about saying 'De Greeks were gods! de Greeks were gods!'"[16] Turner, who first studied the marbles in 1806, before their public exhibition, had been captivated by them. He wrote to Lord Elgin that they belonged to "the most brilliant period of human nature" and had been "rescue[d] from barbarism."[17] Indeed Turner's interest in the

7 *The Tenth Plague of Egypt*. Oil, exh. 1802. 56 ½ × 93 in. (142 × 236 cm). London, Clore Gallery for the Turner Collection (BJ 17)

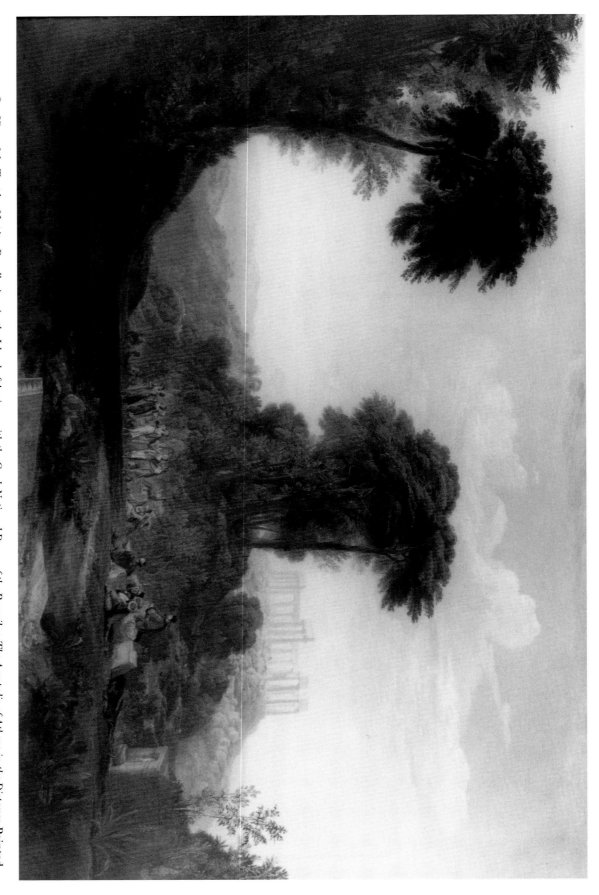

8 *View of the Temple of Jupiter Panellenius, in the Island of Aegina, with the Greek National Dance of the Romaika: The Acropolis of Athens in the Distance.* Painted from a Sketch taken by H. Galley Knight, Esq., in 1810. Oil, exh. 1816. 46¼ × 70 in. (118.2 × 178.1 cm). Collection of the Duke of Northumberland (BJ 134)

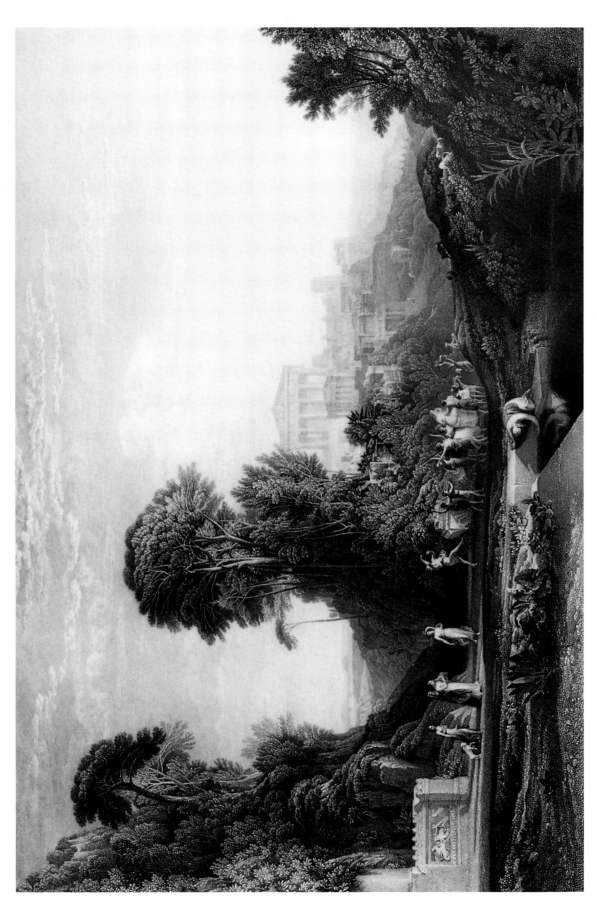

9 *The Temple of Jupiter Panellenius Restored.* Engraving on copper after the oil painting dated c. 1816 by John Pye (1828). 38.1 × 57.5 cm. London, Clore Gallery for the Turner Collection (R 208)

Parthenon sculptures is reflected in his acquisition of casts of its metopes.[18]

However, not all applauded the acquisition of the marbles. Lord Byron objected to their removal from Greece. In his *Childe Harold's Pilgrimage*, he characterized Elgin as a plunderer;[19] One of Turner's early patrons, the connoisseur and author Richard Payne Knight, considered their acquisition a folly; he pronounced them to be of little value; they were, he asserted, "second-rate."[20]

Turner's fascination with Greece included the Greek national cause. For him, freedom was probably as much personal and artistic as it was political; this may account for the recurrence of this theme in his art. During the middle of the second decade his interest in the subjugation of Greece was intensified, perhaps because he may already have read the early cantos of Byron's *Childe Harold's Pilgrimage*. Turner's pictures *View of the Temple of Jupiter Panellenius*, (fig. 8), and its companion, *The Temple of Jupiter Panellenius Restored*, depicting an ancient Greek wedding procession (fig. 9) (both pictures exhibited RA 1816), allude to the subjugation of Greece and represent his first of a series of contrasting pairs of historical landscapes influenced by Claude Lorrain that depict different conditions of civilizations. The second of these pictures of the temple (now called the Temple of Aphaia) was a reconstruction based on recent archaeological discoveries, especially those of the English architect and archaeologist C.R. Cockerell.[21]

The two pictures suggest the continuity of Greek culture.[22] No better indication of their extended meanings can be adduced than by pointing to the significant differences between them. The first picture shows the Greek dance taking place against the background of a temple in ruin, a sky with a late afternoon sun (which for Turner often symbolizes cultural decline) and the presence of Greece's Turkish oppressors; these elements together seem to suggest that Greek culture merely survives.[23] Athens, the former seat of liberty, is barely visible in the background. Turner depicts a Greece that faces adversity. This work was commissioned and based on a sketch by the writer and poet Henry Gally Knight.[24]

However, the second picture presents the temple as it was, under a morning light, which is symbolic of the Greece that used to be – a free Greece. The temple and its commanding position are reminiscent, perhaps not fortuitously, of the Parthenon,[25] a powerful symbol of Greek freedom built during the Athenian commonwealth. However, there is probably also an allusion to the Greece of Turner's day, since he exhibited the picture with unacknowledged poetic lines appended to it that were taken from part 3 of Robert Southey's recently published poem, *Roderick, the Last of the Goths* (1814):

'Twas now the earliest morning; soon the sun,
Rising above Abardos, poured his light
Amid the forest, and, with rays aslant,
Entering its depth, illumined the branking pines,
Brightened their bark, tinged with a redder hue
Its rusty stains, and cast along the ground
Long lines of shadow, where they rose erect
Like pillars of the temple.

Turner may have considered the plight of the Spanish under the Moors to be comparable to that of the Greeks under the Turks and so included poetic lines that he believed could allude to that comparison.[26]

In a stimulating discussion of these two pictures, it has been suggested that the unusual reference in them to the modern Romaika and an ancient wedding was possibly the result of Turner's reading of F.S.N. Douglas's *Essay on Certain Points of Resemblances between the Ancient and Modern Greeks* (1813).[27] It has also been suggested that *The Temple of Jupiter Panellenius Restored* establishes a potent association between the dawn theme of the poetic lines and the bas-relief to the left in the picture (fig. 10) showing the "victorious chariot of the sun,"[28] which proclaims the triumph of light over darkness – the beginning of a new day.[29] That this relief is symbolic of "the active and passive principles of generation" that Richard Payne Knight had discussed in his *Inquiry into the Symbolical Language of Ancient Art and Mythology* (1818)[30] does not seem central, if at all relevant, to the meaning of the relief. I believe that the relief imparts at least two significant messages. First, the charioteer, the sun-god, symbolizes enlightenment – the flourishing of Greek civilization.[31] Second, the relief relates directly to

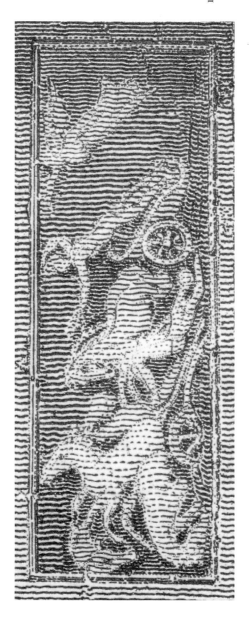

10 Detail from *The Temple of Jupiter Panellenius Restored*

the subject of the painting itself, that is, to the temple dedicated to Jupiter (Zeus). Jupiter was, after all, the "bringer of light," the cause of the dawn of day.

The suggestion has been made that the marriage procession in this picture is concerned with "the wider principles of creation."[32] However, the fact that Jupiter was recognized as the chief patron of the family and of all communal life more readily explains the presence of the procession. Further, the last person in this procession, a young woman, pulls behind her a reluctant white lamb to be sacrificed on this special occasion. It is probably significant that it is a *white* lamb, since such a lamb was traditionally sacrificed to Jupiter on his sacred days. Thus it would appear that this painting is not essentially concerned with principles of creation or with natural processes[33] but rather, and directly, with its major subject, Jupiter and his temple.

From about 1819 Turner's interest in the esteemed realm of antiquity quickened. It was powerfully reinforced by his first visit to Italy in that year when, in Rome, he devoted almost an entire sketchbook to recording classical sculpture fragments in both round and relief. His enthusiasm for the antique did not wane. On his return to England, he accepted the position of inspector of the Royal Academy's cast collection.[34] His curiosity about antique sculpture and architecture was further stimulated by his association with the Scottish landscape painter, Hugh William Williams (1773–1829), called "Greek" Williams, who had been to

Greece and returned in 1818. Two years later, Williams published an illustrated account of his travels. Turner's interest in Greece was also kindled by C.R. Cockerell. As early as 1821 Turner was proposing to prepare drawings of Greek temples for Cockerell, though it appears that only one ever materialized.[35] Both Williams and Cockerell became his good friends.

Turner's visit to Edinburgh in August of 1822 provided an opportunity for them to get together, and it indirectly strengthened his interest in Greece. He was probably encouraged to come at this time by Sir Walter Scott, whom he had met in 1818. This celebrated Scottish figure – novelist, poet, and historian – whose influence on the growth of historical thought in the nineteenth century is well-documented, was greatly admired by Turner. The primary purpose in coming to Scotland was to collect sketches for the final illustrations for Scott's *Provincial Antiquities and Picturesque Scenery of Scotland* (1819–26) and to witness the royal visit of the newly crowned king, George IV. However, despite a busy schedule in the northern capital, Turner found time to see his friends and colleagues, including Cockerell and Williams. Cockerell was in Edinburgh because he had been invited by Lord Elgin, who was an influential member of the committee formed to select an architect for a national monument to be erected on the city's Calton Hill. It was intended to serve as Scotland's memorial to its war dead. Lord Elgin had favoured a Greek design, and he recommended Cockerell's submission, which was Greek. The committee eventually agreed that Cockerell should

11 *Rokeby*, Watercolour, c. 1822. 20.2 × 14.2 cm. The Cecil Higgins Art Gallery, Bedford, England (w 1053)

build it. Turner, Cockerell, and Williams met several times and even dined together, and it seems likely that Greece and the taste for Greek culture was a topic of conversation.

Turner produced several works that abundantly demonstrate his continuing fascination with Greece and his keen awareness of the independence question. In 1822, the year in which he visited Scotland and the year after the beginning of the Greek war of independence, Turner prepared a series of six watercolours for his friend and patron, Walter Fawkes, two of which allude to this struggle.[36] One, *Rokeby*, which represents a view on the Greta River, in England (fig. 11),[37] illustrates descriptive lines from Scott's *Rokeby* (2.9). This is a verse narrative on the English Civil War, a subject that was of particular interest to Fawkes, who had inherited from the Fairfax family a number of relics from the Commonwealth period.[38] *Rokeby* is of especial interest, since it shows a male figure sheltered in the leafy, penumbral gloom of trees. He seems an intrusive figure, since he is unaccountably dressed in Eastern garb. That this figure represents or alludes to the Turks, the oppressors of the Greeks, seems certain, despite the incongruity of the setting.[39] Is there also an allusion intended here to the seventeenth-century struggle between king and parliament? This appears likely.

A Turk appears in a second watercolour from this series, though in a far more appropriate setting – Athens. This watercolour, *The Acropolis, Athens*, dated 1822 (fig. 12), is a view of the Parthenon and is inscribed by Turner with a line adapted from Byron's *Giaour*: "T'is living Greece no more." In this watercolour three figures are depicted in the foreground. On the right, and reclining on a stone block in a position superior to that of two reclining female figures on the left, is a male Turk, scimitar at his feet, who guards them. These women, in chains, personify a subjugated Greece.[40] Significantly, they lie against marble reliefs, metopes, from the damaged Parthenon that looms behind it.[41] Not only does the Parthenon establish the geography of the setting, it functions as a metaphor essential to the watercolour's meaning. This noble structure was built, as has been noted, during a period of Greek freedom – during the Athenian commonwealth – but is now in ruin. The fallen metopes allude to the collapse of this once great culture. The sculptural relief of one of the metopes

12 *The Acropolis, Athens*. Watercolour, 1822.
18.7 × 13.7 cm. Vouros-Eutaxias Museum of the
City of Athens (w 1055)

shows a centaur and appears to be based on one of the battling lapith and centaur designs on the south side of the building that Elgin had brought back to England. This, I believe, is one of the keys to understanding his watercolour. Since Turner possessed a poetic cast of mind and since he displayed a preference for analogy and metaphor to convey or suggest human realities, the centaur here likely stands for war. It is also a symbol of brutality; Turner almost certainly wished to associate this trait with the Greeks' Turkish masters, since when he wrote to Elgin concerning his acquisition of the marbles, he indicated that they had been "rescue[d] from barbarism," that is, from the Turks.

There is a third watercolour concerning Greece that is unrelated to the above series but that seems to contain similar meanings. It dates from about 1834 and is entitled *Temple of Minerva, Sunium, Cape Colonna* (engraved in 1854) (fig. 13).[42] In this representation of a temple in ruin, round which wolves roam, the Parthenon metope appears to function in a way similar to the metope shown in *The Acropolis, Athens*. In Turner's mind the inclusion of the metope in *Temple of Minerva* was surely an allusion to Athens, where the Parthenon was erected as Athene's (Minerva's) temple. Athene was the mistress of lightning and thunder, a role that is suggested in the watercolour by the sky above the temple on the right, which is dark, filled with swollen, threatening clouds and a conspicuous bolt of thunder.[43] This dark sky also alludes to the reputation of the Cape as a place of storms and shipwrecks. In the sea recently swept by storm, to the left, a sinking vessel is depicted; above it is a clear, luminous sky. It is surely significant that Athene was also deity of the clear sky.

Athene was, in addition and most notably, the goddess of war. The metope relief of the centaur, who is battling a lapith, probably alludes to her militant aspect. It is likely that the relief, like the relief shown in the watercolour *The Acropolis, Athens*, represents brutishness, a quality reinforced by the presence of wolves standing and crouching before the metope. The savage-looking wolves are likely a metaphor for the Turks, who had been responsible for the barbarous oppression of the Greeks and for the unconscionable pilfering of the remains of Greek temples, of which the temple at Sunium was considered a notable example.

The oil painting *Phryne Going to the Public Bath as Venus—Demosthenes Taunted by Aeschines* (exh. 1838; London, Clore Gallery, for the Turner Collection) also refers, if indirectly, to the theme of oppression and liberty in modern-day Greece. The picture purports to show Athens of the fourth century BC and depicts Phryne, the famous Greek courtesan, on the right. On the left are shown two Athenian orators of that time, Demosthenes, who opposed the threat of Macedonian control of Greece, and Aeschines, in the pay of the Macedonians, who repeatedly intrigued against him. Demosthenes, in his speeches, bitterly attacked Aeschines, accusing him of treason and reputedly stating that he was the offspring of a prostitute.[44] Due to such intrigue Greece eventually fell into Macedonia's hands, a result that Demosthenes could not tolerate. In consequence, he called on the Athenians to oppose the Macedonian domination and restore liberty; but it was too late. Though Turner depicts the physical splendour of ancient Athens by representing the famed courtesan Phryne in the guise of the goddess of love and by referring indirectly to the presence in the city of political corruption and betrayal, he alludes to those values and conditions of society that will eventually lead to its decline.[45]

ITALY

As much as Turner was attracted to Greece, it was Italy, to which most travelling Englishmen had, over the years, directed their attention, that provided him with most of his emotional sustenance. Though by the late eighteenth century the culture of the Greeks had begun to compete with the admiration for ancient Rome, it became increasingly evident that the Romans, who had for so long been the established measure of civilization for the West, were themselves the Greeks' cultural descendants. Again, for his reading, Turner depended on translations. He read such poets as Ovid and Virgil; in his library he had a translation of Titus Livius's *Roman History* (1686). He also possessed Goldsmith's *Roman History* (1786), which he annotated, and books on the life and culture of the ancients, including Plutarch's *Lives of the Noble Grecians and Romans* (1657). His reading provided him with fresh perspectives on the past that were often introduced into his art.

Turner had hoped to travel to Italy soon after the conclusion of hostilities between Britain and France. However, events had overtaken him, and his trip had to be delayed. He eventually

13 *The Temple of Minerva, Sunium, Cape Colonna.* Engraving on steel after a watercolour of c. 1834 by J.T. Willmore (1854). 38.4 × 59.1 cm. London, Clore Gallery for the Turner Collection (R 673)

arrived in 1819, on a trip that was signally important for him. In a sense he had been preparing for it for most of his life. Up to that time he had been exposed to watercolours and paintings by others who had depicted that country. He had savoured inspired, elegiac views by contemporaries and near contemporaries and especially by eminent artists of the past such as Claude Lorrain and Piranesi. Moreover, he had been stimulated by recent commissions he received for Italian views based on the work of others. Notably, by 1818, inspired by pencil outlines by the architect James Hakewill, he had prepared watercolours of Italy, for Hakewill's *Picturesque Tour of Italy*; the original outline drawings had been created with the aid of an optical instrument, the camera lucida.[46] He had also heard much of the country and its history from friends, colleagues, employers, and patrons who had travelled there. The influence of Sir Richard Colt Hoare, a classical scholar and one of his early patrons was of paramount importance to his education. Hoare himself was an amateur artist and collector whose paintings and drawings (many of which were of Italian subjects) and whose library the young Turner would have had the opportunity to study on his visits to Stourhead. It is possible that Colt Hoare introduced Turner to two important publications on Italy at a time when the artist was beginning seriously to contemplate a trip: *Select Views in Italy* by John "Warwick" Smith, William Byrne, and John Emes (1792–96; Turner made sketches of its illustrations probably around 1818) and *A Tour through Italy* by J. C. Eustace's (originally published in 1813), from which he made notes at about the same time he made sketches from *Select Views*. He also read Colt Hoare's own book, *A Classical Tour through Italy and Sicily* (1819), which was intended as a supplement to Eustace.[47]

The sojourn in Italy was important for Turner. It provided him with an opportunity to study further the works of the Italian masters, especially the Venetians. It could be said that this trip also opened a new chapter in his career by introducing him to Mediterranean light. He studied its qualities and effects on landscape forms, architecture, atmosphere, and water, effects that even before this trip, had whetted his curiosity and, through his imagination, found expression in his art. However, some who knew Turner's art were convinced that after this Italian journey the light and colour effects of his art had undergone a profound

change. One writer, having visited the London house of Turner's patron Walter Fawkes, observed that "The earliest works ... and those which he has done since ... are like works by a different artist. The former, natural, simple and effective; the latter, artificial, glaring and affected ... A public day at Mr Fawkes's is a triumph to Turner; and he should really look back at some of these works, and keep nearer to their truth, than to run riot, as he now does, after a thousand yellow fantasies and crimson conceits."[48]

For Western civilization, the loss of the classical past had, of course, been regretted. However, awareness of its value in assessing the present and future – and, indeed, awareness of one's place in time and of time itself – had assumed fresh significance in the post-Napoleonic era. Unlike his eighteenth-century predecessors, Shelley perceived Rome's ruins positively; indeed, as an "inspiration for the future." As has been observed, "his poetry is a rebirth of beauty from the magnificent fragments of that immortal yesterday which is eternally reborn."[49]

The observations of tourists attest to the enlightened interest in the relationship between past and present. Samuel Rogers remarked in his journal on the powerful images of past and present in Italy: "At Florence we thought only of Modern Italy and of its golden age – As we approached Rome, Antient Italy rushes on the Imagination. Italy has had two lives! Can it be said of another Country?"[50] As Sir Richard Colt Hoare observed, "The object particularly pointed out to us in Italy, is the recollection of former times, and an instructive comparison of those times with the present."[51] The felt presence of this ancient culture sometimes left the viewer dismayed by the contemporary neglect of Italy's ruins, especially those in Rome: "Those monuments which remain are half buried in their ruins; and the Forum of Rome, where the intellect of the world was concentrated, the seat of universal empire is converted into a cattle market, with the contemptible designation of Campo Vaccino; and the walks of philosophers covered with asses, monks, and straw. Such is the mutability of human affairs."[52] However, there was much in Italy to attract the attention of tourists, especially those who were writers or artists. Though they were attracted by its history and landscape, they were also enchanted by the colourful picturesqueness of its inhab-

itants, awed by the elaborate ceremonies of Roman Catholicism and enthralled by tales of Italian bandits.[53]

Visitors to Italy were of course deeply interested in its Roman past. What was especially admired, however, was not the empire but the republic: it symbolized freedom from despotism. Writers after the end of the Napoleonic wars allude to those who in the distant past and relatively modern times struggled against oppression and attempted to restore liberty. In the proto-Renaissance period, Rienzi, friend of Petrarch, was one, and later, in the seventeenth century, there was Masaniello, who had led a revolt of the lower classes against the tyrannical Spanish rulers of Naples.[54] The passing of liberty was mourned, as Byron's lines in *Childe Harold's Pilgrimage* (4.82) reveal: "Alas, for Earth, for never shall we see / That brightness in her eye she bore when Rome was free!"

Byron's poem was probably one of the significant stimuli for Turner's visit to Italy; its contents were to become part of the established furniture of his mind. Italian views by him of the 1820s, 1830s, and 1840s reflect the influence of this poem, especially the fourth canto, which is of particular importance for its Italian references. Divided roughly into two sections, the first part of the canto is concerned with Venice and cities directly to the south; the second relates largely to Rome. Turner chose mainly Venice and Rome as the subjects of his art.

Turner's Venice and Its Light

Turner appears to have been captivated by Venice. The watercolours that he executed while on this first visit, though relatively few in number, demonstrate his first confrontation with Mediterranean light, a light he would come to associate with that city. Though several are highly simplified studies, they probe problems of light and colour; they radiate a range of heightened hues that in part were intended to suggest the manifold combinations of sunlight effects illuminating Venice's heavy, moist atmosphere, playing on the facades of its buildings and glistening on the reflecting, constantly shifting surfaces of its waters.

However, it is difficult to-day to ascertain the exact colour of these works and, indeed, of the remainder of his art. His watercolours and oil paintings have suffered from the ravages of time;

their colours are not what they once were. Still, some works retain a semblance of their former glory. Indeed, one watercolour study, *Venice: The Campanile of St Mark's and the Doge's Palace*, displays a remarkably vivid, immediate effect of colour and light; its radiant architecture appears insubstantial under the relentless, voracious assault of a dazzling sun (fig. 14).

In his perspective lectures Turner had referred to light as being material, of different qualities emanating from different sources and striking planes at different angles, so that "Darkness or total shade cannot take place while any angle of the light reflected or refracted can reach an opposite plane."[55] When he considered the complexity and variability of the effects of light and shade in glass spheres containing water, he was led to remark that in consequence of the "innumerable rays reflected and refracted" in these vessels, any attempt "to define the powers of light and shade upon such changing surfaces is like picking grains of sand to measure time."[56] Venice was an ideal laboratory in which to explore the rich possibilities of the dynamics of light and colour.

Similar, though intensified, effects are found in his watercolour studies of Venice that date from the 1830s and 1840s. These later views of the city are also luminous and abstract. Diluted colours applied to damp paper bestow patterns that function not only in pictorial space but also on the surface. The fragile forms that are created tend to be vague, as if enveloped in veils of heavy atmosphere. Criticisms of Turner's pictures made by Hazlitt in 1816 seem apposite, especially when applied to these later Venice watercolours. Hazlitt, referring to Turner, noted that his work consisted "too much [of] abstractions of aerial perspective, and representations not properly of the objects of nature as of the medium through which they are seen."[57] By strengthening his atmospheric effects Turner was able to imbue his landscapes, which included his historical pictures, with perhaps one of their most powerful dynamics: the incandescent, evanescent power of light, a quality of landscape that had gradually moved to a more central position in his art.

An example of his later Venetian watercolour style is *Venice: The Riva degli Schiavoni from the Channel to the Lido* (1840) (fig. 15). In this work the city appears immersed in mist and drenched in shimmering light. Turner uses Venice's buildings and water as

14 *Venice: The Campanile of St Mark's and the Doge's Palace.* Watercolour, 1819. 22.5 × 28.7 cm. London, Clore Gallery for the Turner Collection (TB CLXXXI, 7). See colour plate 1

vehicles of light; indeed, its architecture, seen through a watery atmosphere flushed with colour, softened and blurred by light, is lighter and more colourful than it actually is. The interaction of colour and light transfigures its architecture, making it appear lacking in substance. Over veils of colour applied to damp paper, skeletal lines are later applied with a pen charged with coloured inks that suggest but do not describe the city's architecture. Even though probably more subdued in colour than when Turner painted it, this watercolour is still striking. Vibrant light blues, pale yellows, and diluted pinks form spreading abstract bands, aided by brush outlines in reddish-brown that create the bobbing vessels crowded with passengers plying the fore- and mid-ground waters. Under Turner's brush and pen, Venice at this time becomes a beguiling compromise between fact and fancy.

Turner's oil paintings of Venice, dating from about the same time, benefited from the breadth and luminosity that his watercolour studies display by exploiting the use of a white ground and oil glazes to approximate, to some extent, the watercolours' luminous effects. Contemporary viewers found their brilliance, breadth, and abstract colour excessive. *The Grand Canal, Venice* (exh. 1837; San Marino, California, Henry Huntington Library and Art Gallery) was one of those sharply criticized paintings. The *Blackwood's Magazine* reviewer decried its bright hues. Alluding to painters like Turner, this reviewer observed, "With some eminent men of the Academy there has been a whim for dazzling lightness and vivid colours." He then proceeded to criticize the "glaring folly" of Turner's pictures, "lest younger artists of the English School ... should be ... [led] astray." Without referring specifically to *The Grand Canal, Venice* (though this was no doubt in his mind), he suggested that Turner's paintings are too abstract: "White brimstone and stone-blue are daubed about in dreadful and dreary disorder. The execution is as if done with the finger and the nail, as if he had taken a pet against brushes."[58] A not dissimilar criticism was directed against another oil painting, *The Dogano, San Giorgio, Citella, from the Steps of the Europa*, exhibited at the Royal Academy in 1842 (fig. 16). Its gleaming colour effects caused the reviewer from the *Art Union* to admonish him for its particular handling, which emphasizes colour over form: "A great error in Mr Turner's smooth water pictures is, that the reflection

15 *Venice: The Riva degli Schiavoni from the Channel to the Lido.* Watercolour, 1840. 24.5 × 30.5 cm. London, Clore Gallery for the Turner Collection (TB CCCXVI, 18)

of colours in the water are painted as strongly as the substances themselves, a treatment which diminishes the value of objects."

In these later Venetian views, as in his 1819 watercolours, Turner portrays Venice as a city bathed in light, colour, and insight. Its transmutation of either colour into form or form into colour is an implicit denial of the traditional distinction established between *disegno* and *colore*. In the ways in which he manipulates light and colour, Turner presents a city of sparkling insubstantiality that, in a number of instances, embodies a further meaning.

As I have said, Turner's attitude seems to have been coloured by Byron's *Childe Harold's Pilgrimage*. Both his paintings and the poem refer to the appearance of Venice and the significance of that appearance. Byron perceived Venice as a latter day Tyre (4.14). During the period of the renaissance, Venice had been a powerful mercantile empire serving as the essential link between Asia and Europe; it became known as the queen of the seas. Thereafter, however, Venetian commercial and military powers gradually weakened. By the late eighteenth century, the city had fallen under the control of the French, and from that time until 1814 it had passed back and forth between France and Austria. In 1802 Wordsworth composed a poem, *On the Extinction of the Venetian Republic*, in which he mourned the end of Venice's liberty. Byron remarked that the festive appearance of the city was a sham: "The pleasant place of all festivity, / The revel of the earth, the masque of Italy!" (4.3). Venice's decadence and deterioration are occasionally alluded to in lines from Byron's poem that Turner attached to some of his exhibited oil paintings of Venice, for example, the lines that accompany the title of his *Venice, the Bridge of Sighs* in the Royal Academy catalogue (1840): "I stood upon a bridge, a palace and / A prison on each hand." These lines were modified by Turner from the original (4.1): "I stood in Venice, on the Bridge of Sighs; / A palace and a prison on each hand." The original stanza continues:

I saw from out the wave her structures rise
As from the stroke of the enchanter's wand:
A thousand years their cloudy wings expand
Around me, and a dying Glory smiles
O'er the far times, when many a subject land

Look'd to the winged Lion's marble piles,
Where Venice sate in state, throned on her hundred isles!

The grimmer reality of Venice is masked by its beautiful, blushing facades, and this idea Turner sought to convey pictorially.[59] Byron believed that Britons should learn from the fate of Venice. He reminded his readers of the resemblances existing between Britain and Venice. Addressing his country, the poet proclaimed:

thy lot
Is shameful to the nations, – most of all,
Albion! to thee: the Ocean queen should not
Abandon Ocean's children; in the fall
Of Venice think of thine, despite thy watery wall. (4.17)[60]

Byron's cautionary lesson appears to be echoed in other paintings by Turner. The artist prepared *Keelmen Heaving in Coals by Night* (1835) (fig. 17) as the companion to his earlier (1834) *Venice*. The relationship between Britain and Venice was very much on his mind. During the late 1820s and 1830s enterprising British coalmen had discovered and had undertaken to develop enormous coal reserves in the vicinity of south and southeast Durham.[61] Thus, when Turner painted *Keelmen* (associated with Tyneside) as a companion for *Venice* (fig. 18), Tyneside's recently expanding economic importance due to coal discoveries would have provided him with a powerful metaphor for Britain's new economic strength and a startling, poignant contrast with Venice's lost commercial power and its poverty.[62]

The allusions to Venice's decline in Byron's poetry and Turner's paintings relate to the familiar, archetypal pattern of a civilization's growth and decay that Gibbon had popularized in his history of Rome. By emphasizing the fleeting effects of light and colour in Venice's representation, Turner seems to have intended to refer to the transience of human endeavours.

The Impact of Rome

Turner's artistic perception of Rome was, not unexpectedly, different from his perception of Venice. Though his landscapes of both

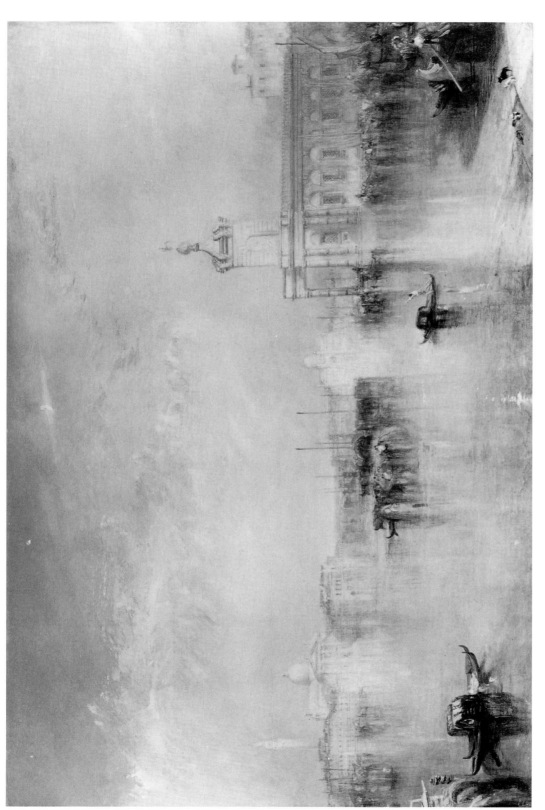

16 *The Dogano, San Giorgio, Citella, from the Steps of the Europa.* Oil, exh. 1842. 24 ¼ × 36 ½ in. (62 × 92.5 cm). London, Clore Gallery for the Turner Collection (BJ 396). See colour plate 2

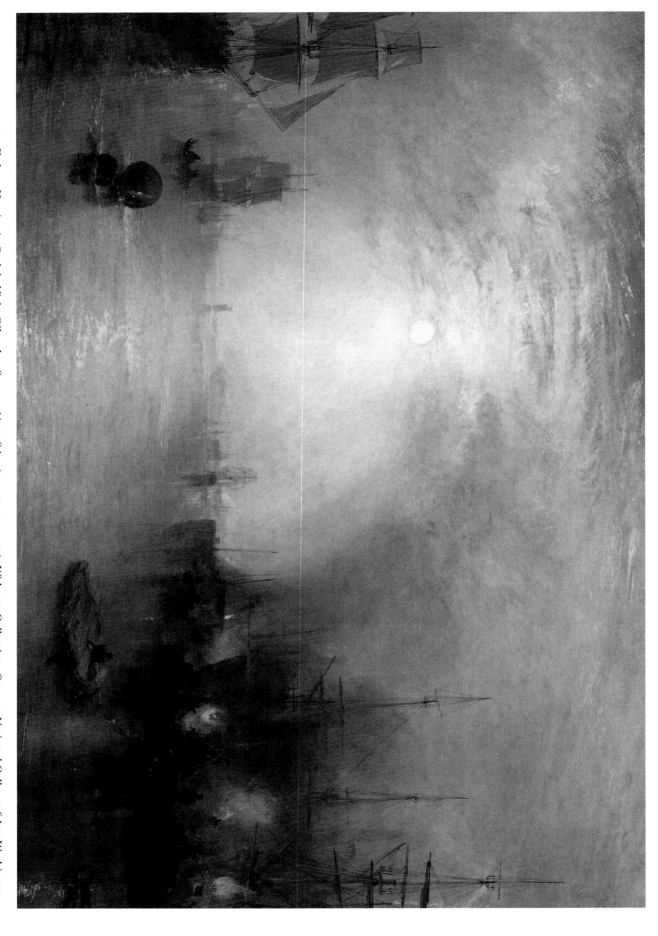

17 *Keelmen Heaving in Coals by Night.* Oil, exh. 1835. 35 ½ × 48 in. (90.2 × 121.9 cm). Widener Collection, © 1994, National Gallery of Art, Washington, DC (BJ 360)

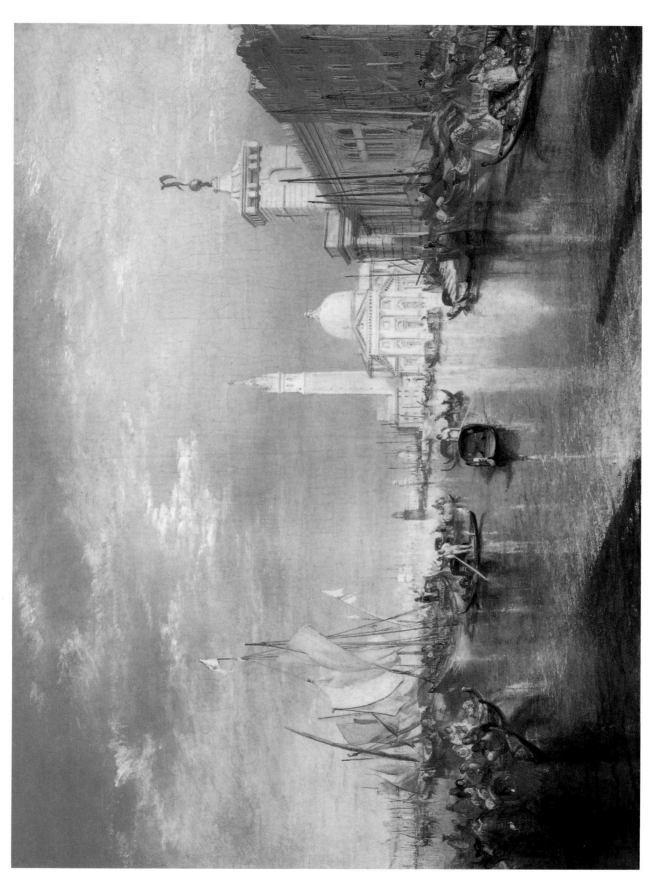

18 *Venice*. Oil, exh. 1834. 35 ½ × 48 in. (90.2 × 121.9 cm). © Board of Trustees, National Gallery of Art, Washington, DC (BJ 356)

cities share an elegiac quality, in those of Rome the forms of the city, whatever their age, are often more solidly represented and are often, though not always, more monumental. Also the Roman past is unusually persistent; it is seldom hidden from the present; indeed, in his pictures past and present are often consciously contrasted.

Rome was a modern city constructed on history; its ancient ruins remained as constant reminders of its former glorious days. These ideas were imprinted on visitors' imaginations. Byron, in *Childe Harold*, observed that the ruins of Rome indicate the survival of art: they remain distinct from and yet, paradoxically, through time, eventually reconcile themselves with nature. Roman ruins become prominent metaphors for the natural cycle, for the process that moulds human history:

> There is the moral of all human tales;
> 'Tis but the same rehearsal of the past,
> First Freedom, and then Glory – when that fails,
> Wealth, vice, corruption, – barbarism at last. (4.108)

Rome, as has been mentioned, was considered the centre of history, the great historical exemplar for the rest of Europe. It had been the former residence of some of the world's most illustrious personalities. Turner was aware of this. He had something in common with the beliefs of his much younger German contemporary, the classical historian Theodore Mommsen (1817–1903), whose first three volumes of *Roman History* were published only a few years after Turner's death. "It is in Rome," Mommsen observed, "that all ancient history loses itself; it is out of Rome that all modern history takes its source."[63] The history of the Roman republic, he noted, "is the history of a municipality, bearing sway over an ever-increasing subject territory; it differed only in scale from the earlier dominion of Athens and Carthage, from the later dominion of Berne and Venice."[64]

Turner's first visit to Rome, as indicated, did not occur until 1819. Probably coincidentally, before he left London for Italy his long-time acquaintance Joseph Farington received a letter from Sir Thomas Lawrence in Rome, who prevailed upon Farington to urge Turner to visit him. When Turner arrived in the autumn, he met Lawrence and other resident and visiting Englishmen, among them his close friend the sculptor Francis Chantrey and

Charles Lock Eastlake, a young artist whose influence on him, in later years, appears to have been significant. He visited Eastlake's studio by the Spanish Steps, at 12 Piazza Mignanelli and would go there when he visited Rome again in 1828.

Well supplied with guidebooks and sketchbooks, Turner began to make sketches and drawings in different media. Some of the smaller sketches appear to have been executed with great rapidity; others are larger, more expansive views and often much more carefully rendered. Rome seems to have released the full energy of his enthusiasm. The sketches and drawings that resulted form a remarkably detailed record of his visit. Of the harvest of sketches that he brought back to England from Italy, almost fifteen hundred seem to have been executed in Rome and its environs. A great many are landscape and architectural studies, though he also sketched paintings and antiquities. Some of the most interesting of these visual records explore Rome's architectural and painted decoration.

It is not surprising that this assiduous sketch-taking soon resulted in a major picture. It is vast; one of his largest historical landscapes, *Rome, from the Vatican, Raffaelle Accompanied by La Fornarina, Preparing His Pictures for the Decoration of the Loggia* (fig. 19) was exhibited at the Royal Academy in 1820. Strongly coloured, it is a complex picture controlled by a narrative that celebrates the life, career, and three hundredth anniversary of the death of one of Rome's most beloved Renaissance artists, Raphael Santi (1483–1520),[65] and commemorates Turner's own first experience of Rome.[66] This picture, in many respects, represents a watershed in Turner's historical landscapes. Unlike his early (exh. 1806), complex *Garden of the Hesperides* (to be discussed in chapter 4, below) he does not depict a traditional historical subject, nor is the painting one that in style is reminiscent of an old master, as is the Poussinesque *Garden of the Hesperides*. Moreover, its allusiveness, though complex, is much more dense and difficult to read than that of the *Garden of the Hesperides*, since the picture depicts an array of disparate objects that are intended to be considered in its overall meaning.

Rome, from the Vatican is similar in size to another monumental, panoramic painting, the impressive *England: Richmond Hill, on the Prince Regent's Birthday* (fig. 52; discussed in more detail in chapter 5, below), which was exhibited at the Royal Academy the year before,

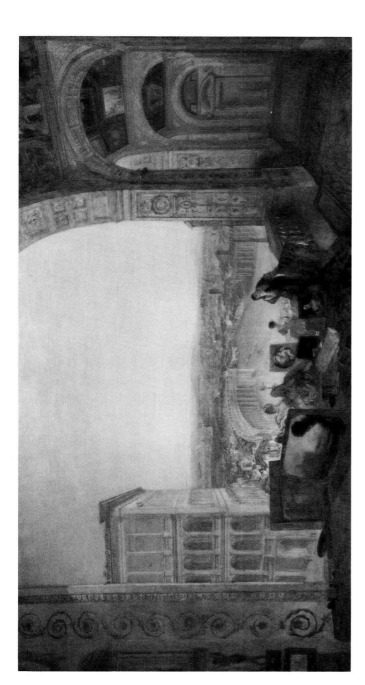

19 *Rome, from the Vatican. Raffaelle, Accompanied by La Fornarina, Preparing His Pictures for the Decoration of the Loggia.* Oil, exh. 1820. 69 ¾ × 132 in. (177 × 335.5 cm). London, Clore Gallery for the Turner Collection (BJ 228). See colour plate 3

in 1819. *Rome from the Vatican* shows a similar, elevated panorama, though its contents are more difficult to interpret. Perhaps this is one of the reasons why some reviewers of the annual Royal Academy exhibitions preferred the view from Richmond Hill. *Rome, from the Vatican* was considered by one critic to be a "brilliant but outré and unsuccessful experiment."[67] Another, the reviewer for *The Repository of Art* (June 1820) complained of the "crossing and recrossing of reflected lights about the gallery" and "the perspective of the foreground." However, the picture was not without admirers. One critic considered it to be a "grand view … possessing all the magical effects, the clear and natural atmosphere, and the glorious lights which give such a beauty and a charm to all his compositions."[68] Regardless of their stylistic and colouristic effects, viewers addressed the nature of the artist's stylistic and colouristic effects; they did not consider the picture's possible meanings.

Turner's initial ideas for this picture can be traced in two pencil compositions that occur on facing leaves in Turner's "Tivoli and Rome" sketchbook. However, because of their rough execution and often smudged and indistinct nature Turner's ideas are not always

clearly presented. At first glance it would appear that the more tentative of the two compositions was the first executed,[69] but I suggest the contrary, that the first was the other stronger and more ambitious composition on the facing page.[70] This composition presents Turner's more resolved ideas. It would seem that his second proposal for the picture is embodied in the other, weaker design, which, in part, is the offset image from the stronger composition. Still, the sequence of execution is less important than the information that they furnish of his initial ideas, especially since their compositions differ from that of the picture in several significant respects.

The stronger of the two sketches is also the more complex. The three darkened arches of the Vatican Loggie and their vaults stand out against the lighter areas of the arch openings, which were intended to accommodate the view of Rome in the painting. The Loggie arcading is distorted in the sketch so that the central arch, parallel to the picture plane, confronts the viewer directly, while the arch on the right, particularly, bends away at an odd angle thereby establishing the Loggie space that, though awkward, is

20 *The Tiber, from a Statue in the Vatican.* Engraving from the Encyclopaedia Metropolitana (1852), 13. London, by permission of the British Library (12220.b8-bb.32)

more commodious and more interesting than would have been possible had Turner placed the arcading uniformly parallel to the picture plane. In the centre of this Loggie space, framed by the opening of the monumental middle arch, Turner has placed his protagonists. Because of their position in relation to the arch opening, one cannot but wonder whether Turner was influenced to some degree by the compositional structure of Raphael's *School of Athens*, located in the nearby Stanza della Segnatura.

In this sketch composition Turner has depicted Raphael standing to the left in the opening of the central arch, apparently drawing the attention of the four seated figures near him to a painting on the Loggie floor to the right. The seated female(?) figure next to Raphael – possibly naked – may be the Fornarina. If the position of the figures in relation to the massive arch opening recalls something of the compositional character of the *School of Athens*, the particular nature of their arrangement suggests more compellingly the work, not of Raphael, but of Watteau. To the extreme right of this sketch composition, at the end of the Loggie corridor against the end-wall blind arch, are suggestions of two large sculpted(?) figures – a reclining, possibly naked male and a standing, naked, full-breasted female. Though it is impossible from this sketch to determine precisely what these figures represent, they do seem to be related. It is possible that what Turner intended was a sculptural group depicting the creation of Eve, since on this visit he was particularly attracted to sculpture, and as we will later see, the creation of Eve is the subject of a Loggie fresco that plays an apparently important role in the picture's meaning.

In the other vaguer, more granular sketch composition, the structure is weaker, partly, as I have suggested, because some lines are offset lines from the other composition. The arcading of the Loggie is particularly vague. The figure of Raphael, however, is clearly rendered. He no longer displays the active pose that he assumes in the first sketch; he is now passive. He reclines – head on hand – and seems to contemplate his frescoes in the Loggie vault (which in this sketch Turner fails to introduce). The only other figure clearly shown (there are possibly others) is the seated, probably naked, female behind Raphael and to his right. This figure, like the one next to Raphael in the other sketch composition, may represent the Fornarina.

The pictorial ideas and hints contained in these two pencil sketches furnish only a beginning for the composition and subject matter that he was to create for his oil painting. For example, in the painting the Loggie arches of the two sketches still appear, though it is the arc of one very large, distorted arch that embraces most of its composition. Turner has also introduced a platform into the Loggie to the left on which Raphael stands surrounded by plans and works of art. Further, in the painting only two protagonists are depicted: Raphael and the Fornarina. Finally, in the painting Turner has modified the stance of Raphael; his pose is contemplative as he peers into the Loggie vault, as in the fainter of the two sketch compositions, but he is now standing, not reclining.

But *Rome, from the Vatican* possesses a complex meaning that is missing from the sketches because of the many objects that the painting shows. The Loggie in the painting is filled with pictures, architectural plans, and the sculpture of a reclining river god, the Tiber (fig. 20), which serve as narrative metaphors. The river god, for example, alludes to Rome's founding by Aeneas and its subse-

21 *Forum Romanum, for Mr Soane's Museum*. Oil, exh. 1826. 57 ⅜ × 93 in. (145.5 × 237.5 cm). London, Clore Gallery for the Turner Collection (BJ 233)

quent history.[71] Further, the centrally located picture of Raphael's well-known *Madonna della Sedia* appears to allude to modern, Christianized Rome.[72] The meanings of these objects furnish an intellectual context for the ideas that Turner apparently wished to impart, which are fully discussed below, in chapter 7.

Subsequent monumental images of Italy and Rome stimulated by this visit and by archaeology and Turner's interest in reconstructions entail correlative themes. These include *Forum Romanum, for Mr Soane's Museum* (RA 1826) (fig. 21) and the paired paintings that still more pointedly contrast Italy of the present with Italy of the past: *Modern Italy – the Pifferari* (RA 1838) (fig. 22) representing devout Christian shepherds "who visit Rome at Christmas to worship the Virgin,"[73] and *Ancient Italy – Ovid Banished from Rome* (RA 1838) (fig. 23), which represents Ovid's exile in consequence of the licentiousness of his poetry.[74] Turner seems to contrast the theme of virtuous Christianity in *Modern Italy* with the degeneracy implicit in its

companion. The relationship established between these pictures provides a meaning that chimes with that of his *Rome from the Vatican*. In this latter work, the centrally located image of Raphael's well-known *Madonna della Sedia*, on the one hand, symbolizes modern, Christianized Rome. On the other hand, the picture's sculpture of the Tiber (which is placed close to a picture on the far left representing the biblical Expulsion) alludes to ancient Rome's corruption and fall.

Turner's fascination with Italy and its history was, as mentioned, also concerned with Rome's beginnings; hence, his interest in the Aeneas legend that will be considered in the next chapter. Legends and myths are especially absorbing when linked with an historical event of far-reaching significance, and Turner would have been attracted to Aeneas's fulfilment of a prophecy, to his instrumental role in Rome's foundation. During his career Turner painted more pictures directly or indirectly associated with Aeneas and Rome than of any other subject.

22 *Modern Italy – the Pifferari*. Oil, exh. 1838. 36 ½ × 48 ½ in. (92·5 × 123 cm). Glasgow Museums: Art Gallery & Museum, Kelvingrove (BJ 374)

23 *Ancient Italy – Ovid Banished from Rome.* Engraving on copper after the oil painting dated c. 1838 by J.T. Willmore (1842). 43.2 × 60.3 cm. New Haven, Yale Center for British Art, Paul Mellon Collection (R 657)

4 The Dynamics of
Myth and Legend

T HE AFFILIATION OF THE eighteenth- and early nine-teenth-century public with the culture of the classical past was often stimulated by pictorial and sculptural imagery that depicted events from myth and legend. Myths and legends, the essential material of much traditional history painting, were un-derstood to convey universal truths; they deal with unchanging human problems and consider divine powers that determine destinies.

Myths may involve processes or metamorphoses epitomizing nature's cycles that are frequently associated with love and pas-sion. These myths include, for example, the stories of Europa and the Bull, Venus and Adonis, Narcissus and Echo, Apollo and Daphne, Bacchus and Ariadne and Glaucus and Scylla. Some myths possess a strong psychological element, such as occur in the story of the Goddess of Discord and of Medea. They concern hu-mans and deities who appear in human form. Some mythological personages are based in actual historical figures remembered for their feats of valour. Such were the subjects and themes that Turner often chose to paint.

During the first half of the first decade of the nineteenth cen-tury, when Turner was establishing his reputation as a painter of historical landscapes, myth and legend were of particular interest to him. This can be determined from the number and variety of subjects for compositions in his sketchbooks for which he pro-vided fresh contexts of interpretation. These compositions would provide inspiration for a number of major canvasses.

One of the fruits of his early interest in myth is the mezzotint frontispiece that he designed for his ambitious didactic enterprise, the print series entitled the *Liber Studiorum* (1807–19). William Fre-derick Wells, who was responsible for encouraging him to under-take this work, also played a crucial role in his development as an engraver. The central subject of the mezzotint frontispiece (fig. 24) is a depiction of Europa and the Bull. Zeus transformed himself into a white bull and enticed and carried away Europa, daughter of the king of Phoenicia, on his back into the sea, swimming with her to Crete, where she eventually bore him sons. The abduction of Eu-ropa is presented as a centred, scroll-framed painting that is within the design in the near, shallow middle ground and shown against a backdrop of blind arcades.[1] In the narrow band of foreground, na-ture and its bounty are presented. To the left is a catch of fish and a basket of eggs; to the right are land and water plants, the latter in a pond. Centrally placed in this natural setting is a live peacock, to the right of which is a fragment of classical cornice sinking into the mud of the pond.[2] As this frontispiece was originally proposed to introduce a projected series of one hundred designs, Turner proba-bly intended it to allude to the broad spectrum of landscape types and subjects that the *Liber* images were to encompass.[3]

Turner's *Europa and the Bull* was likely planned to function in more than one capacity. It probably provides a metaphor for the beginnings of Western civilization and suggests the historical na-ture of landscapes that this series was to include. With its dynamic design and allusion to metamorphosis, Turner's representation of this myth underscores change, which other elements of the frontispiece also reflect. As a backdrop, Turner has provided the historical evidence of architecture. Presented are different archi-tectural styles in apparent succession, tracing the cultural history of Western civilization, beginning with the classical in the fore-ground, followed by a screen of Romanesque arches in the mid-dle ground (behind the framed picture of Europa and the Bull). To the rear of this Romanesque screen, or rather above it, appears a machicolation faced with Gothic arches.

The presentation of this apparent sequence of architectural styles suggests not only historical succession but also the transience

24 The frontispiece for the *Liber Studiorum*. Mezzotint engraving by J.C. Easling (1812). 17.8 × 26 cm. London, Clore Gallery for the Turner Collection

25 *Venus and Adonis, or Adonis Departing for the Chase.* Oil, c. 1803–5. 59 × 47 in. (149.8 × 119.4 cm). Private Collection (BJ 150)

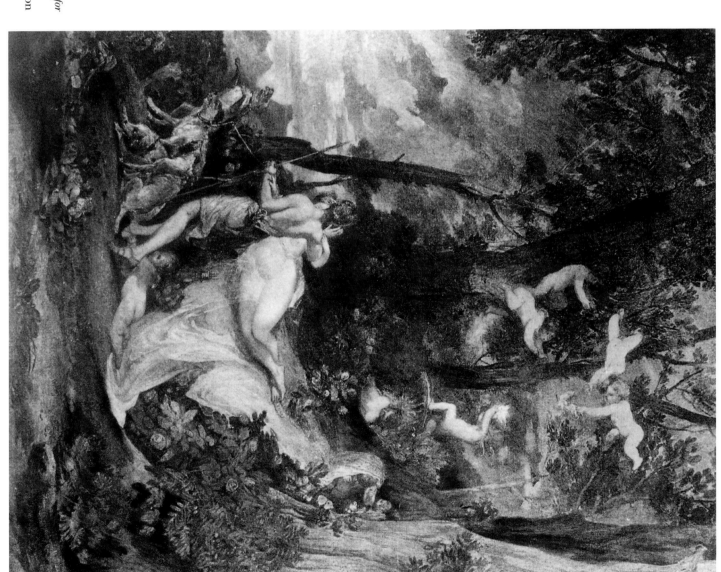

26 E.F. Burney, *The Antique School at Somerset House*. Pen and grey wash, 1779. London, Royal Academy of Arts

of civilizations. The remains of the classical entablature in the foreground that slowly sinks into the muddy waters of the pond particularly dramatize the ultimate victory of nature over the works of humankind. Though the peacock is part of nature, Turner surely also assigns to it a further meaning. Since the peacock is an established symbol of pride and vanity, by showing it next to the sinking fragment of a classical architecture, Turner is probably alluding to the imperfection of humanity, to the fall from grace that introduced not only sin but also time into the world.

Transformations such as that alluded to in the frontispiece's depiction of the rape of Europa are not infrequent in other mythological subjects found in Turner's oeuvre. His subjects, which are in many instances taken from Ovid's *Metamorphoses*, present ideal settings and mostly classically inspired or proportioned figures that are closely integrated with the landscape. Although Turner does not actually represent the process of transformation, he provides a crucially animated moment that leads up to it or occurs after it has taken place. The themes he employs often concern, directly or indirectly, the fateful workings of love and lust. This is displayed in the depiction of the rape of Europa and in other early works, such as *Venus and Adonis or Adonis Departing for the Chase*, which has been dated c. 1803–5; and *Narcissus and Echo* (RA 1804); however, others are later, including *Glaucus and Scylla* (RA 1841) and *Bacchus and Ariadne* (RA 1840).

VENUS AND ADONIS

The transformation of protagonists into plants or animals is a common theme in classical myth. This is true of the myth of Venus and Adonis, which Turner painted early in his career (fig. 25). In this painting, Venus is shown surrounded by her traditional symbols, the amorini and white doves, and by the rose bush and myrtle, which are sacred to her. She is reclining (in a pose reminiscent of Titian's Venuses), imploring Adonis not to go hunting, but he refuses to acquiesce. Turner depicts him, with his dogs, leaving her side. On the hunt he is mortally wounded by a wild boar, and Venus, inconsolable, transforms him into an anemone. Since both Venus and Adonis are associated with nature, what Turner seems to allude to is nature's death and resurrection.

Turner employs formal devices to aid his pictorial presentation of this myth. To enhance the drama and underscore the dynamic of natural process, Turner borrowed ideas from artistic models with which he was by then familiar and that imply change or movement; for example, the vertical composition of this painting was inspired by Titian's much admired *St Peter Martyr* (fig. 2), which he had closely studied in the Louvre in 1802, as we saw in chapter 2. He referred to it in his Royal Academy lectures as "the greatest specimen of Landscape for grandeur and dignified character";[4] he spoke of its composition, which he believed displayed an "unshackled obliquity" and "associated feelings of force [and] continuity."[5] Turner also found inspiration for the pose of Adonis in the striding pose of the antique statue the Apollo Belvedere, which he knew from the cast in the Plaister Academy of the Royal Academy shown at the middle-left in the watercolour by Burney (fig. 26).

27 *Glaucus and Scylla*. Oil on panel, exh. 1841. 31 × 30 ½ in. (79 × 77.5 cm). Fort Worth, Texas, Kimbell Art Museum (BJ 395)

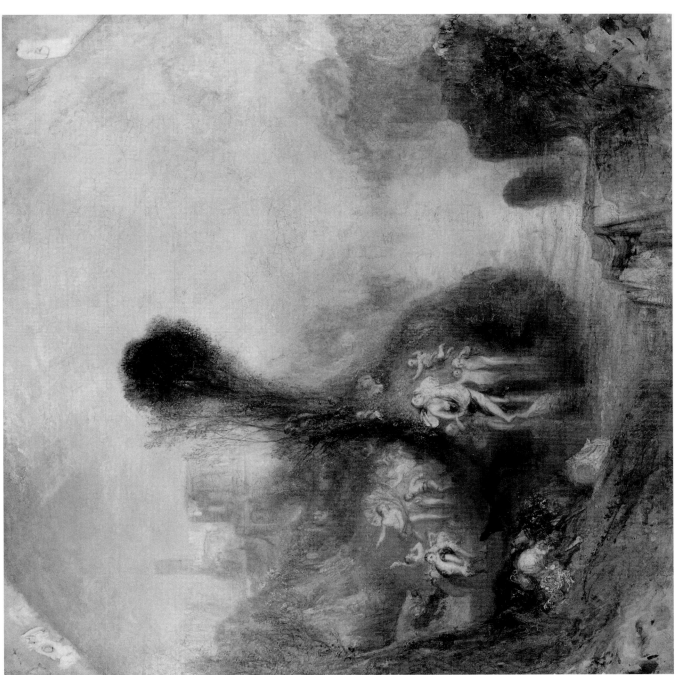

28 *Bacchus and Ariadne.* Oil, exh. 1841. 31 × 31 in. (78.5 × 78.5 cm). London, Clore Gallery for the Turner Collection (BJ 382)

GLAUCUS AND SCYLLA AND BACCHUS AND ARIADNE

Love and transformation are also themes of the two late history paintings mentioned in the last section, *Glaucus and Scylla* (RA 1841) (fig. 27) and *Bacchus and Ariadne* (RA 1840) (fig. 28). Although *Glaucus and Scylla* is usually considered the companion of *Dawn of Christianity* (*Flight into Egypt*) (shown at the Royal Academy in 1841) (fig. 102), it has been suggested that the latter's pendant was *Bacchus and Ariadne*.[6] At different times, could Turner have considered both mythological pictures as companions of *Dawn of Christianity* (*Flight into Egypt*)? The relationships between these three pictures will be considered more fully, later.[7]

Glaucus and Scylla and *Bacchus and Ariadne* do possess a remarkable number of similarities, in terms both of theme and of general appearance. In addition to sharing themes of love and transformation, they both allude to "flight."[8] *Bacchus and Ariadne*, whose design is adapted from Titian's picture of the same subject in the National Gallery, London, shows the maiden Ariadne, who, startled by the sight of Bacchus, the god of wine, turns as if to flee from him. *Glaucus and Scylla* (whose title was accompanied by a reference to Ovid's *Metamorphoses*) depicts the maiden Scylla escaping from the embrace of the amorous river god Glaucus, who had died and was brought back to life (fig. 29).[9] Because he was spurned, Glaucus sent for the enchantress, Circe, to cast a spell on Scylla and make her love him. Unfortunately, Circe fell in love with Glaucus and, seized with a paroxysm of jealousy, transformed Scylla into a horrid creature rooted to an ocean rock, from which she lured ships and sailors to their doom.

The story of Bacchus and Ariadne has a happier ending. Bacchus, who like Glaucus had died and was resurrected, fell in love with and married the beautiful princess Ariadne, who had been abandoned by Theseus. Because she was mortal, when she died Bacchus transformed her into a ring of bright stars.

These pictures share other similarities. They both display a yellow-orange sky, indicating the end of day, that is a complement and contrast to the cool, bluish morning light of *Dawn of Christianity*. The three paintings are also of the same size. Although *Glaucus and Scylla* and *Bacchus and Ariadne* are not painted on supports of the same material,[10] they were both shown in frames with circular openings, despite an earlier suggestion that *Bacchus and Ariadne* was exhibited as an irregular octagon.[11]

APULLIA IN SEARCH OF APULLUS

The dynamic of transformation and love also inspired Turner to paint *Apullia in Search of Apullus vide Ovid* (fig. 30), shown at the British Institution in 1814. This historical landscape was prepared for an annual competition with a 100-guinea prize held for the "best landscape" by the recently formed (in 1806) British Institution, which was established and run not by artists, as was the Royal Academy, but by a group of conservative aristocratic collectors, connoisseurs, and amateurs. Certainly, Turner's entry must have perplexed the judges. By this time he was close to middle age and so could hardly be considered young. Also, he chose to submit his entry eleven days after the competition's closing date.[12] Further, the original requirement of the competition that the subject and style of an entry should be a companion to an old master, preferably a Claude or a Poussin, was no longer in effect.[13] However, Turner himself elected to adhere to this early stipulation. His submission was based on a remarkably careful study of the design of Lord Egremont's Claude, *Landscape with Jacob, Laban and His daughters*. It was not, however, an exact copy; Turner did not believe that such an exercise was very useful. Still, Turner's picture is remarkably close to the original, at least as far as the landscape itself is concerned.[14] Turner added to his title "vide Ovid." This was deliberately misleading. He wished to give a transparently false impression that the subject was from the *Metamorphoses*. Though the Apulian shepherd and his transformation is from Ovid's poem, the shepherdess Apullia is not. To reinforce the mock learnedness of his painting, Apullia, the spurious heroine, assumes the pose of a personification of Apulia, a district in Italy found in an illustration in Cesare Ripa's emblem book *Iconologia*.[15]

Turner's *Apullia in Search of Apullus* was sent, not to win, but—because of its mimicry of both Ovid and Claude—to taunt, as a general protest against the Institution's promotion of the old masters and its neglect of modern British art.[16] More specifically, how-

29 *Glaucus and Scylla*. Pen and Sepia, c. 1813, 22.5 × 28.3 cm. London, Clore Gallery for the Turner Collection (TB CXVIII, P). See note 9, chap. 4

ever, by emphasizing his mimicry of both image and word, Turner seems to have opposed the Institution's obvious intention to promote the precise, uninspired copying of old masters that Turner considered anathema.[17] There is likely more. Turner's *Apullia in Search of Apullus*, like his small *Amateur Artist*, mentioned in chapter 2, was probably undertaken as a malicious exercise directed against the connoisseurs and amateur directors of the Institution, most specifically, against his captious critic, the influential Sir George Beaumont. Sir George would most likely have known Lord Egremont's Claude. The remarkable similarity between Turner's painting and this Claude would have deeply irritated him and increased his antagonism toward the artist.[18] In

1812, two years before Turner exhibited *Apullia in Search of Apullus*, Beaumont had declaimed against what he considered the artist's penchant for unfinished foregrounds and for lightened tonality. Turner and his followers were accused "of endeavouring to make painting in oil to appear like water colours, by which, in attempting to give lightness and clearness, the force of oil painting has been lost."[19] Turner must have deeply felt and keenly resented Beaumont's paraded, sneering dislike of his pictures. *Apullia in Search of Apullus* could have been an impatient painterly response to a particular cutting remark by the Baronet, which Turner may himself have overheard or of which he was informed. John Constable, who had been friendly with Beaumont,

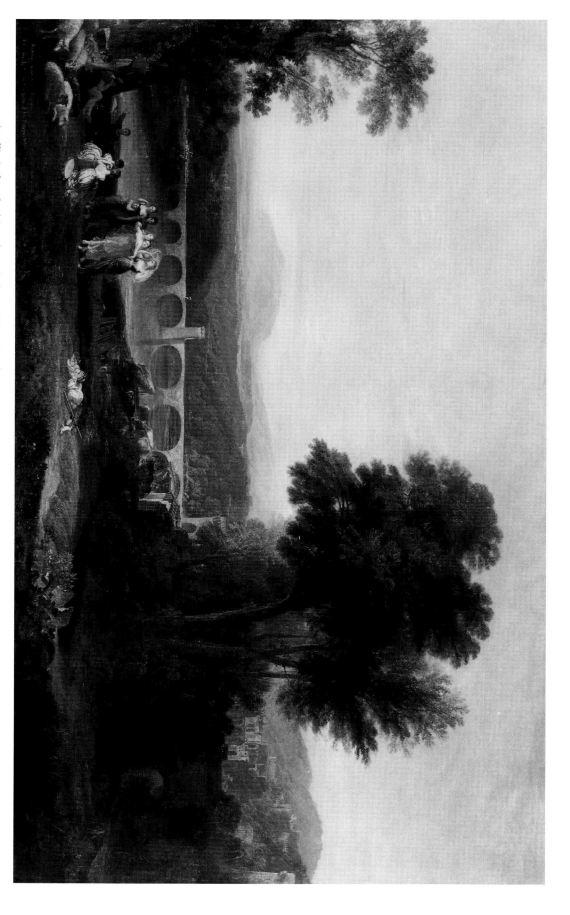

30 *Apullia in Search of Appulus vide Ovid.* Oil, exh. 1814. 57 ½ × 93 ⅞ in. (146 × 238.5 cm). London, Clore Gallery for the Turner Collection (BJ 128)

recounted late in life (in his last lecture on landscape) an occasion when the Baronet had examined a large picture in the style of Claude by a "modern artist," remarking that "[I] never could have believed that Claude Lorrain had so many faults, if I had not seen them all collected together on this canvas."[20] If his remark was directed toward Turner and if Turner knew of it before he painted *Apullia in Search of Apullus*, then his painting could have been intended as a triumphant, particular repost! Whether or not his painting was such a response, Turner never again mimicked a specific Claude landscape quite so precisely.

While Turner's mythological pictures involve process, other themes, such as passion, also animate them. Turner often favoured the dynamics of psychological conflicts such as rejection and retribution, deception and betrayal.

THE GODDESS OF DISCORD

Rejection and retribution are themes of an important early historical landscape (which is slightly later than his *Venus and Adonis*): the *Goddess of Discord Choosing the Apple of Contention in the Garden of the Hesperides* (fig. 31). This painting, ambitiously conceived, was shown at the first exhibition of the British Institution in 1806.[21] Muted in colour to emphasize its sublime, formal grandeur,[22] it is a remarkable work in a number of respects, one of which is that it appears to be the first picture in which he makes extensive use of covert or implied meanings; it is a mythical allegory devised by him from various sources and filled with profoundly evocative images. Poussin, the artist whom Reynolds considered preeminent as a painter of historical landscapes, influenced its style. The transparent allusion to Poussin would surely have found favour with the newly established institution, which favoured showing paintings that made obeisances to the classical masters. Turner noted in his Royal Academy lectures that Poussin's "ruling passion [was] for allegorical allusion,"[23] and this Turner's picture certainly embodies. The landscape design, however, is not based on Poussin but, rather, was largely appropriated from an engraving after an early mythological work by Antoine Watteau, under the influence of Poussin, entitled *Acis et Galathe* [*sic*] (fig. 32). The myth of Acis and Galatea, like the

myth presented in Turner's *Garden of the Hesperides*, is also concerned with rejection and retribution.[24]

In the apparently tranquil atmosphere of the *Garden of the Hesperides* Turner depicts Eris, the Goddess of Discord, choosing a golden apple from those offered by the daughters of Hesperus, whose task it was to help protect the tree that bore this fruit. Because Eris was not invited to the marriage of Peleus and Thetis, she retaliated by throwing down amongst the wedding guests, the assembled gods and goddesses, the selected golden apple inscribed with the words "For the fairest." The ensuing dispute between Hera, Athene, and Aphrodite for the prize of beauty was decided by Paris, son of Priam, King of Troy, in favour of Aphrodite. That decision resulted in the permanent enmity of Hera and Athene toward the Trojans. The disharmony caused by the apple was also considered responsible for the fall of Troy, an event that in the writings of the romantics was often likened to the fall of humankind from divine grace. The fall of Troy could allude therefore to the evil that makes redemption necessary and possible.[25] That Turner intended this allusion in his painting is supported by the contents of the poem *Ode to Discord*, which he wrote in his Verse Notebook on the subject of the Garden of the Hesperides. This poem was intended initially to accompany his picture, but in the end it did not. Its lines, which refer to the Fall of Troy, also allude to the Fall of Man:

Discord, dire Sister of Etherial Jove
Coeval, hostile even to heavenly love,
Unask'd at Psyche's [*sic*] bridal feast to share,
Mad with neglect and envious of the fair,
Fierce as the noxious blast thou cleav'd the skies
And sought the hesperian Garden's golden prize.

The guardian Dragon in himself an host
Aw'd by thy presence slumberd at his post
The timid sisters with prophetic fire
Proffered the fatal fruit and feard thy wrathful ire
With vengfull pleasure pleas'd the Goddess heard
Of future woes: and then her choice preferred
The shining mischief to herself she took
Love felt the wound and Troy's foundations shook.[26]

This verse gives a glimpse of the blossoming metaphorical con-sciousness of this relatively young artist that is considered more fully in a further discussion of the *Garden of the Hesperides* in chapter 9.

MEDEA

Another, much later painting involving rejection and retribution is the *Vision of Medea* (fig. 33), which Turner painted during his second visit to Rome in 1828–29. Turner's thoughts, as noted, of-ten turned to the Fall, the consequence of which was the corrup-tion of nature. It was an event that affected all society and seems to account for his interest in the cyclical character of history. It

also explains his fascination with the flawed nature of humanity – with the decline of heroic individuals – one of whom was Medea.

The tragedy of Medea is known from the plays of Euripides and Seneca. Medea, a sorcerer, was the daughter of the king of Colchis. After betraying her father and murdering her brother, she fled with Jason, the Argonaut, whom she married and assisted with her magical powers. When Jason went to secure the Golden Fleece, she drugged the sleepless dragon that guarded it so that Jason could despatch it (according to some accounts) and remove the Fleece. She also restored to youth Jason's father, Aeson. Jason and Medea eventually went to reside in Corinth, where Jason, now with twin sons by Medea, deceived and betrayed her: he fell in

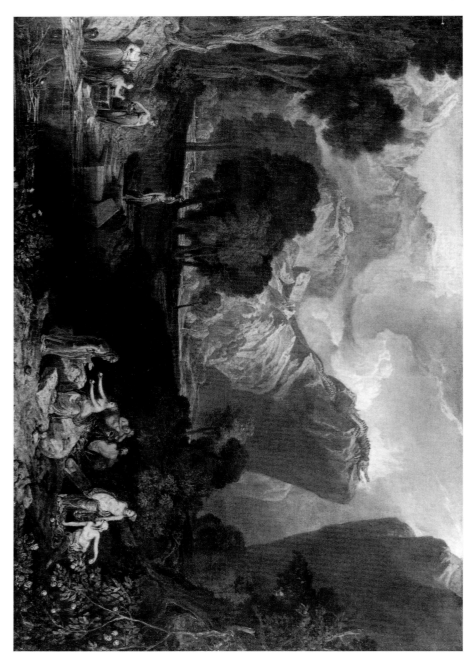

31 *The Goddess of Discord Choosing the Apple of Contention in the Garden of the Hesperides.* Oil, exh.1806. 61 ⅛ × 86 in. (155 × 218.5 cm). London, Clore Gallery for the Turner Collection (BJ 57). See colour plate 4

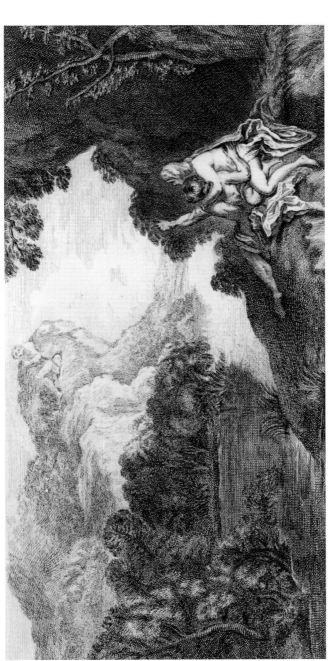

32 J.A. Watteau, *Acis et Galathe.* Engraved by "c.x." for M. de Julienne, *L'Oeuvre d'Antoine Watteau,* 1739. London, British Museum

love with Creusa, daughter of Creon, king of Corinth. On Jason's instigation, the king proclaimed that Medea was forever banished from his realm. However, Medea was given a day of grace. Enraged and embittered by her husband's infidelity and especially his impending marriage to Creusa, she plotted her revenge. She planned to inflict on Jason the deepest wound possible by depriving him of those whom he loved. She sent a beautiful gown to Creusa as a wedding gift and cast a magic spell on it that caused Creusa, when she touched it, to suffer an agonizing death. Yet Medea's rage was not spent. She set fire to Creon's palace (he perished in the flames), murdered her two children, and then, mounting her winged serpent-drawn chariot, fled to Athens.

Turner's *Vision of Medea,* which is Titianesque in style and atmosphere, concerns both the death of Creusa and the murder of Medea's children. It seems probable that his picture was inspired, as has been suggested, by *Medea in Corinth,* an opera by J.S. Mayr that was performed at the King's Theatre, Haymarket, London, between 1826 and 1828.[27] The imagery of Turner's picture is enhanced by his use of strong colour and dramatic light and shade. Medea, accompanied by her maid, who is seated on the ground next to her, raises in the air a snake-entwined wand. Before her is a smoking altar fire, in front of which, though not visible, is the garment on which she casts the magic spell she will give to Jason's bride. In the obscuring, dense smoke appears the vision of

33 *Vision of Medea*. Oil, 1828. 68 ⅜ × 98 in. (173.5 × 241 cm). London, Clore Gallery for the Turner Collection (BJ 293). See colour plate 5

Medea's two children, whom she will stab to death as punishment for their father's betrayal. The dim form of a monstrous, menacing serpent lying coiled amongst ravaged trees to the right alludes powerfully to the forces of the underworld that Medea, through her spell, urgently invokes. It has been suggested that the three Fates, spinning the destinies of humankind, appear in the picture because Turner had confused the Fates with the three Furies mentioned in the opera libretto.[28] As Medea prepared her magic rite for her revenge, she expressed her feelings for these powerful forces: "Though both earth and Heaven / Are hostile to Medea, And hell I will invoke" (act 2, scene 4). That it was the Furies that she summoned rather than the Fates (who, like the Furies, also inhabited the nether regions) is suggested by the Furies' particular role of vengeance against earthly sinners.[29]

The tragedies of both Euripides and Seneca influenced the opera libretto. However, it has been noted that only Seneca's version includes the incantation – the decisive moment in this opera and the subject of Turner's painting. Further, Seneca alone refers to the deadly herbs, ingredients of the incantation shown in the left foreground of the picture, and to Medea's discarding of her children's bodies when departing in her dragon chariot,[30] an event that Turner shows in the left background of his painting. It should also be observed that Seneca's description of Medea's magic is more elaborate and, not surprisingly, of greater poetic density than that of the opera libretto. Further, Turner's painting seems to have captured some of Seneca's richly brooding images, at least as they are found in English translations of the work. During Medea's incantation the great serpent from the underworld responded to her urgent summons: "Dragging his bulk immense with slow career, / ... at her magic voice he coils / His sinewy folds with horror."[31] Such a sublime image would readily have attracted Turner's attention. One can compare this description with Turner's depiction of the immense coils of this gigantic serpent that are to the right of Medea's altar and partly obscured by the trees' penumbral gloom.

Rich images crowd Turner's picture. By presenting or alluding to several events in which Medea participates, he could enlarge and deepen the content of his dramatic depiction, strengthen his picture's poetical character (intentionally or not), and, perhaps most significantly, adhere to the dramatic rule that requires the inclu-

sion of the several stages that constitute a complete action: its causes, growth, climax, and close. Walter Thornbury first alluded to the effective compression of time and space that Turner achieved in this picture – the dramatic rendering of a sequence of related events involving the tragic heroine.[32] Turner provided a gloss for this picture with poetic lines from his so-called manuscript poem, "Fallacies of Hope," creating a potent interplay between image and word. These lines were intended to aid the viewer by clarifying the picture's simultaneous presentations of or allusions to the episodes of Medea's revenge, elaborating their significance and guiding the reader/viewer through their sequence:

Or Medea, who in full tide of witchery
Had lured the dragon, gained her Jason's love,
Had filled the spell-bound bowl with Aeson's life,
Yet dashed it to the ground and raised the poisonous snake
High in the jaundiced sky to writhe its murderous coil,
Infuriate in the wreck of hope, withdrew
And in the fired palace her twin offspring threw.

These lines refer to the spell that Medea cast over the dragon protecting the golden fleece and the magic that rejuvenated Jason's father, Aeson. They inform us that before Jason's betrayal, Medea had employed her magic to aid Jason, though in consequence of her discovery of his perfidy she used this magic against him. It became the terrible instrument of her revenge.

The *Vision of Medea* and its accompanying lines allude to the significant role of the past in shaping events of the present and future. One of the two large bubbles floating above and immediately to the left of the smoke rising from the altar fire (were these bubbles supposed to have arisen from the surface of a boiling witches' brew similar to that described in Shakespeare's *Macbeth*?) accords coherence and direction to the picture's narrative. On the shining surface of the lower of the two bubbles a vision of the armed Jason and the wings of the dragon guarding the golden fleece is sharply etched in white lines: the dragon has been lulled to sleep by Medea's powerful potion and is now about to be struck a mortal blow from the club that Jason wields.[33] Turner here plays past and present against each other. The retrospective process

gives particular vitality to the present. The bubble image provides a laconic metaphor for Medea's love and support for Jason in their early, happy years and an allusion to the positive use of her magic. This is then contrasted with the negative use of it when she learns of Jason's perfidy. After Creusa dies, Medea, still thirsting for revenge, stabs her children. As has been observed, in the left background Turner shows Medea's chariot again, this time in the clouds from which she throws the bodies of her murdered offspring into the burning remains of Creon's palace below.

The theatricality of this picture is notable. Not only is Medea's pose histrionic, but the irregular ground on which she stands is canted, as if showing a raked stage. Still more theatrical is the picture's strong colouring, the bright illumination on the tragic heroine's face and on the bodies of the three Fates. Of this

picture the critic of *The Athenaeum* wrote a damaging review, noting that it "is a piece with the poetry. Here we have, indeed, the Sister Arts – and precious sisters they are! Mr Turner doubtless, smeared the lines off with his brush, after a strong fit of yellow insanity, on canvas. The snakes, and the flowers, and the spirits, and the sun, and the sky, and the trees, are all in an agony of ochre."[34]

The highly dramatic character of Turner's picture, established by Medea's expansive pose and by the number and nature of the events that crowd round her (forming the violent ingredients of her dark vision), is thus strengthened by these light and colour effects. The drama is further augmented by the landscape itself, by its components and their poetic disposition. Turner knew the value of uniting his figures with landscape in order to give added meaning to both: Medea's murderous intent, which is

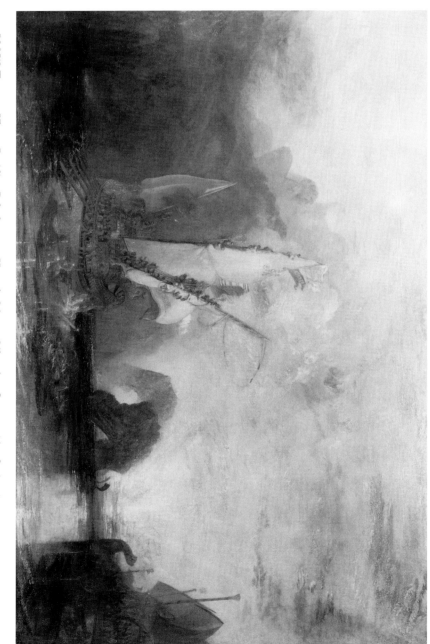

34 J.M.W. Turner, *Ulysses Deriding Polyphemus – Homer's Odyssey.* Oil, exh. 1829, 52 1/4 × 80 in. (132.5 × 203 cm).
© National Gallery, London (BJ 330). See colour plate 6

35 Sketch for *Ulysses Deriding Polyphemus*. Oil, c. 1828. 23 ⅝ × 35 ⅛ in. (60 × 89 cm). London, Clore Gallery for the Turner Collection (BJ 302)

expressed through her frenzied, violent pose, is forcefully echoed by the bold almost threatening diagonals of adjacent tree trunks. This formal relationship between the protagonist's stance and the abrupt, assertive angles of the trees is one of the most affective aspects of Turner's painting. And, on an associative level, a deeper and more profound chord of dramatic significance is struck, not only by the possible relationship between this design and Sir Joshua Reynolds' *Macbeth and the Witches*, with which Turner was acquainted at Petworth House in Sussex,[35] but also, I believe, by the deliberate, faint, and flickering evocation of the most celebrated Venetian historical landscape representing violence and murder known to Turner, in which landscape and figures play a similar dramatic role: Titian's powerful *Martyrdom of St Peter Martyr* (fig. 2), discussed in chapter 2, above.[36]

ULYSSES AND AENEAS

Other myths of deception and intrigue were chosen as subjects by Turner. Some of them, such as those recounting the adventures and vicissitudes of Ulysses and Aeneas, involve a peregrinating hero. The legends of Ulysses and Aeneas appealed to Turner's romantic imagination, since painters and poets of the time often considered themselves as lonely, restless travellers alienated from society.[37] These legends also embody the idea of destiny.

Turner painted only one historical landscape on the epic theme of Ulysses: *Ulysses Deriding Polyphemus – Homer's Odyssey* (c. 1829) (fig. 34, discussed in chapter 3, above), for which, unusually, there is an oil sketch (fig. 35) that must date from the late 1820s.[38] The event represented by Turner was perhaps one of the

most celebrated of Ulysses's adventures when he and his men sailed to the island of the Cyclops. His painting was inspired by lines taken from Pope's translation of Homer's Odyssey:[39]

Now off at sea, and from the shallows clear,
As far as human voice would reach the ear;
With taunts the distant giant I acost,
Hear me, oh Cyclop! hear, ungracious host!
'Twas on no coward, no ignoble slave,
Thou mediat'st thy meal in yonder cave;
But one, the vengeance fated from above
Doom'd to inflict; the instrument of Jove.
Thy barb'rous breach of hospitable bands,
The god, the god revenges by my hands.
These words the Cyclop's burning rage provoke:
From the tall hill he rends a pointed rock;
High o'er the billows flew the massy load,
And near the ship came thund'ring on the flood.
It almost brush'd the helm, and fell before:
The whole sea shook, and refluent beat the shore.

...............................

But I, of mind elate, and scorning fear,
Thus with new taunts insult the monster's ear.
Cyclop! if any, pitying thy disgrace,
Ask who disfigur'd thus thy eye less face?
Say 'twas Ulysses; 'twas his deed, declare,
Laertes' son, of Ithaca the fair;
Ulysses, far in fighting fields renown'd,
Before whose arm Troy tumbl'd to the ground.[40]

These verses and Turner's picture portray the morning after Ulysses and his men had escaped from the giant's cave, where some had been systematically eaten by him. Turner represents the blind Polyphemus atop a smouldering mountain writhing with pain from his wound and also with impotent rage as the result of being tricked and then taunted by Ulysses, shown hands raised in the bow of his departing ship. The giant prepares to thrust down on Ulysses' vessel a great boulder torn from the rocky prominence on which he lies.

There are deeper and more allusive elements that enrich the picture's dramatic meaning and link it in an number of respects with the Garden of the Hesperides. The relationships established between these pictures are probably the consequence of them being conceived about the same time.[41] Ulysses was influenced, if less directly than the Garden of the Hesperides, by the art of Poussin. It, like the Garden of the Hesperides, also contains allegorical allusions,[42] There is also an allusion to the destruction of Troy, an event that is referred to, as was noted earlier in this chapter, in his Ode to Discord, the poem that he intended to attach to the Garden of the Hesperides but did not.

The allusion to Troy in Ulysses Deriding Polyphemus is in the painting, not in the poem just discussed. A flag on the main mast of Ulysses' ship refers to the siege of Troy, since it depicts the great wooden horse.[43] Informed that the only way that Troy could be taken was by treachery, the Greeks built the Trojan horse in which, under the direction of Ulysses, the bravest Greek warriors were concealed. By making reference in his painting specifically to the horse, Turner draws a parallel between Ulysses' personal cunning in deceiving Polyphemus and that spectacularly successful stratagem of deceit he had prosecuted during the siege of Troy.

The early pen, ink, and wash sketch composition (fig. 36) for Ulysses Deriding Polyphemus (c. 1807),[44] though possessing notable similarities with the composition of the oil study and the finished painting, differs from them, especially in the interpretation of the figure of Polyphemus. In the sketchbook design Polyphemus is not easily identified; he appears, however, at the top centre of the composition, a distant figure faintly drawn, seated on a mountain peak. His size relative to the mountain on which he sits may have been inspired by the small, reclining image of Polyphemus on a headland shown in the print of Watteau's Acis et Galathe (fig. 32), whose Poussinesque landscape had been largely appropriated, as we have seen, for the setting of the artist's Garden of the Hesperides. In the oil study for Ulysses Deriding Polyphemus, perhaps prepared in 1828 before his visit to Italy or possibly after his return to England in early 1829, and in the final painting, his conception of the Cyclops had altered. In both works, Polyphemus reclines, and he is no longer quiescent – he writhes. Moreover, he is viewed at

closer range and thereby is imbued with a more powerful presence. He appears as a gigantic, flailing figure, the personification of active, uncontrollable, threatening forces of the earth associated with volcanic activity.[45]

Though the *Odyssey* furnished Turner with the theme for only one finished picture, he turned to Virgil, whose national epic, the *Aeneid* (which was inspired by the *Odyssey*), provided him with the subject matter for many pictures, several containing allusions to Troy. Eleven pictures are either directly or indirectly concerned with the hero, Aeneas, and his exploits: *Dido and Aeneas* (RA 1814), *Dido Building Carthage; or the Rise of the Carthaginian Empire* (RA 1815), *The Decline of the Carthaginian Empire* (RA 1817), *Dido Directing the Equipment of the Fleet, or The Morning of the Carthaginian Empire* (RA 1828), *Aeneas Relating His Story to Dido* (RA 1850), *Mercury Sent to Admonish Aeneas* (RA 1850), *The Visit to the Tomb* (RA 1850), *The Departure of the Fleet* (RA 1850), *Aeneas and the Sibyl, Lake Avernus* (c. 1798), *Lake Avernus: Aeneas and the Cumaean Sibyl* (1814–15), and *The Golden Bough* (RA 1834).

Turner was probably attracted to the Aeneas legend because it was intimately and indissolubly associated with the founding of Rome, symbol of Western civilization and centre of universal history. Virgil's *Aeneid* tells a compelling story of divine guidance and obstruction, and it is to this aspect of the *Aeneid* that many of Turner's pictures on the subject allude. During the destruction of Troy by the Greeks the Trojan hero left by sea with his father, Anchises, his son, Ascanius, Aeneas's Trojan followers, and also "the Deities of Troy and his own Penates," who appeared to him during the voyage and advised him. He was informed by the spirit of his dead wife (who had been killed on their flight from Troy) that his goal was to reach Italy, where the gods "had promis'd to his Race the Universal Empire."[46] Aeneas sailed west, though on the way his father died. Juno (Hera), who, as noted earlier in this chapter, hated the Trojans, was intent on preventing Aeneas from realizing his destiny. She therefore requested that Aeolus, the wind god, create a storm to drive the Trojans off course.

In consequence, the Trojans landed on the African coast where Dido, the Tyrian queen, was building Carthage. Knowing of Juno's powerful influence over Carthage, Venus (Aeneas's mother) caused Dido to fall passionately in love with this Trojan hero in order to protect him from Juno. To accomplish this, Venus sent Cupid, her other son, in the guise of Ascanius. Dido soon felt the effects of Cupid's magic dart, and Aeneas came under the spell of the Tyrian queen. Dido showed him the rising city of Carthage and prepared a royal hunt for his entertainment, during which Juno, with Venus's consent, commanded up a storm causing Dido and Aeneas to seek refuge in a cave, where they consummated their love. Dido's passionate love for Aeneas blinded her to her responsibilities as queen, and she forsook her vow to remain faithful to the memory of her dead husband, Sichaeus. Aeneas, similarly, was so enchanted by his regal mistress that for a time he forgot his mission to lead his followers to Italy. Mercury, the messenger of the gods, was sent by Jupiter to remind Aeneas that his destiny lay in Italy. It was after Mercury's visitation that Aeneas and his men prepared to leave without Dido's knowledge; she learned of their plan, but too late. Aeneas and his men sailed away, leaving behind Dido embittered and forlorn, betrayed by her lover. After the departure of Aeneas's fleet Dido, in dark despair, committed suicide.

Aeneas eventually reached Italy, where at Lake Avernus, south of Naples, he met the Cumaean Sibyl who was to guide him to the underworld. She commanded Aeneas to find and bring a magical golden bough for Proserpine, queen of the underworld, to protect him on his journey. In the underworld he encountered the shade of his dead father, Anchises, who informed him of his future role in the founding of Rome, the new Troy.

In his historical landscapes concerned directly or obliquely with the Aeneas legend, Turner devised compositions, lighting effects, and atmosphere that reflect the influence of the classical landscape tradition, the artistic importance of which Sir Joshua Reynolds had espoused.[47] All but one of these pictures (an early work in the manner of the English artist, Richard Wilson) reflect qualities of the landscapes of Claude Lorrain, which by the second and decade of the nineteenth century Turner found increasingly seductive and of which he had begun to develop a deeper under-

standing. Turner was probably attracted to the Claudean model for his Aeneas pictures in part because Claude's pictures were considered eminently poetical[48] – as noted, Turner possessed an intense interest in the potential relationships between painting and poetry. Also, Claude had often selected episodes from the *Aeneid* for his own paintings (some of which Turner had examined or knew indirectly through Earlom's prints of Claude's *Liber Veritatis*). Turner was further attracted to Claude's landscapes because of that artist's light effects, especially his frequent depiction of the rising and setting sun. These effects were adapted by Turner not only to enhance the expressiveness of his landscapes but also to furnish some of them with a temporal framework that, for example, the *Aeneid* contains.

In addition, the Aeneas legend was probably of interest to Turner because Aeneas had an established association with Britain. It was believed that ancient British kings were descended from Brutus, Aeneas's grandson.[49] Further, Turner perceived national or contemporary significance in depicting or alluding to Aeneas in his pictures. Aeneas's abandonment of Queen Dido led to the enmity and later rivalries between Carthage and Rome, which, during the tense period of the Napoleonic wars, were often compared with the relationships between Britain and France.

These comparisons had a typological basis. They involve a broad, coherent conception of historical typology that, I believe, is often the stuff of Turner's art. He would have encountered typological relationships in books, tracts, and even newspapers. Walter Thornbury, for example, alluded to the secular character of typology when discussing Turner's paired Carthage pictures: *Dido Building Carthage; or the Rise of the Carthaginian Empire* and *The Decline of the Carthaginian Empire*. Painted by Turner at the end of the Napoleonic wars, they were, Thornbury commented, "to show the rise of a maritime empire which he considered typical of England; France and Rome also no doubt being analogous in his mind ... Turner seems to have considered the fate of Carthage as a moral example to England; ascribable as it was to the decline of agriculture, the increase of luxury, and besotted blindness, too prolonged, to the insatiable ambition of Rome."[50]

Another possible reason for Turner's fascination with the Aeneas theme was the dynamic role in the legend of prophecy.

Aeneas's struggle to fulfill his destiny was of especial interest to him, and the themes of several of his pictures are concerned with this.

Eight of Turner's pictures illustrating the story of Aeneas concern, directly or obliquely, the tale of Dido and Aeneas, one of the celebrated love dramas of all times. Some of them allude to the delaying and diverting role that Dido plays in this epic drama, as well as to her despair and death when Aeneas leaves her. The remaining pictures concern Aeneas and the Sibyl in Italy.

Of the paintings on the Dido and Aeneas theme, the earliest is *Dido and Aeneas* (fig. 37), which was exhibited at the Royal Academy in 1814; it is based on a landscape composition in his Isleworth sketchbook.[51] This painting shows a quiet Claudean landscape with a river and the towers of Carthage rising in the background. Dido and Aeneas are on the bridge to the right. Dido had previously shown Aeneas (who had recently arrived in Carthage) the grandeur of her rising city and attempted to impress him with her wealth; as Virgil indicated, "This Pomp she shows to tempt her wand'ring Guest." However, there was further activity to distract and involve Aeneas. He, Dido, and her court were to "shady Woods, for Silvan Game, resort."[52] Indeed, Turner shows them just before they depart on the royal hunt that Dido had arranged, the event that, under the direction of Juno, aided by Venus, was to lead to the consummation of the love of Dido and her Trojan hero. To the left in his picture, Turner has depicted the other courtly participants in the hunt with their hounds.

The landscape setting is unusual for a scene purporting to represent the coastal city of Carthage, since the city is shown on the banks of a river and seems some distance from its mouth. Indeed, the topography appears to be based on the verdant countryside of the Thames in the vicinity of Richmond, sketches of which the Isleworth sketchbook contains.

Richmond had traditionally been associated with royalty and classical associations. A poem, *Richmond Hill*, had recently (in 1807) strengthened these connections. The author, Thomas Maurice, speaks of the countryside about Richmond as being the "The Favoured Haunts of the British Kings and Statesmen"[53] as well as the "fair Parnassus of the British isles," where "many a goddess haunts the Elysian shade."[54] He also refers to views that he considered reminiscent of the classical landscapes of Claude Lorrain and Nicolas Poussin.[55] Further, he refers to the "noblest bards" of the place, James Thomson and Alexander Pope, who were inspired by classical poetry. Maurice mentions Pope's "plunder'd, faded Grot" at Twickenham: "No more, sweet bard, the pointed crystals gleam, / Nor glittering spars reflect thy much-loved stream."[56] The Richmond area's classical associations had begun about the time of Pope and Thomson and continued into the nineteenth century. Turner, who spent much time sketching in the area, was certainly aware of these connections. This may have led him to search for suitable "Genii loci" to preside there and to consider the district as an appropriate setting for a poem that he drafted in a sketchbook (c. 1810–12) on the theme of Aeneas and his Tyrian queen.

There are several drafts of this poem in which Turner seems to allude to the consummation of the love of Dido and Aeneas that occurred on the day of the hunt,[57] the hunt to which the picture *Dido and Aeneas* alludes. As Turner referred to Pope as the "British Vergil," surely it is fitting that in his poem the artist places the love-making of Dido and her amour not in a cave in the environs of Carthage but in Pope's well-known Grotto on the Thames! (This is an example of Turner's merging of fancy and fact.)[58] Could he possibly be alluding to a link here between the fate of Carthage and the future of Britain? Certainly the history of Carthage was a subject that particularly interested him at this time. Because of its setting, *Dido and Aeneas* will be discussed further in the next chapter.

Two of the most celebrated of Turner's historical landscapes on the theme of Dido and Aeneas are the paired *Dido Building Carthage; or the Rise of the Carthaginian Empire* (fig. 38) and *The Decline of the Carthaginian Empire* (fig. 39); the former, in which he reputedly proposed to be wrapped when buried, was exhibited in 1815; the latter was exhibited two years later, in 1817.[59] These pictures show a remarkably close study of the qualities of the seaport compositions of Claude, which persuaded him that they should be willed to the nation and hung in the National Gallery next to two celebrated Claude landscapes in its collection, *Seaport with the Embarkation of the Queen of Sheba* and *Landscape with the Marriage of Isaac and Rebekah*, also known as *The Mill*.[60]

37 *Dido and Aeneas*. Oil, exh. 1814. 57 ½ × 93 ⅜ in. (146 × 237 cm). London, Clore Gallery for the Turner Collection (BJ 129)

These Carthage pictures indicate Turner's remarkable ability not only to compete with Claude but also to provide unambiguous evidence of his gradual reassessment of the historical colour that he had previously employed, for example, in his *Garden of the Hesperides* (c. 1806), with its overall muted hues (what he referred to in his lectures as "Historic tone").[61] However, he seems to have believed that the unifying effect of historical colouring could be achieved not only by an overall "low tone" but also by a "high" one.[62] In these Carthage pictures, he demonstrates most convincingly the latter; he demonstrates that he had learned from Claude over a relatively short period of time that a large area of bright sky, often with a directly observed sun (as occurs in these paintings) and a heavy atmosphere, could be a powerful unifying agent in a landscape. Even though using a centralized focus of light to accent the subject was not uncommon in paintings involving historical themes, the central focus did not normally emphasize the sky;[63] by expanding this light centre not simply to include the sky but to make it stronger and by using its radiance to embrace and unite the rest of the composition, as Claude often had done, Turner was able to achieve a much more brilliant, overall high-keyed effect. To enhance these effects further, he used water (a river or the sea), to mirror sky and sunlight, often to unite or fuse sky light with its reflection, thereby enlarging his focus of light. The heightening of light and colour, influenced by his experience with watercolour and aided by a white ground and glazed colour, is palpably evident in these Carthage pictures and was to influence profoundly the nature and structure of subsequent landscape paintings, many of which have historical themes.[64]

Dido Building Carthage and *The Decline of the Carthaginian Empire* are also significant for their sequential relationship. As mentioned earlier, Turner was familiar with the tradition of *ut pictura poesis* and therefore with the difficulties faced by the painter who is confined by the "single moment." He had probably come to the realization that paired pictures could be poetical insofar as the relationship that paired pictures could expand this moment. The particular lapse of time shown in these Carthage pictures may have been intended to demonstrate what one artist (whose writings were familiar to Turner) had observed, that pictures that suggest the passage of time are "often more than equivalent to all the successive energies of the poet."[65]

These two pictures are palpably allegorical. They link times of day with states of society. Turner associates the rising sun with the building of Carthage, the setting sun with its decline. In doing so he provides an efficacious association that suggests the helplessness of human beings in the determination of their fate. It may not be fortuitous that the occasional verses from Turner's "Fallacies of Hope" – lines from which first appeared in 1812 in the Royal Academy catalogue entry for his *Hannibal Crossing the Alps* – were attached to each of these Carthage pictures. Indeed, it may be significant that this poem provided the only poetical lines to be associated with his subsequent Aeneas pictures, suggesting that in the themes of these works he considered fate to play a particularly significant role.

In *Dido Building Carthage*, Dido is shown on the left directing the building of her magnificent city. Possibly, but not certainly, the figure in armour next to Dido whose back is to us, is Aeneas, who witnesses the activity. On the right of the estuary an elaborate tomb holds the mortal remains of Dido's husband, Sichaeus, who had been killed by her brother and from whom she escaped to found Carthage.[66] Ruskin shrewdly observed that the boys sailing toy boats in the estuary allude to Carthage's promising future.[67] Although this picture received high praise from the critics, Farington recorded that "[Thomas] Philips ... spoke to me of the great injury done to Turner by the reports of Sir George Beaumont and other[s] of His circle. He said Holwell Carr, speaking to a person of Turner's Picture of '*Dido building Carthage*' observed that 'Turner did not comprehend His [Claude's] Art.' – By such speeches Philips thought Turner was greatly injured."[68]

This painting's buoyant optimism and activity, associated with the building of Carthage, are contrasted with the lethargy, meditative resignation, and grief of its companion, *Decline of the Carthaginian Empire*. This latter picture documents the city state near its end and provides a specific indication in its full title of what is represented: Rome, being determined on the overthrow of her hated rival, demanded from her such terms as might either force her into war or ruin her by compliance. The enervated

38 J.M.W. Turner, *Dido Building Carthage; or the Rise of the Carthaginian Empire*. Oil, exh. 1815. 61 ¼ × 91 ¼ in. (155.5 × 232 cm). © National Gallery, London (BJ 131). See colour plate 7

Carthaginians, in their anxiety for peace, consented to give up even their arms and their children.

The ingredients of this second picture lay Carthaginian history before the viewer, reinforcing the work's elegiac mood. In this context the statue of Mercury on the left is not in his role as messenger of the gods sent by Jupiter to Aeneas, since the period represented is not that of Aeneas but a much later epoch. Mercury as a statue against the wall of one of Carthage's buildings officiates, more appropriately, in his subsidiary capacity as the god of commerce and, therefore, serves as a sad reminder of Carthage's former maritime greatness. However, there is also a reference to Aeneas; indeed, to the story of Dido and Aeneas. It occurs in the central foreground, where a crown (symbolic of

Queen Dido) encircling an oar (symbolic of the seafaring Aeneas) together furnish a powerful and poignant metaphor for the tragic love affair that occurred long ago. This was the tragedy Virgil adjudged responsible for the enmity that developed between Carthage and Rome and that resulted, ultimately, in Carthage's defeat, to which this picture alludes.[69]

Carthage is considered again in Turner's art of the later 1820s, in two historical landscapes that provide comparable settings to those of the companion pictures just discussed,[70] *Regulus* (Rome 1828–29; reworked, BJ 1837) and *Dido Directing the Equipment of the Fleet, or The Morning of the Carthaginian Empire* (RA 1828). However, it is only *Dido Directing the Equipment of the Fleet* that concerns, albeit obliquely, the Aeneas legend.

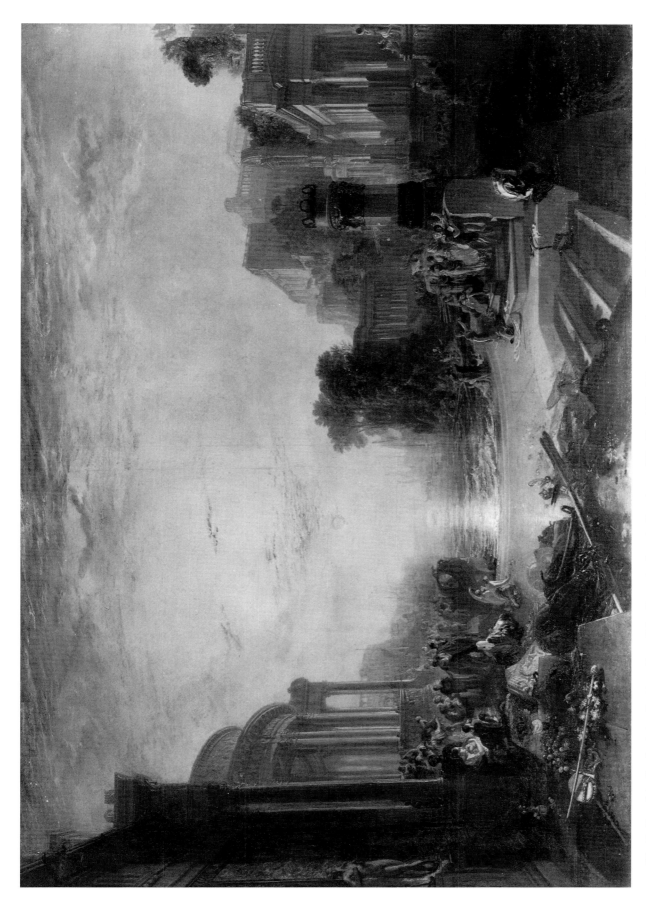

39 *The Decline of the Carthaginian Empire – Rome Being Determined on the Overthrow of Her Hated Rival, Demanding from Her Such Terms As Might Force Her into War or Ruin Her by Compliance: The Enervated Carthaginians in Their Anxiety for Peace Consented to Give Up Even Their Arms and Their Children.* Oil, exh. 1817. 67 × 94 in. (170 × 238.5 cm). London, Clore Gallery for the Turner Collection (BJ 129)

It has been proposed that *Dido Directing the Equipment of the Fleet* (fig. 40), exhibited in 1828, was influenced by the Dido opera that had been staged in London at the King's Theatre, Haymarket in 1827.[71] The discovery of the libretto almost certainly confirms this. The story of Dido and Aeneas involves vengeance, as does a particular episode in the opera, which seems to have provided the inspiration for Turner's picture. King Iarbus, a suitor rejected by Dido, tried to burn down Carthage before fleeing by sea. On hearing of this vengeful act, Dido was furious and ordered her ships to prepare immediately to pursue him:

Dido. Osmidas [Dido's confidant], fly to yonder shore – collect
My fleets, my arms, my warriors –

Speed ye, o'ertake the traitor,
Burn, scatter, sink his vessels in the deep,
Bring here the wretch.[72]

In Turner's painting, Queen Dido appears to be directing her ships from the steps of her palace. The painter has used the stage-like Claudean seaport composition that he had earlier used in his representations of Carthage and would successfully use again.[73]

In its original condition (it subsequently suffered extensive damage) *Dido Directing the Equipment of the Fleet* was considered to be particularly dramatic in its light and colour effects. On 3 May 1828, the *Literary Gazette* referred to it as "a very brilliant and powerful landscape"; a week later, this same publication cautioned

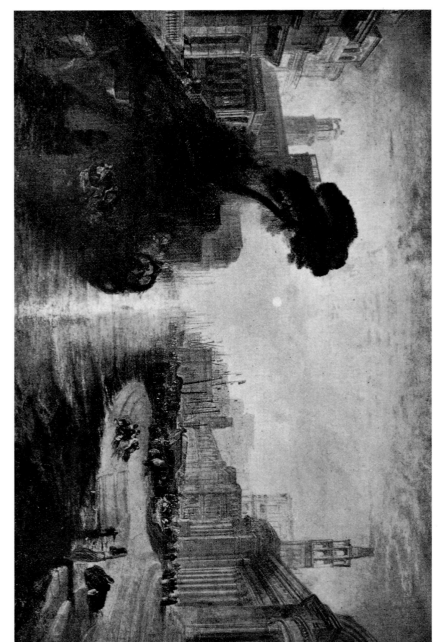

40 *Dido Directing the Equipment of the Fleet, or the Morning of the Carthaginian Empire.* Oil, transf. to plywood, exh. 1828. 59 × 89 in. (150 × 226 cm). London, Clore Gallery for the Turner Collection (BJ 241)

viewers to veil their eyes, otherwise they "will be over-powered by the glare of the violent colours here assembled. It is really too much for an artist to exercise so despotic a sway over the sun."

The specific theme of Dido and Aeneas reemerges very late in Turner's career, indeed in his last four exhibited pictures: *Aeneas Relating His Story to Dido, Mercury Sent to Admonish Aeneas, The Visit to the Tomb,* and *The Departure of the Fleet.* They were exhibited at the Royal Academy in 1850, a year before his death. To all four he attached lines from his "Fallacies of Hope." The critical response to these pictures was, on the whole, positive, despite some concern for their vagueness of form. Reviewers remarked on their colour effects and broad handling. The critic of the *Athenaeum* of 18 May wrote that they were "great pictorial schemes, abounding in rich stores of Nature and deductions from Art – great pictorial ideas, in fact, the principles of which the student will do well to investigate." Of similar size, style, and composition, these pictures were probably intended to be shown as a group;[74] they offer episodes from the story of Dido and Aeneas that occurred shortly after Aeneas's arrival in Carthage and up to, and including, his departure for Italy.[75] Also these pictures, accompanied by poetic lines, emphasize human frailties. For example, the first two (*Aeneas Relating His Story to Dido* and *Mercury Sent to Admonish Aeneas*) allude to dereliction of duty, the third (*The Visit to the Tomb*), to betrayal, the fourth (*The Departure of the Fleet*), to deceit and hostility.

The first of the four late pictures was destroyed, though a poor photograph of it survives.[76] *Aeneas Relating His Story to Dido* was accompanied by the following poetic lines: "Fallacious Hope beneath the moon's pale crescent shone, / Dido listened to Troy being lost and won." Aeneas's story, the subject of this picture, is his recounting of his past history, of the destruction of Troy and his escape. In the *Aeneid,* immediately before the event that Turner depicts, Venus had summoned Cupid, instructing him to make Dido fall in love with Aeneas. However, before Cupid had shot his magic dart, Dido, Venus observed, "now [Aeneas] with Blandishment detains." I believe that Turner's painting alludes to the detention that Venus had noticed. And Turner presents his subject in an imaginative way. Dido and Aeneas are seated in a magnificent galley in a watery setting. Turner here evokes the epic device of woman as an obstacle to duty. The hero, Aeneas, whose

mission is to found Rome, must avoid temptation, which is presented in the form of Dido. She is an exotic temptress, an enchantress, who, as queen of Carthage, was the ancestor "of that hated general [Hannibal] who led his army over the Alps and once almost brought Rome to her knees."[77]

The second picture, *Mercury Sent to Admonish Aeneas* (fig. 41) was accompanied by the following lines: "Beneath the morning mist, / Mercury waited to tell him of his neglected fleet." This painting, like the first, alludes to both the past and the future. Aeneas is presented with Cupid by his side on the left of the composition. Some commentators have failed to identify Mercury in this picture and, indeed, have suggested that he might not be present. However, the absence of Mercury seems unlikely, since the picture's title (provided by Turner) and its accompanying poetic lines presume Mercury's presence. Moreover, it seems improbable, acknowledging Turner's poetic and dramatic interests, that he would relinquish the opportunity to illustrate what is perhaps one of the most highly charged and significant episodes of the *Aeneid*: when Aeneas's fading thoughts of his destiny in Italy are given sudden, fresh intensity as a result of Jupiter's reprimand transmitted by Mercury.[78]

However, if Mercury appears in Turner's picture, then where is he? The only adult male figure shown close to Aeneas and Cupid is seated facing Aeneas, sporting what seems to be a helmet (of the sort that Mercury traditionally wears) and a red cloak. Further, this figure assumes a pose similar to that (though reversed) of a seated Mercury depicted in one of the engravings[79] embellishing the earliest editions of Dryden's *Aeneis,* engravings that, I suggest, Turner studied and that inspired poses of other figures in his pictures on the Aeneas theme. I believe that this seated figure in Turner's painting *is* Mercury and that pictorially his relationship with Aeneas and Cupid creates a dialectic that the story of the *Aeneid* demands. Almost certainly Turner has referred here to Christopher Pitt's explanation of this episode in his translation of the *Aeneid,* since the translator's remarks chime with Turner's dramatic depiction: "The struggle in Aeneas's mind between his passion for Dido, and his regard to the commands of Jupiter, are here pointed out. However Aeneas may be blamed, conquering a passion that retarded his grand design, is a useful one; and I have

41 *Mercury Sent to Admonish Aeneas*. Oil, exh. 1850. 35 1/2 × 47 1/2 in. (90.5 × 121 cm). London, Clore Gallery for the Turner Collection (BJ 429)

42 *The Visit to the Tomb.* Oil, exh. 1850. 36 × 48 in. (91.5 × 122 cm). London, Clore Gallery for the Turner Collection (BJ 431)

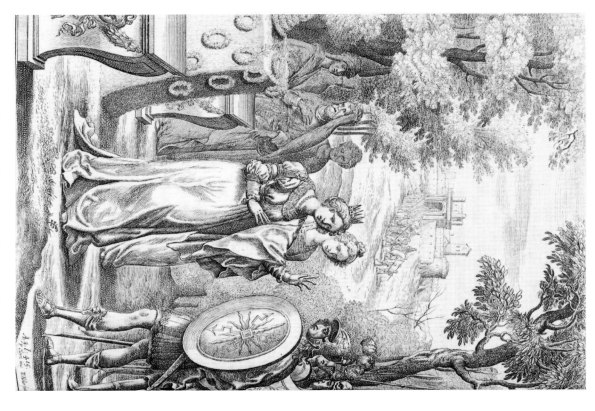

43 Engraving by W. Hollar, after F. Cleyn, illustrating Dryden's *Aeneis* (1698) 3.415. London, by permission of the British Library (1486.m.3)

frequently wondered on this account that his forsaking Dido should be an objection to our hero's conduct."[80] In the arrangement of his three figures, Turner suggests the epic struggle of the hero who must choose between personal happiness and the performance of his duty – between his love for Dido and the fulfilment of his destiny.[81]

The third picture, *The Visit to the Tomb* (fig. 42), has the following poetic line attached to it: "The sun went down in wrath at such deceit." This painting alludes to past, present, and future events, and contains a theme that had earlier attracted Turner: deception and betrayal in love.[82] Dido, in the company of Aeneas and Cupid, surrounded by fluttering whitish doves, symbols of Venus, is shown visiting the tomb of her husband Sichaeus (on the left) that Turner had much earlier represented in *Dido Building Carthage*. Though Dryden's *Aeneis* does not include an event precisely as Turner depicts it, there is reference to the visit to Sichaeus's tomb:

A Marble Temple stood within the Grove,
Sacred to Death, and to her murther'd Love;
That honour'd Chappel she had hung around
With snowy Fleeces, and with Garlands crown'd:
Oft, when she visited this lonely Dome,
Strange Voices issu'd from her Husband's Tomb:
She thought she heard him summon her away;
Invite her to his Grave; and chide her stay.[83]

The appearance and pose of the figure of Dido was appropriated by Turner from an engraving in the early illustrated editions of Dryden's *Aeneis* in which the tragic heroine is also shown standing next to a tomb (fig. 43). The theme of betrayal in this picture and the poetic line attached to it strongly allude to Dido's neglect of her vow to remain faithful to the memory of her late husband. There is also an adumbration of the betrayal that Dido herself was to experience later when Aeneas departed for Italy.[84]

This departure is the subject of the fourth and final picture of the group, *The Departure of the Fleet*. This picture (fig. 44) is accompanied by the following lines: "The orient moon shone on the departing fleet, / Nemesis invoked, the priest held the

44 *The Departure of the Fleet*. Oil, exh. 1850. 35 ⅜ × 47 ⅜ in. (89.5 × 120.5 cm). London, Clore Gallery for the Turner Collection (BJ 432)

poisoned cup." Aeneas's ships are depicted leaving the harbour of Carthage. The scene is a highly charged one. Turner shows Dido not only in the middle ground on a pyre, about to take her life,[85] but also in the foreground, as she falls into a swoon when she concludes that her beloved Aeneas is about to abandon her. She feels betrayed, is enraged and embittered. These sequential actions spatially arranged, with the earlier dramatic action in the foreground and the later action in the middle ground, are comparable to those that Turner had earlier presented in his *Vision of Medea*. The rage and rancour that consumed Medea and that led to the murders she committed were also experienced by Dido and are implied in the poetic lines that accompanied this picture. It was Dido's fury that was translated into the permanent enmity that developed between Carthage and Rome and that Virgil stressed in the opening lines of the first book and at the end of the fourth book of the *Aeneid*.

AENEAS AND THE SIBYL

The second subject from the *Aeneid* that Turner chose to depict was Aeneas and the Sibyl, the story of Deiphobe, the Cumaean Sibyl, whom Aeneas had encountered when he landed in Italy. Similar to the paintings of Dido and Aeneas, those of Aeneas and the Sibyl (of which there are three) were painted at different times during Turner's career.

I have suggested that in some historical landscapes by Turner depicting Dido and Aeneas, Dido, as an instrument (particularly) of Juno, is presented as an obstruction to the fulfilment of Aeneas's destiny. However, in those depicting Aeneas and the Sibyl, it is evident that the Sibyl, to the contrary, facilitates its fulfilment. The story of Aeneas and the Sibyl has an historical significance in that Aeneas' meeting with the Sibyl extends into a moment where the future founding of Rome and the future descendants of the hero are revealed to him in the underworld. This portion of the legend was probably attractive to Turner because it alludes to the realization of a prophecy.

However, unlike Turner's paintings on the theme of Dido and Aeneas, those concerned with Aeneas and the Sibyl do not offer different aspects of the story; rather, they focus on a single ep-

isode: Aeneas's preparation to accompany the Sibyl into the underworld. This event from Virgil's sixth book of the *Aeneid* is, however, pictorially enriched in Turner's paintings through subtle but significant changes in iconography that become progressively more complex.

Turner's earliest known painting of Aeneas and the Sibyl was based on a drawing by the widely travelled classical scholar and his early admirer and patron, Sir Richard Colt Hoare. This painting, entitled *Aeneas and the Sibyl, Lake Avernus* (fig. 45), dates from about 1798, before Turner was 25. It was probably prepared, as has been suggested, as a companion picture to Colt Hoare's painting by Richard Wilson, *Lake Nemi with Diana and Callisto*, since it was painted in Wilson's manner. Though this painting by Turner was initially prepared for Colt Hoare, it seems to have been rejected by that patron.[86] A second painting, *Lake Avernus: Aeneas and the Cumaean Sibyl*, apparently was substituted for it; this painting dates from about 1814–15. It is on the same theme and has a similar composition as the earlier canvas.

This second picture was, however, painted in the manner of Claude rather than of Wilson. It is known to have hung in the same room at Stourhead (the cabinet room) as Wilson's *Lake Nemi with Diana and Callisto*.[87]

The subject of Turner's two pictures suggests that at different times, they were considered as companions to Wilson's picture,[88] According to legend, Lake Nemi was associated with the Temple of Diana (goddess of the moon); Lake Avernus, the setting of Turner's two pictures, was associated with the temple of Apollo, god of the sun, who was Diana's brother. By making this association – if, in fact, he did – Turner not only established a relationship between two topographical settings but also transmuted this association into a dialectic between the forces of darkness and light, a dynamic that would have appeared to him.

In the first (c. 1798) version of his painting of Lake Avernus, the Sibyl, centre stage, is shown importuning Aeneas (who stands next to the Sibyl) to come with her. She holds aloft, in her left hand, the magical golden bough to be given to Proserpine to grant Aeneas safe passage through the underworld. With her right hand the Sibyl gestures toward the shore of the lake where the entrance to Hades is located. To the right of Aeneas are his

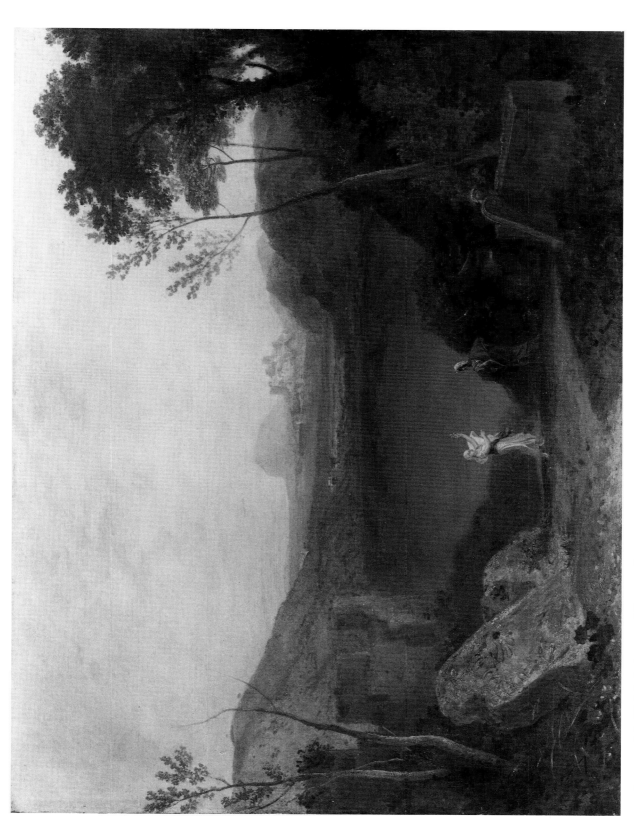

45 *Aeneas and the Sibyl, Lake Avernus.* Oil, c. 1798. 30 ⅛ × 38 ¾ in. (76.5 × 98.5 cm). London, Clore Gallery for the Turner Collection (BJ 34)

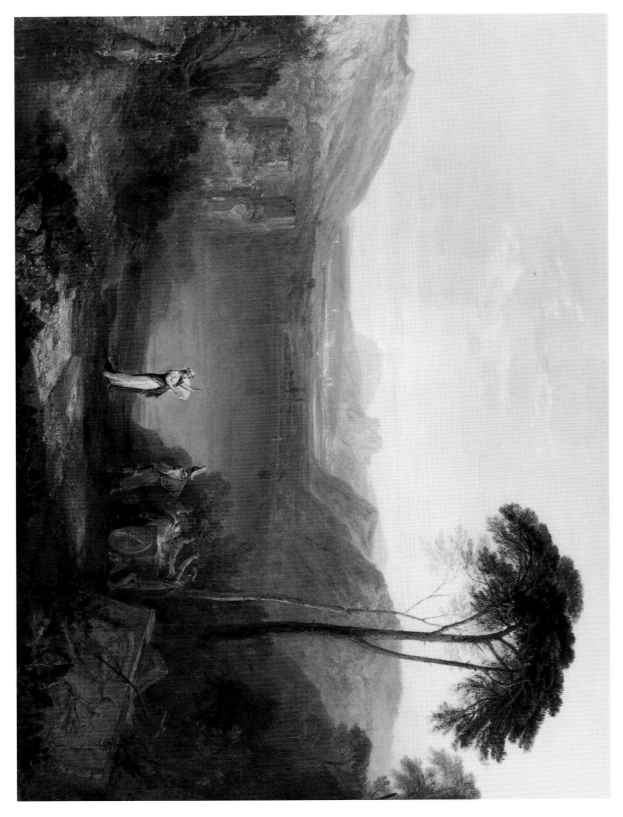

46 *Lake Avernus: Aeneas and the Cumaean Sibyl*. Oil, 1814–15. 28 ¼ × 38 ¼ in. (72 × 97 cm). New Haven, Yale Center for British Art, Paul Mellon Collection (BJ 226)

Trojan followers and a smouldering altar fire on which Aeneas has sacrificed to the infernal deities before entering the underworld.

Lake Avernus: Aeneas and the Cumaean Sibyl, the second landscape on this theme, dates, as mentioned, from c. 1814–15 (fig. 46). It is the picture that seems to have been painted as a substitute for Turner's earlier (c. 1798) picture. Though this second picture is similar in composition to the first, Turner has added fresh ingredients that place emphasis on aspects of the story not considered in the earlier work. Turner begins to interpret the myth in his own way, to give rein to his poetical sensibility. Aeneas's impending journey, the theme of the earlier picture, remains the central subject, though fragments of relief sculpture on the right in this second work now extend it. The relief sculpture shows a male figure, apparently Aeneas, sword unsheathed, preparing to do battle with a many-headed monster, presumably Cerberus, who guards Hades.[89] Further elaboration of the theme is provided by Chryses, the priest of Apollo, who intones over the smouldering altar fire but who, though associated here with the temple of Apollo, has no legitimate place in the Aeneas legend.[90] As has been persuasively suggested, by introducing Chryses, Turner may have wished to establish the opposition between Apollo, god of light, and Hades, the realm of darkness, in order to provide the light/dark contrast and conflict inherent in classical myth.[91] If this is so, then this contrast would augment the similar relationship that seems to exist between Wilson's *Lake Nemi* and Turner's first and second versions of *Lake Avernus*.

Further amplification and embellishment of the Aeneas and Sibyl episode is found in Turner's third and final picture on this subject, *The Golden Bough* (fig. 47), exhibited at the Royal Academy in 1834. Composition and setting in the second painting were influenced, as has been observed, by the Claudean model. This is also true of this third painting, though Turner has extended the foreground so that the setting in consequence is more spacious; also, the figures are smaller in size. However, Chryses no longer appears; nor does Aeneas. In the upper left, is the temple of Apollo. Below is the Sibyl, who commands this ample stage; she seems more energetic than before, and the magical bough that she grasps is more prominently displayed. That Aeneas is missing

at first seems curious. Yet, just as Chryses was an unusual addition in the earlier picture, probably intended to create a distinctive emphasis and meaning for the episode, so Aeneas's absence here suggests that Turner wished to vary the character of his interpretation.

By emphasizing the golden bough, Turner draws still more attention to its magical properties and its role in the story. It serves as a metaphor for Aeneas's journey to Hades, which is suggested by the presence of foxes, a snake, sarcophagi, and the tombs to the right,[92] the latter two alluding not simply to death as has been suggested[93] but to the souls of the dead that Aeneas in Hades will encounter.

A most significant element of this picture has been given only slight attention and has never been explained. Centred in the composition is a large fire round which young women dance. The group of women is similar to dancing figures in an engraving that illustrates the early editions of Dryden's *Aeneis* (fig. 48). Indeed, the female figure on the left of the engraving and the one whose back is showing immediately to her right provided Turner with aspects of the poses of the two figures in comparable positions in his painting.[94] Dryden refers in his dedication to Aeneas's piety, attributable to his obligation to seek an asylum in Italy for his gods, who had "promis'd to his Race the Universal Empire." This fire most likely represents the sacred fire of Hestia (Vesta, the Roman equivalent), goddess of the hearth and maintainer of the public reverence for gods and, if so, serves as a striking metaphor for the revelation to Aeneas – in the underworld – of his future role in the founding of Rome, the new Troy. Coals from the sacred fire of Hestia were transported by colonists from the mother city to the new community's sacred hearth. That this blazing fire in Turner's picture represents the new fire to be established and tended at the foundation of Rome is further supported by the evidence of published references to Hestia contemporary with Turner. It was believed that Aeneas and his Trojan followers had brought the sacred fire with them to Italy and that Aeneas was the founder of the vestals.[95] This belief would explain the presence in Turner's painting of the five young women dancing round the fire and the one tending it; they are almost certainly the six vestals who maintained it.

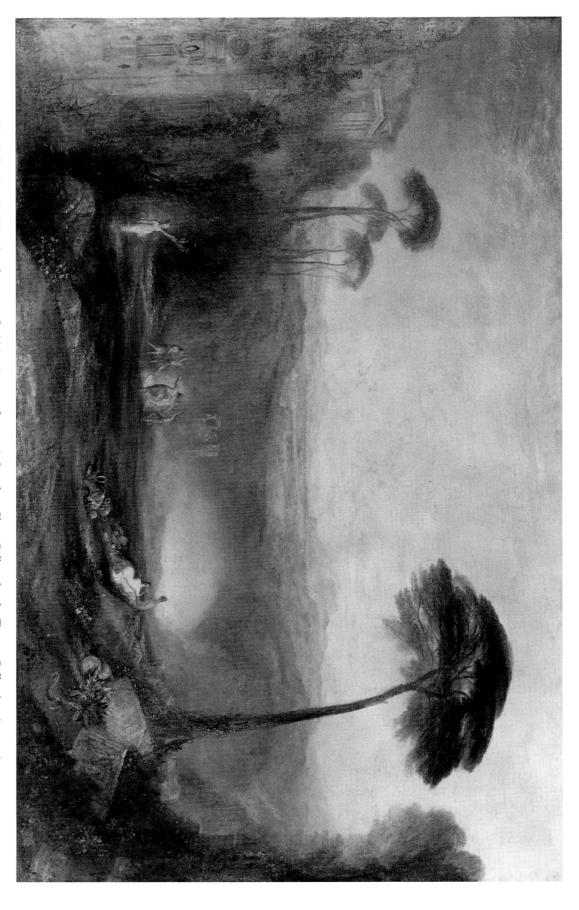

47 *The Golden Bough*. Oil, exh. 1834. 41 × 64 ½ in. (104 × 163.5 cm). London, Clore Gallery for the Turner Collection (BJ 355)

Turner's interpretation and revivification of ancient classical myth and legend in his paintings reflected the cultural context in which he developed but also the structure of his thought and quality of his sensibility. He absorbed their stories and, through his pictures, imbued them with new emphases and meanings. Some of the myths and legends that he chose to paint involve courage, but many more concern hate, hopelessness, and tragedy; there was a facet of Turner's personality that drew him to pessimistic themes, to the realization that human life is under the control of powers that are often hostile, that dash human hopes.

48 Engraving by W. Hollar, after F. Cleyn, illustrating Dryden's *Aeneis* (1698) 7. 290. London, by permission of the British Library (1486.m.3)

Detail, fig. 52

5 Rural Retreats

TURNER'S PAINTINGS of ancient myth and legend not only reflect his sustained interest in the classical past but, as has been noted, his dedication to the category of historical landscape. However, he often prepared history paintings of a different kind, paintings that are concerned with various regions and localities in England where private histories intersect with public ones. His subjects of this latter type are therefore less remote and often include settings to which he, himself, often felt a personal attachment.

Turner's close identification with particular rural localities is a defining characteristic of romanticism that he shared with other artists, notably John Constable. The cult of nature was strong, involving a desire to identify closely with landscape, to savour the atmosphere, appearances, sounds, activities, and history of a locality. This was true both of Constable and Turner. However, for Turner it was sometimes a different kind of attachment, instigated for different reasons and with palpably different results. Constable's leafy landscapes, which often subtly evoke the life and traditions of a place, usually result from his intimate knowledge of it.[1] Turner's experience of landscape was more varied and his attachment to specific locales that he painted was often determined by their association with well-known themes from literature, events from history or with illustrious individuals. Still, these same scenes, especially those of the Thames, were also frequently overlaid with strong personal associations.

Early in his career Turner's life became hinged between two powerful, competing desires. On the one hand, he wished to maintain his developing professional life in London with its public recognition and approbation; on the other, he felt the need, from time to time, to leave it. This could help to account for his desire, at the age of about thirty, to find a rural retreat of his own.[2]

There were probably other reasons. His first years as a Royal Academician (he became an associate in 1799 and a full member in 1802) were tense. They had been marred by petty jealousies that he had encountered, but more especially by internal squabbling and feuding amongst academy members concerning royal interference in academy business. Turner was troubled by the rancorous mood that had developed,[3] and it has been suggested that the title of his *Goddess of Discord Choosing the Apple of Contention in the Garden of the Hesperides*, exhibited, we saw in chapter 4, at the British Institution in 1806, was a comment on this unhappy state of affairs![4] That he wished to escape from the dissension that he had discovered within the Academy's walls, there can be little doubt.

Turner sought relief and contentment in a country retreat not too distant from the city. In 1805 he took a house at Isleworth (Sion Ferry House), opposite Richmond; and in 1806 rented one at Hammersmith.[5] In the spring of 1807, he purchased riverside land in the village of Twickenham in the shadow of Richmond Hill. This year he found time for relaxation and sketching in the Richmond area, lingering by the Thames, which inspired many sketchbook compositions and a series of vigorous oil studies taken from a boat sometimes near the river's leafy banks.

During the early 1800s, Twickenham was a privileged, tranquil haven still largely innocent of development. It was far enough up river to be free from heavy water traffic and yet near enough to the city not to cause inconvenience. It was hallowed not only by its muses but by the many creative luminaries who in the past had chosen to reside there or in the neighbourhood. There was the writer Horace Walpole; also poets John Donne, Alexander Pope, and James Thomson. There were others, such as the influential architect Sir William Chambers and the eminent painters Sir Godfrey Kneller and Sir Joshua Reynolds. Turner may have intended the acquisition of land in this prestigious locale to reflect on his status as a full member of the Royal Academy.

Twickenham was buttressed on either side by established estates. One of them, Marble Hill, was reported to have given the village the "epithet of classic." Henrietta Pye's *A Short View of the Principal Seats and Gardens in and about Twickenham*, of which there were several editions, the first published in 1760, provides a moving Virgilian image of the location:

The genius of the Inhabitants inclines not towards commerce; architecture seams [*sic*] their chief delight: in which if any one doubts their excelling, let him sail up the river, and view their lovely villas beautifying its banks: lovers of true society, they despise ceremony; and no place can boast more examples of domestic happiness. Their partiality for their country rises to enthusiasm; and what is more remarkable, there is scarce any instance of a stranger's residing for a few days among them, without being inspired by the same rapturous affection for this earthly Elysium. Their laws and customs are dictated by reason, and regulated by social love. Happy they to whom it is permitted to spend their lives in such a country, such society, and under such a government; possess'd of

> Elegant sufficiency, content,
> Retirement, rural quiet, friendship, books,
> Progressive virtue, and approving Heaven.[6]

For Turner, Twickenham was to become a palliative, possessing, as it did, qualities of a *locus amoenus*, an earthly paradise. It was there, beside secluded paths, near sparkling waters, and by the sheltering, healing shade of trees, that he, like Pope before him, built a "retirement" residence that both illuminated and defined particular private regions of his personality. He designed and built between 1812 and 1813, when he was about thirty-seven years old, a modest Italianate villa, whose Tuscan character must have seemed appropriate in this rural setting.[7] Set in this Arcadia, it possessed distinctive, simplified classical details reminiscent of the restrained architectural style of his friend John Soane. First called Solus Lodge as a tangible symbol of his deeply felt need for solitude, this villa was later renamed Sandycombe Lodge.

Fruits of Turner's sketching on this particular stretch of the Thames include landscapes commemorative of two of Twicken-

ham's illustrious former residents: the poets Alexander Pope, whose house had recently (in 1807) been demolished (*Pope's Villa at Twickenham*; exh. 1808) and James Thomson (*Thomson's Aeolian Harp*; exh. 1809, Manchester City Art Galleries). In these pictorial paeans, Turner wished to evoke the past, capturing it in Thames settings that show the influence of the classical landscapes of Claude.

The engraver and critic John Landseer sensitively perceived the theme of "loss" in *Pope's Villa at Twickenham* (fig. 49). By depicting the demolition of the villa, Turner was expressing his solemn concern that a significant memorial to this celebrated poet, situated on the banks of the Thames, was being destroyed.[8] In his criticism in *The Review of Publications of Art* (no. 2, 1808), Landseer shrewdly observed that in this painting Turner presented "not merely a portrait of this very interesting reach of the Thames, but all that a painter would think and feel on beholding the favourite retreat of so great a poet as Pope, sinking under the hand of modern improvement." It was, Landseer stated, a unified "pensive" landscape. "On the banks of a tranquil stream, the mansion of a favourite poet which has fallen into decay, is under the final stroke which shall obliterate it for ever: a ruined tree lies athwart the foreground: the time represented is the decline of day, and the season of the year is also declining." It is an autumnal evening landscape full of sentiment and solemnity. Its inhabitants consist "of peasants and two … country labourers who may be supposed to have been employed during the day on the work of destruction, [and who] have stopped to rest or to converse." These figures, he opined, "act the same part" as do the poet and "hoary-headed swain" in Gray's *Elegy*.[9] The particular poignancy of this painting adumbrates characteristics and, specifically, elegiac qualities present in the *Decline of the Carthaginian Empire* and many other paintings, including a most significant later work, *The Fighting Temeraire Tugged to Her Last Berth to Be Broken Up, 1838*.[10]

The landscape celebrating the poet James Thomson, *Thomson's Aeolian Harp*, was exhibited in 1809 in Turner's own gallery (which he built in 1804). It is Claudean and owes compositional characteristics to his *Opening of the Vintage of Macon* (RA 1803, Sheffield City Art Galleries).[11] To *Thomson's Aeolian*

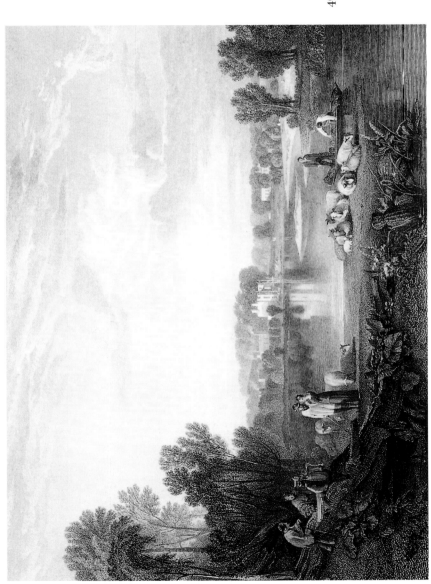

Harp Turner attached a long poem (versions of which occur in the artist's Verse Book)[12] that is palpably in the style of Thomson and contains allusions to that poet's *Seasons* and *Ode on Aeolus's Harp* (first printed in 1748), though the picture's subject was possibly also suggested to Turner by William Collins' *Ode Occasion'd by the Death of Mr Thomson*, written in 1749.[13]

Thomson's Aeolian Harp was exhibited with a number of other landscapes that depict the Thames, including *Near the Thames' Lock, Windsor* and *London*. These latter two paintings both possess poetic tags; the first has lines from the poetry of Thomas Gray, the second, verses that, apparently, are Turner's own. These pictures are the only two of the Thames in this exhibition that are the same size and that were accompanied by poetry. Possibly Turner intended them

as a pair. Whether he did or not, they do contribute an informed contrast. *Near the Thames' Lock, Windsor* (fig. 50) is a misty idyll, an enchanted classical landscape of the Thames banked by leafy trees and deep, moist meadows that is enjoyed by delinquent school boys dreaming away a summer's afternoon. The picture is accompanied by Gray's poetic lines addressed to the river:

Say Father Thames for thou hast seen
Full many a sprightly race,
Disporting on thy margin green,
The paths of pleasure trace,
Who foremost now delight to cleave
With pliant arms thy glassy wave.

49 *Pope's Villa at Twickenham.* Engraving on copper after the oil painting of c. 1808 by John Pye (figures by C. Heath) for Britton's *Fine Arts of the English School* (1811). 17.5 × 22.9 cm. London, Clore Gallery for the Turner Collection (R 76)

50 *Near the Thames' Lock, Windsor.* Oil, exh. 1809, 35 × 46 ½ in. (88.9 × 118 cm). Tate Gallery and The National Trust (Lord Egremont Collection) Petworth House (BJ 88)

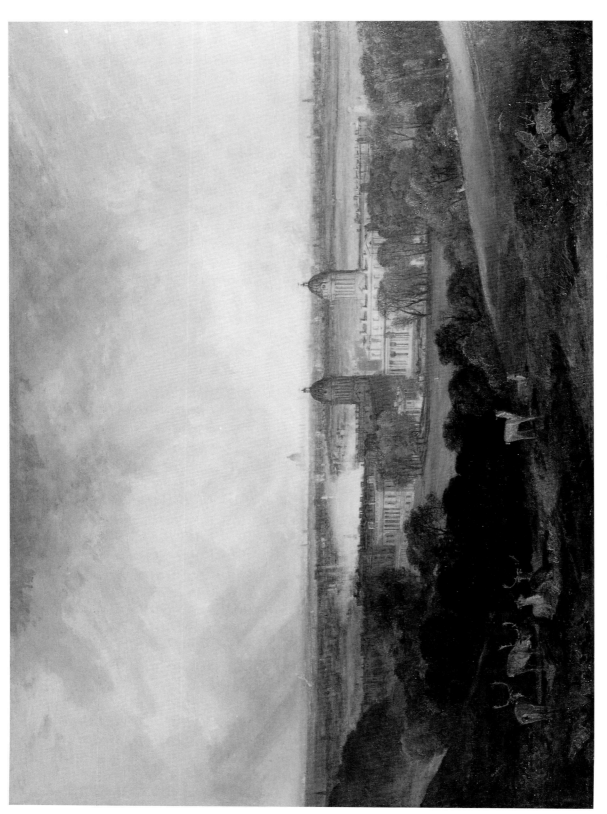

51 *London*. Oil, exh. 1809. 35 ½ × 47 ¼ in. (90 × 120 cm). London, Clore Gallery for the Turner Collection (BJ 97)

The passive bucolic pleasure evoked by *Near the Thames' Lock, Windsor* and its poetic tag is in contrast to the mood of the painting *London* (fig. 51) and its attached lines:

> Where burthen'd Thames reflects the crowded sail,
> Commercial care and busy toil prevail,
> Whose murky veil, aspiring to the skies,
> Obscures thy beauty, and thy form denies,
> Save where thy spires pierce the doubtful air,
> As gleams of hope amidst a world of care.

This painting, a prospect from Greenwich Hill, presents a less intimate view of the Thames. Also its atmosphere, surprisingly, is not hazy but relatively clear, except for the smoke that spews from the city's distant chimneys and settles over the river plain. Instead of enhancing a mood, as does the atmosphere in *Near the Thames' Lock, Windsor*, it "obscures ... [the landscape's] beauty." Paradoxically, nearby architectural forms (Greenwich Hospital and the Queen's House) are sharply outlined. The treatment of these buildings has, in many respects, the character of a traditional topographical record taken from an elevated position, a "prospect," looking down on one of the most eminent and prosperous commercial centres in the world. The active elements of commerce in this painting are bolstered by the poetic lines in which, however, commerce is not viewed in an altogether positive light.[14] Indeed, Turner's later feeling toward industrialization and the Enlightenment's heady notion of progress (referred to in chapter 8, below) may have its roots in the feeling he expresses here.

By including *London* among this group of Thames pictures, Turner, like writers of topographical poetry, appears to draw a distinction between two contrasting categories of river landscape: between the active commercial life of the Thames in and surrounding the city of London and the passive enjoyment of nature and retirement associated with the countryside of the Thames above London.[15]

In late seventeenth-century British poetry sensual pleasure – specifically, love-making – was associated with retirement. The long reach of this tradition was probably not overlooked by Turner. The fact that Richmond was considered a locus of retire-

ment, that the artist referred to Pope as the British Virgil, and that Aeneas was associated with Britain surely gives significance to his drafts of a poem on the theme of Dido and Aeneas in which Pope's celebrated grotto at Twickenham – *not* a cave in the environs of Carthage – contributes the setting for the love-making of the protagonists.[16] Perhaps not fortuitously, a poem by the late seventeenth-century poet Aphra Behn makes specific reference to amorous retirement in a grotto:

> Recesses Dark, and Grotto's all conspire,
> To favour Love and soft desire;
> Shades, Springs, and Fountains flowry Beds,
> To Joys invites, to Pleasure leads,
> To Pleasure which all Humane thought exceeds.[17]

About five years after Turner painted *Dido and Aeneas* (the specific setting of which is in the environs of Richmond), he exhibited one of his grandest landscapes showing the Thames, *England: Richmond Hill, on the Prince Regent's Birthday* (fig. 52), which was accompanied by lines from Thomson's *Seasons*,[18] a poem well known to Turner in which the view from Richmond Hill is identified with "Happy Britannia."[19] This immense, patriotic canvas, which seems to radiate a confidence instilled by the recent defeat of Napoleon, may have been a bid, as has been suggested, for the Prince Regent's patronage.[20] Of particular interest is its assemblage in the foreground of figures reminiscent of those in Watteau's paintings.[21] These figures have not, I believe, been adequately explained.

At this juncture in his career Turner was strongly attracted to Watteau's *fêtes galantes* with their stage-like park settings showing aristocratic couples and groups occupied with life's fleeting pleasures, such as music making, conversing, or playing the game of love. Relationships have been suggested between *Richmond Hill* and several paintings by Watteau, specifically, *L'Accordée de Village*, *Pelerinage à l'Ile de Cythère*,[22] and *L'Ile Enchantée*.[23] However, the similarities between them seem superficial. Though Turner has created a frieze or line of figures in *Richmond Hill* that bears a general resemblance to the contiguous groups forming a weaving string of figures in *L'Accordée de Village* and *Pelerinage à l'Ile de Cythère* and

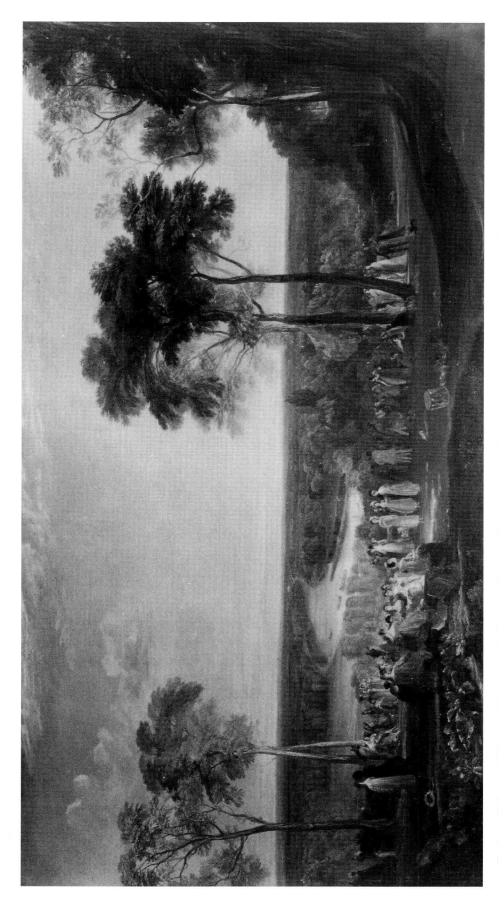

52 *England: Richmond Hill, on the Prince Regent's Birthday.* Oil, exh. 1819. 70 ⅞ × 131 ¾ in. (180 × 334.5 cm). London, Clore Gallery for the Turner Collection (BJ 140)

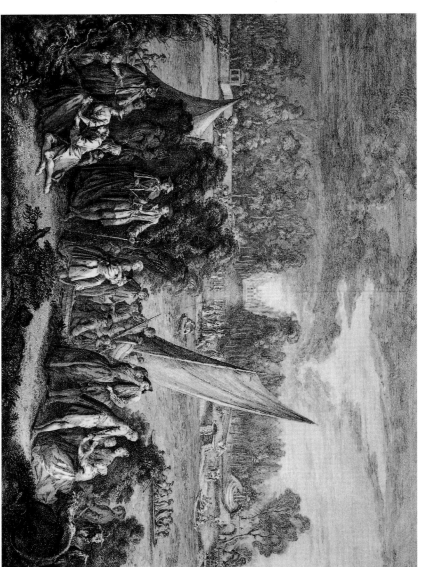

though he has placed his figures on the crest of a hill overlooking a landscape panorama that includes water, as in *Pèlerinage à l'Ile de Cythère* and *L'Ile Enchantée*, they have little else in common. In Turner's picture figures are more restrained and more consciously elegant; also, they are not specifically related either in stance or in attitude to those in Watteau's pictures.[24] Many of Turner's figures in *Richmond Hill*, unlike those in *Pèlerinage à l'Ile de Cythère* and *L'Ile Enchantée*, are placed against a centred backdrop of trees that blocks a view of the river Thames, which can be seen to the left and only glimpsed to the right.

I believe that Turner's inspiration for his figures may *not* be paintings by Watteau; he may have been inspired by prints after paintings influenced by that well-known French master. A print of the kind I propose is one of the several states (fig. 53) of the engraving by Jean Baptiste Claude Chatelain, *Veüe de la Maison Royale de Richmond*, that dates from 1736. This attractive design has a number of qualities that superficially might have appealed to Turner had he known it, not the least of which is that the engraving shows a view of the Thames at Richmond. It is a view, taken from the Middlesex bank of Richmond Lodge and its gardens, with a high central foreground containing a frieze of elegant Watteauesque figures.[25] Some of the figures in Chatelain's print are set against a central clump of foliage, and the river is viewed, as in Turner's *Richmond Hill*, on either side of the landscape, though these particular relationships are probably coincidental. Turner has not employed the same or similar poses for his figures,

though their proportioned elegance is certainly comparable. It has been observed that this print, its various states, and a companion print "are among the first to place elegant French figures in an English setting."[26]

There are, I suggest, compelling reasons for the introduction of similar Watteauesque figures in Turner's painting. In Watteau's *fêtes galantes*, the figures represented are often amorous couples, and the theme of love is often associated with Watteauesque figures in Turner's paintings.[27] Amorous retirement, as has been noted, is a subject of the poetry of Aphra Behn. It occurs in another poem, one adapted by her from the French, entitled "A Voyage to the Isle of Love." In this poem, the *fêtes galantes* imagery establishes another, perhaps more compelling, connection between retirement and love:

A thousand gloomy Walks the Bower contains,
Sacred all to mighty Love;
A thousand winding turns where Pleasure reigns;
Obscur'd from day by twining Boughs above,
Where Love invents a thousand Plays,
Where Lovers act ten thousand Joys.[28]

If themes of love and retirement furnish a reason for the appearance of Watteauesque figures in *Richmond Hill*, a further explanation may be the picture's specific subject: the celebration of the prince regent's birthday. Richmond had a long and well-recognized association with aristocracy and royalty. As noted earlier, the dedication page of Maurice's poem *Richmond Hill* (1807) refers to Richmond as "The Favoured Haunts of Kings and Statesmen." Not only had it been the site of royal palaces, it and its gardens had been a special domain of Caroline, wife of George II. The park and garden adjoining the royal family's summer residence had been "something of a spiritual oasis" for her.[29] William Kent had built for her two follies, the Hermitage and Merlin's Cave; these were rural retreats. Another important personality associated with Richmond was Turner's Twickenham neighbour from 1815, the exiled Louis-Philippe, duc d'Orléans (who was chosen king of the French in 1830). The artist's awareness of Richmond's manifold associations with "Kings and Statesmen"

seems to be borne out by his Carthage-upon-Thames painting, *Dido and Aeneas* of c. 1814, since in it he depicts Queen Dido and her court and kingdom in that locality.

Richmond's royal connections explain, I believe, the aristocratic figures in Chatelain's *Veüe de la Maison Royale de Richmond* of 1736 and, indeed, this conjecture seems to be confirmed by their presence in other contemporaneous engravings of Richmond associated with royalty and aristocracy.[30] Thus, the presence of courtly, Watteauesque figures in Turner's *Richmond Hill* appears to be a compelling reaffirmation of that established connection.

Far from Richmond and the Thames, in the south of England, there was yet another place of retirement that Turner visited and painted, one that seems to support the argument for the presence of Watteauesque figures in his *Richmond Hill*. In 1827, toward the end of July, he travelled to the Isle of Wight as the guest of the generous and hospitable John Nash, the architect whose picturesque battlemented mansion, East Cowes Castle – built by Nash in 1798 – commanded a sweeping view of the Solent. Turner was given a painting room while there, and in and around the castle he undertook a number of oil sketches and drawings. Several pictures resulted. Of these, two were of the castle with the Cowes regatta, and there was a Carthaginian subject, *Dido Directing the Equipment of the Fleet* (fig. 40; discussed in chapter 4, above), and another historical work, *Boccaccio Relating the Tale of the Birdcage.* The settings of the last two are also associated with Cowes. As observed previously, Queen Dido was linked in Turner's mind with the Richmond area, I believe, because of its royal connections. For the same reason, I suggest, Turner may have associated her with Cowes. However, *Boccaccio*, with its Watteauesque figures, better explains the royal connection with Cowes.

The stage-like setting of *Boccaccio* (fig. 54) seems to have been influenced by the Watteauesque designs of Stothard, the artist with whom Turner shared the task of illustrating Samuel Rogers' important 1830 edition of his poem *Italy*. Like *Richmond Hill*, Turner's *Boccaccio* presents a particular topographical location. In this latter canvas, Turner presents a tower of East Cowes Castle that serves as the picture's "backdrop,"[31] against which are shown courtly figures.[32]

54 *Boccaccio Relating the Tale of the Birdcage*. Oil, exh. 1828. 48 × 35 ⅝ in. (122 × 90.5 cm). London, Clore Gallery for the Turner Collection (BJ 244)

*I have great pleasure in visiting
this part of my dominions*

55 Anonymous, *George IV and Mrs Nash. Catalogue of Political Satires and Personal Satires*, vol. 9, no. 13854. London, British Museum

The title of Turner's picture indicates that it purports to illustrate a scene from the work of Boccaccio, the prerenaissance Italian poet. However, it does not.[33] But it is significant that Turner refers to Boccaccio, who was the author of the *Decameron*, a collection of licentious tales of courtly life. The "birdcage" depicted and referred to in the picture's title cannot be found in the *Decameron*, though it does possess a traditional lewd meaning.[34] Turner, yet again, seems to associate retirement with "love."

Like Richmond, East Cowes was associated with "Prinny," the prince regent. He was Nash's patron and often visited the castle, where he was lavishly entertained. In 1820, many months after he had been proclaimed monarch of his British domains, a scurrilous ballad was published entitled "The Royal George Afloat; or, Tom Tough in High Glee," which concerned an alleged liaison between the new king and Mrs Nash. Six verses are introduced by a pictorial satire (fig. 55) showing Mrs Nash in a ship's cabin being enthusiastically embraced by an amorous monarch. On the floor of the cabin lies a sheet inscribed: "The Loyal Address of Cows." The corpulent George, while embracing his equally well-nourished amour, exclaims, "I have great pleasure in visiting *this part* of my dominions." Among the lines of verse are the following:

> The dirty tricks of G ——— ge – oh! at last they are found out,
> What the Devil I'm to do – only God himself can know.
> In the boat with Mrs. N —– sh,
> To the Isle of Wight I'll dash,
> In my cabin smoke and drink, and forget I have a foe.[35]

over a period of almost two decades. Though seeming to have little in common, they are, nevertheless, united by landscapes identified with retirement, royalty, and love. These associations would appear to have determined at least some of their meanings.

Turner was almost certainly aware of Cowes' royal connection. The depiction of courtly Watteauesque couples in *Boccaccio* and the reference in its title to the "birdcage" and to the licentious stories of courtly life by Boccaccio surely involves innuendo. This picture appears to indicate that Turner was cognisant of the malicious gossip and rumours, and if so, it can be assumed that it makes oblique allusion, tactfully and prudently, to the alleged affair between Mrs Nash and the king.

Turner's *Dido and Aeneas, Richmond Hill, Dido Directing the Equipment of the Fleet*, and *Boccaccio* were history paintings executed

6 "In memory's mystic band": Commemorating the Past and Present

chisel on my tomb
Thank Time for all his favours.

TB C; verses on cover and fly leaf[1]

The poetry of history does not consist of imagination roaming at large, but of imagination pursuing the fact and fastening upon it ... Just because it [an event] really happened, it gathers round it all the inscrutable mystery of life and death and time.

Thomas Babington Macaulay (1800–59)

MEMORY IS THE STOREHOUSE of the human mind; it keeps the past alive, and in doing so establishes the unity of experience. It was particularly valuable for Turner in the world he knew, a world that had already undergone and was still undergoing rapid change. As a painter he wished to recall and preserve elements that had disappeared or were changing. In certain respects he can be considered as both inheritor and custodian of the past. In his historical landscapes he sometimes measured the past against the present and, conversely, the present against the past. However, as he lived in a period of strife and change, the present was especially important to him and its significance in his landscapes seems to have been strengthened over time.

Turner's knowledge of current or relatively recent events would have been aided, at least in part, by the information made available as the result of the increased number of newspapers, magazines, pamphlets, and books that spewed from both capital and provincial presses. He painted many pictures of significant events rooted in recent history or of events that were more contemporary and presented them in various ways. For example, contemporary history appeared in the guise of events from the Bible: there are probably allusions to Bonaparte's Egyptian campaign and the terrible pestilential conditions suffered by French troops in his two large biblical plague paintings, *The Fifth Plague of Egypt* (RA 1800) and *The Tenth Plague of Egypt* (RA 1802) (fig. 7).[2] Other references to contemporary history can be less oblique. For instance, though a topical event might be more directly represented or suggested in a landscape, this event need not necessarily be its subject; the subject can be the landscape itself. The presence in the landscape of small figures of a certain proportion and in particular dress can establish their social class and their relationship with the depicted locality. But they can also function in another way; through their actions and circumstances they can allude to a topical event. By so doing, they are able to imbue the subject landscape with an aura of the present. This occurs, for example, in watercolours engraved for his celebrated series *Picturesque Views in England and Wales* (1825–28).[3] However, the watercolour *View of London from Greenwich* (c. 1825), which seems to have been intended for another engraved series, offers a different approach to the present. Crowded with incident, this landscape celebrates, with the aid of symbols, the occasion of three hundred years of the city's history and achievement.[4] *The Fighting Temeraire* (which depicts a great British line-of-battle ship at the end of its days) represents a further way of approaching the present: the event depicted was a contemporary one, considered newsworthy, but in its interpretation the picture resonates with allusions to the past; indeed it is conceived as a pictorial elegy.[5]

In representing recent or current events and the personalities associated with them, Turner sometimes chose to allude to comparable events and personalities from the past. Sometimes a painting or watercolour will generate an allusion to the past that, while it is highly significant, is so personal that it is probably overlooked by the viewer. Such an allusion occurs in Turner's small vignette design *Fontainebleau* (fig. 56), one of many designs he

56 *Fontainebleau.* Vignette for Sir Walter Scott, *Prose Works* (1834–36), vol. 15. Engraving on steel by W. Miller. 9.6 × 7.6 cm. London, Clore Gallery for the Turner Collection (R 538)

prepared for Sir Walter Scott's *Life of Napoleon Buonaparte*, in an edition of Scott's *Miscellaneous Prose Works* (1834–36).

In the introduction to the *Prose Works* the publisher, Robert Cadell, referred specifically to Turner's designs for the *Life of Napoleon*, remarking that the places represented are "most strikingly associated with the history of that extraordinary man." However, since Turner was illustrating a biography, he prepared more than simply associative landscapes. In his view of Fontainebleau, for example, he chose to represent Napoleon. Turner presents an especially dramatic moment in the career of the emperor, surrounding him with resonances that Scott's text supplies.

While in many ways alienated by Napoleon, Scott still admired him. Alluding to the fatalistic process at the heart of his approach to history and implicit in the Napoleonic narrative of the time – the rise and fall of empires – he remarked that "the reader may be disposed to pause a moment to reflect on the character of that wonderful person, on whom Fortune showered so many favours in the beginning and through the middle of his career, to overwhelm its close with such deep and unwonted afflictions."[6] Turner was sympathetic to such an approach and, as will be demonstrated, it is reflected in his design of Fontainebleau.

Scott had written in his *Life* that in 1814 when the allied forces had invaded France and Paris was taken, they were convinced that Napoleon's defeat was imminent and so contemplated France's future. Discussions centred on the possibilities of a regency or of the restoration of the Bourbon dynasty. Napoleon, in his temporary headquarters in the chateau of Fontainebleau, southeast of Paris, sent his emissary to the capital. He was advised that the allies would not entertain a treaty with him; that whatever future was decided for France, "the abdication of Buonaparte was a preliminary condition." Napoleon had intended to march on Paris, but his senior general staff, on hearing of the the allied ultimatum, believed that this march should not now take place and that the emperor should abdicate. With reluctance he eventually agreed[7] and ordered his trusted envoys to depart for Paris with the instrument of abdication.[8]

The mood created by Napoleon's abdication, his imminent departure from Fontainebleau and his future exile on Elba, as related by Scott, infuses Turner's design with meaning. In this vi-

gnette Turner seems to allude to two separate events that are integrated. He presents the Emperor atop the grand entrance staircase of the palace shortly before his departure. He has addressed his senior staff but has apparently not yet reviewed members of his Imperial Guard, who are shown assembled in the palace's forecourt. Scott first describes Napoleon's meeting with his senior staff:

Napoleon looked around upon his officers, and made them the following exhortation: – "Gentlemen, when I remain no longer with you, and when you have another government, it will become you to attach yourself to it frankly, and serve it as faithfully as you have served me. I request, and even command you to do this; therefore, all who desire leave to go to Paris have my permission to do so, and those who remain here will do well to send in their adhesion to the government of the Bourbons." Yet, while Napoleon used this manful and becoming language to his followers, on the subject of the change of government, it is clear that there lurked in his bosom a persuasion that the Bourbons were surrounded with too many difficulties to be able to surmount them, and that Destiny had still in reserve for him a distinguished part in the annals of Europe.[9]

The second, separate event alluded to in the *Fontainebleau* vignette is the review of his Imperial Guard as described by Scott:

Napoleon having now resigned himself entirely to his fate, whether for good or evil, prepared … to depart for his place of retreat. But first he had the painful task of bidding farewell to the body in the universe most attached to him, and to which he was probably most attached, – his celebrated Imperial Guard. Such of them as could be collected were drawn out before him in review. Some natural tears dropped from his eyes, and his features had the marks of strong emotion, while reviewing for the last time, as he must then have thought likely, the companions of so many victories. He advanced to them on horseback, dismounted, and took his solemn leave. "All Europe," he said, "had armed against him; France herself had deserted him, and chosen another dynasty. He might," he said, "have maintained with his soldiers a civil war of years; but it would have rendered France unhappy. Be faithful," he continued, "to the new sovereign whom France has chosen. Do not lament my fate; I will always be happy while I know you are so … Adieu, my

brave companions, – Surround me once more – Adieu." Drowned in grief, the veteran soldiers heard the farewell of their dethroned leader; sighs and murmurs broke from their ranks, but the emotion burst out in no threats or remonstrances. They appeared resigned to the loss of their general, and to yield, like him, to necessity.[10]

Inevitability, necessity and fate are concepts inextricably woven into the fabric of Scott's narrative describing Napoleon as he prepares to leave Fontainebleau. By making the chateau the backdrop for his design, Turner has created a stage on which this particular drama can be enacted. Although the figures are minuscule in the vignette, by location and action the protagonists are identifiable. Turner has focused strongly on Napoleon. By means of pose and position in the composition and also by chiaroscuro, the artist has effectively subordinated the architecture and Napoleon's senior staff and troops to the departure of their leader.

However, the drama of this tiny vignette, Napoleon's departure into exile, is further enhanced by the psychological component of the design. Turner depicts a pensive Napoleon standing alone, separated physically and emotionally from his senior staff grouped behind him. The artist has wrung high drama from this episode. Yet a psychological dimension of this drama has remained unsuspected. In his mind, Turner has associated the military leader Napoleon with a great military leader from the classical past.

When Turner was in Rome in 1828, he painted two historical landscapes that possess notable dramatic qualities; one was the *Vision of Medea*, the other was *Regulus*. *Regulus* (Rome 1828–29; reworked 1837) (fig. 57). I believe, was an important inspiration for Turner's *Fontainebleau* in terms both of its content and of its form. However, in order to consider the influence of this earlier painting, it is first necessary to relate events from the courageous Roman general Regulus's life and to discuss the content of the painting.

Turner found the story of Marcus Atilius Regulus of great interest, particularly his stoic acceptance of his fate; this account the artist had earlier (c. 1811) poetically described.[11] Regulus was captured by the Carthaginians and later sent from Carthage to Rome to negotiate an exchange of prisoners. However, when he

57 *Regulus*. Oil, 1828; reworked 1837. 35 ¼ × 48 ¾ in. (91 × 124 cm). London, Clore Gallery for the Turner Collection (BJ 294). See colour plate 8

spoke with the Romans, Regulus advised them against this exchange, aware that when he returned to Carthage, as he had promised, he would forfeit his life. Though entreated by his countrymen to break parole and remain in Rome, he refused, returning to accept his fate. When Regulus arrived in Carthage, he was killed by the outraged Carthaginians, though not before being subjected to terrible tortures that involved shutting him up in a wooden barrel pierced full of sharpened nails so that he could not lean or rest against any part without suffering excruciating pain. He also had his eyelids removed and was forced to stare into the sun until blinded.

In his painting, Turner represents Regulus's departure for Rome from the port of Carthage to arrange for an exchange of prisoners.[12] Though the painting was later reworked, it seems to have originally possessed remarkable light effects, displaying the artist's growing fascination with light and colour that is also richly evident in his other works dating from the period of his second Roman visit in 1828–29. *Regulus* was possibly influenced by a painting that Turner had recently exhibited at the Royal Academy, indeed, in the same year that he left for Rome: *Dido Directing the Equipment of the Fleet* (fig. 40). This latter picture, now in damaged condition, is larger than *Regulus*, though in its original state

it possessed brilliant light and colour effects that were probably comparable to those of *Regulus* before *Regulus* was reworked in 1837.[13] In that year *Regulus* was exhibited at the British Institution and subsequently, in 1840, engraved on copper by the young Scot, Daniel Wilson.[14]

The picture, overlaid with scumbled white paint to increase the landscape's light,[15] posed a challenge and opportunity for the young engraver. The burning brilliance of the sun, intensified by Turner's alteration, gave the landscape a shimmering and dazzling insubstantiality. The "effect of brilliant sunlight absorbing everything and throwing a misty haze over every object"[16] contributed to obscuring the minute figure of Regulus, who stands at the top of the palace stairs. As Wilson observed, "the small figure in Roman toga ... is not likely to be noticed in the ... picture ... In the final touches as the engraving drew to a close Turner gave prominence to it in the touched proof."[17]

Yet even in Wilson's engraving the figure of Regulus is not easily identifiable; and the embarkation, though the subject of Turner's picture, is almost overwhelmed by the harsh light and other components of this evocative landscape. Regulus, the protagonist, has relatively little dramatic value of his own. Indeed, the story's dramatic content has, in many respects, been made internal and metaphorical. Turner considered the embarkation for Rome to be a means of evoking related events that followed in Regulus's life: his unselfish, patriotic commitment to Rome; his decision to return to Carthage; and his torture and death at the hands of the furious Carthaginians who felt betrayed by him.

When Turner began to consider his subject for the vignette *Fontainebleau*, it was the personality of the emperor as described by Scott that quickly attracted his attention; Napoleon reminded Turner of Regulus. There is a conspicuous relationship between Turner's dramatic presentation of Regulus at the top of a long flight of palace stairs and his later representation of Napoleon atop the grand staircase of Fontainebleau. The difference, however, is that Turner has more strongly focused on the diminutive figure of Napoleon. Yet each protagonist plays a similar dramatic role. Regulus and Napoleon, on their respective stages, stand in epic isolation both physically and psychologically;[18] Turner considered both leaders to be tragic heroes.

Though Turner may have anticipated that at least some of his viewing public were familiar with the crucial events in Regulus's life, he introduced powerful symbols into his painting (a barrel and a searing sun) to remind his audience of the horrible events that befell the general on his return to Carthage.[19] The moment depicted by Turner, as has been indicated, is when Regulus is about to board a ship for Rome. This episode is balanced by symbolic ingredients that point to his later, savage reception when he returned to Carthage.

In the vignette *Fontainebleau* Turner's intention is different. There are no symbolic components in the landscape, since the design is illustrative – fully supported by Scott's account that Turner has imaginatively interpreted. However, there is an especial cogency to the comparison between this miniscule vignette and *Regulus*. The circumstances of the two tragic heroes are comparable. Both Napoleon and Regulus are about to depart; both had to deeply reflect and consider their futures in their respective states of adversity. Napoleon stands apart from his senior staff, having pondered his fate – having stoically decided, as did Regulus, to place the welfare of his country ahead of his own.

Turner, as noted previously, also painted historical subjects that concern the past but that contain allusions to the present. It was Walter Thornbury who first suggested that Turner's historical landscape *Snow Storm: Hannibal and His Army Crossing the Alps* (RA 1812) alludes to the struggle between England and France during the Napoleonic wars. At war with France for most of the time between 1793 and 1815, Britain was only too conscious of French absolutist and expansionist policies, particularly the dynastic intentions of Napoleon. As has been observed, Turner believed that Napoleon shared qualities with the Roman general Regulus. He was also persuaded that parallels could be drawn between Napoleon and the Carthaginian general Hannibal.

In the third century BC the Carthaginian general, with elephants and a relatively small army, undertook an invasion of Italy over the Alps. However, he and his troops were set upon by mountain men – the Salassians. Surviving this attack and others, he continued on toward Rome, his destination. His initial battles in Italy were successful. He crossed the Appenines and was victorious over the main Roman army that he encountered at Lake Trasim-

eno. With his limited forces he did not attempt to strike directly at Rome but went round it, hoping to incite a general revolt. Despite his initial success in building opposition against the Romans and receiving support from the south of Italy and especially from Capua, his fortunes changed. Lacking reinforcements, he was unable to mount an assault against Rome itself. Eventually the Romans reconquered Capua, and his opportunity to subdue Rome was lost forever.

It is probable that, indirectly, J.R. Cozens' lost painting, *Hannibal in His March over the Alps Shewing to His Army the Fertile Plains of Italy*, and Turner's sight of a storm in the Yorkshire Dales in 1810 inspired the latter's *Snow Storm: Hannibal and His Army Crossing the Alps* (fig. 58).[20] It seems likely that during the planning of his painting, Turner also studied his copy of Goldsmith's *History of Rome from the Foundation of the City of Rome, to the Destruction of the Western Empire*.[21] Among his other sources was probably John Whitaker's *The Course of Hannibal over the Alps Ascertained* (1794). In his painting Turner had concerned himself with the ambush of Hannibal and his troops by the Salassians. Whitaker, referring to the accounts by Polybius and Livy, contributes a vivid description of this attack that would have aided Turner in his preparation.[22]

Turner was attracted to Hannibal as a subject for painting because he was fascinated, as has been observed, by the operations of fate; the thwarting of human ambition is an important theme in Turner's history paintings. It was given emphasis, when he exhibited his picture, by the inclusion in the Royal Academy catalogue of the initial published lines from his poem "Fallacies of Hope," whose fateful imagery is reminiscent of that in poetry attached to his earlier pictures.[23] He considered the following lines appropriate for his epic theme. They concern Hannibal's assault on Italy, which is accompanied by ominous portents, beginning with the attack by the Salassians:

Craft, treachery, and fraud – Salassian force,
Hung on the fainting rear! then Plunder seiz'd
The victor and the captive, – Saguntum's spoil,
Alike became their prey; still the chief advanc'd,
Look'd on the sun with hope; – low, broad, and wan;
While the fierce archer of the downward year

Stains Italy's blanch'd barrier with storms.
In vain each pass, ensanguin'd deep with dead,
Or rocky fragments, wide destruction roll'd.
Still on Campagnia's fertile plains – he thought,
But the loud breeze sob'd, "Capua's joys beware!

In this poetry Turner emphasizes, as does Whitaker in his book, the perfidious nature of the Salassian attack. The storm-filled sky of Turner's picture alludes to this attack and to Hannibal's future woe – his eventual defeat.

However, Hannibal does not appear to be the only subject of Turner's painting and its attached poetic lines. Turner, as previously mentioned, probably also alludes to Napoleon. The association between the two was current in Britain, though it had likely been established in Turner's mind at a much earlier date.[24] As mentioned in chapter 2, in Paris in 1802 he had certainly examined and been impressed with David's painting *Napoleon Crossing the St Bernard* (fig. 1), in which Bonaparte is associated with the valiant Carthaginian general.[25]

A stunning neoclassical equestrian portrait with a dramatic design and strong authoritarian overtones, David's painting is a propaganda piece with an unambiguous iconography. Employing the typological and epic device of recollection and anticipation to establish particular relationships in history, David draws attention to precedents. He establishes correspondences between Bonaparte and Hannibal and another great military leader of the past who possibly offers Bonaparte an imperial line of descent: inscribed on the rocks in the picture's lower left is Bonaparte's name, beneath which is carved that of Charlemagne (inscribed "Karolus Magnus Imp."); Hannibal's name is also carved there. Both Charlemagne and Hannibal had crossed the Alps to defeat their foes, just as Bonaparte is shown crossing the Alps on the way to conquer his.

At the beginning of the war with France, Britain was fearful of the spread of revolutionary doctrine, and later, of Napoleon's imperialism. When Turner visited David's studio, he could not have missed the iconography that allows historical truth to intersect with epic convention. Nor could he have easily overlooked the allusion to Bonaparte's impending victories through allusions

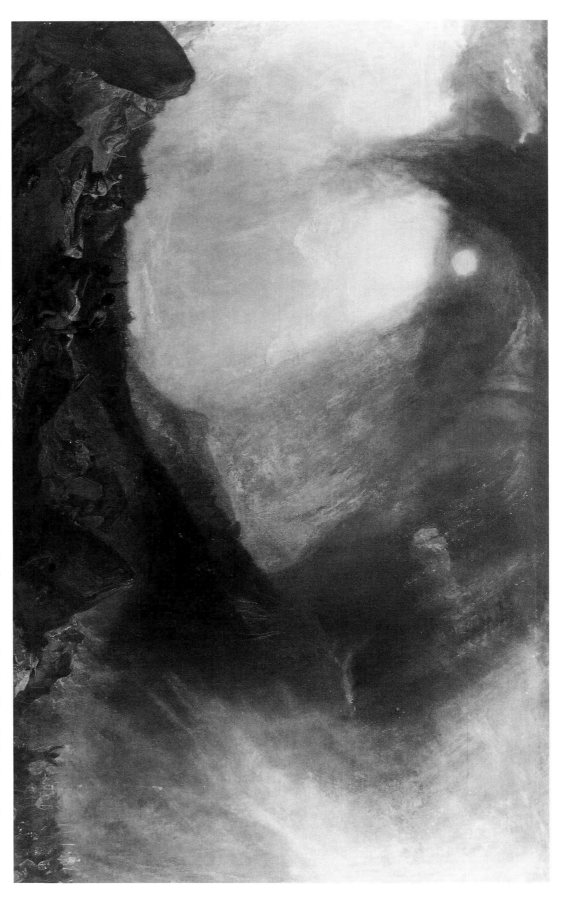

58 *Snow Storm: Hannibal and His Army Crossing the Alps.* Oil, exh. 1812. 57 ½ × 93 ½ in. (146 × 237·5 cm). London, Clore Gallery for the Turner Collection (BJ 126)

to victories of military leaders from the past; David not only compared him with these heroes, he allowed Bonaparte to merge with them.

To consider Bonaparte in relation to conquerors of the past and to consider France in relation to Rome or Carthage were commonplace rhetorical comparisons during the Napoleonic period. They were being made in Britain. In 1802, during the Peace of Amiens, Coleridge published a series of articles entitled "A Comparison of France Now with Rome under Julius and Augustus."[26] Such appeals to the past were increased when the Anglo-French struggle resumed in the next year, vitalizing British parliamentary debate and frequently giving resonance to reports in the popular press. In parliament in 1806 the treasurer of the navy, George Canning, compared Napoleon with Caesar, Alexander, and Frederick the Great – generals whose successes were not due to the "enthusiasm of liberty or to the energy of a constitutional government."[27] Parallels were also drawn between the republican French and republican Romans.[28] As has been observed, Britain was sometimes compared with Carthage. Of France and ancient Rome it was believed that "both are conquerors of the world, [and] both have a Carthage for their enemy. Rome could not bring down Carthage at a blow, so a victorious war paved the way for an advantageous peace which in turn laid the foundation of a successful war." Furthermore, it was said that the French rival the Romans in their command, "in the grandeur and wisdom of their plans" and "their boldness and constancy in executing them."[29]

A typological approach, as noted before, was not inimical to Turner's way of thinking. That there is an allusion to the Napoleonic threat in his *Snow Storm: Hannibal Crossing the Alps* seems likely, even though the figure of Hannibal is not definitely shown.[30] Napoleon's ambitions weighed heavily on the British public's mind at that particular time. As British press reports reveal, as much as Napoleon's military prowess was admitted and grudgingly admired, he was also deeply feared. Three years before Turner exhibited his painting, the *Edinburgh* prophesied Napoleon's conquest of the whole continent.[31] The idea of tyranny overcoming liberty was abhorrent. Moreover, Britain had been deeply aware of the distress caused by Napoleon's Continental System, which was intended to strangle Britain economically.

Even though cognisant of France's recent defeat at Trafalgar, many Britons, in 1810–11, secretly regarded Napoleon as invincible, ready to invade Britain and capable of doing so successfully.[32] In 1811, the year before he exhibited his *Snow Storm*, Turner likely had Napoleon in mind when he wrote of the "great Demagogues that tyrannise on earth."[33] Can it be coincidental that Turner's picture of Hannibal's invasion of Italy was painted at this particular moment?[34] Under those conditions, the subject of this picture seems to acquire a more acute relevance.

If Turner admired Napoleon, it was from a British perspective. He was staunchly patriotic and deeply devoted to history, especially a national history. For him, as has been noted, Britain (but especially England), its traditions and institutions, were intensely personal. Through his pictorial tributes to royalty, military heroes, artists, and poets as revered instruments of history, his focused attachment to country was given tangible expression. Even though the luminaries he represented might not always be British, they had, in most instances, some British connection.

The commemoration of illustrious persons and events of national significance was of especial interest because it tended to foster British pride, particularly a sense of Englishness with which he, himself, identified. We have seen that Turner celebrated the prince regent's birthday in his patriotic painting of *Richmond Hill*, which was likely an attempt to attract the prince regent's favour. After Turner's visit to Scotland in 1822, he proposed a grand series of paintings – and probably engravings – of the pomp and circumstance surrounding the state visit of the newly crowned monarch. This commemorative scheme was nothing if not ambitious. Though never realized, this series was to record settings and depict ceremonies of the royal visit which had been planned and stage-managed by Sir Walter Scott. The ceremonies Scott devised made unambiguous allusion to historical parallels between the British past and present.[35] Scott had decided that the overarching theme behind the pageantry should be the union, embracing the union of the crowns under James VI of Scotland – who became James I of England in 1603 – and the parliamentary union of 1707. By deliberately using the union as the matrix of the ceremonies and processions, he skilfully wove into them three conspicuous, complementary strands of meaning: first, Scotland's reconciliation with

England; second, Scotland's cultural independence; and third, the nostalgic blending of Scotland's past and present.

Scott seems to have directed Turner to prepare illustrations of the ceremonials for the title pages of his *Provincial Antiquities and Picturesque Scenery of Scotland* (1819–26) – one for each of the two volumes of the collected work. The watercolour for the title-page design of volume 2 represents the recent arrival in Scottish waters of the king's yacht, the *Royal George*, depicted at anchor in Leith Roads. Three barges are shown approaching the yacht, in one of which is Sir Walter Scott, who is to welcome the king to Scotland. Below this representation Turner has depicted the classical motif of the clasping of hands.[36] Since one hand is meant to be that of the king and the wrist of the other hand is covered in tartan, it must allude specifically to the meeting of the king and Scott on board the royal yacht. However, it also symbolizes the union, and more significantly, the reconciliation of England and Scotland, of which George IV, during the visit, had been presented as the effective instrument. Though Turner was responsible for this design, the content of the vignette strongly reflects the ideology of Scott.[37]

British victories and heroic deeds during the Napoleonic Wars also attracted Turner's attention and provided him with a rich variety of subject matter for his art. For example, the Battle of Trafalgar was an event of ramified significance. He had made on-the-spot studies, collected on 22 December 1805, when he witnessed and sketched the *Victory* entering the Medway on its return from Trafalgar with the body of Admiral Lord Nelson on board. This was the battle in which the British fleet under the command of the valiant Nelson won a decisive victory over the allied French and Spanish fleets. Twenty enemy ships had been captured, while the British lost no vessels. This battle, which continued to fascinate Turner, occurred off Cape Trafalgar on the southwest coast of Spain.

Although Nelson was killed, struck by a musket ball shot from the French ship *Redoubtable*, this victory left Napoleon without ships and thus effectively ended his domination of the seas and rendered highly unlikely a French invasion of England. When considering these implications, Turner's early work *The Battle of Trafalgar, as Seen from the Mizen Starboard Shrouds of the Victory* (exh. Turner's gallery; reworked, BI 1808) (fig. 59) unfinished in 1806, assumes a particular sense of relevance. Turner, influenced by

Dutch marine painting – perhaps by J.S. Copley's *The Siege and Relief of Gibraltar, 13th September, 1782* (1783–91) and, more generally, by the embattled seascapes of Philip James de Loutherbourg – shows the mortally wounded hero, not against a backdrop of acrid smoke and the clash and clamour of battle, as in Benjamin West's famous *Death of General Wolfe* (1770), but more like the hero of J.S. Copley's *Death of Major Pierson* (1783), in the midst of the fighting. Unlike West's painting and in some respects like Copley's *Death of Major Pierson*, Turner's painting presents what appears to be a pictorial account that is primarily factual. Not only did Turner make sketches of the *Victory's* arrival, he went on board, made careful studies of the ship and its rigging, and interviewed sailors and faithfully recorded the details of their dress.

"As a pictorial representation of a great naval engagement the picture is astonishingly successful," observed Finberg in his biography. It represents the battle soon after Nelson was fatally wounded. When Turner first exhibited it in his own gallery, he provided a key to the main figures and actions of the piece.[38] Yet this historical event is not interpreted in a dry, detailed, reportorial manner. Turner provides allusions to events immediately surrounding the fatal moment when Nelson was struck down by a ball from a marksman's musket on the *Redoubtable*. Turner is not only depicting the English admiral's demise, he is representing the decisive moment of the battle. Nelson's brilliant, winning tactic (called "Nelson's Touch") was to divide his fleet into two and assault the enemy line in two places. One part of the fleet was under Cuthbert Collingwood, who commanded the *Royal Sovereign*; the other was under Nelson, in the *Victory*. In his painting, Turner shows the *Victory* with the *Téméraire*, cannons blazing, penetrating the line of enemy ships. Turner's powerful portrayal of the event is intensified by making the viewer a participant, a lesson he had learned particularly from the structure of his alpine views of 1802.[39] Moreover, in order to elevate his representation, he has imbued his picture with an epic character; he, like Benjamin West in the *Death of General Wolfe*, looked to the Christian past. Though Turner's figures are small, the artist assigned to Nelson the slumped pose of the dying Christ, thus endowing him with the visage of the Christian hero who, like the Saviour, gave his life – not for humankind but for a grateful nation and empire.

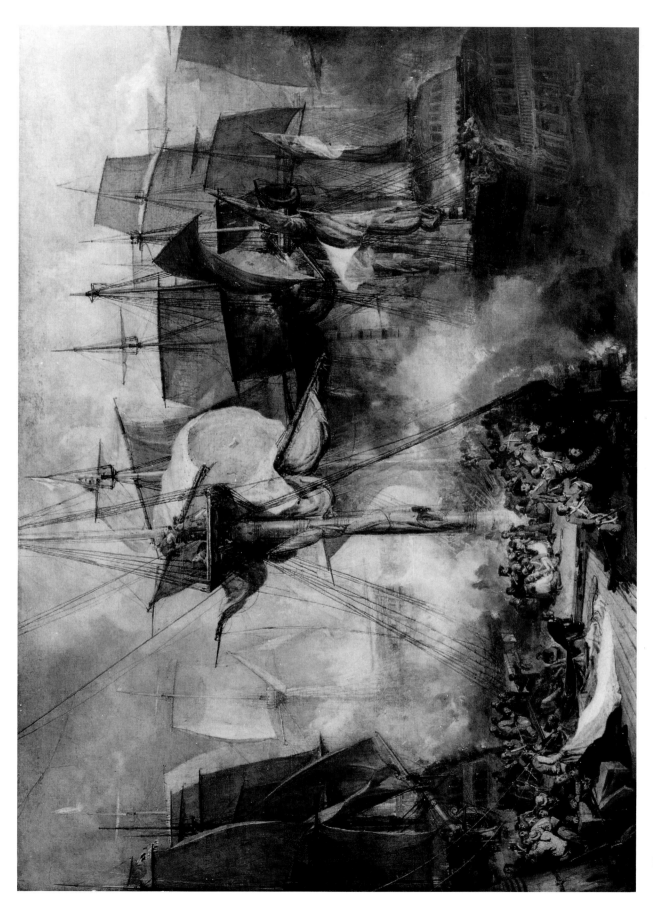

59 *The Battle of Trafalgar, As Seen from the Mizen Starboard Shrouds of the Victory.* Oil, exh. 1806; reworked 1808. 67 ¼ × 94 in. (171 × 239 cm). London, Clore Gallery for the Turner Collection (BJ 58)

Reaction to the first showing of the picture was not favourable. Farington, when he saw it exhibited in June of 1806, adjudged it a "very crude unfinished performance" with figures "miserably bad."[40] Some opinions, however, changed after it was reworked. When shown at the British Institution, two years later, it was described and tidily summed up by one critic as "a British epic picture ... the first picture of the kind that has ever, to our knowledge, been exhibited." The critic also suggested that the artist conveyed the totality of the event: "Mr. Turner ... has detailed the death of his hero, whilst he has suggested the *whole* of a great naval victory which we believe has never been successfully accomplished, if it has been before attempted, in a single picture."[41] In discussing the manner in which an artist should approach the representation of the death of Nelson, the contemporary critic and theorist Prince Hoare observed the importance of capturing more than the suggestion of a mere instant: "There is a very material distinction to be drawn between a representation of the subject, and of the *matter of fact*; between such a representation of various objects, as will fill his [the artist's] mind with satisfactory sensations adequate to his idea of a whole event, and a representation of any confined or precise act, which yet stands most distinguished in the accomplishment of that event." It is the idea of "wholeness," of embracing more than a single, isolated moment, however significant, that is important to Turner's representation. This could be achieved, it was believed, by artistic licence, which, as Hoare observed, could convey more convincingly, the occasion of Nelson's death. The artist should not present, he insisted, the "bare and precise matters of fact attending the last moments of the Hero." Instead, he should attempt "to collect in one spot all the circumstances, which conspire to form in the mind an idea of the total event; and all these circumstances must be, in their essential points grounded on matters of fact."[42]

Turner's fascination with this battle did not wane. He was to refer to it in other works. In addition to *The Victory Returning from Trafalgar* (1806), he painted *The Battle of Trafalgar* (1823–24), which was a commission from the Crown through the good offices of his friend Sir Thomas Lawrence. This latter painting was planned to hang as a pendant to Loutherbourg's *Lord Howe's Victory* in one of the state rooms of St James's Palace. However, it failed to win accolades or approval even as the artist "with epical grandeur, aggregated the events of several different hours."[43] It was eventually removed to Greenwich.

The momentous battle is alluded to in a watercolour by Turner, *Yarmouth Sands* (c. 1827), which was intended for an unrealized series, "Picturesque Views on the East Coast of England." Yarmouth was the home port of the North Sea fleet, and on the sands a cluster of sailors and their ladies reenact "Nelson's Touch" by deploying toy boats on the beach, under the shadow of the columnar monument surmounted by Britannia commemorating Nelson's victories.[44] A painting with a further allusion to Trafalgar is *The Fighting Temeraire* (fig. 81, discussed in detail in chapter 8, below), which commemorates the demise of the noble warship that had played a dramatically important role in that famous battle.

Another battle commemorated by Turner was that of Waterloo. His painting *The Field of Waterloo* (RA 1818) (fig. 60), like his *Battle of Trafalgar*, has a striking immediacy and is concerned with loss. While the imminent death of a hero is commemorated in the painting of Trafalgar, *The Field of Waterloo* is more of an elegy for the battle's unknown victims. In 1817, after the Napoleonic wars, Turner crossed the English Channel specifically to survey and sketch the Waterloo battlefield where Wellington had been triumphant. It was a scene that stirred reflection, though not patriotic thoughts, as the lines from Byron's *Childe Harold* (3.28) attached to it indicate:

Last noon beheld them full of lusty life,
Last eve in Beauty's circle proudly gay,
The midnight brought the signal-sound of strife,
The morn the marshalling in arms, – the day
Battle's magnificently-stern array!
The thunder-clouds close o'er it, which when rent
The earth is cover'd thick with other clay,
Which her own clay shall cover, heap'd and pent,
Rider and horse, – friend, foe, – in one red burial blent!

When he sketched the battlefield, Turner included the shell of the ruined manor house of Hougoumont, an important element in the finished picture because of its strategic importance in

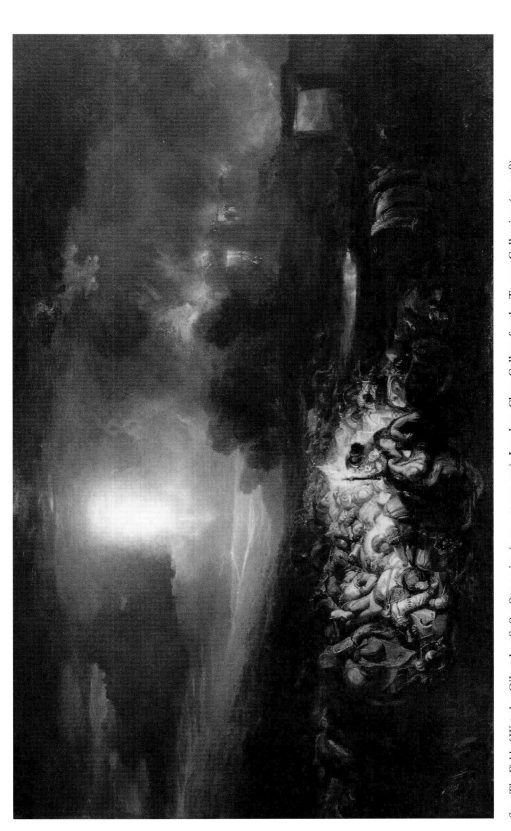

60 *The Field of Waterloo*. Oil, exh. 1818. 58 × 94 in. (147.5 × 239 cm). London, Clore Gallery for the Turner Collection (BJ 138)

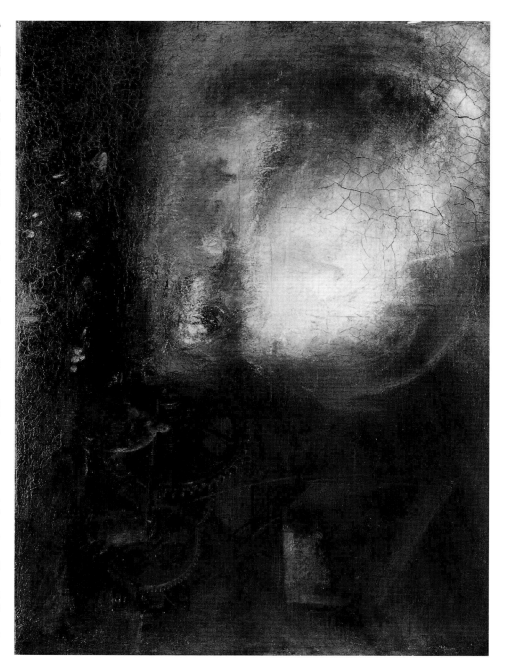

61 *The Hero of a Hundred Fights.* Oil, reworked and exh. 1847. 35 ¾ × 47 ¾ in. (91 × 121 cm). London, Clore Gallery for the Turner Collection (BJ 427)

Wellington's victory.[45] However, this painting and his watercolour designs of the battlefield avoid what has been referred to as the "pomp and circumstance of self-righteous nationalism."[46] For some Britons the war, with its carnage and extreme suffering, had been the cause of pessimism; not only had the toll of life been great and its costs high for the middle classes, it had furnished considerable economic gain for the narrow moneyed strata of society.[47] Its specific, apocalyptic light and shade effects, which sug-

gest the influence of Rembrandt (whose style was believed during the late eighteenth and early nineteenth centuries to be fitting for representations of the sublime), emphasize the inflicted pain and distress, as well as a general indictment of man's inhumanity to man.[48] With its attached lines from Byron, Turner's *Field of Waterloo* is a clear indictment of war.

If *The Field of Waterloo* possesses no patriotic overtones, *The Hero of a Hundred Fights* (RA 1847) (fig. 61) surely does. This pic-

ture, which makes a pronounced commemorative statement, is once more associated with the Napoleonic wars. The hero, Wellington, is indirectly the subject of this painting, which was painted over an earlier (c. 1800) picture of an industrial subject.[49] In its reworked state it depicts M.C. Wyatt's gigantic bronze equestrian monument (1845) dedicated to the Iron Duke that was provisionally placed atop the triumphal arch on Constitution Hill in London. The statue was condemned by many because of its scale and site. In December 1846 Queen Victoria decided that it should be removed from the arch, at which time Wellington, still alive, "had let it be known that he could only interpret the removal of his statue as an indication of personal disgrace."[50] There is an allusion to the negative reactions to the statue in Turner's reference to the "Fallacies of Hope" that he attached to the painting. As has been observed, it is a reference to "hope confounded."[51] However, it is more than this; it is also an allusion to what Turner himself had felt about human failure to recognize talent: the neglect, the ungratefulness, the "benefits forgot" of greatness.[52]

There were individuals other than royalty and military heroes to whom Turner pictorially paid tribute. He admired great artists, both poets and painters, who he believed had some common aims. For example, Sir Walter Scott was a poet highly regarded by Turner, and the artist's tributes to Scott can be readily documented. Turner prepared pictures and illustrations, some of which are overtly commemorative of the poet, with allusions in their designs to funerary wall tablets.[53] Commemorative aspects of other works dedicated to him are, however, more oblique. For example, Turner painted a tray with the landscape of the Tweed and Abbotsford, Scott's neo-Gothic manorhouse (fig. 62). It shows Scott as Turner had known him when he visited him there in 1831. The tray appears to have been given by the artist to Scott's family shortly after the author's death in 1832.[54]

Following Scott's demise, Turner had also involved himself openly in discussions concerning a monument to be dedicated to the poet. Indeed, there is reason to believe that Turner actually executed a rough sketch of an obelisk of "commanding size." An illustration of the poet's Edinburgh house, prepared to embellish Scott's biography, almost certainly introduces the base of this proposed grand obelisk, intended for what he considered an appro-

priate site in Edinburgh, before the official selection of a particular style and site for the monument had been determined (c 1836; for J.G. Lockhart's *Memoirs of the Life of Sir Walter Scott* [1839]; New York, Pierpont Morgan Library). In the end, a design for a great Gothic cross (based on a market cross) submitted by George Meikle Kemp was chosen and erected in Princes Street.[55]

Although Scott's genius was widely recognized and celebrated, Turner believed that the contributions of poets and painters were sometimes overlooked in their own day or forgotten with the passage of time. As indicated in the last chapter, he celebrated pictorially, through allusion, important British poets of the past. For example, the destruction of Pope's villa prompted him to paint an elegy on the obliteration of a significant memorial to this illustrious poet.

His tributes to painters were equally important. For instance, he alluded pictorially to the achievements of the British painter Richard Wilson, a founding member of the Royal Academy who was still alive when Turner was a child. His talents, Turner felt, were never adequately acknowledged. Indeed, one of those who publicly failed to recognize Wilson's notable talents was the first president of the Royal Academy, Sir Joshua Reynolds. In his *Discourses*, Reynolds adjudged Wilson's efforts to produce historical landscape to be a failure. He considered Wilson guilty "of introducing gods and goddesses, ideal beings, into scenes which were by no means prepared to receive such personages. His landskips were in reality too near common nature to admit supernatural objects."[56] Turner believed that Reynolds was mistaken. He countered Reynolds' severe criticism of Wilson in one of his own Royal Academy lectures, where he referred to Wilson's Italian contemporary Zuccarelli, whose paintings he considered inferior to Wilson's: "His [Zuccarelli's] figures are often beautiful, but in general poor, plac'd always to demand attention as to colour, yet they defrauded the immortal Wilson of his right and snatched the laurel from his aged brow. In vain did his pictures of Niobe in the possession of Sir George Beaumont and the Duke of Gloucester flash conviction of his powers, as Ceyx and Alcyone and Celadon and Amelia display contending elements or Cicero at his Villa sighs for the hope, the pleasures of peaceful retirement, or the

62 *Abbotsford.* Oil on japanned oval metal tray, 1834–36. 20 × 25 in. (50.8 × 63.5 cm). Indianapolis, Indianapolis Museum (Gift in memory of Evan F. Lilley, photograph © 1997: Indianapolis Museum of Art) (BJ 524)

commemorates Wilkie. In order to begin to understand Turner's intentions, one must examine the poetic lines that accompany them. The lines associated with *War* will be examined first:

Ah! thy tent-formed shell is like
A soldier's nightly bivouac, alone
Amidst a sea of blood ———
——— but you can join your comrades!"

In these lines Turner establishes the parallel between the isolation of the limpet, a mollusk with a flattened conical shell, and the exile of Napoleon on St Helena in the South Atlantic. The "sea of blood" in which the limpet is shown and in which Napoleon is mirrored is the red colour reflected from the setting sun. It is an allusion to this soldier's field of battle, to the lives lost during the Napoleonic wars.[60] Though the limpet is free to "join his comrades," Napoleon is imprisoned on this island and cannot escape. The island, "ten leagues in circumference was inaccessible, guarded by brigs, posts within sight of each other and placed on the shore, and all communications with the sea ... rendered impracticable."[61] In Turner's painting, behind the figure of Napoleon is one of his British guards. It is probably not fortuitous that Napoleon contemplates a limpet. Although in the poetic lines accompanying the picture reference is made to the freedom of the limpet ("you can join your comrades"), ironically, the limpet was a commonplace symbol for imprisonment! By selecting a "rock" limpet, Turner was pictorially entertaining the suggestion of a pun, for St Helena was widely referred to as "the rock."

The contemplation of Napoleon in isolation was likely influenced by two illustrations prepared for Sir Walter Scott's *Life of Napoleon Buonaparte* that Turner had completed in the early 1830s. These are the vignette designs *Fontainebleau* (fig. 56), previously discussed, and *Bellerophon, Plymouth Sound*. In both, Napoleon is presented as a meditative figure. In the first, he is shown standing on the top of the staircase at Fontainebleau contemplating his future; in the second, the recently captured Napoleon on board the *Bellerophon* awaits with equanimity the decision as to his fate. However, these illustrations were not the only influence on *War*. A probable common influence on the painting and the

dignified simplicity of thought and grandeur, the more than solemn solitude that told his feelings. In acute anguish he retired, and as he lived he died neglected."[57] Turner considered that Wilson's neglect was comparable with that experienced by Cicero. Turner's public tribute to Wilson takes the form of pictures that emulate the simplicity and facture of Wilson's style and sometimes his subject matter; the brilliant ancient orator Cicero is commemorated in Turner's late picture, *Cicero at his Villa* (exh. 1839), the subject of which was inspired by one of Wilson's canvasses.

Another British artist to whom Turner paid tribute was Sir David Wilkie. This well-known subject painter had become both his friend and rival. He had died in 1841 on board the steamship *Oriental* on his return to Britain after a sketching tour of the Middle East. Turner saluted Wilkie in his painting *Peace – Burial at Sea* (RA 1842), whose companion picture, *War. The Exile and the Rock Limpet* (RA 1842), was concerned with Napoleon. These two pictures, one dark, the other light, extend and develop an enriched relationship in which their meaning is structured largely in terms of opposites, a relationship similar, at least superficially, to what he had earlier established in his *Watteau Study* and *Lord Percy* (RA 1831).[58]

Peace (fig. 63) was apparently painted in friendly competition with his friend, the artist George Jones, who had produced a drawing showing Wilkie's burial from the deck of the ship, rather than, as in Turner's picture, a night burial viewed from the sea. When exhibited, Turner's painting was not well received. One of its critics was the eminent landscape and marine painter Clarkson Stanfield, who reputedly objected to the darkness of the *Oriental's* sails as Turner represented them. Turner allegedly replied in answer to this complaint that "I only wish I had any colour to make them blacker."[59] Additional insights into Turner's meanings in these two pictures are provided by the lines from his "Fallacies of Hope" that accompany their entries in the Royal Academy catalogue.

But *Peace* is not simply a depiction of a recent event. Its content is enriched by the context provided by *War* (fig. 64). At first glance, a painting depicting Napoleon seems an odd choice for a picture that was intended by Turner as a companion to one that

63 *Peace – Burial at Sea*. Oil, exh. 1842. 34 ¼ × 34 ⅛ in. (87 × 86.5 cm). London, Clore Gallery for the Turner Collection (BJ 399)

64 *War. The Exile and the Rock Limpet.* Oil, exh. 1842. 31 ¼ × 31 ¼ in. (79.5 × 79.5 cm). London, Clore Gallery for the Turner Collection (BJ 400). See colour plate 9

vignettes was popular prints. Many English caricatures that appeared during Napoleon's last days on St. Helena refer to his meditations. One of these caricatures was specifically entitled "The Exile of St Helena, or Boney's Meditation" (August 1815) and shows a monumental Napoleon standing with legs astride, feet planted on rocks on either side of the bay of St Helena; the inscription reads, "he weeps copiously, and the expression of his countenance is very rueful."[62] The lines that Turner attached to *War* also emphasize Napoleon's isolation and grief; he is presented again as a heroic victim of history.

Still, the question remains as to the specific contents that inform and bind together *Peace* and *War*. Was the fact that Wilkie was buried without his friends, patrons, and colleagues gathered round a reason to consider him "isolated" like Napoleon? Wilkie had been acquainted with the first and believed that he understood the second. He had read Scott's *Life of Napoleon Buonaparte*. However, Turner's main reason for choosing them was his desire to recognize men of exceptional talent who had passed away.

The poetic lines attached to *Peace* provide a key to this reading: "The midnight torch gleamed o'er the steamer's side / And Merit's corse was yielded to the tide." In these lines, not only does Turner provide a description of the scene he represents, but also he speaks of "Merit's cor[p]se" being given up to the sea.[63] We know that he felt that artists of genius should be accorded proper recognition, even in death. When his friend Sir Thomas Lawrence died in the winter of 1830, Turner sketched from memory his funeral at St Paul's. At that time, in a letter to George Jones, he expressed his belief in the necessary acknowledgment of greatness. "It is something to feel," he wrote, "that a gifted talent can be acknowledged by the many who yesterday waded up to their knees in muck to see the funeral pomp swelled by carriages of the great."[64] Turner was only too aware of the lack of acknowl-

edgement that surrounded what he seems to have believed was the unceremonious decanting of Wilkie's body into the deep.

Since *War* is the contrasting correlative of its companion picture, its subject and resonances thicken the texture and extend the meaning of the event depicted in *Peace*. In the year of Wilkie's death (1841), Turner's old acquaintance the King of the French, Louis-Philippe (whom he had met in Twickenham), capitulated before France's Napoleonic faction and allowed the emperor's remains to be shipped from St Helena to Paris, where they were ceremoniously received and suitably enshrined in the Dôme des Invalides in a vast tomb dedicated to his memory. In establishing a relationship between *Peace* and *War*, Turner wished to compare what he considered the lack of respect extended to Wilkie's remains and the recognition implied by the ceremoniously reinterred ashes of Napoleon.[65] The relative stasis or lack of action in these paired pictures underlines their particular reflective themes.

If Turner attempted to enshrine pictorially references to some individuals whose contributions he believed might be overlooked or forgotten, he did not forget himself. He hoped he would be remembered in the pantheon of great artists, but his virtues had not brought him all the rewards he wished. He was never a recipient of the accolades that a number of his artist friends and acquaintances had received. If he did not feel cheated of the eminent place he felt he should enjoy, then he believed, at least, that he was deprived of it. He had imagined the benefit of royal patronage and had hoped to receive it. However his various schemes to engage the attention of monarchy were almost entirely unsuccessful.

Still, his reputation had been long and securely established through the acclaim that his exhibited pictures had received and as a result of his position within the Royal Academy. His celebrity was further enhanced by his career as a landscape illustrator, a vocation that had brought his designs, especially through the 1830s (when he was still in his fifties), before an international audience. Of importance were his illustrations in the three volumes of the *Rivers of France* series, which appeared in 1833, 1834, and 1835. The first volume, entitled *Wanderings by the Loire*, was published in London; the second and third volumes, entitled *Wanderings by the*

Seine, were published in Paris and Berlin as well as in London. Turner was also known to members of the artistic community in Paris. He may have met J.B. Isabey, and he certainly encountered Isabey's devoted friend Eugène Delacroix.[66] In 1836 Turner's reputation in France was sufficiently well-established for the influential French journal *L'Artiste* to have published a detailed biographical sketch of him that is probably one of the fullest of the contemporary accounts.[67] Even Louis-Philippe honoured him.[68]

In addition, Turner's deep attachment to the Royal Academy and to British art in general had involved him in generous philanthropic acts that would not have gone unnoticed. He indicated his desire to establish a Professorship of Landscape Painting at the Royal Academy as well as a Turner Gold Medal. In 1831, he donated Hogarth's palette, which he had purchased, to the Academy.[69] He was involved with the management of the Artists' General Benevolent Institution, though he resigned in 1829 as chairman and as treasurer, of that body in order to undertake an independent charitable project.[70] This project, though never realized (because it was successfully contested by his family after his death), is described in his first will – instructing his executors to construct buildings that would house a combination of art gallery and almshouses for "decayed," single English landscape artists, probably on a Twickenham property he had acquired in 1818. It seems reasonable to suppose, as has been suggested, that he was influenced by his friend Soane, who in 1814 had made similar plans for his building in Dulwich.[71]

Turner planned to present his pictures to the nation. In his first will he bequeathed *Dido Building Carthage* and *The Decline of the Carthaginian Empire*. These pictures were left on condition that they would be shown in competition with celebrated landscapes by Claude: they were always to hang in the National Gallery between Claude's *Seaport with the Embarkation of the Queen of Sheba* and *The Marriage of Isaac and Rebekah*, otherwise known as *The Mill*. In his will of 1831, *The Decline of the Carthaginian Empire* was replaced with *Sun Rising through Vapour*. In 1848 there were two further codicils added to his will. His pictures would be left to the nation on the condition that a Turner Gallery be erected, attached to the National Gallery. Until this occurred, his finished pictures would

remain in his own gallery in Queen Anne Street, where the lease was to be regularly renewed. The second codicil of this year stipulated that the bequest to the nation would be void if the terms of the first codicil were not met within certain stipulated periods. If the accommodation was not provided after ten years by the National Gallery, then the pictures were to remain in his own gallery, which was to be open with free admission to the public. If the lease could not be renewed on this property, then the finished pictures would be sold to benefit his charitable institution. In the final codicil to his will, which was added in 1849, he instructed that the lease on Queen Anne Street not be renewed. If the National Gallery failed to comply with his wishes to build a room, or rooms, for his pictures, then the finished pictures would be exhibited during the current lease, less two years, and then sold. The residue of his monies would be distributed, in varying amounts, to the Pension Fund of the Royal Academy, to the Artists' General Benevolent Institution, the London Orphan Fund, and, perhaps significantly, the Foundling Hospital in Bloomsbury, the institution that the illustrious Hogarth had supported.[72]

7 "Let my words / Out live the maker"

THE COMMEMORATIVE ASPECT of Turner's historical landscapes depicting or alluding to painters and poets is sometimes complex, especially when those depictions or allusions possess an autobiographical dimension. In a remarkable instance of prescience, in 1796 Turner audaciously celebrated his own future fame. In that year he exhibited the imposing watercolour of the *Interior of Westminster Abbey* (fig. 65), where he had inscribed his name and the date of his birth on a stone slab of the abbey floor.[1]

However, the first truly elaborate commemoration of himself appears to be embodied in the complex historical landscape *Rome, from the Vatican* (fig. 19), which was discussed in chapter 3. This painting, exhibited at the Royal Academy in 1820, is, at first glance, primarily a celebration of the genius of the renaissance artist Raphael. It reflects a contemporary trend: painters of Turner's time chose to represent incidents from or anecdotes about the lives of great artists of the past.

Raphael is dramatically presented in the Vatican Loggie. Turner chose to place Raphael in the Loggie for at least two reasons. First, the view is remarkable. Samuel Rogers considered it "perhaps the richest ... of a Metropolis in the World."[2] The scene presented is of a landscape that has been shaped and severely changed through the city's tumultuous history. However, as a setting of Raphael's time, Turner's view is anachronistic. It is not the

Rome that Raphael knew but the one that Turner sketched, with its mix of ancient and quite recent buildings.[3]

The second and perhaps essential reason why Turner chose the Loggie was that Raphael was their architect and in charge of their decoration. The Loggie vaults display an important cycle of biblical frescoes, of which genre Raphael was considered a preeminent master. He also prepared intricate designs for the Loggie that were based on *grotteschi*, an ancient type of decoration that had been found in the remains of excavated Roman buildings. Raphael was fascinated with the art and architecture of classical antiquity and was convinced that it should be preserved. Ironically, Raphael's Loggie frescoes were in a deteriorated condition at the time of Turner's visit because of their exposure to the weather for three hundred years, and Turner, conscious of this, may have wished to record them before they had further decayed.[4]

In Turner's painting Raphael is presented to the right of the Fornarina, his mistress, who is gazing out over Rome as he steadies with his left hand, an easel picture of the Old Testament scene the *Building of the Ark*. This picture is actually a fresco design from one of the Loggie vaults. Another fresco that is similarly transformed into an easel painting representing Adam and Eve expelled from paradise is on the left. While steadying the *Building of the Ark*, Raphael contemplates one of his frescoes, the *Sacrifice of Noah*, in situ, in the vault. In the vault behind this, a further fresco is shown, the *Creation of Eve*. It, unlike the other vault frescoes, is clearly focused and, indeed, brightly illuminated (fig. 66). This particular fresco, I believe, was probably intended by Turner to assist in clarifying his picture's meaning.

There are other easel paintings in the Loggie. All are assembled on a platform that Raphael also occupies. In the centre of the composition on this platform is Raphael's celebrated painting the *Madonna della Sedia*, in front of which lie architectural plans. There is a further significant element here, a deliberate anachronism – the top architectural plan appears to be that for Bernini's great colonnade in St Peter's piazza, executed more than a century after Raphael's premature death. Immediately beneath it is Raphael's Loggie plan. It is possibly significant that these plans (particularly that of the Loggie) are located near Raphael's *Building of the Ark*, which Raphael steadies; the Ark is a well-known prac-

65 *Interior of Westminster Abbey, with the Entrance to Bishop Islip's Chapel; Looking from the Ambulatory to the North Aisle.* Watercolour, exh. 1796. 54.6 × 39.8 cm. London, Clore Gallery for the Turner Collection (w 138)

figuratio ecclesiae. Typological relationships, both secular and biblical, aided Turner in developing the particular intellectual structuring of his art and the elaboration of its meaning, and these occur here. Though Noah was considered a prefiguration of Christ (see chap. 12), he was also the first architect of ecclesiastical buildings. By spatially associating Raphael's own architectural plan for the Loggie with the fresco of the *Building of the Ark*, Turner was probably suggesting that Raphael was one of Noah's inspired modern counterparts.[5]

The Loggie are presented by Turner not only as a place to display Raphael's decorative genius but, fancifully, as a temporary artist's studio and as a means of alluding to this renaissance artist's personal life – specifically, to his enjoyment of earthly pleasures and his claim to fame. Propped before the easel painting of the *Expulsion of Adam and Eve from Eden* (which was, as noted, a design of one of the vault frescoes), on the platform to the left, is a painting in the manner of the classical landscape painter Claude Lorrain. It may be significant that Claude had been referred to during the eighteenth century as the "Raphael of landscape painting."[6] Though Claude, like Bernini, lived a century after Raphael, along the lower edge of this painting Turner has inscribed the words "Casa di Raffaello,"[7] referring to the substantial residence that was built for him by the illustrious architect Bramante. Turner appears to have considered it evidence of Raphael's material success and enjoyment of the good life.

A further indication of the good life – a life of the senses – is provided by the presence, to the right, of Raphael's mistress, the ample-bosomed Fornarina, who, standing by the balustrade, surveys Rome. Her presence palpably alludes to Raphael's reputation as a lover of women. His love for the Fornarina was said to have been of such deep intensity that when painting he required her stimulating presence.[8] The Fornarina's outward gaze probably symbolizes her worldliness. She is shown (fig. 67) fastening a brooch to her elaborate gown; the gown is reminiscent of a style worn by the young woman on the left in Titian's *Sacred and Profane Love*, which Turner knew and, indeed, had sketched on his visit to Rome in 1819.[9] On the coping of the balustrade where the Fornarina stands lies a string of pearls, next to which is an open plucked rose, symbols, respectively, of vanity and love. In this context the

Fornarina becomes a foil for Raphael. She is presented, like Dido, as a temptress and almost certainly personifies the transient material world of pleasures.

The illuminated vault fresco of the *Birth of Eve* and the easel painting on the platform to the left, the *Expulsion from Eden*, also appear to confer an extended meaning upon Turner's painting. As previously noted, the stories of the creation and fall are significant in Turner's art, albeit underlying themes. Eve and Adam were con-

sidered to have established the framework for human history, and Eve, whose birth in the Loggie vault is given strong illumination, is presented historically, as the archetypal temptress, since she was considered responsible for Adam's fall from grace. The Fornarina appears to be presented as an antitype, the postfiguration of Eve.

These historical reverberations confronting past and present may provide striking parallels, but they also establish that the past is a link to the present. A particularly illuminating example of this is

67 *Rome, from the Vatican. Raffaelle, Accompanied by La Fornarina, Preparing His Pictures for the Decoration of the Loggia* (detail)

Turner's unexpected allusion here to himself. It has been astutely observed that in this picture Turner invites a comparison with Raphael.[10] Just as David in his *Napoleon Crossing the St Bernard* intended Napoleon to be identified with great military heroes from the past, so Turner wished to identify himself with the artistic greatness of Raphael. There are other persuasive self-referential clues in *Rome from the Vatican* that draw the past even closer to the present. The Rome that Turner depicts, as noted, is not the Rome of Raphael; it is the Rome that Turner himself recorded. Also, the Claudean painting on the platform is probably a reference to Turner's deep admiration for the sunlit Italian vistas of Claude and, indeed, was likely intended as an allusion to his own Claude-inspired landscapes. This personal identification with the past and blurring of chronology are significant. Turner felt so intensely about relationships between past and present that occasionally in his art they appear to coexist and indeed, as here, almost to coalesce.

68 *Watteau Study by Fresnoy's Rules.* Oil on oak panel, exh. 1831. Approx. 15 ¾ × 27 ¼ in. (40 × 61.5 cm). London, Clore Gallery for the Turner Collection (BJ 340)

69 *Lucy, Countess of Carlisle, and Dorothy Percy's Visit to Their Father, Lord Percy, When under Attainder upon the Supposition of His Being Concerned in the Gunpowder Plot.* Oil on oak panel, exh. 1831. Approx. 15 ¾ × 27 ¼ in. (40 × 61.5 cm). London, Clore Gallery for the Turner Collection (BJ 338)

Thus, though *Rome from the Vatican* is a public salute to Raphael, it is also a private celebration of Turner's own visit to Rome and a commemoration of himself as heir to Raphael's genius. As this heir, perhaps Turner saw himself as a major exponent of that great national art that Reynolds believed Britain needed to produce to make its art the equal of what had developed in Europe. On the left of the platform on which Raphael stands, next to the *Expulsion from Eden* (a pictorial metaphor for the corrupted, temporal world), lies an artist's palette, brushes, and some fruit and flower petals, which are surely not chance additions. Nor can their position in the composition next to the *Expulsion* be considered accidental. The palette is an established symbol of the eternal nature of art; the fruit and flower remains are well-known allusions to the fugitive, superficial, and deceptive nature of the pleasures of this postlapsarian world. Turner seems to be suggesting that though life is short (and Raphael's was cut particularly short) art is eternal.

That Turner intended such a meaning is borne out over a decade later, when he was spending more time with his old friend and art collector George Wyndham, third Earl of Egremont. In the hospitable atmosphere of Petworth House, West Sussex, the artist occupied the Old Library as a painting room. It may have been here that he began, and perhaps completed, the two companion pictures he was to exhibit at the Royal Academy in the spring of 1831, *Watteau Study by Fresnoy's Rules* (fig. 68) and *Lucy, Countess of Carlisle, and Dorothy Percy's Visit to Their Father Lord Percy, When under Attainder upon the Supposition of His Being Concerned in the Gunpowder Plot* (fig. 69), referred to henceforth as *Lord Percy*. The interiors depicted suggest in a general way the type of rooms found in Petworth House; if so, these settings, like that of *Rome from the Vatican*, would have had particular significance for him.[11]

These paintings share other themes. Both consider the theme of Art and both allude to mortality. The theme of Art unites and articulates their subject matter and assists in accommodating their more specific meanings. The theme is at once apparent in *Watteau Study*, though it is more elusive in its companion. However, the faces, costumes, and poses of *Lord Percy*, his two daughters – Lucy on the left, possibly Dorothy to

the right – and an unidentified third lady between them are direct quotations from portraits by, or attributed to, Sir Anthony Van Dyck that hung in Petworth House.[12]

Mortality is the second theme they share and is provided by the historical contexts of both pictures. In *Lord Percy* the context is established by the main protagonist, Henry Percy, ninth Earl of Northumberland (1564–1632), then the owner of Petworth, whom Turner depicts under house arrest awaiting his removal to the Tower of London for suspected complicity in the Gunpowder Plot. There he faced death. The historical background of *Watteau Study* is less clear. The French painter Antoine Watteau (1684–1721), the subject of this picture, was never at Petworth; he did, however, visit England in 1719, while still relatively young. He was suffering from a severe lung ailment and came to consult the famed London physician Dr Richard Mead, but died in France soon after his visit.

Mortality was on Turner's mind during the period in which he painted these two pictures. Death seemed to be trailing him through family and friends. The demise of his father in 1829 had been a heavy burden to bear; indeed, it affected his life deeply, plunging him into a state of despair. Thornbury interviewed the son of the Reverend Henry Scott Trimmer, who recalled that after the death of Turner's father the artist came to stay with Trimmer's father whom Turner had known since about 1806; the artist "was fearfully out of spirits ... [he] never appeared the same man [again]."[13] There had been other deaths, and there would soon be more. Turner's friend and patron Walter Fawkes passed away in 1825. Four years later, the artist George Dawe died, followed in January of 1830 by Turner's champion, the president of the Royal Academy, Sir Thomas Lawrence. These bereavements also affected him. After Lawrence's funeral he wrote ruefully to his artist-friend George Jones: "Alas! only two short months Sir Thomas followed the coffin of Dawe to the same place. We then were his pall-bearers. Who will do the like for me, or when, God only knows how soon. My poor father's death proved a heavy blow upon me, and has been followed by others of the same dark kind."[14]

But *Watteau Study* and *Lord Percy* appear to yield more than superficial references to art and mortality. *Watteau Study*, ideologically the more important of the two, establishes through the

theme of Art specific connections with *Lord Percy*. These links are generated by lines from the poem "*De Arte Graphica or The Art of Painting*," by the French artist and poet Charles Alphonse Du Fresnoy, lines that accompany the title of *Watteau Study* in the Royal Academy exhibition catalogue.[15] The edition of the poem that Turner used was the translation into English verse by William Mason, a copy of which Turner owned. These lines concern the pictorial function of white. Because white by implication demands black, just as light requires shade, Du Fresnoy follows the two lines on white with four more on the function of black:

White, when it shines with unstain'd lustre clear
May bear an object back or bring it near.
Aided by black, it to the front aspires;
That aid withdrawn, it distantly retires;
But black unmix'd of darkest midnight hue,
Still calls each object nearer to the view.[16]

Turner quotes only the first two lines, probably because he believed that white is the more efficacious pictorially, since it is synonymous with light.[17] Light is a positive force, he believed; it generates shade and colour. Black, its opposite, which is discussed in the next four lines of the poem, though a necessary adjunct of white, is in itself a negative force, synonymous with darkness – the absence of light. Still, Turner fully realized that it, as well as white can be considered a "colour."[18]

Both *Watteau Study* and *Lord Percy* illustrate the formal functions of white and black and of light and shade. Indeed, they are probably the first paired pictures by Turner in which light and dark are consciously structured into the complex bipolar relationship that characterizes some of his subsequent paired pictures. In *Watteau Study*, the canvasses by Watteau placed about the room and the figures and other elements of the picture illustrate some of the dynamics of white and black. Du Fresnoy stated that white "may bear an object back or bring it near." The picture *Les Plaisirs du Bal* by Watteau in the left background seems to demonstrate that white as light and atmosphere can have a recessive effect, can deepen pictorial space. This "retiring" effect of white is also suggested by the light through the partially open door to the right of

and behind Watteau. However, whitish forms and shapes in the foreground defined by shaded areas seem to illustrate Du Fresnoy's dictum that white "Aided by black ... to the front aspires." The function of black alone is also illustrated. The forward, centrally located figure of Watteau wears a costume, significant parts of which are of a "black unmix'd [that] calls ... [the] object nearer to the view."

These dynamics of black and white Turner had pictorially explored before. For example, ideas concerning black introduced in *Watteau Study* and *Lord Percy* were of particular importance in his *Mortlake Terrace, the Seat of William Moffat, Esq. Summer's Evening* (RA 1827) (fig. 70):

A broad light lies on the river; the lime trees cast long shadows on the golden sward, where a garden chair and a portfolio tell of the artist; and on the river are gilded barges and the glancing wherries of holiday-makers, to bark at which a dog has just leapt up on the parapet. Mr Tom Taylor adduces the dog as a proof of Turner's reckless readiness of resource when an effect in Art was wanted. Suddenly conceiving that a dark object here would throw back the distance and increase the aerial effect, Turner instantly cut a dog out of black paper and stuck him on the wall; where he remains; where he still remains, for, either satisfied or forgetful, he never replaced him by a painted one.[19]

Turner also considered the specific dynamics of white before, which, from the evidence of his studies in white body-colour on blue paper in one of the Isle of Wight sketchbooks (c. 1827), he seems to have associated with Watteau (fig. 71). Certainly some of these studies provided preliminary ideas for the Watteauesque *Boccaccio Relating the Tale of the Birdcage* (RA 1828) (fig. 54), discussed in chapter 5. In this painting white is the defining "colour" of the distant tower. Because the tower is shown against a dark sky, it is given a powerful presence. Turner skilfully demonstrates one of Du Fresnoy's principles he was to experiment with in *Watteau Study* – that white aided by black "to the front aspires."[20]

Watteau Study and *Lord Percy*, in addition to illustrating the formal functions of black and white, seem to embody Turner's personal critical commentary on Du Fresnoy's precepts. While Du Fresnoy considered only the formal dynamics of black and white

70 *Mortlake Terrace, the Seat of William Moffat, Esq. Summer's Evening.* Oil, exh. 1827. 36 ¼ × 48 ⅛ in. (92 × 122 cm). Andrew W. Mellon Collection,
© 1994 National Gallery of Art, Washington, DC (BJ 239)

71 *East Cowes Castle with Lovers.* Bodycolour, pen and ink, c. 1827. 14 × 19.1 cm. London, Clore Gallery for the Turner Collection (TB CCXXVII(a), 34)

in painting, Turner appeared to believe, as a romantic, that white and black assume a further, equally important role as pictorially expressive constituents. Thus, through the open door and window in *Watteau Study*, the Petworth interior is flooded by light, which he considered, as noted, a positive, active principle. However, in the pendant painting, the room occupied by Lord Percy is relatively dark and confined; the window in the right background is barred and in shadow. Darkness is conceived as a negative, passive principle. The mood-laden interiors of these two paintings are important, for they serve as physical analogues for their occupants' mental states. *Watteau Study* and *Lord Percy* are dominated, respectively, by light and darkness. In *Watteau Study*, Turner presents Watteau actively painting, in a pose that derives from a Watteau design and one of his own pencil sketches for *Rome, from the Vatican* (fig. 72).[21] In the open, light-filled interior Watteau personifies the active life. His apparent sanguine mood is symbolized by the red jacket he wears. In several respects the companion picture, *Lord Percy*, presents the antithesis of *Watteau Study*. Lord Percy is passive, seated in a relatively dark interior. Depression heavily marks his mood. Sunk in a black gloom, he assumes, as he does in the Van Dyck painting (from which his pose and likeness are taken) the contemplative pose and, also, black clothing associated with the melancholic. The relatively dark, confined character of the room becomes the reflector of Percy's own psychological state. Yet to understand the context of Lord Percy's depression and of Watteau's apparent optimism, it is necessary to be more familiar with the background of each of the protagonists and the contents of these paintings.

In Turner's *Lord Percy*, Percy is shown under house arrest awaiting his removal to the Tower and possible execution. This would, of course, explain Percy's melancholy. His present and future confinements are metaphorically suggested by the pictures on the wall. St Peter is shown in prison, and there is also a representation of the Tower of London.[22] However, as the critic for the *Library of Fine Arts* (June 1831) observed, "the flood of light pour[s] ... like water over the ledges of a cataract into Lord Percy's chamber, dispelling its sombre hue"; this may be a symbolic portent of Percy's eventual release: through a fortunate marriage Percy's daughter, Lucy, was able to arrange her father's

liberation. Further, the painting on the wall to the right of Percy, representing St Peter in prison, may contain a similar portent, since the saint's cell is also occupied by an angel, the instrument of his deliverance.[23]

The ingredients of *Lord Percy* are illuminated by the life of Percy, but those of *Watteau Study* are not as easily interpreted. When Watteau visited England for medical treatment, he did not visit Petworth House, but it seems that Turner has presented him in a Petworth setting as a metaphor for this English visit.[24] As mentioned, Watteau had come to England because he was seriously ill – faced with death – and in spite of the ministrations of Dr Mead, his health continued to deteriorate. However, if Petworth *is* a metaphor for England, then Watteau should not appear sanguine, considering the condition of his health. In the companion picture, Percy's melancholic mood can be accounted for, as we have seen, since he is represented while under attainder and threat of death, but the optimism of Watteau in his particular cir-

cumstances does not lend itself to such a ready explanation. However, Turner appears to supply one.

The key to the apparent paradox seems to be the paintings by Watteau spread round the room and the objects in the foreground: the book, the lute, and the palette – all symbols of the arts. (This cluttered room was perhaps suggested by the room Turner was given when at Petworth, which he used for painting.) There is also a folio of black and white prints shown – most likely prints of Watteau's own work – instruments of artistic expression that have an essential role in establishing or extending an artist's reputation and fame.[25] That Turner should wish to suggest pictorially the value of the print to the artist at this time is suggested by the phenomenal financial success of his first really important watercolour illustrations for poetry – for Rogers' *Italy* (1830).[26]

By representing these symbols of the arts in *Watteau Study*, Turner alludes to the adage *ars longa, vita brevis*. Thus, in this picture Watteau's optimism does not turn on his chances of regain-

CLXXIX 26

26

73 *Watteau Study by Fresnoy's Rules* (detail)

ing his health but rather is kindled by his belief that he can claim immortality through his art. Watteau the man may die but his artistic genius will guarantee the survival of his name. Apparently to reinforce this idea, on top of the cupboard behind and immediately above Watteau and to this artist's right (fig. 73), Turner appears to represent small busts of illustrious individuals being crowned with laurel wreaths emblematic of their success and celebrity.

Turner's commemoration of Watteau thus owes a considerable debt to both the substance and imagery of *Rome, from the Vatican*.[27] Not only do both pictures commemorate exceptional artists of the past whose lives were cut short, but they show them in studio-like settings containing symbols of the eternal nature of art and the transience of human existence. These settings also contain deliberate anachronisms: they combine fancy with truth. Temporal dislocations occur, as noted, in *Rome, from the Vatican*; a comparable dislocation is also present in *Watteau Study*, though here it is spatial as well as temporal. Watteau, as has been observed, was never at Petworth.

A further significant relationship between these two paintings lies in their autobiographical content, particularly that of *Watteau Study*. Just as Turner suggests in *Rome, from the Vatican* that he is a modern Raphael, so in *Watteau Study* he considers himself the postfiguration of Watteau. In each of these two pictures, separated in time by approximately a decade, Turner not only suggests that through art the past can endure but also that he, Turner, is the recipient of the mantle of artistic genius passed down from the masters of the past. It is surely significant that he had earlier copied verses presenting images and containing sentiments that chime with those that I have suggested are conveyed in these paintings:

World I have known the[e] long & now the hour
When I must part from thee is near at hand
I bore thee much good will & many a time
In thy fair promises repos'd more trust
Than wiser heads & colder hearts w'd risk
Some tokens of a life, not wholey passed
In selfish strivings or ignoble sloth

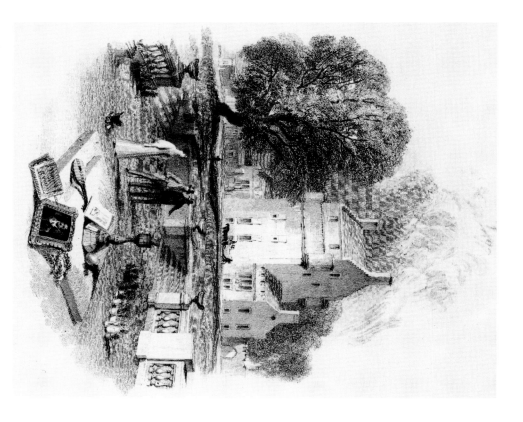

74 *Bemerside Tower*, Vignette for Sir Walter Scott, *Poetical Works* (1833–34), vol. 5. Engraving on steel by J. Horsburgh. 11.7 × 9.2 cm. London, Clore Gallery for the Turner Collection (R 502)

Haply these shall be found when I am gone
Wh[ich] may dispose thy candour to discern
Some merit in my zeal & let my words
Out live the maker who bequeaths them to thee
For well I know where our possessions end
Thy praise begins & few there be who weave
Wreaths for the Poet['s] brow, till he is laid
Low in his narrow dwelling with the worm.[28]

The autobiographical significance of *Rome from the Vatican* and *Watteau Study* is illuminated in yet another work. When Turner exhibited *Watteau Study* and *Lord Percy*, he was involved in a fruitful collaboration with Sir Walter Scott and Scott's publisher. He had been commissioned to prepare illustrations for a new edition of Scott's *Poetical Works*.[29] In 1831, Turner visited Scotland, staying for almost a week with Scott at Abbotsford, near Melrose, where he made numerous sketches of the countryside. He then travelled north on a tour to collect further sketches. While at Abbotsford he became attached to the surrounding Border country and to his host. As I have indicated elsewhere, the small illustrations that Turner prepared are highly distinctive, especially the vignettes that depict particular sites on the Borders that he visited and recorded. The watercolour vignettes possess framing embellishments "communicating the historical events to which the poetry bears reference, and which are so conceived and executed as to give a new idea of the rich fancy of Mr. Turner."[30] More significant, however, are the private references to that visit that these landscapes also present.[31]

There is a particular illustration for the *Poetical Works* that should be examined in relation to *Rome from the Vatican* and *Watteau Study*. It is one of several designs for the *Poetical Works* in which, against a specific landscape background, Turner's personal experience and feelings have been astutely conveyed. The vignette design of *Bemerside Tower* (fig. 74) embellishes the title page of the volume 5, which contains Scott's edition of the ancient metrical romance "Sir Tristrem." It is an unusual design depicting a mediaeval fortified house that Turner, Scott, and Scott's publisher, Robert Cadell, had visited during Turner's stay at Abbotsford. Cadell documented this visit in his diary. It is not the ar-

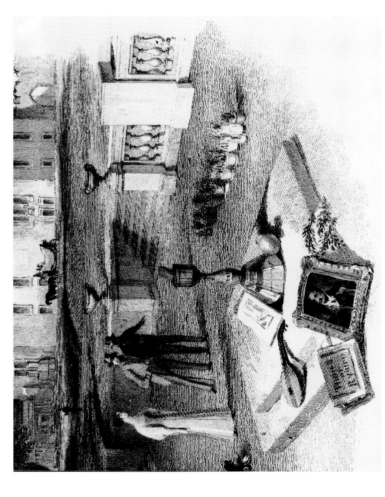

75 *Bemerside Tower*, (detail), engraving on steel

chitecture but the identifiable figures and emotionally charged objects in the foreground of the vignette that truly animate its meaning. Turner learned from Cadell that the poet was extremely unwell and, indeed, was not expected to live. The design, because of that knowledge, seems to radiate a particular poignancy. In the foreground Scott is shown in a light-coloured suit and seems to be supported by Cadell, standing next to him. Behind them, Turner, a minute figure, is depicted sketching.

Although Turner was remarkably accurate in reconstructing this brief visit to Bemerside, he used his imagination in certain parts of the design to move it beyond mere reportage – to provide it with a more exalted truth. In the foreground of this vignette an imagined sunken garden is shown displaying an ancient sundial (that still survives in the grounds) and, on its broad base, a spilled crock, both alluding to the shortness of life (fig. 75).[32] Also on the base of the sundial is a painted portrait of Scott with laurel branches next to it, emblematic of his poetical gifts and of his present and future fame. Close by this portrait rests a book of verse by Thomas the Rhymer, the mediaeval Scottish bard. That a reference to the Rhymer occurs here is not by chance. Not only was he traditionally associated with Bemerside, he was, according to Scott, the author of "Sir Tristrem."[33] (Scott provides an account of him in the prefatory memoir of volume 5.) However, there is further significance in the linking of Scott's portrait with the Rhymer's book. The reader/viewer of this volume who was familiar with the writings of Scott would probably realize that Scott the historian as well as Scott the poet is presented here. Scott was a committed conserver of the past; he collected artifacts and fought to preserve ancient architecture. He was also renowned for his acquisition of manuscripts of ancient ballads, romances, and other literary texts, which, like his "Sir Tristrem," he published with extensive historical notes.[34] A further implication of the association of portrait and book is that Scott's achievement is celebrated within the context of the Scottish literary tradition.

This symbolism strongly suggests a kinship with elements of the imagery of *Rome from the Vatican* and *Watteau Study*. For example, by introducing a spilled earthenware vessel on the broad-stepped base supporting the sundial, Turner seems to be referring not only to the poor state of Scott's health but also to his own

health, since death was at that time very much on his mind. Yet there is a further significance to these suggestions of mortality. By means of the design's symbolism Turner alludes to the adage mentioned above, that art alone has immortality. For that reason, Turner depicts the poet's portrait with laurel branches next to it; as mentioned, they are emblematic of his fame, which will live on. The allusion to Turner, himself, is more oblique. He depicts himself as a tiny figure sketching in the background and shows on the base of the sundial possibly a folio of prints (like the one in *Watteau Study*), which refers to the means by which the artist's fame can be spread and, again, to his artistic achievement, which will survive his death. This is a commentary that chimes with those allusions that occur in both *Rome from the Vatican* and *Watteau Study*.

Thus *Rome from the Vatican*, *Watteau Study by Fresnoy's Rules*, and *Bemerside Tower* possess compelling relationships that absorb and reflect the poetical, romantic cast of Turner's imagination; each picture combines fact and fiction, invokes the past, commemorates an uncommonly gifted artist, and is overlaid with autobiographical allusions. Turner, as an artist of exceptional talent – like Raphael, Watteau, and Scott – and as a painter of historical landscapes, was able to create poetical effects, because, as a contemporary artist shrewdly observed, the painter is not bound by the historian's facts and by events that "have no dominion over the poet or painter ... history is made to bend and conform to the great idea of art."[35] The artist's poetical effects "break the fetters of time" by means of simultaneous allusions to the past, present, and future, by judicious combinations of reality and fantasy.[36] Turner has pictorially suggested in these works that the past is a human memory that must be nurtured and maintained. If the Claudean landscape painting on the Loggie platform in *Rome from the Vatican* is meant to allude to Turner's own pictures, then it is a compelling symbol not only of his deep devotion to the past but also, paradoxically, of his essential rivalry with it. Turner, with Raphael and Scott, had felt a need to preserve the culture that had gone before; they had also borrowed from it, transformed it, and claimed it as their own.

8 Steam Triumphant: Bane or Benefit?

Droops the heavy-blossom'd bower, hangs the heavy-fruited tree –
Summer isles of Eden lying in dark-purple spheres of sea.
There methinks would be enjoyment more than in this march of mind,
In the steamship, in the railway, in the thoughts that shake mankind.

Tennyson, Locksley Hall (1842)

*T*URNER WAS BORN INTO AN AGE galvanized by revolution. The established economic and social order of the country that he knew was being changed before his eyes. Physical evidence of the British past that he admired was fast disappearing as a result of industrialization. Initially in his paintings he was alert to and seems largely to have accepted the remarkable transformations that were occurring. Later, however, there is the strong suggestion that his attitude altered, that he became more ambivalent toward these changes. He seems to have come to realize that progress should be viewed within the larger context of civilization's ultimate decline.

The impact of these changes was first noticed during the second half of the eighteenth century, in the period of the Enlightenment, when confidence was expressed in the preeminence of human reason – in the potential for the improvement of human-

kind. Scientists', writers', and artists' objectives were reconciled in their common pursuit of knowledge, which was reflected in the formation of the combined scientific, literary, and philosophical societies that blossomed in the Midlands and northern industrial centres and that stimulated and increased public interest in science and technology and their practical applications. The scientist and theologian Joseph Priestley was a distinguished member of the Lunar Society of Birmingham, writing on such diverse subjects as philosophy, theology and history, educational theory, and politics. The social reformer and author Thomas Day was a notable member of the Lichfield literary association, a group that also included, Erasmus Darwin, an eminent medical man and poet. Darwin, grandfather of Charles Darwin, is perhaps best known for his poems, *The Botanic Garden* (1789–91) and *The Economy of Vegetation* (1792), in which he expounded Linnaeus's system of botanical classification. However he is also known for his theory of the earth (1803) and for considering the steam engine in terms of mythology by "restoring deified natural processes embodied in the classical myths to their original natural functions by using them as poetic illustrations of the latest scientific theories."[1]

There was a discernible optimism at that time. Public imagination was fired by the scientific and technological changes that were occurring. Science was, after all, an organized body of knowledge concerning nature, and the technological innovation that developed from it seemed to promise widespread economic and social benefit. Yet concern was also evident. This is reflected not only in the poetry but in the prose and the paintings and the prints of the period. One is immediately reminded of the disturbing, ominous aspects of the industrial revolution – the images of "dark, Satanic mills" of which Blake wrote. Still, technology and science became the fresh, exciting subjects of art – at least for some.

The depiction in art of mines, furnaces, workshops, and factories in operation appears during the second half of the eighteenth century. Not only did these subjects provide artists with new imagery, they manifested the triumphal notions of progress and, as has been observed, they reflected the interest of the rising class of wealthy merchants and financiers in profit.[2] By linking scientific subjects and industry with landscape and with concepts of

the picturesque and sublime, painters and writers infused science and technology with aesthetic qualities, thereby legitimizing their place in prose, poetry, and art. The Reverend William Gilpin and other travellers in search of the picturesque had extolled the sublimity of certain types of landscape. A sublime scene should seem to be threatening,[3] or at least unsetting. To achieve this, a landscape could be spacious or barren and rocky, with "blasted" trees, deep, dark crevasses and the noise of deafening, dashing waterfalls. Ideally, such environments should be darkened, obscured by mist or rain, or starkly illuminated by lightning during a storm.

Industrial sites possessed many qualities that complemented natural sublimity. The dark, hulking forms of industrial structures, the infernal effects of machinery in operation, its throbbing noises, its belching, noisome smoke and flashing flames, could be harmonious with certain locations, providing suitable subject matter to accompany a "sublime" landscape. Hence travellers like Arthur Young associated industrial activity with craggy, bare rocks,[4] and Henry Wyndham, in search of picturesqueness, discovered sublimity when smoke from flaring blast furnaces and burning limekilns was viewed against a background of imposing mountainous terrain.[5] One might conclude that the poetry, prose, paintings, and prints that describe or depict industrial subjects would present them as slightly sinister.

One of the earliest and most significant painters of the industrial scene in Britain, whose work the young Turner may have known, was Joseph Wright of Derby (1734–97). Influenced by the chiaroscuro effects of seventeenth-century continental art, Wright created a mode of dramatic, indeed often mysterious, painting in which nature, science, and industry evince what has been called a "kind of vague unease."[6] There is a sense of unease, but it is an unease that is not always or entirely associated with the impact of machine on nature and human life. Rather, it is linked with the aesthetic system of the sublime, which Wright seems to have alluded to in order to dramatize and give special artistic significance to his new and unusual pictorial subject matter. For example, his *Arkwright's Cotton Mills, by Night* (c. 1782–83) (fig. 76) elicits a feeling of mystery. It is a "sublime" landscape. Nature and technology are dramatically presented in a pictorial equilibrium; the illuminated, active mill is contrasted with the dark serenity of the sleeping, leafy countryside. Yet there is a hint of "unease" that does not have an aesthetic basis. Wright, in this work, seems to adumbrate what others were later to discuss often and openly; that industrial activity is unrelated to the rhythms of nature that had previously determined how and when human beings worked.[7]

Another painter of the industrial scene was Philip James de Loutherbourg, whose work Turner certainly admired. Loutherbourg, too, viewed contemporary industry in conjunction with nature as a suitably sublime pictorial subject. His dramatic view of the blast furnaces of Coalbrookdale in Shropshire, *Coalbrookdale at Night*, published in *Romantic and Picturesque Scenery of England and Wales* (1805), records the mysterious, sublime qualities of its landscape. The manner in which Loutherbourg has placed the dark chimneys against the light-coloured smoke and the light chimneys against a dark hill, and in which he has included in the scene a figure on horseback owes a palpable debt to seventeenth-century Dutch landscape in general and also, possibly, to some specific light and shade effects associated with the landscapes of Rembrandt, whose dramatic style was believed to be suitable for representations of the sublime.

Turner was not the only British artist of the early nineteenth century who showed a fascination with industrial activity, but he was one of very few; and of those, he was the only one to make it a significant subject of his art. His representation of industrial activity began early in his career. It was relatively novel as an artistic subject, but it was an ingredient of English life that was becoming ever more evident. In painting, Turner's initial reaction to this subject appears to have been mainly positive, reflecting the approach adopted earlier by both Wright and Loutherbourg. In the late 1790s, perhaps influenced by Loutherbourg's series of small pen and ink and wash drawings on card of industrial subjects, then in the collection of his recent employer, Dr Monro,[8] he sketched limekilns and foundries, which were involved in the process of making iron and the cast forms that this metal assumed. He also executed oil paintings of these subjects.[9] His painting *Limekiln at Coalbrookdale* (c. 1797) (fig. 77), with its mysterious lighting effect, shows a debt to Rembrandt.[10] However, his interest in industry soon began to deepen. Though the poetic lines attached to his view of London (exhibited in 1809; discussed in

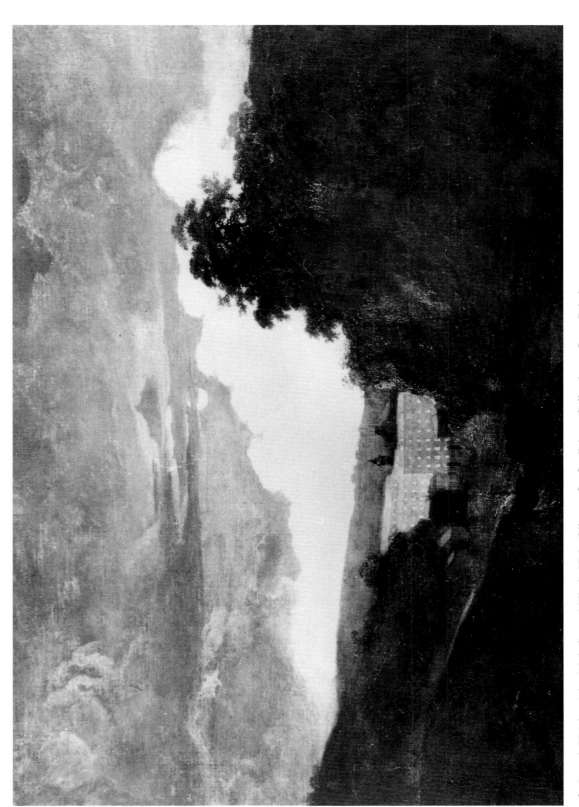

76 Joseph Wright, *Arkwright's Cotton Mills, by Night*. Oil, c. 1782–83. Private Collection – Great Britain

80 J.M.W. Turner, *Rain, Steam and Speed – the Great Western Railway*. Oil, exh. 1844. 35 ¾ × 48 in. (91 × 122 cm). © National Gallery, London (BJ 409)

81 J.M.W. Turner, *The Fighting Temeraire Tugged to Her Last Berth to Be Broken Up*, *1838*. Oil, exh. 1839. 35 ½ × 48 in. (90.2 × 122 cm). © National Gallery, London (BJ 377)

increasingly being regimented by the machine's anonymous, relentless force; the machine, he believed, was replacing nature; "nothing is left to be accomplished by old natural methods."21 Dickens in *Hard Times* had regretted that the machine had robbed men and women of their humanity and undermined those essential rhythms of nature that had previously regulated life.22 Wordsworth, too, had spoken critically of those mills that had destroyed the cadences of pastoral existence.23

However, the appearance of steam trains was often considered in a more positive light. The speed with which they could cross the country was astonishing and advantageous. Because of their relatively high speeds trains could carry, at low cost, a greater variety of goods, and, notably, they could carry perishable goods otherwise not transportable from one part of the country to the other. In 1835, the Reverend Matthew Marsh wrote to Lady Holland concerning the proposed Great Western Railway, remarking that "The Railroad will bring the fat oxen and the cheese of North Wiltshire very cheaply and quickly to London. It is to pass through the heart of Grittenham. But it will also bring provisions of every kind from Ireland and swamp us ... I see the projected railway to York is advertised as to perform the journey from London in 10 hours. What prodigious changes in every respect in England within a few years."24

Steam technology also altered the way in which Britons perceived their world. Rail travel had magically transformed England. Train travellers were forced to reconsider their established conceptions of space and time. Riding on a train made the traveller oblivious of the towns and villages through which it passed and thus of the distances that the train had covered.25 Samuel Smiles spoke with pleasurable excitement of the railway, as "a magician's road. The locomotive gave a new celerity to time. It virtually reduced England to a sixth of its size. It brought the country nearer to the town, and the town to the country ... It energized punctuality, discipline, and attention; and proved a moral teacher by the influence of its example."26 By the 1830s and 1840s, evidence of the highly successful application of steam power was everywhere. Books, pamphlets, and even song sheets enthusiastically trumpeted its achievements. Engravings and lithographs displaying and promoting railway development were commonplace. Views of termini, viaducts, and steam locomotives were published in quantity, reflecting the confidence and pride of Britons in this new age.27

Still, even steam trains had their negative aspects. Steam power was notorious because it had engendered social instability. It had begun to imperil established communities. One critic remarked that railroads had "slashed like a knife through the delicate tissue of a settled rural population."28 Locomotives with their steam, dense smoke, and penetrating noises, their stations, their stock and freight yards, impaired the beauty and invaded the quietude of the landscape. It was believed that trains would speed the decay and loss of those cultural and historical values that Britons had always held dear.

Steam technology captured Turner's imagination. Two of the most significant and impressive of his works associated with it are *Rain, Steam, and Speed – The Great Western Railway* (RA 1844) (fig. 80) and *The Fighting Temeraire Tugged to Her Last Berth to Be Broken Up, 1838* (RA 1839) (fig. 81). They are major paintings of contemporary history, but like other paintings of history by Turner their historical content has been manipulated in order to reveal a more elevated truth. As one of Turner's contemporaries noted, the painter is not bound by the historian's facts and by events that "have no dominion over the poet or painter ... history is made to bend and conform to the great idea of art."29

The subject matter presented in these two pictures is unusual and may have been intended by him to attract the attention of the new audiences – the affluent members of the middle-classes, the professionals, the industrialists and the merchants – the interests of whom were not always different from those of his aristocratic patrons but were, nevertheless, much less circumscribed by traditional taste. These two pictures are certainly more than mere pictorial descriptions of steam power, and more than celebrations of contemporary events in British life that Turner considered significant. In them he alludes to his personal response to change that had often found expression in his paintings of history and in some of his illustrations. At this particular period of his career he seems to have reached a moment when he discovered a rhetoric that made sense of the bewildering technological change that steam power, already well established, had wrought. I believe that

these pictures are essentially poetical representations that express his deeply felt, but ambivalent, response to technology. His feelings of faith and doubt were, it would seem, complementary and interdependent.

When these pictures were exhibited at the Royal Academy, the critics largely accorded them high praise; they were recognized as a new kind of exhibition picture. About 1870, a writer on Turner suggested that in *Rain, Steam, and Speed* formal concerns had been subordinated to intellectual ones.[30] Indeed, the picture is a largely poetical depiction.[31] Though Ruskin had reacted with distaste to industrialization, he considered *The Fighting Temeraire* "The last picture in which Turner's execution is as firm and faultless as in middle life." He characterized it as belonging to Turner's "Third Period," (which he determined was from 1835 to 1845) when his mind was "in a state of comparative repose, and capable of play at idle moments." Ruskin noted that it and nearly all subjects of this period possess "some pathetic meaning."[32]

Both *Rain, Steam, and Speed* and *The Fighting Temeraire* possess a powerful "pathetic meaning." There is in both (though more clearly suggested in the latter than in the former) a bleak poignancy – a loss of harmony and continuity. Cosmo Monkhouse, in establishing a relationship between these two pictures, shrewdly observed that they embody the notion that the secure past is being abandoned to the "quick-living future."[33] Though it is true that the *Temeraire* was obsolete by 1815, I believe it would be mistaken to dismiss the suggestion made by Monkhouse and other writers that in this picture the old order is giving way to the new. This suggestion seems to have been borrowed from the assessment of the picture by a critic who viewed the picture when it was first exhibited in 1839.[34] Though such an interpretation may make "little sense historically,"[35] this painting is palpably not a literal depiction. It does not simply report an event as it actually occurred; it is, as contemporary critics recognized, a profoundly poetical interpretation of the event. It must be examined on various levels.

Since both *Rain, Steam, and Speed* and *The Fighting Temeraire* appear to contrast the old with the new, one should examine how, pictorially, this contrast was accomplished. What Turner did to achieve this contrast was to establish a relationship between space

and time. From the beginning of his career he had understood and adhered to traditional ideas concerning pictorial unity – the strongly felt need to create and sustain pictorial decorum and consistency. Though not enthusiastic about theory, Turner learned that in history painting a protagonist's action or an event needed to be presented in an appropriate locale and to occur at a time consistent with that of the action or the event. However, Turner's images such as those that appear in *Rome from the Vatican* and *Watteau Study* (see chap. 7), suggest that these interrelated and interdependent unities could be manipulated to give his work a deeper expressiveness. He seems to have believed that the importance of space and time as ingredients of art lies not only in what they are but in what they can represent, that the coordinates of time and space can appear to intersect; space and time can be considered as equivalents. In some of Turner's pictures and illustrations, actions and objects are separated in time by their spatial location. Turner often places ancient, crumbling architecture in the distance as an expressive metaphor for the gulf existing between past and present. In his watercolour, *Dudley, Worcestershire* (c. 1832) (fig. 79), the ancient town with its church and castle are, as noted earlier, in the background, while the new industrial structures and conveyances colonize the middle ground and foreground.[36]

This same interaction of space and time occurs in *Rain, Steam, and Speed.* The locomotive that steams diagonally forward into the picture's foreground appears to exist in the present, leaving the past behind it, ready to plunge inexorably into the future. By contrast – but drawn inevitably into this metaphor – is the minute, frail ploughing figure in the right middle ground who slowly moves away from us rather than towards us (fig. 82). The two horses and plough of this remote figure were probably conceived as faint wistful images of the old order – of the agrarian age of the past and the continuities that it represented. They are contrasted with the strong, assertive form of the speeding train – the dynamic emblem of change – the new technology of the present and future that has replaced the more primitive technologies of the past. Indeed, awareness of change wrought by new technology and its consequences even attracted the interest of the poet Ebenezer Elliott, the "Corn-Law Rhymer," whose *Poetical Works*, pub-

82 *Rain, Steam, and Speed – the Great Western Railway* (detail). From engraving on steel by R. Brandard (1859–61). 19.2 × 25.6 cm. London, Clore Gallery for the Turner Collection (R 748)

lished in 1840, included the poem "Steam," in which the poet expressed regret that the highly respected skills of the engineer of the past are no longer of value in the technological world of the present: "His ancient fame, he feels, is passed away; / He is no more the wonder of his day – / The far-praised, self-taught, matchless engineer."[37]

In *Rain, Steam, and Speed* Turner palpably alludes to the differences between the world of his day, increasingly regulated by steam machinery, and the one of the past, of tradition, regulated by nature. This contrast between machine and nature is enriched and strengthened by the specific relationship that he establishes between mechanical and animal power with the vigorous metaphor of a hare running ahead of the speeding locomo-

tive. The contrast between mechanical and animal power had already been firmly fixed in the popular imagination. Competitions, both planned and fortuitous, were held between locomotives and horses. A brilliant engineer and early manufacturer of "portable" steam engines, Richard Trevithick, organized such a competition in 1808, in London, off the Euston Road. The entry ticket to the event read "mechanical power subduing animal speed."[38] On the illustrated cover of a popular song sheet of the 1830s entitled "Steam! Steam!! Steam!!!" an astonished locomotive witnesses a steam-powered mechanical cat in determined pursuit of a "natural" rat (fig. 83). It therefore seems probable that the hare being "pursued" by the locomotive in *Rain, Steam, and Speed* is a pictorial metaphor for the competition between me-

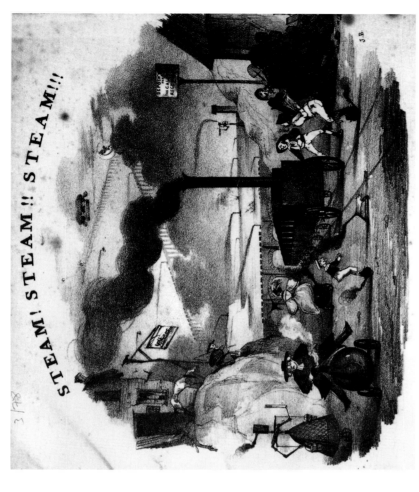

3/78

STEAM! STEAM!! STEAM!!!

J B

chanical and natural power that the exhibition-going public
could readily appreciate. Though the hare might, at times, be
able to achieve a higher maximum speed than the locomotive,
Turner probably knew, as a consequence of his familiarity with
hunting – particularly at Farnley Hall – that the hare can maintain
these high speeds only briefly. Because of this, the blurred form
of the train and the relatively clear image of the hare on this long
viaduct suggest that Turner wished to stress the greater speed of
the former.[39]

Though there was amongst some a growing disenchantment
with this new age, in prose and poetry the comparisons between
the machine and nature, between the industrial era and previous
times, were not necessarily negative. In pictures and prints this is
equally true. Life in the industrial age is sometimes presented as
coexisting with traditional ways of living. This is clearly shown, for
example, in Turner's watercolour *Leeds* (1816) (fig. 78), exam-
ined previously in this chapter. A watercolour by W. Humber, *The
Welwyn Viaduct* (1850) (fig. 84), which was used as the design for
a lithographic print, admirably presents these distinctive ways of
living. A monumental train bridge is shown striking across a beau-
tiful valley. Though the viaduct is set back in the landscape, its
form is intrusive – and made even more so by the train crossing it.
Below and in front of this viaduct stretch cultivated fields in which
farm labourers are haying. Their movements, when compared
with the motion of the steam train, seem slower and more lei-
surely; the harvesters' movements are in tune with the natural cy-
cles of their pastoral existence, while the fast, linear, mechanical
motion of the train is not. This design, which establishes the
profound differences between nature and technology, also cele-
brates that technology: it commemorates the unique beauty of
this impressive viaduct and the engineering brilliance that led to
its creation. On one level, Turner's *Rain, Steam, and Speed* presents
a similar kind of commemoration of progress; it is a tribute to
modern steam power and much-vaunted British technological in-
genuity. Turner may be specifically celebrating the contemporary
technological achievement of the Brunels, who had developed
the famous broad-gauge rail of the Great Western Railway. It ran
over their monumental bridge at Maidenhead – the bridge repre-
sented here[40] – on which, in 1840, Daniel Gooch's famed "Fire-

fly" achieved a new speed record of fifty miles an hour from Twyford to Paddington. However, the commemoration could relate to a more recent event. In the year in which Turner exhibited this painting, the Bristol and Exeter Company opened its line to Exeter, which gave the Great Western a main line of almost 194 miles – longer than that of any other rail company in Britain.[41]

That Turner chose a steam train as the subject of his picture not only reflects his interest in the contemporary scene – notably his interest in the so-called "Railway Mania"[42] – but also manifests the operation of a highly original artistic mind familiar with and interested in this new technology.[43] The richness of meaning with which this picture seems to be endowed surely reflects its special status. For Turner the importance of his subject, like others that he chose from contemporary history, lay in the challenge that it

presented him. Though steam trains may have become a familiar subject in popular prints, they had never been considered the subject of high art. One way in which Turner seems to have elevated his subject was to give his picture a complex metaphoric meaning; another, related way was to invest the subject with qualities of the sublime.

Not surprisingly, the locomotive's bulk, its smoke, nauseous odours, and deafening noises were qualities that had already been linked with the sublimity of active industrial sites. There were others. The locomotive possessed a malevolent, even satanic, appearance, an attribute that had especial currency in the early phases of the age of the locomotive.[44] For example, Thomas Carlyle, in recounting his railroad journey of 1839, observed that "To whirl thro' the confused darkness on those steam wings, was one of the

84 W. Humber, *The Welwyn Viaduct*. Watercolour, 1850. Ironbridge Gorge Museum Trust: Elton Collection

strangest things I have experienced. Hissing and dashing on ... snorting, roaring we flew; – the likest thing to a Faust's flight on the Devil's mantle."[45] Charles Dickens' account of Mr Dombey's train trip in *Dombey and Son* (1846–48) also alludes to the train's sinister nature.[46] This aspect of the train is openly conveyed in a full-page wood engraving of a locomotive in *Punch* entitled "The Railway Juggernaut of 1845," which shows a devil lurking behind the locomotive's tall funnel.[47] The dark locomotive in *Rain, Steam, and Speed* shares similar malevolent qualities.

Turner's locomotive possesses another defining quality of the sublime: obscurity. It is created by effects of light and shade and by broad, expressive brushwork, particularly around the engine. The style is suggestive of Rembrandt.[48] This unclear train image shows that Turner had grappled with the effect that a moving object has on the eye. The modified appearance of an object when moving was given validation by the new technology of photography which, in his later years, attracted him. The long exposure required to make a photograph resulted in a preserved image in which any moving object within the camera's optical ambience was captured as a blur, and yet, remained as an indisputable record of an event. Turner's blurred image of the speeding train surely demonstrates that he understood this image as representing qualities, states or conditions of the train's form rather than the form of the train itself. The title that Turner gave to his picture: *Rain, Steam, and Speed* attests to that.[49]

The sublime in *Rain, Steam, and Speed* is also generated by the immediacy of the train image, as obscure as it is. Like many other late pictures by Turner, this one embodies energy as an expression of power, a quality of the sublime. Turner avoids the layout of traditional "grounds" and provides a higher than normal viewpoint, showing the bridge as a diagonal that thrusts forward from the centre to the bottom right corner of the composition. The viewer is not a passive observer but a participant in the scene, forced to relate himself or herself to the viaduct and the powerful speeding train. Turner has thus established a positive link between the viewer and the scene viewed, which, in some respects, is similar to that linkage of subject and object established in the alpine landscapes that resulted from his continental visit of 1802.

In Burke's theory of the sublime, the efficacy of the sublime sensation is intensified by the proximity of the threatening object to the viewer. By giving his train a diagonal, forward thrust Turner has imbued it with a powerful, pugnacious assertiveness, an intrusive immediacy that transcends the constraints of the pictorial format. In so doing, he has reduced the distance between the pictorial expression of a speeding train and the physical experience of it and has thereby increased substantially its threatening nature. That Turner intended this particular sublime response seems to be borne out by the reaction of at least two contemporary critics, that of the *Morning Chronicle* (8 May) and that of *Fraser's Magazine* (June). The reviewer for *Fraser's* felt compelled to declare, "there comes a train down upon you, really moving at the rate of fifty miles an hour."[50]

Rain, Steam, and Speed shares several significant qualities with *The Fighting Temeraire*. Exhibited in 1839, the *Fighting Temeraire* was painted before *Rain, Steam, and Speed*, though it is equally powerful in its visual impact and meaning. Turner's special interest in the *Temeraire* was its potent association with Nelson and the Battle of Trafalgar, which he had commemorated several times before.[51] He attached poetic lines to the picture adapted from Thomas Campbell's "Ye Mariners of England": "The flag which braved the battle and the breeze, / No longer owns her." The *Temeraire*, a ninety-eight-gun ship, played, as we have seen, an important role in that battle. The victory was of enormous importance, possibly symbolizing for Turner the ending of Napoleon's threat from the sea, since it rendered unlikely a French invasion of England. However, this battle may also have been interpreted by him as a victory of British freedom over French tyranny. Ruskin, in reflecting on *The Fighting Temeraire*, observed that the ship was "crowned in the Trafalgar hour of trial with chief victory – prevailing over the fatal vessel [the *Redoubtable*] that had given Nelson death – surely, if ever anything without a soul deserved honour or affection, we owed them here."[52]

Ruskin's remarks capture something of Turner's intentions, since this picture cannot be considered simply a record of the final hours of an heroic old ship-of-the-line. It is meant to convey much more. We already have evidence of the way in which Turner pictorially embellished an event in order to imbue it with greater

85. J.M.W. Turner, detail from *The Fighting Temeraire Tugged to Her Last Berth to Be Broken Up*, *1838*

significance. This is evident in the vignette of Bemerside for Scott's *Poetical Works* completed early in 1832, seven years before Turner exhibited *The Fighting Temeraire* (see above, chap. 7). Turner was remarkably accurate in reconstructing his brief visit to Bemerside, which can be firmly established by the contents of Cadell's diary. However, he used his imagination in certain parts of the design to move his imagery beyond mere *reportage*. This he has also done in *The Fighting Temeraire*. This picture, likely based on newspaper accounts rather than on his experience of the event,[53] introduces elements that he invented. For example, as has been established, the *Temeraire*, on this its final journey, did not display temporary masts as has been usually stated.[54]

It has been pointed out that the *Temeraire* had been "sold out of the Navy"[55] so that "The flag which braved the battle and the breeze, / No longer owns her." In Turner's painting, the artist has provided a pictorial metaphor for this: the *Temeraire's* jack staff is missing from the top of the bowsprit cap, from which the union flag would formerly have been flown (fig. 85).[56] This is significant. However, Turner's interpretation of Campbell's lines attached to this picture furnishes a further meaning, one that requires an understanding of the way in which Turner thought. For instance, one will recall Landseer's perceptive remarks concerning Turner's *Pope's Villa at Twickenham* (exh. 1808; see chap. 5, above): "On the banks of a tranquil stream, the mansion of a

The steam tug in *The Fighting Temeraire*, like the locomotive in *Rain, Steam, and Speed*, moves diagonally forward through the present into the future. The stoic *Temeraire* is the embodiment of past British pride and symbol of Britain's former greatness, her proud naval history, though like the plough in *Rain, Steam, and Speed* it seems also to symbolize the older technologies that were now obsolete.

The new era that steam introduced was not universally welcomed. Turner and his generation were well aware of the economic dislocations and physical and social transformations that it had caused. The dark locomotive of *Rain, Steam, and Speed* and the tug of *The Fighting Temeraire* may, in these particularly poetical contexts, symbolize the terrifying nature of this recent technology, but the latter picture seems to reflect a further, still more negative response to it: the belief that its benefits are transient, that this technology may contain the seeds of the nation's destruction. This meaning is suggested when the picture is considered in relation to what I consider the likely implications of the watercolour *Dudley, Worcestershire* (c. 1832), and the meanings of a significant pair of pictures, also of the 1830s: *Keelmen Heaving in Coals by Night* (RA 1835) and *Venice* (RA 1834).

As mentioned in chapter 3, when Turner painted *Keelmen* (fig. 17) as a companion for his *Venice* (fig. 18) for the wealthy Manchester industrialist Henry McConnel,[58] Tyneside provided the artist with a contrast with Venice's lost commercial power and poverty,[59] which was made the more dramatic and cogent by the discovery during the late 1820s and early 1830s of enormous coal reserves in south Durham. *Keelmen*, with its nocturnal activity, recalls Joseph Wright of Derby's *Arkwright's Cotton Mills, by Night* (fig. 76) and Turner's own *Dudley, Worcestershire* (fig. 79) insofar as it suggests that the old working rhythms established by nature that had previously shaped and structured the lives of a pastoral society now no longer apply. That Turner should have chosen to depict Tyneside and to adopt a composition and colour scheme similar to what he had employed much earlier (1823) in the watercolour *Shields, on the River Tyne* (fig. 86), prepared for the *Rivers of England*,[60] implies not that he had little pictorially new to say but that the subject, because of these recent major discoveries of coal, had assumed a fresh significance.

favourite poet which has fallen into decay, is under the final stroke which shall obliterate it for ever." Perhaps implicit in this sensitive commentary is the recognition of the fatalistic processes that are often at the heart of Turner's approach to history. Surely this belief has reverberations in Turner's depiction of the decay and obliteration of Pope's villa, and also in *The Fighting Temeraire*. However, there is a more important implication common to these two pictures. In depicting the demolition of Pope's villa, Turner was expressing his solemn concern and regret that a significant landmark of this celebrated poet was being destroyed. A sentiment similar to that is echoed in his representation of the heroic *Temeraire*, identified with Nelson and Trafalgar, which is about to be obliterated. In this work he alludes to what he felt about the neglect, the ungratefulness, the "benefits forgot" of greatness.[57]

But in this poetical picture there are surely other levels of significance. Like *Rain, Steam, and Speed*, *The Fighting Temeraire* seems to involve a muted dialectic between natural and mechanical power. In the former picture this is alluded to, as previously noted, in the race between the hare and the locomotive. In *The Fighting Temeraire* the contest is between wind and steam; between the motive power of the old *Temeraire* and that of the tug. In this picture, however, the contest is over: steam power's victory is celebrated by the triumphant, puffing tug towing the helpless but proud ancient sailing ship to its last berth and destruction. On viewing Turner's picture at the Royal Academy exhibition of 1839, the critic of the *Athenaeum* for 11 May perceived its poetical attributes. He opined that the artist had imbued his picture with a "sort of sacrificial solemnity [that] is given to the scene, by the blood-red light cast upon the waters by the round descending sun, and by the paler gleam from the faint rising crescent moon, which silvers the majestic hull, and the towing masts, and the taper spars of the doomed vessel, gliding in the wake of the steamboat – which latter … almost gives to the picture the expression of such malignant alacrity as might befit an executioner." The painting's lurid sunset could, like sunsets in some of his slightly earlier works, indicate how much coal smoke of the revolution had already polluted England's skies, but in Turner's solar cycle it was also symbolic of the end; it was the end not only of the *Temeraire* but also of an era.

86 *Shields, on the River Tyne.* Watercolour, 1823. 15.4 × 21.6 cm. London, Clore Gallery for the Turner Collection (w 732)

By contrasting Tyneside with Venice, Turner may have intended to impart a further idea. As has been observed, what often aroused his interest and shaped the themes and treatment of many of his historical pictures were the contrasts provided by the rise and fall of empires. In his exhibited pictures relating specifically to Venice, Carthage, Athens, and Rome, Turner embodied his belief that different civilizations undergo changes that bring about their eventual tragic collapse. There is no indication that England was to be an exception. Venice had already fallen: it had lost its wealth and freedom, and so as the pendant of his picture of Tyneside, it might provide Britons not so much with a cautionary lesson as with a foretaste of things to come: contemporary Britain now prosperous and free could, regretably, follow the same or a similar pattern of decline.[61]

It has been suggested elsewhere that *The Fighting Temeraire* is an expression of Britain's decay as the foremost maritime power and that it provides in this respect an interesting, informed parallel with Turner's *Decline of the Carthaginian Empire*.[62] If this meaning can be applied to *Decline* and *The Fighting Temeraire*, both elegiac pictures, then the latter can also be seen as a dark reminder of the incipient decay of Britain implicit in the attitudes of its society. As Turner aged (he was in his sixties when he painted *The Fighting Temeraire*), he probably discovered that he possessed little in common with the restless younger generations around him. They belonged to a new society that had emerged. According to a rural magistrate writing in 1808, "The instant we get near the borders of the manufacturing parts of Lancashire we meet a fresh race of beings, both in point of manners, employ-

ments and subordination."[63] Brash, deliberately and unashamedly self-seeking, this new society was, above all else, disdainful of anything not of its own creation and severe, if not unequivocal, in its condemnation of the culture and technology of the past. It appears probable that the attitudes of different generations are covertly contrasted in this painting. By representing the squat, black form of the steam tug towing the noble and heroic, but grizzled and ghostly, old *Temeraire* to her destruction, Turner seems to have been hoping to raise public consciousness by allegorizing this event, transforming it into an image of national significance. The wraith-like *Temeraire* is representative of those spiritual and heroic values of the British past that Turner cherished and had pictorially enshrined[64] but that an indifferent nation readily discards: the "benefits forgot" of greatness. Whatever the future was to hold for Britain, Turner realized that the present can have no meaning if it forgets the accomplishments of the past.

9 The "Terrible Muses": Astronomy and Geology

9

Science in the immeasurable Abyss of thought,
Measured her orbit slumbering.

Ms, Fallacies of Hope[1]

T URNER'S ENGAGEMENT WITH IDEAS of the new technologies was paralleled by his curiosity about science – that structured body of knowledge of the organic and inorganic aspects of the world. Technology was very much part of Turner's view of the contemporary scene, and, not unexpectedly, so was science. Science, in explaining the world as it is, had also, in the not too distant past, begun to shed light on the character of the planet earth and its development. By the eighteenth century scientists had come to the conclusion that the world was not static but dynamic; this led to the historicization of nature.

Nature and science went hand in hand. The physical world that provided Turner with the subjects for his art was also the world of science: the landscape, he demonstrated, was susceptible of new meaning. Despite Finberg's confident repudiation,[2] Turner's interest in contemporary science and its effect on his perception is not open to doubt, nor can it be questioned whether it found expression in his art. But the character of that expression merits exploration.

Science was of interest to Turner not for its own sake but for the sake of his art. The sciences contributed the means of know- ing and understanding the universe and revealing something of its dynamism, the connectedness of its parts, its inner, hidden harmony. For Turner the romantic painter a particular aim was to locate these connections. His adept, unusual methods of drawing together and unifying the disparate aspects of his pictures' content without overlooking the significance of their separate aspects was a notable characteristic of his art. This suggests a close correspondence with the *Vorstellungsarten* characteristic of the scientific writing of Goethe.[3]

Turner's interest in science developed from a deep, abiding love of nature. Thornbury provided an insight into this when he recorded that "among … [his] papers were found the leaves of flowers and careful notes of their times of opening."[4] His exquisite drawings of birds (c. 1815–20) painted for his patron and by then close friend, Walter Fawkes of Farnley Hall, were the subject of a fairly recent exhibition.[5] These bodycolour/watercolour drawings reveal not only his developed technical skill but also his acuity of observation, which resulted in neither tightness nor stiffness. Indeed, these birds, whether partial or complete images, whether represented dead or alive, seem to resonate with life or with the suppleness and lingering warmth of recent death. However, his close and loving observation and recording of nature must have led him to crave a deeper understanding of what he examined and pictorially documented, and this required some knowledge of science, knowledge that was generally accessible and that personal contacts within the scientific community could clarify and supplement.

Scientific books and articles published at that time and intended for an interested educated public had wide repercussions, influencing in varying degrees what was written, read, drawn, and painted. Mary Somerville, the celebrated mathematician and science writer, was responsible, for example, for the successful adaptation into English of Laplace's monumental *Traité de la mécanique céleste* (1799–1825), which appeared in 1831 as *Mechanisms of the Heavens*. Influenced, as many writers were, by the associationist language of the picturesque, John Macculloch, the geologist, wrote easily comprehended papers and books on the rocks of Scotland, notably, *The Highlands and Western Isles of Scotland* (1824), which was in the form of letters to his friend Sir Walter

Scott. Romantic poetry and art were also effective vehicles for popular scientific ideas, since science had provided insights into the workings of nature and the relationships of humanity to God and His creation. These were concerns of poets such as Coleridge. His *Rime of the Ancient Mariner* (1798) shows a deep interest in meteorology. Lord Byron's lyrical drama *Heaven and Earth* (1823) has notable astronomical allusions and specific discussions of diluvial geology. Shelley also employed scientific imagery, as did other poets, including Wordsworth and Tennyson. Even the lesser poets, like Samuel Rogers, found ample inspiration in science.

The community of painters was equally attracted. Perhaps one of the better known is John Martin, whose spectacular landscapes of the Noachian Deluge exhibit the earth's geological beginnings.[6] He was also employed to illustrate books on prehistoric reptiles. Turner's close friends and colleagues were also interested, including the watercolourist "Greek" Williams[7] and the sculptor Francis Chantrey, who had considerable knowledge of the natural sciences and had collected minerals and fossils.[8] In addition, John Constable had an interest in science.[9]

Popular publications of the time also reflect the currency of scientific ideas within the cultural community. For example, of general interest was the Vulcanist/Neptunist controversy. It had attracted public attention because of the stridency of the debate, which centred on whether heat or water was the prime ingredient in the formation of the earth's crust. In the *Literary Gazette* (14 May 1831) can be found a witty acknowledgement of popular interest in the debate contained in a review of the Royal Academy exhibition in London in that year. The reviewer took special note of Turner's painting *Caligula's Palace and Bridge* and of Constable's *Salisbury Cathedral from the Meadows*, remarking that the first is like "fire," the second like "water": "If Mr Turner and Mr Constable were professors of geology, instead of painting, the first would certainly be a Plutonist, the second a Neptunist."

Turner's love of nature and his intellectual inquisitiveness were, I believe, stimulated by artistic preoccupations rather than by an interest in science for its own sake or for the sake of fashion. He always considered science to be a handmaiden of art and never its mistress. This was suggested by Thornbury who com-

mented that "his thirst for scientific knowledge was remarkable chiefly for its leaning towards Art."[10] Certainly, this is true of his interest in light. The emotional pull of optics and theories of colour and light – and later, of photography – was because of their potential value for his art. Light, as observed previously, stirred, absorbed, and indeed, one might say, obsessed him, helping to give his landscapes the presence and power that distinguish them and that for subsequent generations altered the way nature was perceived.

There were other equally interesting scientific subjects to which Turner was responsive and that provided fresh perspectives for his art, in particular for his historical landscapes and illustrations. Among these subjects were astronomy, the most ancient of the physical sciences, and geology, one of the youngest. Though his interest in the sciences may have fluctuated over time according to the pictorial subject he was preparing, he was never indifferent to them.

Broadly speaking, Turner's interest in the sciences seemed to stem not only from his love of nature but from deep philosophical needs – a need to understand the universe and the individual's place in it and a need to consider its dynamism, harmony, and unity. These important interests were often placed in the service of his art. However, to determine the role or roles of science in Turner's paintings and watercolours is a challenge. When considering the impact of science on his art, one must exercise caution, since the relationship between them is complex and variable. Although some manuscript evidence exists for his engagement with light and colour,[11] there is relatively little documentation for his other scientific interests. The most valuable reflector of them is certainly his art. In consequence, one must examine his pictures carefully and pose appropriate questions. One must try to assess to what degree science engaged him and to what extent he was able to master its fundamentals; why science was enlisted by him and in what capacity it entered into his art. One must consider how scientific ideas acted upon themes and forms and then attempt to determine whether the role was either central or marginal.

It is mostly marginal, for example, in his literary illustrations and historical landscapes. In these works assessment is difficult,

87 *Galileo's Villa*. Watercolour, c. 1827. Vignette for Rogers' *Italy*, 1830. 11.5 × 14 cm. London, Clore Gallery for the Turner Collection (TB CCLXXX, 163)

since science is treated largely in a symbolic or metaphoric way as part of his pictures' overall thematic structure. Still, the presence of science in his landscapes and literary illustrations is significant and worthy of extended discussion, not only because science and its advances were part of his own experience but also because he believed that it revealed aspects of nature that could augment the content of his art.

Astronomy impinges on Turner's art in a minor yet significant way. As I have suggested elsewhere, in some of his illustrations for the biography of Sir Walter Scott, astral imagery is a potent element.[12] This is also true of several of his important historical canvasses. However, this imagery has little to do with astronomy. The suggestion has been made that his interest in astronomy was stimulated by his contact with Mary Somerville. It has been proposed that a diagram of the Copernican system in a rejected version of *Galileo's Villa* (which Turner prepared for the 1830 edition of Samuel Rogers' poem *Italy*)[13] and a depiction of the Copernican system in a design for Milton's *Poetical Works* (1835) entitled the *Mustering of the Warrior Angels*[14] were probably the "result of conversations with Mrs Somerville whose treatise on astronomy, *Mechanisms of the Heavens* (1831) he [Turner] acquired."[15] Though Somerville was *not* the author of the treatise that she published – her book was, as mentioned, a successful rendition in English of Laplace's monumental *Traité de la mécanique céleste*[16] – she was knowledgeable in science, and certainly Turner could have been stimulated by and could have learned from her. However, there is, in fact, little that would suggest that his art with astronomical content reflects a significantly scientific point of view – which makes this particular influence doubtful.

Turner was certainly aware of the Copernican system; knowledge of it was commonplace. The growing belief in the seventeenth century that the earth was not the centre of the universe and not part of a closed system had meant liberation from the old Ptolemaic system, a philosophical and scientific paradigm that had formed human perception of the universe since classical times. According to investigations by the sixteenth-century scientist Nicolaus Copernicus, the earth rotates on its axis and, with all the other planets, revolves around the sun. This changed perception was to have profound philosophical and religious consequences. Galileo's mathematical calculations and his careful

88 *Mustering of the Warrior Angels.* Vignette for Milton's *Poetic Works* (Macrone 1835). Engraving on steel by Robert Brandard (1835). Image size: 10.4 × 9.1 cm. New Haven, Yale Center for British Art, Paul Mellon Collection (R 598)

scrutiny of the heavens through his telescope (he perfected it in 1609–10 and was responsible for making the first astronomical use of it) seemed to have confirmed the validity of the heliocentric doctrine that Copernicus had espoused; it also revealed a vastly expanded universe.

The changed perspective introduced by the Copernican system stimulated growth of a more general interest in the stars. In Britain, well before the time Turner was preparing his illustrations for Rogers' and Milton's poetry (in the 1820s and 1830s), public lectures on astronomy were commonplace; popular astronomical books were being printed and fashionable periodicals were publishing articles and regular columns describing astronomical events. Turner's fascination with astronomical ideas is reflected, as noted, in the distilled, compressed images of the small vignettes that he prepared for publication. For example, his published version of *Galileo's Villa* (fig. 87), which Turner prepared, as mentioned, for Rogers' *Italy* (1830), is concerned with Galileo's investigation of the heavens. In Rogers' verses (which echo lines from *Paradise Lost*) the poet mentions the scientist's villa and its lawn, "where many a cypress threw / Its length of shadow, where he [Galileo] watched the stars." Although Galileo himself seems to be absent from the design, Turner depicts his villa with dark cypresses casting their shadows on the moonlit lawn. Further, Turner shows a crescent moon and Galileo's telescope, both of which were inspired by Rogers' lines: "And let us from the top of Fiesole, / Whence Galileo's glass by night observed / The phases of the moon." There is one ingredient of the design to which Rogers' verses do not refer and that convincingly demonstrates Turner's familiarity with traditional astronomical apparatus: the prominently displayed celestial globe situated next to the telescope indicates that Galileo was not merely viewing the stars but observing their relative positions.

Astronomy itself, however, is neither the subject of this vignette nor of *Mustering of the Warrior Angels*, which, as mentioned, Turner later prepared for Milton's *Poetical Works* (1835), specifically, to illustrate the first book of *Paradise Lost*. The scientific content of *Mustering of the Warrior Angels* (fig. 88) has been consciously diminished in order to provide a poetical image. In it, the brilliant effulgence of the sun, round which the planets travel,

89 *Raphael, The Universe.* Fresco, c. 1510. Rome, Stanza della Segnatura, Vatican

symbolizes the Godhead that serves as a background for the battalions of angels assembled on the design's expansive celestial stage. Though minute in size, this work is remarkably impressive in conception and scale, providing the design with spatial effects and an epic allegorical grandeur reminiscent of historical paintings of the baroque. This baroque quality is characteristic of a number of Turner's literary vignettes of the 1830s and also of his visionary paintings of the 1840s.

Still, the contents of *Mustering of the Warrior Angels* seem to have been inspired specifically, not by a baroque model, but by a design by the Italian renaissance painter Raphael, whose *The Universe* (c. 1510) (fig. 89) Turner had had the opportunity to study in Rome's Stanza della Segnatura in the Vatican. In Raphael's design, Urania, the muse of astronomy, presides over a transparent celestial globe, an imaginary sphere representing the pre-Copernican universe, with the earth at its centre and stars on its surface.

If Turner was influenced by this design when preparing his illustration, then he failed to perceive (or chose to overlook) the transparency of its globe and made it a representation of the earth. Similarly, Raphael's small earth suspended within this transparent sphere seems to have become, in Turner's design, a moon encircling the earth. Further, in Turner's illustration, the arc of small, brilliant stars that seems to extend to the earth, to the left of the crescent moon of a mysterious dark planet, recalls the stars on the surface of Raphael's sphere. Though It is possible that the relationship between Raphael's design and Turner's is coincidental, I believe this unlikely. Whatever the case, his depiction of the string of tiny stars barely above the earth must surely militate against any suggestion that his interpretation was intended to be scientific, and reinforces the belief that his inspiration was primarily artistic.

Though the heavens were of interest to him, Turner found the science of geology more absorbing. He had probably discussed it with friends such as Chantrey, the sculptor, who was knowledgeable on the subject. Perhaps this interest was stronger because rocks were tangible, more familiar, more intimately a part of his life as a traveller and landscape artist. He would also have been aware of their potential economic value in terms of their carbon and mineral content.

The remote beginnings of rocks and their particular characteristics must have also stirred Turner's interest and vigorously challenged his imagination, since his curiosity and sense of time were intense and deeply felt. For him and his contemporaries, rocks created a temporal awareness comparable with the expanded spatial sensibility that the Copernican revolution had stimulated.

The science of geology, the study of the earth's past through its structure and composition and the agencies and processes that shape it, was of interest in Britain from the seventeenth century. At that time it was believed that the character of the earth was determined by the action of water in cycles of erosion and deposition. However, these processes were observed to be slow in operating. Indeed, they were considered too slow to have any significance for the earth's history in the context of biblical chronologies that had determined the earth to be only six thousand years old. In consequence, some concluded that these cycles were not significant; others formulated theories in which the cycles involved periodic flooding of catastrophic proportions, in order to hasten earthly change and thereby allow the cycles to be accommodated within the brief biblically allotted time.[17]

Theories of geology abounded. During the late eighteenth and early nineteenth centuries, they gave rise to factional debates involving scientists who were labelled "vulcanists" and "neptunists," "uniformitarians" and "catastrophists," terms that suggest a degree of polarity and consistency of opinion that really did not exist. One British geologist whose theory was significant in these debates was the Scottish scientist, James Hutton (1726–97). He arrived independently at various conclusions about the nature of the earth that had been previously established by others. His theory, published as the *Theory of the Earth* (1795), contained much that was original, but in its presentation it was complex, turgid, and vague. However, it became better known in consequence of the publication after his death of *Illustrations of the Huttonian Theory of the Earth* (1802), by his friend John Playfair. It was a clarified but reinterpreted – indeed, distorted – version of Hutton's ideas.[18]

Change in the earth was gradual, Hutton believed, occurring over a vast, indeed infinite, expanse of time. He revived the notion of unceasing cycles of nature involving erosion and deposition and independently determined that in strata the lowest rocks are the oldest and the uppermost the youngest, unless somehow deranged or inverted. He rejected biblical chronologies because of their time limitations, yet was convinced, nonetheless, that changes in the earth followed a divine plan. Although his theory did not include a discussion of cataclysms, they were, he believed, a significant dynamic in the history of the earth. He also asserted that modifications in the earth's surface that took place in the geologic past are consistent with those occurring in the present.[19]

Hutton was also deeply interested in the dynamic role of the earth's internal heat. He perceived more clearly than his contemporaries its essential role in the formation, reformation, cementing, buckling, and uplifting of strata and the specific function of volcanoes as safety valves.[20] Though he was not the creator of the notion of an igneous geology, it was his interest in the earth's interior heat and its surface manifestations that began the controversy (c. 1800–20) between the followers of Hutton (the vulcanists) and those of Abraham Gottlob Werner (1749–1817) of Freiberg (the neptunists). Werner rejected the geological significance of the earth's internal heat, which Hutton espoused. He believed that originally an ocean, from which rocks were precipitated in layers, had covered the entire earth.[21] Werner, a mineralogist, believed that these layers of strata, were chemically bonded together.[22] From the British perspective a universal ocean had the merit, for a while, of being consistent with the biblical flood. However, in consequence of the increased importance of empirical evidence – of fieldwork and the collection, examination, and classification of gathered geological samples – the significance of the biblical flood diminished and eventually was abandoned as an explanation for the particular character and condition of rocks. Between about 1810 and 1830 vulcanism gradually triumphed over neptunism, though this was not due to Hutton's theory but rather was the consequence of independent discoveries made by scientists in continental Europe.[23]

The renowned Scottish-born geologist Sir Charles Lyell (1797–1875), who agreed with a number of Hutton's ideas, published his *Principles of Geology*, in three volumes, between 1830 and 1833. In it he distorted and denigrated Werner's contribu-

tion because he was opposed to neptunism. He was also responsible for spreading the myth that the celebrated debate between the vulcanists and the neptunists had been international in scope.[24] Lyell believed, as did Hutton, that the earth's present geological processes could illuminate its geological activities in the past, that geological change due to erosion and deposition occurred slowly, with regularity and uniform intensity over extended periods of time;[25] "for him the earth was steady, stable and self-perpetuating."[26] However, Lyell was nonetheless critical of Hutton's theory. For example, he rejected Hutton's reliance on the notion that the globe's internal heat was central to the formation and modification of the earth's crust. He also deplored the fact that Hutton did not discuss the development of life, which Lyell considered important for many aspects of the globe's geological chronology.[27]

Lyell's theory, when published, generated scientific opposition and led to what became known as the uniformitarian-catastrophist debate. By the 1830s most geologists had rejected the concept of a steady-state world, believing that the earth revealed evidence of progressive change, such as gradual cooling; on this Lyell avoided discussion. More important, these scientists were convinced that the earth had experienced periods of major catastrophes, such as deluges. However, few by this time, particularly those living outside Britain, identified the last of them with the biblical flood.[28]

One of the most celebrated continental scientists who developed a theory of catastrophism was the French Baron Georges Cuvier (1769–1832). In his *Discours sur les révolutions de la surface du globe* (1825) he postulated a series of cataclysmic floods that resulted in widespread, successive extinctions of life forms. During the late 1820s and the 1830s scientists expressed increasing interest in the development of life as reflected in the fossil record. Lyell himself was convinced of its importance and indeed, as mentioned above had criticized Hutton for not considering it. However, this interest also created controversy. Although some believed that life must have developed gradually, others were persuaded that there were progressive "jumps" in life caused by major catastrophes; that is to say, because of these catastrophes life forms perished, but new life came into being during the interven-

ing quiescent periods. Cuvier, for example, provided persuasive evidence for extinction when he discovered the fossil remains of large creatures in the Paris basin that had no equivalent in the present world.

These lively debates and controversies concerning the formation and development of the earth and its life had some effect on Turner and his art. It should be noted that in the early period of his career Turner made sketches that reveal a scrutiny of rocky terrain having something in common with the careful field investigations of geologists. Many of his more accurate sketches of rocks are from the late 1790s; others are datable to 1801, when he visited Scotland. However, the most powerful and acute are the paintings, watercolours, and drawings that resulted from his visit to Switzerland in 1802. It was certainly his alpine journey that crystallized this particular interest. What is especially notable about Turner's alpine views is not only their fresh verisimilitude and bold conception but their striking immediacy of effect. In these landscapes, space clearly defined by planes of rock serves as an emotional link between the viewer and the mountains viewed. The watercolours, drawings, and paintings resulting from this first visit helped to provide the foundation for his later representations of rocks and mountainous terrain: watercolours that were sometimes prepared for publication and oil paintings, more ambitious in scale and imaginative in conception, that were destined for exhibition.

By this time, stratigraphy was of considerable interest to geologists. Based on the law of superimposition, stratigraphy established that the most recent deposition is on the top, the most ancient at the bottom. This realization provided geology with a potent historical dimension. It was believed that the relationships and configurations of strata reflected changes that occurred to the earth's crust in primordial times and that the specific nature of fossil remains (the petrified remnants of once living creatures, many of which had become extinct) contained in strata could reveal the nature and sequence of these changes.[29]

Turner expressed an interest in the nature of strata. Apparently in advance of a two-month visit in the summer of 1811 to the south coast of England, he was determined to learn as much as possible about the geography of the region. He had been com-

luted or "serpentine" strata of "shelly limestone" with "seams of chert or rock-flint" give these rocks their "singular wild appearance." Turner's *Lulworth Cove* focuses on its unusual, wavy rock stratification (caused by the earth's internal heat and pressure), which is made a significant element within the design. The interest of this text to readers, as Turner's illustration amply demonstrates, was factual and geological, albeit considered in the context of the picturesque.[33]

In the late eighteenth century, it was the aesthetic system of the picturesque that embraced the dual concepts of Burke's sublime and beautiful and forged an essential link between geology and art, and that, well into the nineteenth century, influenced aesthetic and pictorial responses to geological formations. A picturesque point of view, for example, lies behind illustrations of rocky terrain that Turner prepared for Sir Walter Scott's *Poetical Works* (1833–34).

Scott, who was an enthusiastic advocate of the picturesque, had asked Turner to visit him in Scotland, near Melrose, in 1831, and to make a journey north and west from there to the Highlands and Hebrides to collect sketches of locations described or alluded to in the *Poetical Works*. One of the locations most difficult to reach was Fingal's Cave in the southwestern coast of the barren, windswept Isle of Staffa in the Inner Hebrides; another site equally difficult to reach (also in the Inner Hebrides) was the mountain-girdled Loch Coruisk (called by Scott "Loch Coriskin") in the Isle of Skye. Views of both were to illustrate the volume of Scott's stirring metrical romance *Lord of the Isles*. Scott was initially not certain whether these subjects were suitable or whether, if chosen, Turner would have time to visit them or whether the weather would cooperate if he did. Turner was fortunate on all counts.

Caves or caverns had a special interest for travellers in search of the picturesque. They were admired for their unusual character but were equally appreciated for their history and their geology, which preserved information about the earth's past and especially its dynamic forces. The basaltic Fingal's Cave, on Staffa, was initially brought to the public's attention by Sir Joseph Banks, who visited it in 1772. It was named after the Highlanders' hero, Finn mac Cumhal, whose exploits were recorded in long narrative

missioned to prepare views for W.B. Cooke's *Picturesque Views of the Southern Coast of England* (1814–26) that pictorially would embrace the coastal landscape from the Thames to the Severn. This was Turner's first major commission as an illustrator for which he was engaged to prepare watercolours for engraving. Caught up in his enthusiasm for the project, he composed, on his own initiative, a long topographical poem with strong patriotic overtones and hoped that it would accompany the publication's plates. He was disappointed when the publisher rejected it. *The Southern Coast*, begun near the end of the Napoleonic wars, was the first of a series of major publications on British landscape illustrated by Turner that can be considered important expressions of nationalism.[30]

When Turner came to prepare his poem and watercolours for the book, he was aware that he required some knowledge of the geology of the area and that specific geological correctness was imperative in at least some of his designs. For this reason he transcribed, albeit hurriedly and carelessly, an account of the coastal region's geological character that specifically outlines the range of its chalk deposits and provides a brief indication of the mineral constituents of its strata.[31]

Perhaps one of the most noteworthy of his landscape designs depicting specific geological characteristics was *Lulworth Cove* (engraved in 1814) (fig. 90), which, when published, was accompanied by a descriptive text highlighting the unusual nature of the Cove's rocks, which had been determined by the earth's activity in the distant past. It is significant that by the late eighteenth century the new geology had been inducted into the picturesque – that connoisseurship in scenery that had had a significant effect on the way landscape was viewed.[32] Tourists were familiar with the picturesque character of this part of Dorsetshire, especially the Cove and its adjacent village of West Lulworth, sequestered as it is in a deep chalk valley. It had been, according to the text accompanying Turner's illustration, "a frequent resort of water-parties from Weymouth, during the summer," before "its attractions were heightened by the discovery that the geology of the country is in the highest degree interesting." The "high rocky projections, forming the flanking piers to the [Cove's] narrow entrance ... are marked most curiously by greyish limestone crags" whose convo-

90 *Lulworth Cove, Dorsetshire.* For W.B. Cooke's *Picturesque Views of the Southern Coast of England* (1814–26). Engraving on copper by W.B. Cooke, 1814. 14.3 × 21.6 cm. London, Clore Gallery for the Turner Collection (R 92)

91 James Ward, *Gordale Scar.* Oil, 1811–13. London, Tate Gallery. See note 31, chap. 9, for a discussion of this picture.

poems and stories that inspired the celebrated *Fingal* by James Macpherson.[34] The cavern, adjudged a locus of the sublime, became a favourite destination for tourists and later, during the 1810s and 1820s, was even considered suitable as a subject for stage scenery.[35]

Fingal's Cave was considered the most spectacular natural formation on this uninhabited island; it is over two-hundred feet deep and composed of mainly pentagonal basaltic crystals in columnar form.[36] These crystals (of igneous, or volcanic, origin) were considered most unusual, and it is not surprising that visitors often wrote about the cave's remarkable appearance, which afforded striking comparisons between natural and man-made

architecture. Tourists, with an allusion to natural theology, often emphasized the superiority of the former over the latter. The cave's high ceiling, noted Sir John Stoddart, had natural crystalline decoration reminiscent of the "rich ornaments of some grand Gothic buildings," which was well calculated "to form the eye and taste of a picturesque architect."[37] Scott, conditioned by the picturesque viewpoint, had visited the cave in 1810 and responded to its unusual geological character, as did Stoddart, noting that its interior was similar to that of a "cathedral."[38] On his second visit four years later, Scott elaborated on that first impression, observing, for example, the colour effects of the interior and the dreadful noise of the surf as it rushed wildly into the cave.

92 *Fingal's Cave, Staffa.* Vignette for Sir Walter Scott, *Poetical Works* (1833–34), vol. 10. Engraved on steel by E. Goodall, 1834. 12 × 8 cm. London, Clore Gallery for the Turner Collection (R 512)

"Staffa," he exclaimed on this occasion, "may challenge sublimity as its principal characteristic."39

Though Turner sketched several aspects of the interior of the cave for his proposed illustration, ultimately he decided on a view that depicted the entrance from the interior (fig. 92), presenting its basalt-columned walls scoured by the constant and relentless force of the tide and showing too the choppy sea beyond that the cave opening frames. Such a view is typical of later eighteenth-century picturesque views and suggests the influence of Scott himself, since it reflects his particular picturesque interests.40 It also responds to Scott's poetic lines from the *Lord of the Isles* that captures the rhythm of the pounding surf echoing through the cave's crystal-encrusted chamber:

Nor of a theme less solemn tells
That mighty surge that ebbs and swells,
And still, between each awful pause,
From the high vault an answer draws,41

Although the vignette records the cave's particular geological character and therefore alludes to its connection with the early history of the earth, Turner's prime aim was to contribute a suitable pictorial accompaniment for the poetry.

The sublime poetic lines describing the cave that Turner illustrated in his vignette were also chosen by him to accompany a painting of Staffa, a grand view entitled *Staffa: Fingal's Cave* (fig. 93), which was exhibited at the Royal Academy in 1832. Although not a painting of history, *Staffa* embodies a strong personal reminiscence: it presents a potent mixture of pictorial probity and autobiographical evocation. In this painting Turner celebrates his visit there in 1831; he shows the *Maid of Morven* steamer, on which he was a passenger, braving the stormy seas off the island.42

It has been noted that the vignette of the cave records the special crystalline character of its interior. Turner, like Scott, would have considered the cave "picturesque" – a "curiosity" – possessing sublime qualities. While it was suitable as a subject for a picturesque illustration, he apparently did not consider it independently as an appropriate subject for painting, as his eighteenth-century

93 *Staffa, Fingal's Cave.* Oil, exh. 1832. 36 × 48 in. (91.5 × 122 cm). New Haven, Yale Center for British Art, Paul Mellon Collection (BJ 347)

94 *Loch Coriskin*. Watercolour, 1832. 8.9 × 14.3 cm. Edinburgh, National Gallery of Scotland (w 1088)

95 Photograph of Loch Coriskin (Coruisk), Skye

predecessors would have done. He defined landscape as a subject for painting in a different way; for this reason he chose to capture the bleak grandeur of the island itself. However, as the island's reputation as a place to visit had been largely established by this remarkable cave, it would have been difficult for him not to acknowledge its presence in his painting. He *has* acknowledged it, if only indirectly, by including reference to it in the title of his picture and in the above lines from the *Lord of the Isles* that accompanied it. Though David Wallace-Hadrill is probably correct that in representing the south side of the island, Turner appears to indicate the location of the cave as a gray area on the left of the cliff face,[43] it remains merely a suggestion. Turner had not wished to emphasize the cave's spectacular, well-publicized entrance, an archway supported by basaltic columns twenty to forty feet high, which, as one writer, observed, provides "the most striking scene on the whole island."[44]

Though the cave possessed "sublime" attributes, Turner considered this to be true of the island itself, hence the dramatic treatment of his painting of Staffa. In it he has distilled and amalgamated elements of the island's salient features with those of its surroundings. He has painted its majestic, basaltic cliffs (whose geological character is vaguely suggested) rising up behind a dark, dangerous, heaving sea with its pitching, smoky steamer set against a dramatic, stormy sky. Though this painting is autobiographical, it is foremost a tribute to Scott's poetry. Turner has transposed the natural cadence of the surging and ebbing tide in the cave (which Scott's poetic lines that accompany this picture capture) and, with remarkable discrimination and authority, has employed its rhythms to assist his design – to unite the ingredients of his grand vision of Staffa's cliffs, its sea and sky. "All is in unison in this fine picture" reported a reviewer of the Royal Academy exhibition in 1832; it is "a scene where solitude is enthroned in grandeur, and where the very elements seem to breathe a poetry that may be felt, if not heard."[45] The subjects chosen by Turner for the vignette and especially the painting are less significant for their geology (and therefore as historical evidence of the eruptions and formations of the young earth) than for their artistic, poetical effect.

While in the Hebrides, Turner travelled to Loch Coruisk, or Coriskin, in the Isle of Skye, which Scott, who had visited it in

1814, considered as a possible subject for illustration in the po-etry. It was there that Turner almost suffered a serious accident. He later recalled that in attempting to gain the best view of the loch he lost his footing on its rocky slopes (composed of a fine-grained igneous rock), which were smooth, wet, and often slip-pery, and had it not been "for one or two tufts of grass," he would have "broken his neck." Coriskin, like Fingal's Cave, was to illus-trate lines from the *Lord of the Isles*:

rarely human eye has known
A scene so stern as that dread lake,
With its dark ledge of barren stone.
Seems that primeval earthquake's sway
Hath rent a strange and shatter'd way
Through the rude bosom of the hill,
And that each naked precipice,
Sable ravine, and dark abyss,
Tells of the outrage still.[46]

It has been suggested that the design of *Loch Coriskin* (fig. 94), like that of the *Warrior Angels*, which Turner prepared for Milton's *Poems*, was influenced by scientific ideas. John Macculloch, the Scottish geologist, was acquainted with Loch Coriskin and wrote about it in his *Highlands and Western Isles of Scotland* (1824). It has been stated that "it is more than likely that Scott ... showed [Mac-culloch's book] to Turner when the painter was planning his visit to Western Scotland, on the poet's behalf in 1831" and that the "sublime scale and precision of geological description [of Maccul-loch's account] are also the characteristics of Turner's wonderful drawing."[47] However, an examination of the evidence does not support this conclusion, since it ignores the possibility of Scott having shown his own account of Coriskin to Turner. It was, after all, Scott's poetry that Turner had been commissioned to illus-trate. Indeed, so important did Scott consider his own description (taken from his journal) that he included it in the volume of the poetry that contains the engraving of Turner's *Loch Coriskin*. Turner would, no doubt, have been attracted by Scott's long de-scription, which concludes with the following exalted reverie that the scene had induced: "though I have seen many scenes of more

extensive desolation, I never witnessed any in which it pressed more deeply upon the eye and the heart than at Loch Corisken [sic]; at the same time that its grandeur elevated and redeemed it from the wild and dreary character of utter barrenness."[48]

Macculloch described the rocks of Coriskin as being formed of sheets that are "at very high angles [and] perfectly barren" ex-tending "from the base to the very summit of the ridge."[49] Deeply interested in the mineral aspects of rocks, Macculloch named them "Hypersthene," a "member of the trap family"[50] which, as noted, derived from an igneous source. It is, he correctly ob-served, "inimical to vegetation" and its "surface does not appear to undergo the slightest decomposition."[51]

Turner's watercolour, though reflecting the ability of the site to generate a particular mood, does not display the geological characteristics that Macculloch described. Macculloch indicated that the rocks are "dark," "dark brown," or "black"; those in Turner's watercolour are a light buff colour. Nor does Turner's watercolour suggest the nature of the rocks that Macculloch indi-cated. On the contrary, Turner's watercolour shows a tilted rock of sedimentary character showing stratification running mainly parallel with the ground. This agrees neither with Macculloch's description nor with the evidence of a photograph (fig. 95) of the location that is here illustrated. On the basis of this, one must conclude that Turner's watercolour is indebted to a poetic rather than a scientific interpretation and thus is deficient in the geolog-ical precision that has been attributed to it.

Now the question must be asked, why did Turner choose to represent a stratified rock when none occurs at this location? It might be argued that he was not especially interested in Coriskin's rocks. Here, however, two points may be urged in reply. First, there is ample evidence of Turner's early interest in geology. In the ravaged, Rosa-inspired landscape of Turner's *Ja-son* (fig. 96), shown at the Royal Academy in 1802, before his first visit to the Alps, he clearly depicts stratified rocks.[52] This particu-lar kind of rock seems to have interested him, because he refers to such rocks again in the patriotic poem of about 1811 that he planned for Cooke's *Southern Coast*, but which was never pub-lished. There he described the rocks as possessing "Horizontal strata, deep with fissure gored."[53] This was written about the

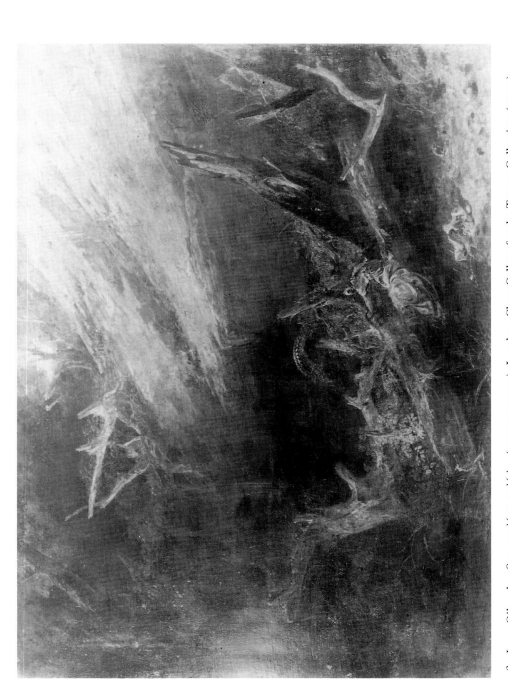

96 *Jason*. Oil, exh. 1802. 35 ½ × 47 ⅞ in. (90 × 119.5 cm). London, Clore Gallery for the Turner Collection (BJ 19)

same time that he recorded information on the geology of the south coast. During the next few years he probably acquired the first two volumes of the *Transactions of the Geological Society* (1811–14).

The second reason that militates against Turner not being interested in the specific nature of Coriskin's rocks, is that he is acknowledged to have possessed a powerful visual memory for places, events, and natural detail. This is demonstrated in the other watercolour designs of Scottish subjects undertaken at this time for Scott.[54] When Turner began to prepare the watercolour *Loch Coriskin*, the few on-the-spot sketches may have served as

aides-mémoire, though no more than this. These perfunctory, jerky pencil notations present relatively few details of the topography; indeed, Turner seems to have had little interest in documenting the rocks' precise character. His experience of the site (he in fact seems to show himself in his watercolour, sketching the loch), filtered through his imagination and memory, was nourished by Scott's powerful lines from the *Lord of the Isles*, providing him with the essential means of isolating and intensifying the landscape's distinctive character. Certainly, the sense of place is admirably captured and distilled in this sublime, rocky crucible. In the distant past Loch Coriskin had experienced a geological cataclysm

that its rocks, as Scott observed, still record. Yet, as has been noted, Turner's watercolour does not represent the precise geological facts of Coriskin. I suggest that he has intentionally *not* suggested igneous (volcanic) deposits, but has chosen instead to depict stratified (sedimentary) rock in order to participate more directly in Scott's poetic vision.

As Turner matured artistically, the importance of objects was increasingly measured less for what they were than for what they represented. This was sometimes true of rocks. By the time he completed his watercolour of Coriskin, there had been a substantial shift of interest in the geological community from igneous to sedimentary rock (which often contained fossils), due in part to the stratigraphic researches and discoveries of the late eighteenth and early nineteenth centuries.[55] For those without scientific background, sedimentary rock was more familiar than hypersthene and pictorially more readily identifiable; it also implied a measured time scale.[56]

By the beginning of the nineteenth century not only had strata become the object of intensive study, they had presented a story to the romantic eye and mind. To read strata "was to read an autobiography of great revolutions, decay and restoration, the struggle of titanic earth forces."[57] Indeed, it is important to stress the close connection established at that time between geology and history. William Buckland (1784–1856), the celebrated Oxford geologist, repeatedly vindicated geology on the grounds that it was "a subterranean extension of human history."[58] Turner, by ordering his observations, experience, and knowledge, by integrating them and placing them in the service of Scott's verse, has imaginatively imbued his landscape of Coriskin with added meaning. By pictorially presenting rocks that have the character of uplifted sedimentary beds expressive of the dynamics of the early earth, of the earthquake that Scott's poetry describes, Turner appears to have provided a telling pictorial metaphor for the essential message of this poetry: the great antiquity of Coriskin's rocks. Thus it seems that in Turner's watercolour science is again a means and not an end; his interpretation, which alludes to the earth's early history, appears to have been determined by artistic rather than scientific criteria.

The geological ingredient of Turner's art is controlled by the pictorial function it serves. For example, *Lulworth Cove* illustrates the particular character of the rock that its accompanying text describes. However, when the accompanying text is poetry rather than descriptive prose – as with *Staffa, Fingal's Cave* and *Loch Coriskin* – the artist's creative freedom is enlarged and deepened; the viewpoint and interpretation of landscape are adjusted to respond to qualities of the poetry. In *Loch Coriskin* artistic manipulation of the facts changed the character of the rock, apparently in order to share the mood of Scott's poetry. As Reynolds had observed, "a landskip ... under the influence of a poetical mind, will have the same superiority over the ordinary and common views as Milton's *Allegro* and *Penseroso* have over a cold prosaick narration or description."[59]

When, however, we proceed from Turner's works representing specific sites to those historical paintings whose landscapes are essentially imaginary (on which he seems to have believed his reputation would ultimately rest), there is a further shift in which science participates more subtly and obliquely in a larger artistic vision, embracing a complex system of analogy and correspondence that this category of landscape is attuned to accommodate. This is particularly true of five historical landscapes with geological overtones that are metaphorical or figurative expressions of considerable density. The first two have been briefly examined before: *The Goddess of Discord Choosing the Apple of Contention in the Garden of the Hesperides* (RA 1806) (fig. 31) and *Ulysses Deriding Polyphemus* (RA 1829) (fig. 34);[60] the third and fourth are the late paired Deluge pictures: *Shade and Darkness – the Evening of the Deluge* (fig. 118) and *Light and Colour (Goethe's Theory) – the Morning after the Deluge – Moses Writing the Book of Genesis* (fig. 119), both exhibited at the Royal Academy in 1843. In these last two pictures, and especially in *Light and Colour*, history takes the form, if not the substance, of apocalypse. There is, in addition, a fifth, related painting, an unexhibited version of *Shade and Darkness*, entitled simply *The Evening of the Deluge*, that possesses particular geological significance. In these paintings geology is sometimes employed to expand the pictures' theological meanings.

The *Garden of the Hesperides* (fig. 31), as has been mentioned,[61] depicts the Goddess of Discord, Eris, selecting a golden

apple from the two offered to her by one of the daughters of Hesperus. It also alludes to subsequent events in this legend when Eris, not having been invited to the marriage of Peleus and Thetis, angrily threw down amongst the wedding guests – the assembled gods and goddesses – the selected golden apple that was inscribed "For the fairest," in order to create disharmony amongst them. The resulting dispute between Hera, Athene, and Aphrodite for the prize of beauty was decided by Paris, son of Priam, King of Troy, in favour of Aphrodite, resulting in the permanent enmity of Hera and Athene toward the Trojans. This disharmony is an underlying theme of Turner's painting. Executed only a few years after his alpine experience of 1802, the *Garden of the Hesperides* is in content a confident, richly textured work. As in many of Turner's later historical landscapes, the meanings of this picture's images are determined with reference to a larger frame of significance of which they form a part. Much of the painting's distilled thought is elaborated by means of allusion.[62]

The importance of this picture cannot be overestimated. Turner wished, it would seem, to make a particularly strong impression with it at the first exhibition of the British Institution held in 1806, whose mandate, so trumpeted, was to "encourage and reward talents of the artists of the United Kingdom" and "to open PUBLIC EXHIBITION for the sale of the productions of British artists."[63] The landscape of this work demonstrates again Turner's interest in the geology of mountainous terrain. Indeed, John Ruskin, a protégé of the eminent scientist William Buckland, who was the reader in geology at Oxford University during Ruskin's student days, considered the *Garden of the Hesperides* the most important composition of Turner's first period. He remarked that it "is the first composition in which … [he] introduced the mountain knowledge he had gained in his first Swiss journey."[64] Yet this painting possesses meanings that lie beneath its surface, so that many of its geological aspects are not readily perceived. They are dynamically allusive, and allusiveness is a significant constituent that helped to establish an allegorical way of thinking that was to reveal itself not only here but also in his later historical canvasses.

The *Garden of the Hesperides* is profoundly evocative. Turner has allegorized this well-known ancient story; the earth becomes its underlying theme. He has emphasized here the role of the earth in myth. By representing the inky waters of the stream sluggishly flowing through this garden, Turner likely offers an allusion, as Ruskin persuasively suggests, to the underworld.[65] Further, the tree bearing the golden apples in the lower right of the painting had been a gift from the goddess of the Earth to Hera, at her wedding; it had subsequently been entrusted to the keeping of the daughters of Hesperus and had been protected by the smoke- and fire-breathing dragon Ladon, which Turner associated with the earth's inner heat and which is shown in the upper right of the picture stretched out on, and appearing to be almost part of, a rocky ridge (fig. 97).[66] Finally, the foreshortened churning column of smoke that invades this peaceable garden from between the nearer, lower mountains, which help define the garden's limits, is not, as has been suggested, a cloud.[67] This twisting, threatening column issues, as can be readily determined on examination of the picture, from beneath the distant range of enclosing high mountains and was to represent "imprisoned winds," the exhalations of subterranean activity with which Turner believed the garden's bony sentinel, Ladon, was intimately associated.

This dragon possesses further geological associations that concern not only the early history of the earth but also the earth's dynamic nature. Though intended by Turner to display universal dragon characteristics such as wings and an extremely long tail (engendered by its association with serpents), Ladon's essential form is that of a crocodile. This is geologically significant. Ruskin noted its "strange unity of vertebrated action, and of a true bony contour, infinitely varied in every vertebra, with this glacial outline; – together with the adoption of the head of the Ganges crocodile, the fish-eater, to show his sea descent (and this in the year 1806, when hardly a single fossil saurian skeleton existed within Turner's reach), renders the whole conception one of the most curious exertions of the imaginative intellect with which I am acquainted in the arts."[68]

However, by the time Turner painted this picture fossilized remains of crocodiles and crocodile-like creatures had been discovered and written about, adumbrating the imminent shift of British scientific interest from mineralogy to palaeontology; especially vertebrate palaeontology.[69] It is possibly significant that in

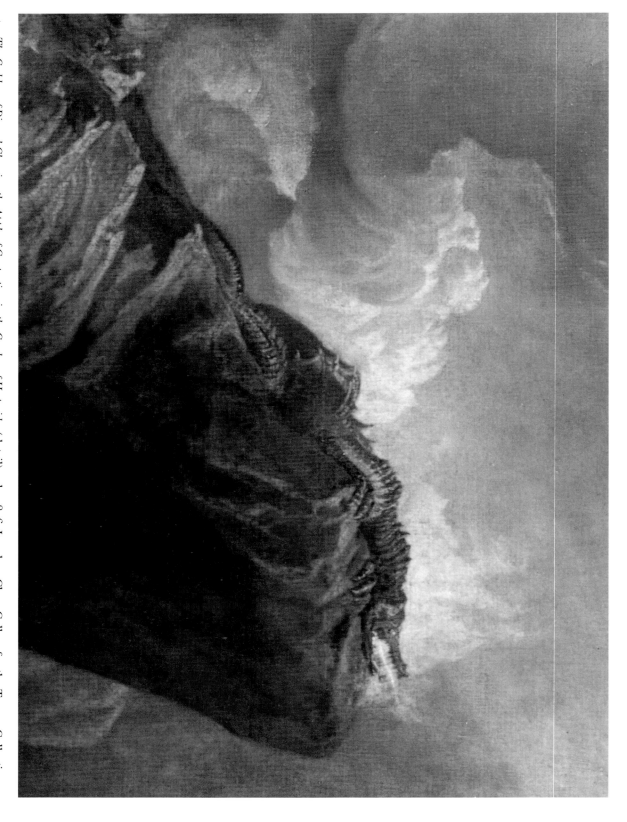

97 *The Goddess of Discord Choosing the Apple of Contention in the Garden of Hesperides* (detail) exh. 1806. London, Clore Gallery for the Turner Collection

1805, the year before Turner exhibited this picture, a fossilized skeleton of a putative crocodile was unearthed at Weston, near Bath. It was widely reported in the press, since it was, according to reports, in a state of "high preservation[,] the teeth even covered with enamel."70 Though it is impossible to know whether Turner had read or heard of this particular fossil, he was almost certainly aware of similar discoveries. The essential anatomical structure of his dragon surely confirms this.

Some geologists in Britain still relied on scripture to help explain the nature of the earth, and Turner enriched his painting's meaning by associating Ladon (and other inhabitants of the Garden) with the biblical Fall. This association is introduced here allusively, as Ruskin perceptively observed. Ladon, Ruskin noted, recalls the serpent in Eden, while the tree bearing golden apples alludes to that garden's tree of knowledge.71 Ladon thus appears to mediate between Hesperides and Eden. Eris's securing of the golden apple presaged the destruction of quietude and harmony, just as Eve's plucking of the apple from the tree of knowledge foreshadowed worldly imperfection.72 Thus, though this painting clearly presents the garden as a haven of tranquility, it is a garden under threat. In the notes for his Royal Academy lectures, Turner associated the ideal with nature before the Fall,73 and the classical setting of this painting, reminiscent of the landscapes of Poussin, was probably intended to reflect the timeless, ordered serenity existing immediately before the onset of earthly change. However, in this picture he introduced two anticipatory metaphors for the transformation inflicted by the resentful Eris, who – as Ruskin observed, quoting from Spenser – had "sought to bring all things unto decay."74 One of these metaphors is the ominous column of smoke caused by volcanic activity that was traditionally identified with the Fall; serpent-like, it is shown penetrating the garden's boundaries. The other metaphor concerns the tree in the garden in the lower right, heavy with golden apples, displaying a major branch that, significantly, has *fallen* (fig. 98).75

The relationship between Turner's *Garden of the Hesperides* and the later (c. 1829) *Ulysses Deriding Polyphemus has already been noted*,76 though not their geological connections in particular. As has been observed, Turner adapted the essential structure of the landscape background of the engraving after Watteau's *Acis et*

Galathe (fig. 32) for the Poussinesque setting of his *Garden of the Hesperides*. The reclining figure of Polyphemus on the crest of the distant mountain in the print has been replaced by Turner with the dragon Ladon. In establishing a specific geological relationship between the *Garden of the Hesperides* and *Ulysses Deriding Polyphemus*, it is important to observe the link between Ladon and Polyphemus, both of whom are depicted on similar rocky headlands. Both were also associated with volcanic activity. In the *Garden of the Hesperides* volcanic activity is allusively suggested, as noted, by Ladon's smoky and fiery breath and the threatening column of churning smoke. In *Ulysses Deriding Polyphemus*, it is suggested by tongues of flame that escape from beneath the smoke-shrouded headland.77

Significant allusions to geology also occur in Turner's three late Deluge pictures. *Shade and Darkness* and *Light and Colour* are among the most powerful and deeply symbolic of his late works in which artistic perception has been altered to become vision. This group also includes the unexhibited version of *Shade and Darkness*, entitled, as mentioned, *Evening of the Deluge*.

Turner was one of the most significant romantic painters of the Deluge. It was an attractive theme for him, especially in his later years, because of its apocalyptic overtones. It was a foreboding of the cataclysm at the world's end. Although Turner had painted the Deluge earlier in his career,78 in these two exhibited late pictures he explored fresh emotional terrain, resolving their contents into a *concordia discors* – a dynamic equilibrium. Although they can be read simultaneously on a number of levels, they appear to concern the reconciliation of the physical and spiritual worlds, figuring forth the theme of redemption, symbolized by the ark of Noah at the centre of *Shade and Darkness*, and by the Brazen Serpent at the centre of *Light and Colour*.

Turner has integrated these concepts with other ideas that are discussed below, in chapter 12, such as aspects of Goethe's *Theory of Colours* and Newton's *Opticks*. The meanings of these canvasses are thickened by their "scientific" content, which, however, is kept at arm's length by the pictures' fertile allusiveness. Structuring the subject of the Deluge and the theme of sin and redemption, and expanding their meanings, is the natural cycle that is alluded to in the exhibited pictures' titles, *Evening of the Del-*

98 *The Goddess of Discord Choosing the Apple of Con-
tention in the Garden of the Hesperides* (detail)

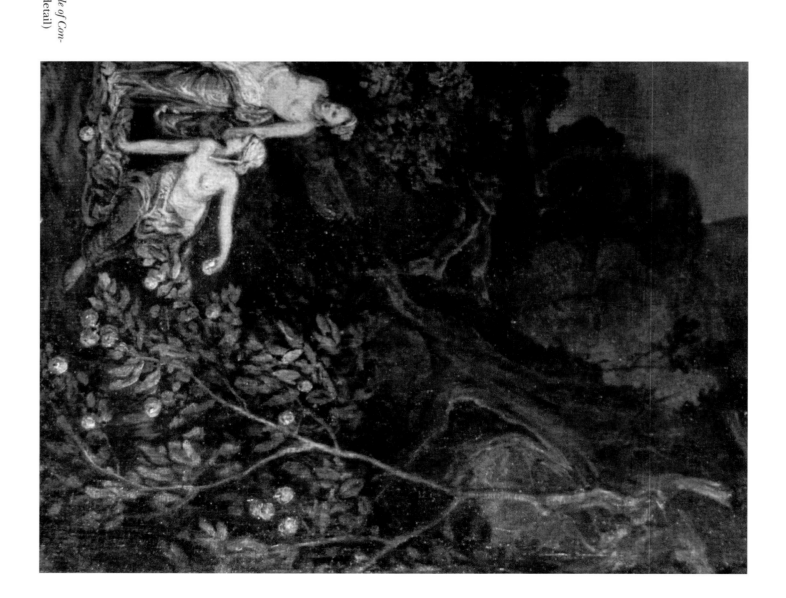

uge and *Morning after the Deluge*, a circular imagery that is reinforced by the poetic tag from Turner's "Fallacies of Hope" attached to the second of these pictures. In these lines he refers to the "summer fly which rises, flits, expands and dies," a reference to life that ends where it begins – a symbol of permanence in change.

In both *Shade and Darkness* (fig. 118) and *Light and Colour* (fig. 119) the Deluge becomes the means of understanding the pictures' geological references – as oblique as they are. Since science and religion in Britain remained closely allied through the eighteenth and into the nineteenth centuries, the Mosaic account of the Deluge still played a role in scientific discourse, helping to explain the composition and character of rocks and the organic remains they contained.

It has been proposed that Turner's interest in geology, including the link between Genesis and geology, may have been stimulated by the catastrophist ideas espoused by Sir Humphry Davy (1778–1829).[79] It has been suggested that Turner's awareness of Davy's doctrine was stimulated by his personal contact with this scientist with whom, it is stated, the artist was friendly.[80] This suggestion is not persuasive. There is no evidence of a friendship between Turner and Davy. Although they probably met, it seems likely, from existing evidence, that their contact was relatively brief.[81] Still, they were likely exposed to many of the same ideas. It has been argued that in *Light and Colour* Turner appears to endorse Davy's theory[82] and that Davy's theory is a compromise between a historical/scientific and a traditional religious explanation of the world.[83] Turner does illustrate this compromise, but such a compromise is neither explicit nor implicit in Davy's writings. Though Davy deeply respected the sacred scriptures, he believed that they did not furnish "the true account of creation." Indeed, he was "doubly critical of those who attempt to blend their scientific explanations with biblical literalism."[84]

A more likely influence on Turner was the ideas of William Buckland, one of Baron Georges Cuvier's most able British followers. Cuvier, as noted, was a leading proponent of catastrophism. Buckland proclaimed that geological evidence attested to the existence of a recent universal catastrophe, that is, a deluge. He believed that this catastrophe could be identified with the Noachian

Deluge. Buckland, in his inaugural lecture at Oxford (1819), defended geology against the accusations that the evidence of scientific enquiry had undermined the plausibility of Christian revelation. He maintained that the two could be readily reconciled and that the "Mosaic account is in perfect harmony with the discoveries of modern science."[85] Although he later abandoned his belief that a recent universal flood was the Noachian Deluge, he remained a supporter of catastrophism. Like others with catastrophist convictions (including Davy), he believed that creatures from the deep past had become extinct in consequence of major, violent, world-wide cataclysms and that new life occurred in the quiescent periods between them. Like others, he believed the fossil record indicated that there had been progressive "jumps" in life during each period of renewal. Buckland maintained that a link could be established between antediluvial and present forms of life.[86] Since Turner had been in touch with Buckland during the period when the artist painted his Deluge pictures,[87] I shall argue that it is possible that these pictures reflect Buckland's beliefs.

These pictures seem to embody at least two ideas that, at different times, had interested Buckland. First, they are concerned with the Noachian Flood that, early in his career, he believed had imprinted itself on the geological record; a belief that, as indicated, he later abandoned. However, the second, and more important, idea that Buckland embraced was the concept of continuity[88] – his postulation of a link between antediluvial and present life forms. In 1836 he published a book in which he argued that fossils were links "that appeared deficient in the grand continuous chain which connects all past and present forms of life, as part of one great system of Creation."[89] Continuity in the chain depended on the inclusion of past species with those of the present. "Plenitude became a historical notion; the chain of being would have no deficiencies if considered as a chain of history. All past life should be intercalated in the sequence of current species."[90] This idea of continuity is suggested in Turner's Deluge picture that was never exhibited, the *Evening of the Deluge* (fig. 99).

In the right foreground of this painting Turner depicts a reptile that witnesses the coming of the Flood and the embarkation of animals into the ark.[91] The observation has been made that this reptile is intended to depict an ichthyosaur.[92] However, the

bly chose to represent this creature without a mate, separated from the paired animals proceeding to the ark, not only to allude to the extinction of species but also, I shall argue, to suggest a thread of continuity existing between past and present.

Though the crocodile in Turner's painting is seemingly "modern" in appearance, it displays a head that, on close inspection, reveals strikingly unfamiliar features. It provides evidence that Turner was acquainted with fossilized crocodile-like skulls referred to by geologists who championed the concept of continuity as those of an extinct species related to the modern Gavial or Gangetic crocodile.[96] The skulls of these ancient creatures, which were sometimes determined as being those of the ichthyosaur,[97] had been illustrated by the time Turner painted this picture, and though one cannot rule out the possibility that he actually saw fossil skulls, some of which were available at that time in the British Museum, it seems that the form of the head was more likely inspired by illustrations in books.[98] Still, whatever skulls he encountered, whether in a museum or in a book, his intention was certainly to suggest the head of an extinct antediluvian creature. In presenting a crocodile whose form is similar to, yet different from, modern crocodiles, Turner appears to have used artistic licence (as he had, though not to the same degree, in his depiction of the rocks of Coriskin) in order to extend and enrich the meaning of his art. Although the crocodile in Turner's painting was not destined to survive the Deluge, its unusual appearance seems to embody the idea of progressive development. By attaching this ancient head (palpably modelled on the skull of an ichthyosaur) to what appears to be the body of a modern crocodile, I suggest that he was drawing attention, rhetorically, to the disparity, and yet, paradoxically, to the explicit connection, such as Buckland had proposed, between antediluvian and present forms of life. Thus Turner's crocodile appears to reflect contemporary scientific ideas regarding continuity, ideas of permanence in change, a concept that the artist readily embraced.[99]

Turner's decision not to depict this creature in the second version of his picture that was exhibited has been considered significant. During the 1830s there was an increasing concern to separate geological and biblical accounts of creation, and it has been suggested that Turner felt uncomfortable with the notion of

representing the reptile, a symbol of the geological beginnings of the earth, in the second, exhibited version, and so did not include it. Turner, we are told, wished to present only the "purely human and mythical status of the story of the Flood."[100] This suggestion is compelling. Yet if this is so, then why do the Deluge pictures illustrate aspects of the science of colour as part of their mythographical context? In Turner's work, I maintain, art and science, to a greater or lesser degree, are always integrated – and most especially in his important historical landscapes, of which the Deluge pictures must be considered eminent late examples.

Astronomy and geology had an impact on Turner's painting. However, science was not his prime interest; it was art. It was his belief that science would be of benefit if it could further his artistic aims. Science could do that; science for Turner was a means of conveying truth – truth, however, that through art was elevated to a higher order, to the ideal, a poetical ideal. The realization of this truth was a central intellectual and emotional priority. Whether the evidence of science in his paintings and watercolours was consciously included or whether it was incidental, it does affect what appear to be its meanings. In some paintings and watercolours physical facts and relationships rigorously observed provided his art with greater literal accuracy, sharpening and intensifying, at least in parts, the naturalness and authentic quality of his representations – and yet the degree of literal accuracy varies with the artistic context provided. However, it never obstructs or overpowers the ideal, poetical interpretation of the world that was essential to his art. In historical landscapes by Turner inspired by literature or accompanied by poetry these facts and relationships sometimes appear to have been openly subverted. They seem to have been manipulated or modified to become part of the imaginative symbolic order that shared or accommodated his astonishing poetic vision. And though Turner always considered science to be a handmaiden of art and never its mistress, it often provided his paintings with a consistency and inner structure that affirmed his belief in nature's essential unity.

10 Biblical History: Fall to Apocalypse

L IKE MANY ROMANTICS, Turner may have believed that by understanding the workings of nature that was the could heal the profound rift between nature and humanity that was the consequence of the Fall.[1] There is no evidence Turner was especially devout, yet religious ideas often furnished valuable underpinnings for his paintings' themes and, on a number of occasions, provided their subject matter. Of particular interest are those of the 1840s that were influenced by his biblical and visionary illustrations of the previous decade.[2] Two of these pictures are the *Dawn of Christianity* (*Flight into Egypt*) (RA 1841) and *The Angel Standing in the Sun* (RA 1846). The former is believed to have had a pendant; the latter did.

Like many of his predecessors, Turner was drawn to the notion of painting *en série*, which suggested coherence or relationship of subject matter among pictures to extend their meanings and thereby enlarge their significance. Of particular relevance in this respect are the late paired works in which complementary and contrasting characteristics intertwine and collaborate. In them, it would appear that opposing ideas dynamically participate in the higher order of reality that comprehends them. These paired pictures probably include *Dawn of Christianity* and certainly include *The Angel Standing in the Sun*.

Dawn of Christianity (fig. 102) was exhibited at the Royal Academy in 1841 with a poetic line attached to its entry in the cat-

alogue taken from the cleric Thomas Gisborne's poem *Walks in a Forest*. The line reads, "That Star has risen."[3] It possesses notable symbolic content. A shining morning welcomes the Virgin, shown riding a donkey and holding in her arms the infant Jesus, who is strongly illuminated by a shaft of mystical light from a brilliant star hidden by the fronds of a large palm tree. The star is the daystar, to which the poetic line attached to this picture refers; this star may also allude (since it shines specifically on the Christ child) to the star that led the shepherds to the Bethlehem manger where Christ was born. The snake floating on the surface of the river to the left is possibly a symbol of the Nile, though it more likely alludes to the evil that Christ was to encounter through his life.[4] The motif of the palm tree has several relevant meanings. Perhaps the most cogent here is its allusion to Christ's victory over evil. As the palm tree is a specific symbol of the Resurrection and as the Resurrection is an important theme of Gisborne's poem, it seems likely that this idea was uppermost in Turner's mind.

A further important symbol is the ruin of an ancient bridge. The gap between the arches frames a distant temple that appears Egyptian in character.[5] The bridge itself is certainly Egyptian, displaying lotus capitals. It functions as a geographical marker. In its ruinous state, it also represents the symbolic break between the pagan past and Christianity. The rising sun is also symbolic, and when interpreted in conjunction with the picture's other elements, stands for this new religion: its strengthening rays sweep away the darkness of the old pagan faiths. To reinforce this meaning, the donkey carrying the Virgin and Christ child passes along a section of the road to the right, the steep banks of which are littered with the remains of ancient Egyptian idols. The most conspicuous one is covered with quasi-hieroglyphs (fig. 103).[6]

The line from Gisborne's poem attached to this painting further assists in elucidating its meaning. It was taken from the section "Spring," which includes the following lines:

He on a world, in Gentile darkness lost,
Pitying look'd down: He to bewilder'd man
Bade Spring, with annual admonition, hold
Her emblematic taper; not with light
Potent each shade of doubt and fear to chase,

Yet friendly through the gloom to guide his way,
Till the dawn crimson'd, and the impatient East,
Shouting for joy, the Day-star's advent hail'd,
That star has risen, and with a glow that shames
The sun's meridian splendour, has illumined,
Eternity!7

The subject of this poem, its author states, was influenced by the writings of the ancient poet Moschus, who "flourished about two hundred years before the Christian era." Moschus was interested in the comparison between "the supposed Non-existence of Man after Death with the vernal Revival of the Vegetable World – The Lesson which ought to have been deduced from that Revival."8 Gisborne, not surprisingly, uses Moschus's ideas as the basis for his Christian poem, in which, through references to the eternal alternation of day and night, light and darkness, and spring and winter, he provides contrasting spiritual metaphors for human life and death. In the section "Spring," resurrection is a powerful theme: "And the sun rose from Chaos" alludes to the son of God, who "In cloudless majesty ... / Sprang glorious."9

In subsequent lines there is an unambiguous reference to the end of time, the end of history, dominated and controlled by Christ, who is at the fulcrum of universal history. At the end of history "when all things shall be subdued unto him, then shall the Son also himself be subject unto him that put all things under him, that God may be all in all" (1 Cor. 15.28). At that time, Gisborne observes,

When, at the Archangel's [Michael's] voice the slumbering
 dust
Shall wake, nor earth nor sea withold her dead:
When starting at the crash of bursting tombs,
Of mausoleums rent, and pyramids
Heaved from their base, the tyrant of the grave,
Propt on his broken sceptre, whilst the crown
Falls from his head.10

Turner may have perceived a connection between the cataclysmic demolition of tombs at the Last Judgment in Gisborne's

poem and the destruction of idols on the coming of Christ. He may also have remembered the following biblical quotation from Isaiah (19.1): "Behold, the Lord ... shall come into Egypt: and the idols of Egypt shall be moved in his presence." Still, his most likely source was Milton, a poet whom Turner had always admired and who still, at this late date, remained particularly influential. Approximately six years before Turner painted *Dawn of Christianity*, he completed a series of illustrations for Milton's *Poetical Works* (published in 1835)11 for John Macrone. *The Works* contain the well-known "Ode on the Morning of Christ's Nativity" (not illustrated by Turner), in which Milton "celebrated the meaning of the Incarnation not only in history but after history is over, an event both in and not within created nature, a place both in and not within created time."12 The following lines of this poem, which concern the destruction of idols on the coming of Christ, may have been in Turner's mind when he embarked on the composition for this picture:

The oracles are dumm,
No more or hideous Hum
Runs through the arched roof in words deceiving
Apollo from his shrine
Can no more divine
With hollow shriek the sleep of Delphose leaving
..................
And sullen Moloch fled,
Hath left in shadows dred,
His burning idol all the blackest hue
In vain with Cymbals ring,
They call the grisly King,
In dismall dance about the furnace blue;
The brutish gods of Nile as fast
Isis and Orus, and the Dog Anubis.13

If Turner did intend a companion picture for *Dawn of Christianity*, then it would seem reasonable to assume that on the basis of what he read about Moschus, as presented by Gisborne, he could have chosen as an effective contrast and complement an appropriate pagan subject such as that of either *Bacchus and*

102 *Dawn of Christianity* (*Flight into Egypt*). Oil, exh. 1841. Diam. 31 in. (78.5 cm). Belfast, Ulster Museum (B) 394). See colour plate 10

Ariadne or *Glaucus and Scylla* (discussed in chap. 4, above). Both these paintings of classical myth, showing a setting sun, may have been considered, at different times, pendants of *Dawn of Christianity*. The introduction of pagan gods as a complement to Turner's Christian subject is likely, since they not only symbolized the powers and functions of nature but were often considered as "types" of Christ. Writers such as Jacob Bryant's well-known *New System, or, an Analysis of Ancient Mythology* (1774–76) and George Stanley Faber's *The Origin of Pagan Idolatry Ascertained from Historical Testimony and Circumstantial Evidence* (1816) consider classical myth in typological terms. If at least one of these mythological pictures served as a companion for *Dawn of Christianity*, then the evidence of Moschus's interests, the Christian theme of Gisborne's poem, and contemporary fascination with typological relationships between pagan and Christian deities should be considered relevant. Moreover, the fact that, like Christ, Bacchus and Glaucus had experienced resurrection, may be significant. Thus it is possible that if one mythological picture or both were associated with *Dawn of Christianity*, then the setting sun that they display, while a powerful metaphor for the end of the pagan era, also foreshadows the Christian era, which is the subject of *Dawn of Christianity*.[15]

Other pictures by Turner painted in the 1840s also place emphasis on the spiritual world; they reflect Turner's continued fascination with religious themes. As Turner's health deteriorated and his close circle of friends continued to diminish, thoughts of death intensified, and he withdrew even further into himself. In 1841, shortly after he exhibited *Dawn of Christianity*, his colleague Wilkie died suddenly on his voyage back from Egypt, and later in the same year his old friend Chantrey, the sculptor, passed away. Turner's state of mind is reflected in a letter of this time: "very low indeed for our loss in *Dear Chantrey*."[16] Still, though he was ill and depressed, there was no obvious waning of intellectual vigour and resource. His paintings, however, began to explore the topic of religion more profoundly, and, in so doing, they often gathered more pessimistic substance, reflecting his growing preoccupation with death, with the nature of humankind and the world of the spirit.

103 *Dawn of Christianity (Flight into Egypt)* (detail)

These late paired paintings possess powerful imagery; they are light-filled and often apocalyptic; they indicate the distance separating Turner from his contemporaries and the powerful individuality of an artistic personality that had increasingly thrown off the traces of convention. In 1845 the reviewer of the *London Illustrated News* was critical of Turner's current manner, which he described as possessing a "feverish glare." He accused the artist of a "systematic defiance of every kind of principle in art or appearance in nature," though he admitted that Turner "still continues to find admirers." He added, "He is the very William Blake of living landscape painters."[17]

The comparison with Blake (1757–1827) with respect to these late works is interesting and enlightening. The two painters possessed similarities in style and imagery, to which this critic was probably alluding. It may not be fortuitous that Blake, like Turner, admired Henry Fuseli, who had championed the idea of developing a more imaginative art than was practised by Royal Academicians.[18] That Turner was familiar with Blake's work through his contacts with Fuseli we do not know, though there were certainly opportunities for him to learn of Blake's art. Occasions may have presented themselves as a result of his early association with the miniaturist Ozias Humphrey, who knew Blake. Turner was acquainted with John Linnell and Sir Thomas Lawrence, who also knew Blake. And there were Blakes in the collections of Turner's patrons Hugh A.J. Munro and Lord Egremont.

There are further relationships between Blake and Turner, especially Turner in his late career. Both were fascinated with the notion of death and salvation and believed that a struggle exists between the spiritual and the material. They seem to have concurred that creation was corrupted by the Fall until redemption was vouchsafed through the love of Jesus Christ and his death on the cross. They also seem to have shared the belief that humanity's material aspirations were doomed.

The art of Turner is similar to that of Blake in that Turner sometimes imbued his work with mystical qualities evoked through subject matter, composition, and qualities of light. Perhaps *The Angel Standing in the Sun* (fig. 104) is closest to Blake in feeling. There are similarities between the essentially balanced,

104 *The Angel Standing in the Sun*. Oil, exh. 1846, 31 × 31 in. (78.5 × 78.5 cm). London, Clore Gallery for the Turner Collection (BJ 425). See colour plate 11

iconic design of the *The Angel* and that of Blake's etching *Glad Day* (1780), in which a youth in the rising sun is probably a metaphor for the new day.

Light was of central importance to Turner, and, as a painter of landscape often influenced by the work of Claude Lorrain, it is not surprising that Turner frequently used the directly observed sun as a powerful source of light in his works. It has been shown that the sun appears as a recurrent metaphor that broadens and deepens the significance of his art from context to context: the sun's position in the sky, signifying different times of day, can allude to positive or negative states of the subjects represented. The sun can have other meanings. In *Regulus*, for example, it serves as a metaphor for the torture endured by its hero. The sun was also a symbol of deity[19] and this particular symbolism occurs in *The Angel Standing in the Sun*, whose companion picture is *Undine Giving the Ring to Masaniello, Fisherman of Naples*. Both pictures were shown at the Royal Academy in 1846.

When exhibited, the late broad style and diffused images of these pictures caused some dismay. The critic of the *Spectator* (9 May) remarked that "of the figures [in *The Angel*] one can only say that Mr Turner has taken leave of form altogether." Others were mystified or perplexed. The *Times* reviewer (6 May), however, considered these pictures serious artistic expressions. *The Angel*, he wrote, is

a truly gorgeous creation. The central figure of the angel is illuminated with a blaze of golden light, which diffuses itself about surrounding multitudes, and wraps them in warmth. The throngs vanish in the distance with the nicest regard to atmosphere, and the space behind the angel merges into infinity through a series of circles that succeed each other with the most delicate gradations ... the Undine giving a [sic] ring to Masaniello ... [is] remarkable for that favourite white light of Turner's from a region of which the undefined Undine peers forth, in vivid contrast to the dark blue sky, with its mass of red flames (probably Vesuvius) in the background ... It is all very well to treat Turner's picture's as jests; but things like these are too magnificent for jokes; and the readers of the Oxford Graduate [John Ruskin] know that many of these obscurities are not altogether unaccountable.[20]

Turner, to enrich the content of these pictures, has again followed the convention of attaching poetry to painting. Associated with *The Angel* are lines from the book of Revelation and from Samuel Rogers' poem *The Voyage of Columbus*. The lines from Revelation appear to be the more significant insofar as they seem to allude to a theme of the picture – the transient, imperfect nature of humankind, a theme that is referred to in a number of Turner's works: "And I saw an The Angel standing in the Sun; and he cried with a loud voice saying to all the fowls that fly in the midst of heaven, Come gather yourselves together unto the supper of the great God; That ye may eat of the flesh of kings, and the flesh of captains and the flesh of mighty men, and the flesh of horses, and of them that sit on them, both free and bond, both small and great" (Revelation 19:17–18).

Described in these verses, the painting's centrally located angel, sword in hand, head upturned and mouth agape, cries with a loud voice to those "fowls that fly in the midst of heaven." These ominous birds wing their way from the left background to the middle ground and foreground to devour, presumably, the "flesh of kings and of captains and of mighty men" from among those there assembled. The book of Revelation, if largely descriptive of the spectacle of God's power, is also concerned, though less directly, with the forces of good and evil in the world and the eventual judgment of humankind.

The lines from Rogers' *The Voyage of Columbus* also illuminate the meaning of *The Angel*. "The morning march that flashes to the sun; / The feast of vultures when the day is done." The inclusion of these lines paradoxically provides the timeless apocalyptic vision of *Revelation* with temporal buttressing. Turner may have chosen these lines partly because of their solar imagery, imagery that is frequently found in his own poetry.[21] In a broader sense, however, *The Voyage of Columbus* was also significant for him because this poem contains the theme of revolution, which he relates both to this picture and to its companion.[22]

The Angel resists an adequate interpretation unless one assumes, I believe, two major premises: first, that Turner was aware that at the time of the Last Judgment all of history would be laid bare and second, that he was intent on including historical repetitions. Concerning the first premise, Turner seems to have estab-

lished temporal boundaries: creation at the beginning and apocalypse at the end. The angel represented here, St Michael the archangel, is the instrument of God who expelled Adam and Eve from paradise and gave them a prophetic glimpse of the Last Judgment. Concerning the second, Turner seems to have regarded historical repetitions, or types and antitypes, as important here, since he is concerned with a biblical theme.

The striking visionary imagery of *The Angel* suggests Turner's apocalyptic, baroque-like vignette compositions of the later 1830s that illustrate Rogers', Campbell's, Moore's, and Milton's poetry.[23] St Michael stands against the brilliance of the sun; the sun is a metaphor for God.[24] In pictorial representations of the Last Judgment, to which this painting alludes, St Michael is presented either as a weigher of souls or, with the sword (as he appears here), as the oppressor of evil. In this painting he stands brandishing his sword directly above the chained serpent on earth.[25] Here the symbolic line that links the angel and the serpent measures the distance between heavenly good (pure nature) and earthly evil (corrupted nature) and furnishes, at the same time, the composition's vertical axis, separating figures to left and right. To the left, Adam and Eve are shown discovering the body of their son Abel, while his brother, Cain flees (fig. 105). This subject, which is not in the Bible, had attracted Blake and was painted by him.[26] To the right, Delilah fatally incapacitates Samson, and Judith decapitates Holofernes (fig. 106). In the apocalyptic context of this picture, Turner has attempted to suggest the breadth of biblical history and his fascination with historical inclusivity.

The inclusion of Adam and Eve and the fleeing figure of Cain in *The Angel* and their appearance in Blake's art was probably due to the influence of Salomon Gessner's celebrated volume *The Death of Abel*, which was first translated into English in 1761. Gessner describes Adam and Eve finding the body of their son Abel while Cain, thwarted by the archangel Michael in his attempt to flee, admits his responsibility for Abel's death. The archangel, sent by God, stood before the terrified Cain declaring that he "forever shalt ... wander a fugitive and a vagabond."[27] That St Michael is represented in Turner's picture strengthens the suggestion that one of Turner's sources for his imagery was Gessner's book. This is reinforced still further by the presence, behind and

105 *The Angel Standing in the Sun* (detail)

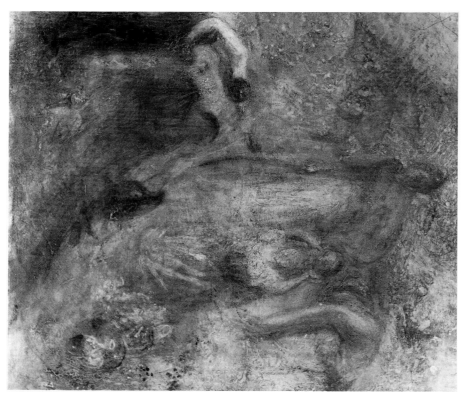

106 *The Angel Standing in the Sun* (detail)

107 Anonymous, *Death and the Soul*. Wood engraving from Francis Quarles, *Emblems, Divine and Moral*, ed. S.W. Singer, London (1845). London, by permission of the British Library. See note 28, chap. 10 (11630.a28(1))

to the right of Adam and Eve, of a skeleton witnessing this drama. Its gesture of grief echoes that of Adam and therefore establishes a link between them. Seated at the skeleton's feet is a tiny, almost obscured figure of an infant. In conjunction the skeleton and the infant symbolize, respectively, the mortality of the body and the immortality of the soul.[28] Can it be fortuitous that in Gessner's book, body and soul in relation to Adam and Eve are specifically mentioned? Adam remarks that "We live, my beloved Eve! though the body sinks into dust, the soul survives."[29] However, the skeleton and infant in the painting may also relate to an underlying and allusive dynamic: the cycle of human life and humanity's inheritance of imperfection, an implicit theme in many of Turner's paintings that also had broader implications for the romantic and immediately postromantic eras.[30]

Imperfection, or, more specifically, the genesis of deceit, is suggested by the presence of Adam, Eve, and Cain. Was it not Eve who declared "the serpent beguiled me and I did eat"? And was it not Eve who, with Adam, attempted to hide their sin from God? Cain, who tried to hide Abel's body and his murder, flees. On the right of the painting are later biblical personalities, the inheritors of deceit. Turner has presented the betrayal of Samson by the courtesan Delilah, who, by cutting Samson's hair, deprived him of his strength, an act that ultimately resulted in his death. Deceit is also illustrated by Judith and Holofernes. Judith, by beguiling and slaying the military officer Holofernes, saved both her city and the lives of its inhabitants. Both Delilah and Judith practised deceitful love, though while the love of one has a negative resonance, the other has a positive one. This theme of deceitful or false love also occurs in the pendant painting *Undine Giving the Ring to Masaniello, Fisherman of Naples* (fig. 108).

By conflating the story of Masaniello, the Italian fisherman and revolutionary, and that of the sea sprite Undine, Turner has created his own myth. Masaniello, the seventeenth-century Neapolitan leader who led a popular insurrection in 1647,[31] was said to have been deceived by his own supporters and eventually assassinated – a story that would have appealed to the romantic mind. The setting of *Undine Giving the Ring to Masaniello* is the peninsula forming part of the rim of the Bay of Naples. Masaniello, born on the siren coast, where in ancient times sirens were said to have

lured sailors to their death, stands near the shore drawing in his net. In addition to fish, the net contains the haloed form of Undine, with a ring in her hand, is shown luring the fisherman into the sea. To the left, behind Masaniello, Vesuvius erupts. The volcano is probably more than just a geographical marker. Since Masaniello wears a red liberty bonnet (which was familiarly associated with and widely used as a symbol of the French Revolution),[32] the volcano likely refers to the latent energy released by Masaniello's revolt, a metaphor that first occurred in a play from the seventeenth century.[33]

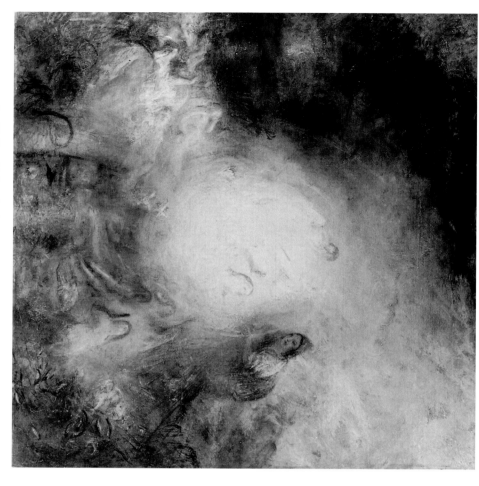

108 *Undine Giving the Ring to Masaniello, Fisherman of Naples*, Oil, exh. 1846. 31 ⅛ × 31 ⅛ in. (79 × 79 cm). London, Clore Gallery for the Turner Collection (BJ 424). See colour plate 12

During the nineteenth century the Masaniello story, with its theme of freedom from tyranny, seems to have acquired a fresh relevance in theatrical productions, as Masaniello's revolt became intimately associated with the political agitation in France that culminated in the July revolution of 1830. Turner may have known of or attended a performance of a ballet entitled *Masaniello*, based on the well-known French opera *La Muette de Portici*, by Auber. The ballet, which had clear revolutionary overtones, had delighted London audiences between 1829 and 1835[34] and had led a reviewer in the *Foreign Quarterly Review*, in 1829, to remark that "Masaniello's revolution ... affords grounds of deep reflection for those who may be disposed to compare events passed on another stage and terminating in a different manner, with the singular occurrences of the same character which have astounded our time."[35] The writer was possibly alluding to recent disturbances both at home and in France. Fear of rebellion in Ireland led to the passing, in that year, of the Catholic Emancipation Bill, which removed oppressive regulations that had for so long fettered Roman Catholics, giving them most of the same rights as Protestants. The strong rumblings of revolt across the Channel in France against the oppressive policies of Charles X, the Bourbon king who had attempted to restore absolutism, may also have been on that writer's mind. In the next year (1830), Charles X was deposed and succeeded by Louis-Philippe.

In addition to the Masaniello ballet, an opera, *Masaniello*, was performed in London, significantly, in 1831, the year following the removal of Charles X. In this opera Masaniello, incensed by the bondage of his people, brooded obsessively over their plight. One of the opera's other characters, Moreno, asked a compatriot what was preoccupying Masaniello. The response was, "Our slavery, no doubt; they say he talks of it in his sleep."[36] This same opera also reestablished the association between Masaniello's revolt and the eruption of Vesuvius, which I now believe, as I have indicated, is one of the meanings intended by Turner in *Undine Giving the Ring to Masaniello*.

Immediately after Louis-Philippe ascended the throne, Turner himself made subtle pictorial comparisons between this recent revolution and revolts or frustrated revolts in England in the past and present. For example, his painting *The Prince of*

Orange, William III, Embarked from Holland, and Landed at Torbay, November 4th, 1688, after a Stormy Passage, exhibited at the Royal Academy in 1832, makes allusion to the Glorious Revolution, when King James II was deposed for his absolutist policies and was succeeded by William III and Mary II.[37] Turner's allusion to (and, indeed, support of) political change at home, which culminated in the passing of the Reform Bill of 1832,[38] is also embodied in watercolours that he prepared for an engraved series at that time.[39] In one watercolour, *Northampton, Northamptonshire* (private collection, U.K.),[40] he alludes to the danger of opposition to political change. At a political meeting, old Lord Althorp, white-haired and suffering with gout, "clearly symbolizes the spirit of opposition to Reform."[41] Significantly, next to him stands the young Marianne, not "the personification of the French people" as has been stated,[42] but of Liberty. By placing her hand on his shoulder, she provides "both a timely reminder of the recent insurrection in France and a subtle suggestion of the alternative to peaceful concession."[43]

That Turner was conscious of the contemporary association established between Masaniello and Louis-Philippe there can be little doubt. One particular source he seems to have drawn upon for *Undine Giving the Ring to Masaniello* is another ballet entitled *Masaniello* that was performed in London between 1843 and 1848. In this ballet Matteo the fisherman draws in his net to discover that he has caught the sprite Undine. Turner appears to have associated Masaniello with Matteo, since this is precisely the action that Turner represents in his mythic narrative. While in the ballet the sprite, who is in a shell, beckons Matteo into the water among the rocks with a beguiling gesture of her arm,[44] in Turner's painting she holds out a ring from within a glowing orb.

The proffering of the ring establishes the focus of the painting's dramatic action, and therefore the meaning of the gesture is essential to the interpretation of the myth. However, Undine's gesture can be interpreted only when considered with reference to the meanings of other images in the picture that establish the theme of false love. For instance, to the lower right, in the sea, a mermaid holds up a mirror (fig. 109), an established symbol of false love (fig. 110); further, a net filled with fish, such as Masaniello draws in, is a traditional image of deceit (fig. 111).[45] The

most convincing explanation for the proffering of the ring, which supports the theme of false love, is provided by published accounts of the story of Undine and the tribe of Mediterranean sea sprites to which she belongs. According to these accounts the sprites are soulless and therefore mortal. To gain a human soul and thereby achieve immortality, a sprite was obliged to assume human form and trick a human into marriage, a marriage that would seal the latter's doom.[46] The ring that Undine proffers, then, is a wedding band, here a symbol of false love and of Masaniello's destruction that finds a parallel in the fates of Samson and Holofernes in *The Angel.*

Undine Giving the Ring to Masaniello is, in content and colour, the complement and contrast of *The Angel Standing in the Sun.* In these pictures Turner stresses, as he sometimes did in his late dialectical pairs, the opposition of light and darkness and of yellow and blue that he had recently employed in his Deluge pictures (RA 1843). In *The Angel,* the archangel Michael is presented as the pictorial antithesis of the sprite Undine. While this radiant angel exists in the yellow, sunlit, timeless zone of heaven and symbolizes pure nature and goodness, the glowing water sprite is confined to the moist, dark, blue temporal zone of earth, the precinct of corruption and evil. While the figures of *The Angel* represent biblical events of the past whose moral lesson is generally and eternally applicable, it seems likely that the allusion to Masaniello's revolt in *Undine Giving the Ring to Masaniello* enshrines a modern historical allusion, so that while *The Angel* makes a generalized statement about deception, *Undine* makes a more particular one concerning a contemporary situation.

In *Undine,* did Turner intend to associate Masaniello with Louis-Philippe? Did he view them as personifications of freedom, as opponents of tyranny? Both were considered revolutionary heroes; both had been the victims of political intrigue. Both had suffered from assassination attempts. Between 1830 and 1840, the French king had miraculously survived six attempts on his life.[47]

For Turner to have associated the "fisherman king" Masaniello, as he was sometimes referred to in England, with the "citizen king" Louis-Philippe, seems likely. The artist had long known the French king, whom he had first met during the summer of 1815, when they were neighbours at Twickenham. Turner was soon

109 *Undine Giving the Ring to Masaniello,*
Fisherman of Naples (detail)

attracted to him. A remarkable degree of sympathy appears to
have developed between them, especially after the July Revolution
of 1830. That this relationship was sustained is supported by sur-
viving evidence from the 1830s and early 1840s. Probably late in
1835 or early in 1836 Turner sent the king engravings that were
dedicated to him. They were possibly a set of proofs from one of a
recent series of published views. In return, the king sent him a
medal in gratitude and admiration.[48] In 1838 Louis-Philippe pre-
sented the artist with a gold snuff-box.[49] When the king came to
England in 1844 to visit Queen Victoria, Turner was at Ports-
mouth to witness his disembarkation.[50]

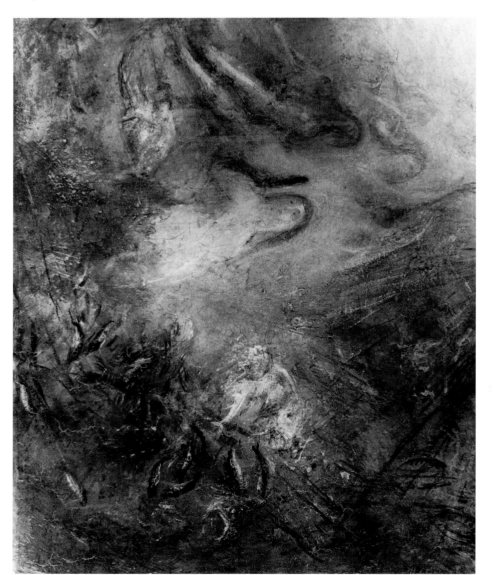

The next year, 1845, when Turner went to France, he visited
the king at his château at Eu, following the visit of Queen Victoria
and the prince consort who had arrived at Tréport on 8 Septem-
ber and the prince consort who had arrived at Tréport on 8 Septem-
ber aboard the royal yacht. Evidence has come to light indicating
that Turner left England for France probably on 18 September.[51]
When Turner eventually arrived at Eu, it was reported by the Red-
graves that he had nothing with him but a change of linen and
sketchbooks. He therefore

found it necessary to have his shoes repaired, and took a lodging in the
house of a fisherman. He had not been long there before an officer of



the court inquired for him, and told him that Louis-Philippe, the King of the French, who was then staying at the Chateau, hearing that Mr. Turner was in town, had sent to desire his company to dinner ... Turner strove to apologise – pleaded his want of dress – but this was overruled; his usual costume was the dress-coat of the period, and he was assured that he only required a white neckcloth, and that the King must not be denied. The fisherman's wife easily provided a white neckcloth, by cutting up some of her linen, and Turner declared that he spent one of the pleasantest evenings in chat with his old Twickenham acquaintance.[52]

The festivities associated with the visit of Queen Victoria and the prince consort were over. But there are several watercolours that suggest that not all festivities were at an end. For example, one sketch represents a glittering banquet.[53] Depicted is a gleaming vast table, illuminated by enormous candelabra and decorated with an elaborate centrepiece of sculpture (perhaps a Diana and stag). However, Turner would probably have had the opportunity to enjoy the company of Louis-Philippe in a more informal atmosphere. Despite the celebrations at the château associated with the visit of the British queen and her consort and the festive functions that seemed to continue after their departure, Turner was probably aware that all was not well with the French king, that his popularity was flagging and that he no longer commanded the respect in his country that he had once enjoyed. He was older now and more set in his ways, and because of a series of recent events, his future was in doubt.

Turner would have heard of at least some of these events. As noted, the king had survived a number of assassination attempts during the 1830s. In 1840 Louis Napoleon, a nephew of the Emperor Napoleon, who was living in England, steamed to Boulogne with fifty conspirators to begin a revolution, but their efforts were thwarted. There were other crises. In 1842, the accidental death of the Louis-Philippe's son, the popular duc d'Orléans, seriously weakened the king's dynastic ambitions.[54] In the next year, 1843, a plot was hatched in London to remove the king, to place the duc de Bordeaux, grandson of Charles X, on the throne. Though this conspiracy failed, the king was probably particularly disturbed to discover that he had been deceived by two peers and five deputies who had previously pledged to him their unswerving loyalty.[55]

110 "c.m.," *False Love.* Engraving from Cesare Ripa, *Iconologia*, Perugia (1765), 3. London, by permission of the British Library (87.k.l)

111 "c.m.," *Deceit.* Engraving from Cesare Ripa, *Iconologia*, Perugia (1765), 3. London, by permission of the British Library (87.k.l)

112 Anonymous, *Attempted Assassination of King Louis-Philippe at Fontainebleau.* Wood engraving from the *Pictorial Times* (25 April 1846). London, by permission of the British Library (27)

Turner was working on *Undine Giving the Ring to Masaniello* following 16 April 1846, when Europe and Britain were scandalized by the news that a further assassination attempt had been made on the life of Louis-Philippe (fig. 112).[56] On receiving intelligence of this event, Queen Victoria immediately wrote to the king congratulating him on his escape. Indeed, it was widely felt that his survival was miraculous; the would-be assassin, a disgruntled gamekeeper, had a reputation for being one of the best marksmen in France. At least one newspaper account referred to the attempt in terms of a struggle between good and evil.[57] Could the act of Undine offering the ring to Masaniello in Turner's painting be a symbolic gesture alluding to the deception and intrigue suffered by Louis-Philippe, especially the recent attempt on

his life? If Turner in this painting compares the political past with the political present, as his contemporaries had often done and as he himself frequently did, then the subject of *Undine Giving the Ring to Masaniello* represents much more than a contrived myth.[58]

11 Light and Colour: Theory and Practice

THE OMNIPOTENCE OF LIGHT that Turner associated with God fascinated him throughout his long life. His engagement with the science of optics and theories of light and colour was an expression of that fascination. He had limited faith in the value of theory, believing that it could fetter creativity. Yet he was not entirely negative about it. Although he had much more respect for science, he believed that both theory and science could be of benefit if they could further his artistic aims. He believed that they could and, indeed, they did. During his career there were several periods when the science and theory of colour seem to have had specific, pronounced effects on his painting. Certain changes in the colour of his work occurred, first as a result of his stay in Venice in 1819 (discussed in chapter 3); second, following a visit to Scotland in 1822; third, during and following a visit to Rome in 1828–29; and fourth, after the publication, in 1840, of Charles Lock Eastlake's edition of the translated didactic part of Goethe's *Zur Farbenlehre*, which the editor entitled *Theory of Colours*.

The subject of light and colour had long engaged Turner's attention. It had penetrated, seemingly imperceptibly, the warp and woof of his early experience. It was strengthened by his early study of the old masters in the Louvre. As was indicated in chapter 2, he often focused on the means employed by these artists to create their pictorial colour effects, hence his particular fascination with the breadth of style and techniques of north Italian painters,

especially the Venetians, and Titian in particular. This interest in style and technique was followed by a study of the science and theory of colour that occurred after his election in 1807 as professor of perspective in the Royal Academy, when he began to prepare his lectures. One of the lectures on light and colour was first delivered in 1811. In preparation for this lecture he undertook, as has been noted, extensive reading that provided him with a basic understanding of the subject, which eventually led him to consider ways in which effects of light and colour could unify and enhance the appearance of his own pictures. The lightening and brightening of his colour was soon achieved in oil painting assisted by the use of a white ground, scumbling, and the application of colour glazes, techniques that he had learned not only as a result of his careful study of old master paintings and of basic optical and colour principles but in consequence of his own experience as a highly skilled watercolourist.

The brighter effects that Turner achieved were noted by Sir George Beaumont, his most vocal opponent, who, as noted, whispered disobliging remarks about his pictures behind his back. Beaumont boldly criticized Turner's methods and their results and also referred disparagingly to younger artists, such as A.W. Callcott, who admired and emulated Turner's effects. Turner and his circle were referred to by Beaumont as the "white painters."[1] Beaumont also sharply criticized Turner in his remark that "Much harm ... has been done by endeavouring to make painting in oil to appear like water colours, by which, in attempting to give lightness and clearness, – the force of oil painting has been lost."[2]

Although we can reasonably assume that such astringent criticism reached Turner's ears, increasing his discomfort, he remained undeterred and continued to heighten tonalities, to suggest the atmospheric brilliance and unifying effect of light. As noted, Turner was aware that nature was considered to be dynamic. He discovered, perhaps in Newton's *Opticks*, that the scientist had alluded to the energetic materiality of space, which he believed was filled with corpuscles of light and ether particles.[3] In the notes for his perspective lectures, Turner spoke of colour as a material substance to stress its tangible nature. "Every body," he observed, "emits or reflects numerous inconceivably small particles of matter from each point and plane of its surfaces,

continually and in all directions."[4] Wherever light penetrates, there is colour, since "Light is ... color."[5]

Turner fully grasped the dynamic materiality of light and atmosphere that had the power to erode form; he attempted to capture their effects in his art. In 1816 Hazlitt anticipated this development in his painting when he remarked that (as quoted in chapter 3) his pictures consisted "too much [of] abstractions of aerial perspective, and representations not properly of the objects of nature as of the medium through which they are seen." The imaginative challenge of these ideas is reflected increasingly in Turner's art and most tangibly in later pictures of history in which transient qualities of nature are emphasized over form. Two of these pictures, which present contemporary themes, are *Rain, Steam, and Speed* (RA 1844) and *The Opening of the Wallhalla, 1842* (RA 1843) (fig. 113). Of the latter, a critic perceptively observed the manner in which the artist created this light- and atmosphere-drenched landscape. He observed that the colour is laid on the canvas in "a successive elaboration of touches, each one more delicate and slightly differing in tint from its predecessor. It is in this way, we believe, he has succeeded, beyond all other artists, in getting the atmosphere – the colour – the depth of nature itself into his pictures. Let any one compare the aerial tint in this picture with those of others in his immediate neighbourhood, and they will at once see and understand the difference."[6] A few years earlier, in 1836, John Constable was apparently alluding to the powerful interaction of atmosphere and colour in Turner's pictures when he remarked that the artist "seems to paint with tinted steam, so evanescent and airy."[7]

Many contemporary or near contemporary artistic handbooks discussed colour and its relationship with light and shade. Some considered it with regard to optical theory;[8] a few, such as George Field in his *Chromatics or, An Essay on the Analogy and Harmony of Colours* (1817), investigated it from other perspectives. In his study Field presents a complex analogical system in which he hoped to persuade his readers that colour possesses a unity "like the universe." Turner knew Field, and Field sent him a copy of this book. While Turner agreed with some of Field's ideas when the two subsequently met, Field asked him for his opinion of this book: "You have not told us too much" was the artist's acerbic retort.[9]

Turner's attitudes to colour had been significantly shaped by the accepted artistic belief that there are three primary hues in nature – red, yellow, and blue (in pigment and in light) – from which secondary colours (orange, green, and purple) can be created. From all six, subdued tertiaries can be mixed. However, Turner was interested not only in the chromatic component of colour but also in its value; its place in the scale between white and black. In his lectures he asserted that "Color, the use of which aids, exalts, and in true union with Light and Shadow, makes a whole."[10]

Turner continued to investigate the nature of colour in the course of his career. Particularly important for his art in this respect was the decade of the 1820s. Indeed, it was during this period that the science and theory of colour and light had a particularly pronounced effect on his art. A crucial moment occurred in the summer of 1822 when he undertook a visit to Edinburgh primarily to discuss the subjects of illustrations that he was to prepare for Sir Walter Scott's *Provincial Antiquities and Picturesque Scenery of Scotland*.[11] After he conferred with Scott, he made an elaborate sketch record of major events of George IV's visit (which had lasted a fortnight). However, there was another reason for his visit; he wished to meet and discuss optical ideas with Sir David Brewster, the eminent Scottish physicist, who at that time was undertaking new experiments with light and colour. Unfortunately for Turner, Brewster was not available at that particular time.[12] However, the scientific and cultural community of Edinburgh (which Turner came to know in 1818) was relatively small and eminently cohesive, and this enabled him to speak of his interests and concerns with at least one of Brewster's circle who was aware of the scientist's current optical experiments.

To understand better the structure of the spectrum, Brewster, in 1821, had begun analyzing light using "absorbing media" or coloured filters. The initial results of this method of analysis were given in that year in a paper entitled "Observations on Vision through Coloured Glasses," which he read before the Royal Society of Edinburgh.[13] A second paper, discussing the absorption of prismatic rays by coloured media, followed shortly after; this paper, which he read before the Society in the spring of 1822, had especial relevance, it would seem, for Turner's art. Brewster indi-

113 *The Opening of the Walhalla, 1842.* Oil, on mahogany panel, exh. 1843. 44 $^{5}/_{16}$ × 79 in. (112.5 × 200.5 cm). London, Clore Gallery for the Turner Collection (BJ 401)

cated that he believed the spectrum proposed by Dr William Wollaston (1766–1828) and Thomas Young (1773–1829), composed of four colours – red, green, blue, and violet – was wrong.[14] As a result of experiments with colour filters, Brewster concluded that yellow, which these scientists had omitted from the spectrum, had, in fact, "an independent existence in the spectrum."[15]

Unfortunately, the context of that experiment and its results were not adequately presented in its originally printed form and gives an analysis of his results without ever describing the observations on which the analysis is based. We are left in the dark so to speak."[16] Brewster, in recalling his early experiment, noted that after examining the absorption and transmission of coloured rays through a glass filter, he inferred that "blue light mixed with yellow gave green, and yellow light mixed with red gave orange."[17] When he demonstrated to his satisfaction that yellow was a potent component of the spectrum, he was not implying that he believed that the spectrum was composed of four colours.[18] Rather, these remarks, which concern the mixing of colours red, yellow, and blue, suggest that by 1822 he had already considered that the spectrum might be composed of "three overlapping spectra of [the three] primary colours."[19] That he had proposed this at that time can now be given some support from a significant published analysis in the *Edinburgh Journal of Science* published in 1825 – three years after Brewster delivered his paper – in which the anonymous author, who probably knew Brewster, observed that in his paper the scientist had considered "that the orange and green are really composite colours"; this, "if verified," opined the analyst, "would be a fact of the highest importance."[20]

Thornbury reported that while in Scotland (date not given) Turner, though unable to speak with Brewster, discussed the physics of light with "savans." The results "enabled him to create the varied effects he has displayed in his works."[21] Evidence indicates that the discussions took place in 1822, and one of the "savans" with whom Turner probably had discussions was the amateur artist, historian, and scientist James Skene the younger, son of the Laird of Rubislaw.[22] Skene was engaged in scientific writing[23] and

displayed a particular interest in optics.[24] In a tribute to Skene following his death Brewster stated that he had possessed "a great general knowledge of science."[25] Compelling evidence suggests that Skene knew Turner. J.G. Lockhart, Sir Walter Scott's son-in-law, states in his biography of Scott that Turner and Skene met in Scotland and, indeed, had been companions.[26] There is also an indication, tenuous as it may be, that Turner borrowed a sketch or watercolour from Skene for one of his own watercolours depicting an episode from the king's visit to Edinburgh in 1822.[27] But there is more persuasive evidence.

In early 1823 Skene published an article on painting in the *Edinburgh Encyclopaedia* (edited by Brewster) in which allusion is made to George IV's Scottish visit in the late summer of the previous year. This article considers the way in which the dynamic effects of natural light and colour influence the appearance of landscape, effects that the art of painting can only hope to "approximate." The article also contains a discussion of Turner and his art.[28] This appears to be the first important published account of Turner's interest in optical ideas. The context of the article suggests that Skene discussed Brewster's new light experiments with Turner, since the article includes a reference to Turner's fascination with optics in relation to his art. Skene considered that by investigating the possible application of optical concepts in painting, Turner was following a "new route."[29]

There is still further evidence that Turner's "new route" was stimulated by what he had learned while in Edinburgh in 1822. Some watercolours for the *Rivers of England* series that were completed after his return to London reflect his attempt to apply optical ideas to painting, to make pigment colour mimic the effects of light. These effects are sometimes striking, as in his prismatic *Norham Castle* (fig. 114) which, stylistically, must date from late 1822 or, more likely, early 1823. This small watercolour shows the sun low in the sky behind the ruins of the castle, which is positioned on a bluff overlooking the slow-moving Tweed. What Turner appears to represent are the dynamic effects of sunlight. The watercolour shows that the sun's rays pass over and through the openings of the ruins. The shadowed portions of the castle wall in the immediate vicinity of these openings display remarkable prismatic colour effects. Is it possible that Turner was familiar

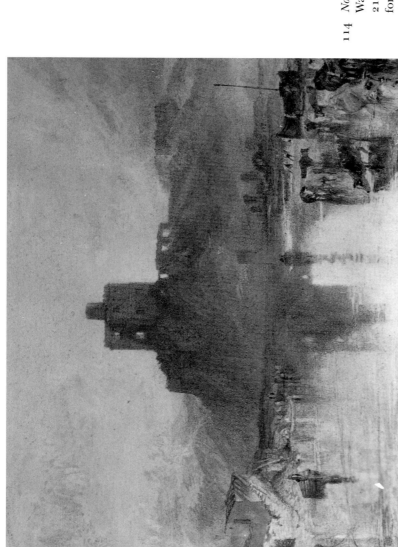

114 *Norham Castle, on the River Tweed.*
Watercolour, c. 1823. 15.6 ×
21.6 cm. London, Clore Gallery
for the Turner Collection
(TB CCVIII, O). See colour plate 13

with the phenomenon of "inflexion" (diffraction) described in Newton's *Opticks*?[30] (Inflexion results from a beam of white light striking the edge of a solid body or being directed through a small opening, resulting in the splitting of the beam into a series of coloured spectra.) It appears likely that he was. In the watercolour minute, discrete, transparent dots of the primaries – red, yellow and blue – appear in the shadows immediately around the edges and openings of the ruin. Two of these three colours occasionally, but systematically, are superimposed on another – red on blue, yellow on blue, and yellow on red – to produce dots of purple, green, and orange. These dots of colour are produced by the point of an exceedingly small (probably a miniaturist's) brush.[31] What Turner is representing are the three primary "coloured" rays – "divergent" rays – which he believed are deflected and re-

flected to produce the three secondary "coloured" rays. Though Turner accepted the widely held artistic premise that these three basic colours, from which all other colours derive, exist in nature, Brewster's researches at that time with coloured spectra, with the mixing of what he believed were the three rays of primary colour to produce the rays of secondary colours, appeared to give this artistic premise scientific legitimacy; Turner's experiment in this watercolour seems to allude to this premise.

Turner continued in his Royal Academy lectures to augment and develop his ideas on light and colour. In one of his early lectures on light and colour he had prepared watercolours of glass spheres, one partially and one completely filled with water, to demonstrate the principles of reflection and refraction.[32] For a later version of this lecture, perhaps in 1825, he prepared two

colour diagrams whose configuration of integrated triangles within a circle displays both material and aerial hues.33 As Lindsay first observed, the integrated triangles within a circle that compose his colour diagrams indicate that Turner had studied Moses Harris's *Natural System of Colours* (1811) and had adapted Harris's colour circle for his own purposes. Turner discarded Harris's diagrammatic colour arrangement and devised his own, replacing Harris's dominant red with yellow.34

Pigment colour, with its limited strength and range of values, is vastly inferior to light colour; this, all artists understood. Turner was particularly conscious of the shortcomings of pigments. He considered yellow the most efficacious of aerial hues and the closest colour to white light, the generator of colours. Yellow in pigment colours, despite its inferiority to aerial yellow, he adjudged superior to other pigment colours because of its association with white light. In his later pictures yellow, not surprisingly, often dominates, which led eventually (in 1846) to a published caricature showing him wielding a mop drenched in chrome yellow that is about to encounter the surface of one of his canvasses (fig. 115).

Turner's convictions concerning colour – and yellow in particular – are expressed symbolically in his two colour diagrams; for there, yellow is given pride of place. The superior position assigned to yellow in his diagrams may have have been suggested by the diagram in M. Gartside's *New Theory of Colours* (1805), which is a single triangle showing the three primary colours, with yellow at its apex, since, as Gartside observed, "Yellow, from its brilliancy [has] an affinity to light."35 However, Turner himself had long believed in the particular efficacy of this colour and its association with light.

The nature of Turner's two diagrams has not been fully understood. These diagrams attempt to recognize the relationships and distinctions that, he believed, exist between pigment and light colours. By demonstrating that the three primary hues, whether in pigment or in light, have significant tonal relationships, one to the other, he has emphasized the essential role of light and darkness in their dynamics. Though he indicates that when these colours are mixed they produce secondary colours, he has omitted from both diagrams the secondary colour purple. Turner apparently felt that the darker value of purple might con-

fuse the viewer; since the artist wished to consider here not only colour but also the broader concept of darkness and light that is inextricably associated with it.36

The two diagrams represent, separately, aerial and material colours, though in them Turner attempts, as we will see, to relate them diagrammatically. In the first diagram, *Colour Circle No. 1*, (fig. 116) Turner depicts three triangles of the primary "light" or aerial colours – red, blue, and yellow. The second diagram, *Colour Circle No. 2*, (fig. 117) depicts triangles of the three "material" or pigment colours – red, yellow, and blue. In the first diagram the two lower triangles, those of blue and red, abut; the third, superior triangle, which overlaps those of blue and red, is yellow. This overlapping results in yellow mixing with the blue and red to produce, respectively, the secondary colours green and orange. The second diagram shows smaller triangles of material colour in which the yellow triangle is once more in a superior position to those of red and blue.37 All three triangles overlap each other to show a grey/black, which demonstrates that when physically mixed, these material colours are destroyed and are considered, apparently, the equivalent of darkness.38

The enclosing circles of these two sets of colour triangles reveal further complexity. In the diagram of aerial colours (*No. 1*) the colour ring displays the three material colours arranged in contiguous bands, with yellow once more placed in a superior position in the upper part of the circle and the darker blue and red in the lower part. In the diagram of material colours (*No. 2*), the enclosing ring is composed of the three aerial hues, with yellow at the top, red and blue at either side, and dark grey/black at the bottom. In this ring the aerial colours (and the portion of dark grey/black) do not appear as discrete bands, as in diagram *No. 1*, but as bands that clearly flow into each other in order to show that the colours are aerial and dynamic. They represent, as Turner observed, "lights in continuation … [which are] incorruptible … [and which when] commixt [produce] white."39 However, the dark grey/black portion of the ring appears, not as light or even as a "colour" but, it would seem, as a symbol of the absence of light. In its position at the bottom of the ring it is opposite yellow, which is at the top, the nearest colour equivalent of white light.

It would be misleading to suggest that Turner at any time possessed a personal theory of colour. He would not have agreed with theorists and artists who devised colour "recipes." He would have rejected outright Benjamin West's notion that, for example, "*the Order of Colours in a Rainbow,* is the true arrangement for Colours in an Historical picture."[40] Yet he seems to have subscribed to a natural harmony of colours, since he believed that this harmony inheres in light as an expression of the underlying unity of nature. The colours, he seems to have believed, when interrelated in certain ways, can result in determinable visual effects that are intrinsically harmonious. This harmony, of course, is predicated on the centrality and dynamic interaction of red, yellow, and blue.[41]

Light and colour were pictorial qualities that increasingly interested him. A greater intensity of colour is notable in his canvasses and his watercolours and gouache drawings, especially

those painted during the second half of the 1820s. At this time reviewers frequently took issue with the colour effects as they appeared in his exhibited pictures. In 1825 he exhibited his *Harbour of Dieppe* at the Royal Academy, which brought forth a barrage of criticism. The reviewer of the *Literary Magnet* (3, 140) objected to this "brilliant experiment upon colours, which displays all the magic of skill at the expense of all the magic of nature."[42] Although the artist had chosen a specific scene from nature, he failed to match it with the colours of nature. Another exhibition-goer had the following reaction to this picture: "No one can find fault with a Garden of Armida, or even of Eden, so painted. But we know Dieppe, in the north of France, and can't easily clothe it in such fairy hues."[43] In the *Literary Gazette* of the next year (13 May), a similar criticism was directed at his *View of Cologne.* The reviewer spoke of its "glitter and gaud" but admitted that "it is im-

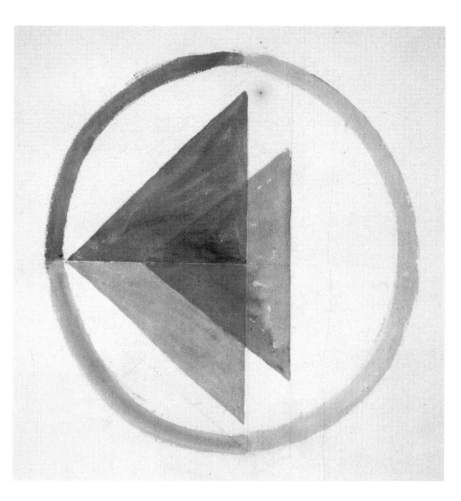

116 *Colour Circle No. 1*. Watercolour, c. 1825. 54 × 74.3 cm. London, Clore Gallery for the Turner Collection (TB CXCV, 178). See colour plate 14

possible to shut our eyes to the wonderful skill and the lightness and brilliancy which he has effected; so that had the subject been a fairy scene, we should have regarded it with admiration."

Turner continued to experiment with pictorial illumination and in 1828–29, during and following a second visit to Rome, his paintings seem to have displayed increasingly striking colour effects. In Rome he shared the studio accommodation by the Spanish Steps in the Piazza Mignanelli with his painter friend, Charles Lock Eastlake, who, in advance of his arrival, had been instructed to purchase painting materials for him.[44] Eastlake was a staunch supporter of Turner and considered him the foremost painter in Britain. At this time, Eastlake was attempting to "form his own style," thereby to gain freedom "from the influence of the age and its taste."[45]

While in Rome, Turner began painting, according to Eastlake, eight or ten pictures,[46] completing; it would appear, only four: two historical landscapes whose subjects are classical, *Vision of Medea* and *Regulus* (see chapters 4 and 6), and two pure landscapes, *Palestrina* and a view of Orvieto. *Medea, Regulus,* and *Orvieto* were exhibited in rooms where he had moved not far from the Quattro Fontane. They were hung in crude frames of rope painted with yellow ochre. Although viewed by thousands of visitors, the pictures were not well received. "How they [the critics] talk" Eastlake wrote; it "would be worth relating if they knew anything of the matter ... Regulus is a beautiful specimen of his peculiar power, yet the wretches here dwelt more on the defects of the figures and its resemblance to Claude's compositions than on its exquisite gradation and the taste of the architecture. The latter was perfect for beauty of design, more Italian than Italy itself."[47]

The colour of *Vision of Medea* (fig. 33) as it originally appeared must have been remarkably strong. When later shown in London, in 1831, it aroused severe criticism. The reviewer of the *Gentleman's Magazine* (May) considered it "a daub of unseemly colouring – a mere chaotic mass of pink and yellow." Less negative was the writer for the *Literary Gazette*, who exclaimed: "Colour! colour! colour! Still there is something so enchanting in the prismatic effect which Mr Turner has produced, that we soon lose sight of the extravagance, in contemplating the magical result of his combinations" (7 May). Turner introduced a Titianesque style

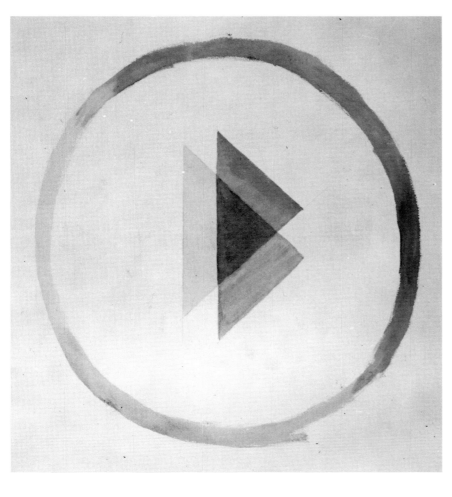

117 *Colour Circle No. 2.* Watercolour, c. 1825. 54 × 74.3 cm. London, Clore Gallery for the Turner Collection (TB CXCV, 179)

and rich colour whose intensity, though diminished over time, indicates that he wished to achieve a special lighting effect. He is not essentially concerned with daylight but with artificial illumination. The artist appears to have enhanced his colour and light effects to emulate contemporary stage lighting. However, the relatively intense light that is reflected from the bodies of these figures, even considering the loss of some surface glazing,[48] cannot be easily explained by the dim, soft, spreading illumination of traditional stage candles and oil lamps, and so one must seek another reason for its unusual strength. I believe that Turner was trying to create the more intense, dramatic effects of the new gas lighting introduced to the London stage as early as 1817 in the Drury Lane Theatre and the Lyceum Opera House.[49]

The King's Theatre, Haymarket, was one of the London theatres that soon followed the lead of Drury Lane and the Lyceum and installed this new lighting system. In 1818, it hung a grand chandelier with gas burners and also gas footlights that significantly modified the stage illumination, altering the effect of the costumes and the scenery: "the stage picture was somewhat changed in the brighter luminous flux from the gas jets, and the new scenery must have been made with somewhat altered technique, with deep and darker, *more saturated colour* and a more exact, plastic painting of light and shade."[50]

If Turner attended a performance of *Medea in Corinth* at the King's Theatre between 1826 and 1828, which now seems likely, he would have viewed this production lit by gas. We can reasonably assume that the effects created by this new lighting would not have gone unnoticed by him.[51] The staging effect resulting from this stronger lighting and the advantages of a "gas table" that controlled and coordinated all illumination within the theatre heightened and focused the richer, colourful appearance of costumes and sets.[52] As well, the lighting would have increased and given cohesion to the expressiveness of the stage action – especially in an opera such as *Medea in Corinth* – and particularly to the staging of the dramatic incantation scene that Turner, while in Rome, seems to have selected for his *Vision of Medea.*

However, there are other factors that influenced the dramatic intensity and variety of colour in Turner's works painted at this time, especially his history paintings. I believe we must exam-

ine his specific association with Eastlake, who was a proponent of the Venetian technique. Turner, already long familiar with the scumbling and glazing of the Venetian method, most likely discussed with him the rich variety of light and colour effects that could be achieved and that he demonstrated in the distinctively Titianesque style and technique of his *Vision of Medea*.

Turner returned to London from Rome early in 1829. The pictures he exhibited in Rome were to be shown at the Royal Academy exhibition in the spring, though, in the event, they were not shown because they failed to arrive in time. For that reason, he prepared the painting of *Ulysses Deriding Polyphemus* (fig. 34) based on an oil composition (discussed in chap. 4) that was almost half the size of the finished picture (fig. 35).[53]

Turner's *Ulysses Deriding Polyphemus* is in many respects one of his most important historical landscapes; indeed, one of his supreme achievements. It is a significant summing up of pictorial ideas on colour that had crystallized by the second decade. By this time he had come to realize that the unifying principle of colour in an historical landscape is light rather than what he considered "Historic tone," an overall muted tone. However, the character of the colour presented in *Ulysses Deriding Polyphemus* is also, in some respects, an anticipation of the greater engagement with colour that his later works reveal.

When shown at the Royal Academy in 1829, *Ulysses Deriding Polyphemus* elicited the same critical disapproval that its companions had received in Rome. However, reaction in London was not entirely negative. The critic of the *Athenaeum* (13 May) remarked,

If sober reason will not allow us altogether to approve this wonderful display of Mr. Turner's power, yet can we not withhold from it our admiration. The colouring may be violent, and "oversteps the modesty of nature"; and, were that alone to be considered, the picture could not be justified: but the poetical feeling which pervades the whole composition, the ease and boldness with which the effects are produced, the hardihood which dared to make the attempt, – exhort our wonder and applause. It should be borne in mind, moreover, that the subject is not drawn from the common realities of life. Nor do we see that the blood-red effects which accompany the mounting car of the God of day and light, tinging the scattered vapours with brightness and amber, and burnishing the gal-

ley of the hero, protected by the Ægis-bearing Goddess, are at all more out of nature than the Cyclops himself. How colossal and mysterious the form of the monster appears, as we view him writhing under the agonies of the recently-inflicted torture, and obscured by the vapours of Ætna!

One can only imagine how striking in colour the painting originally appeared. But these effects also elicited remarks that were not so complimentary. The *Morning Herald* (5 May) observed that Turner's picture demonstrated that his bright colouring was getting worse and had "reached the perfection of unnatural tawdriness. In fact, it may be taken as a specimen of colouring run mad." What is unusual and of especial interest and, I believe, significance, are the last lines of this review, in which reference is made to *Ulysses* possessing "all the vehement contrasts of a Kaleidoscope or a Persian carpet." What the kaleidoscope and Persian carpet have in common is not only rich varieties of colour but colours that are presented as *strong two-dimensional shapes*.[54] This flattening and isolation of specific colours in defined areas is a fundamental characteristic of Turner's *Ulysses*. It has been suggested that Turner had been impressed by the paintings of the Italian primitives that he had seen in Rome,[55] which may be so. What is certain is that the particular colour effects of *Ulysses* had, up to that time, no equal among his exhibited pictures.[56]

The artistic priority of colour over form as demonstrated by Turner in *Ulysses Deriding Polyphemus* was not novel. It had long been investigated in theory and practice and had led to serious consideration of the aesthetic of colour "blots" or abstract colour composed in a suitable manner, sometimes without reference to any subject matter.[57] For example, the structure of abstract colour was thoughtfully discussed by Thomas Tredgold in "The Principles of Beauty in Colouring" in the *Philosophical Magazine* (1817):

If we suppose a piece of canvass to be covered with unmeaning masses of light and shade, richly and harmoniously coloured, and the light and shade distributed by the tasteful hand of a superior artist; there cannot be doubt respecting the beauty of such a composition: and it is evident that its beauty proceeds from two causes; the one arising from association, the other from sensation. The pleasing effect produced on the eye would lead us to admire the skill and knowledge displayed by the artist;

and the effect would not be diminished, at least in the eye of a trained judge, when he found that it was not an imitation of any particular object.[58]

Turner seems to have become increasingly aware of the abstract implications of form and colour in art, not only as a result of the growing breadth of his own style but also, perhaps, from the experience of what he had read. If he had earlier carefully studied Richard Payne Knight's *Landscape* (1794), he may have noted that Knight remarked that an object appears on the retina as a two-dimensional pattern that is similar to its appearance on the surface of a work of art.[59] However, the abstract shape of an object on a two-dimensional surface is also a subject discussed in treatises on perspective that Turner had read, many of which included, as did Knight's book, discussions of the relationships between the two-dimensional nature of pictorial images, the three-dimensional objects in the external world and their two-dimensional projection on the retina, which is translated by the experienced mind.[60] Indeed, this knowledge is reflected in Turner's notes for his Royal Academy lectures.[61] He observed that "All bodies ... become the objects of perception from Figure [shape] or color."[62]

However, there is a good possibility that the change in Turner's use of colour in *Ulysses* was due, at least in part, to the recent influence of Charles Eastlake. In Rome, the two artists almost certainly discussed the nature of art, and probably also the contents of an essay concerning the philosophy of the fine arts that Eastlake was then preparing for publication. The essay was accepted in 1829 for publication by Sir Walter Scott's son-in-law, John Gibson Lockhart, editor of the influential *Quarterly Review*. However, it was later withdrawn by Eastlake and was not published until 1848 as a "fragment" in *Contributions to the Literature of the Fine Arts.*

One of the important aspects of this essay is Eastlake's discussion of the role of colour in nature and art. He considered it a preeminent quality, since "all creatures endowed with sight are assisted by colours in distinguishing objects for physical purposes." Indeed, colour, he believed, was more essential in defining objects than were light and shade: "The varieties of forms, aided by all the relief which light and shade can give, would be insufficient

to enable us to discern objects clearly without the aid of colour." It appears, he continues, "that throughout nature, colour serves this purpose only; and, if so, it may be said to approach the abstract idea of distinctness."[63] Turner would have been receptive to Eastlake's ideas of abstract colour, because he was already favourably disposed to them. These specific ideas may be boldly embodied in *Ulysses Deriding Polyphemus.*

In Turner's work from the last years of the 1820s onward, clearly presenting the three-dimensional existence of objects is often not a priority. The solidity of depicted forms is in many instances undermined by his increased attraction to light, colour, and atmosphere, which suggest nature's ephemeral effects. The traditional role of colour as an adjunct to form in chiaroscuro painting is often diminished in his work as, increasingly, colour shapes assume the role of form and provide pictorial structure.

The greater responsibilities that light, colour, and atmosphere assumed in Turner's art, as in *Ulysses Deriding Polyphemus*, place, therefore, a particular burden on the spectator who must interpret these colour shapes. As Turner's art became less descriptive and more abstract and expressive, less important as a mirror of nature and more significant as a crucible of his own responses to nature, greater effort was required to interpret it. In this way Turner significantly extended the language of his art, though there was public resistance to it, demonstrated by the shrill complaints of contemporary critics.[64] The philosopher Dugald Stewart had understood "spectator effort" as a reflection of the enhanced role of expression during the romantic era: "To deceive the eye by accurate representations of particular forms, is no longer his [the history or landscape painter's] aim; but, by the touches of an expressive pencil, to speak to the imagination of others. Imitation, therefore, is not the end which he proposes to himself, but the means which he employs in order to accomplish it: nay, if the imitation be carried so far as to preclude all exercise of the spectator's imagination, it will disappoint, in a great measure, the purpose of the artist."[65]

But it is not only colour shapes that are remarkable in *Ulysses Deriding Polyphemus*: the range and balance of prismatic colour that it still displays, while not unique in his painting, is notable. The nature of the colour suggests that in his conversations with

Eastlake during this Roman visit he may have absorbed some ideas derived from Goethe's *Zur Farbenlehre* (1810), which Eastlake, an avid enthusiast of German culture, probably had read by this time and may have explained to Turner, since Turner did not read German.[66] It is remarkable that the quality and disposition of light and colour presented in *Ulysses* seems to conform to some degree to principles that are at the heart of Goethe's theory.

It is necessary first, however, to consider briefly Goethe's *Zur Farbenlehre*, particularly the didactic part of the theory that Eastlake believed would be useful for artists. This part of the treatise contains sections on physiological, physical, and chemical colours, followed by three parts that include headings concerned with such topics as the metaphysics of colour and the relationship of colour to other disciplines, including psychology, aesthetics, and ethics. In the introduction to the English translation of this part of the treatise, which he published in 1840, Eastlake, as both translator and annotator, adjudged the work more "applicable to colour harmony" than any that derived from the established doctrine" and that it utilized "the phenomena of contrast and gradation, the two principles which may be said to make up the artist's world, and to constitute the chief elements of beauty."[67] Eastlake also alluded to Goethe's strong anti-Newtonian stance. Goethe had savagely attacked Newton's theory of colour in his treatise,[68] though his vehemence seems initially to have been the result of a misunderstanding of Newton's aims, due to the "defective presentations of Newton's theory in eighteenth-century texts" that he had consulted.[69] After discovering this error, he was not mollified; he became convinced that Newton's version was still flawed. Goethe objected to his mathematical approach, since he believed that, because of its highly abstract nature, it was difficult to reconcile its results with the human perception of colour. Indeed, mathematics, he was convinced, obscured the phenomenal world, which should be the object of study. Though mathematics addressed the quantitative in nature, it failed to consider the qualitative.[70]

Goethe adjudged the basic defect of Newton's system to be methodological. He was convinced that Newton "had marshalled

his evidence to prove a theory, not to become acquainted with the subject matter."[71] Goethe vehemently assailed Newton's assertions concerning the nature of white light and the production of colour. Newton had concluded that white light is compound, containing, he believed, seven colour-producing rays of different refrangibility, whose existence and nature were verified by his experiments with the prism.[72] Goethe disagreed; he maintained that on the basis of observation white light is homogeneous and that by stating it is compound, Newton had destroyed the unified, harmonious character of light.

Goethe had developed his theory of colours from his experiments with the prism. He accepted that the prism creates colours, though he disagreed that they are produced from white light. He believed that colour is produced by the prism at the boundaries of light and darkness and this, he deduced, is the consequence of the interaction of darkness and light (an Aristotelian concept) in a prism, which, in his view, is comparable with a colourless, semi-transparent (turbid) medium. He believed that light exists in permanent opposition to darkness, which he adjudged a force in nature as powerful as light. All colours contain a degree of darkness, he asserted, and are expressed in terms of a system of polarities. He believed that there exist two fundamental, contrasting colours – blue and yellow. One is cool in nature, the other warm. These two colours are created by augmentation, which is the darkening or intensification of colour caused by the interaction of darkness and light in different proportions. When these colours are further augmented, blue tends to violet and yellow tends to red.

It has already been noted that Turner was conscious of the materiality of atmosphere and light, and these seem to play a dynamic role in *Ulysses Deriding Polyphemus* (fig. 34). Since the mixing of darkness and light is, as noted, at the heart of colour production in Goethe's theory, it is possible that Turner's painting reflects some of his ideas. Two notable areas in *Ulysses Deriding Polyphemus* suggest this: first, a large blue/light violet area to the left, which is on the surface of the billowing smoke in the vicinity of the mountain or headland that supports the flailing figure of the one-eyed giant Polyphemus; a second location is in the right of the picture, where a contrasting strong, yellowish ambient

space (enriched with small patches of red cloud) encircles the brilliant morning sun, "the mounting car of the God of day and light."

Darkness and light that mix under particular conditions are the cause of various colour effects, according to Goethe. If darkness is viewed through a semitransparent medium, such as atmosphere, and a little white light is directed toward the surface of that atmosphere, this light, largely reflected from its surface, mixes with the darkness that penetrates through the atmosphere, resulting in the creation of a blue colour. Blue, Goethe associated with darkness. One widely experienced natural effect Goethe used to demonstrate his principle is that of smoke rising from a chimney, which, when seen against a dark background and illuminated by a small amount of white light, appears blue in colour.[73] Blue, then, is the result of background darkness penetrating through this atmosphere and interacting with a little light that strikes the surface of the atmosphere. If this atmosphere is thinned, more darkness penetrates through it to interact with the small amount of light, resulting in a deeper blue. Further thinning of the atmosphere results in a greater amount of darkness interacting with the small amount of light, resulting in "the most beautiful violet."[74] Yet further thinning leads to the penetration of more darkness, which eventually leads to the creation of black.

In *Ulysses Deriding Polyphemus* the (white) light glances off the smoke and mist to the left of the rising sun; this is to the right of and below the figure of Polyphemus. The thickest concentration of smoke and mist is here, and it possesses a strong blue tinge. To the left and above, the smoke and mist obscuring the shadowed figure of Polyphemus and the headland on which he lies is much thinner and takes on a delicate violet hue. Turner may have been illustrating Goethe's principle that colour is produced by background darkness penetrating through a turbid medium (the smoke and mist) and mixing with a little light.

Similarly, the yellow effulgence and red clouds associated with the rising sun to the right in the painting may demonstrate the other principle of colour production in Goethe's theory, that is, the creation of the second fundamental colour, yellow, which, like Turner, Goethe adjudged the nearest colour to white light. While blue and violet result from darkness penetrating through a

thickened atmosphere and interacting with a little white light on its surface, yellow, considered blue's opposite, is the result of a white light source (here, the sun) placed *behind* the semitransparent medium or atmosphere so that the light is transmitted through it. In passing through the medium, the light interacts with some darkness that the medium contains and emerges on the other side of the medium as yellow. If the semitransparent medium or atmosphere is thickened, as in a cloud, its component of darkness is thereby increased so that more darkness interacts with light, with the result that when the light emerges, it appears as a yellow-red (orange). If the atmosphere is thickened further, the yellow-red becomes red. Yellow depends on the interaction of yellow-red with a little darkness; increase the darkness and the the result of the interaction is the tendency toward red.[75]

The suggestion that Goethe's ideas influenced Turner's *Ulysses Deriding Polyphemus* must, however, remain tentative. Still, if this picture does *not* reflect Turner's awareness of Goethe's ideas, then, in some respects, it establishes a remarkable coincidence of theory and independent artistic observation that furnishes an explanation for Turner's later interest in the *Farbenlehre*. This interest is expressed in his paired Deluge pictures that are the subject of the next, final chapter.

12 "*The dark'ning Deluge*": Shade and Darkness and Light and Colour, *the Late Deluge Pictures*

The deluge was a shadow of the day of judgment, the everlasting salvation of some and destruction of others at that day.[1]

THE PAIRED HISTORICAL LANDSCAPES *Shade and Darkness – the Evening of the Deluge* and *Light and Colour (Goethe's Theory) – the Morning After the Deluge – Moses Writing the Book of Genesis* are remarkably complex works that are among those impressive few and radically different visionary pictures by Turner of the last decade.[2] When exhibited at the Royal Academy in 1843, these two paintings, with their then vivid, glazed colouring were not a *succès d'estime*. The gallery-going public must have been baffled by them; many critics were. The *Spectator's* critic (13 May) perceived "in these two octagonal-shaped daubs only two brilliant problems – chromatic harmonies of cool and warm colours." The assessment of the reviewer for the *Times* (11 May) was harsher. He assailed *Shade and Darkness* as a "ridiculous daub," and its pendant, he opined, was even worse: "A wretched mixture of trumpery and conceits, involving an anachronism that the meanest scholar at a parish school could rectify." As will be explained, the underlying intellectual order of the pictures redeems them from such strictures.

But there was an important prelude to the creation of these two pictures: it was Turner's notations scribbled in the margins, and sometimes the text, of his copy of the *Theory of Colours*, Eastlake's edition of the didactic part of Goethe's *Zur Farbenlehre*. What this edition contained, however, was not entirely new to Turner; there were concepts that he had previously studied or encountered in contemporary and earlier British books on the nature of light and colour;[3] Also, it seems almost certain that by the time he made these notations, he had discussed Goethe's theory with Eastlake.

Yet these notations are difficult to interpret and, indeed, sometimes defy interpretation. They are occasionally careless and usually brief. Sometimes it is not clear to which printed line or lines they refer or what particular issues they address. It is also uncertain what significance can be accorded to the sections of this work that he has left unmarked. Still, his notations are important, since they are his only known written response to what Goethe had to say. As they have already been transcribed and scrutinized,[4] I shall refer only to those notations that appear germane to the discussion of these two pictures.

Though Turner expressed a limited faith in theory, his notations proclaim that he and Goethe agreed on several matters. Painter and poet shared the gift of bringing together disparate elements toward an organic whole;[5] they embraced the notion of the unity of nature, the subjective, qualitative approach to colour, and the intimate relationship between value and hue. They were also in agreement that darkness, light, and colour can be symbolic. Turner was especially attracted to the section in the *Theory of Colours* concerned with the metaphoric, symbolic, and mystical uses of colours in painting, a subject that Goethe in his treatise, however, never fully addressed.[6]

But there were also disagreements with Goethe. These disagreements abound, and they are as instructive and revealing as their shared interests and similar outlooks. Turner took issue, for example, with Goethe's failure to distinguish between material and aerial hues; it was a valid criticism. Yet the notations reveal that some disagreement was due to misunderstanding. Turner seems not to have comprehended some of the inner complexities of Goethe's system. For example, he did not fully grasp what Goethe had to say about the number, nature, and relationship of the primary hues. As a painter, he had long subscribed to the estab-

118 *Shade and Darkness – the Evening of the Deluge*, Oil, exh. 1843.
31 × 30 ¾ in. (78.5 × 78 cm). London, Clore Gallery for the
Turner Collection (BJ 404). See colour plate 15

lished view in British artistic circles – which had been given scientific support by Brewster – that there exist in nature three primary colours – red, blue, and yellow. To Turner, Goethe appeared to be vacillating between two and three principal colours – blue and yellow and red, blue, and yellow. However, this was not so. Though Goethe conceded that painters, for practical purposes, were justified in assuming that there were three primary colours (red, blue, and yellow) from which others could be created,[7] his was a highly personal theory based on two fundamental and opposing near-complementary hues – blue and yellow.[8]

Turner's notations occasionally betray mild irritation. As has been rightly observed, Goethe's repudiation of Newton seems to have chafed him.[9] Yet, surprisingly, the notations do not indicate clearly a preference for the fundamental concept, derived from Newton, that colour is the product of light, nor do they offer support for Goethe's belief that colour results from the interaction, under certain conditions, of darkness and light. Still, Turner seems to have remained convinced that light is the prime active principle in nature and art and the cause of colour.[10]

When Goethe observed that he "found a primordial vast contrast between light and darkness, which may be more generally expressed by light and its absence,"[11] Turner disagreed. He objected to Goethe's reference to the "absence" of light. Though he would have admitted that it was theoretically possible to speak of absolute darkness, in practice this was uncommon. In one of his lectures delivered at the Royal Academy in his capacity as professor of perspective, he observed that "Darkness or total shade cannot take place while any angle of the light reflected or refracted can reach an opposite plane."[12] He seems even more persuaded of the pervasiveness of light in one of his notations in his copy of the *Theory of Colours*. He directly questioned whether one can ever experience "actual darkness," since "the smallest portion of Light – the retina acknowledges."[13]

Some of these notations illuminate aspects of Turner's Deluge pictures. Dialectically related, *Shade and Darkness* (fig. 118) and *Light and Colour* (fig. 119) offer a religious subject that has been manipulated in order to accommodate Goethe's and Turner's own ideas. In these pictures two of the most crucial underlying themes – they are not treated in a mutually exclusive way

119 *Light and Colour (Goethe's Theory) – the Morning after the Deluge – Moses Writing the Book of Genesis.* Oil, exh. 1843. 31 × 31 in. (78.5 × 78.5 cm). London, Clore Gallery for the Turner Collection (BJ 405). See colour plate 16

– concern the nature and relationship of light, darkness, and colour and the biblical subject of fall and redemption. The principles of darkness and light establish the appropriate contrasting tonalities that furnish the sequential narrative logic of their subject matter: the allegorical evening before and morning after the Flood. Goethe's reference to "the *primordial* phenomenon of light and darkness"[14] may have inspired him to select for his pictures the subject of the Noachian Deluge from Genesis, since darkness and light play such a significant symbolic role in that book.[15]

Shade and Darkness and *Light and Colour* provided Turner with the opportunity to consider the theoretical relationships – especially the relationships between darkness and light – that he had earlier essayed in his paired historical canvasses *Lord Percy* and *Watteau Study* (RA 1831; see chap. 7). Darkness and light, considered as discrete, abstract concepts, are presented in each of these two pairs: darkness dominates one picture in each pair; light the other. Theoretical principles may be illustrated, but in each pair Turner also seems to take issue with or allude to the limitations of the very principles he considers.

While Goethe considered darkness negative and light positive, John Gage concludes that Turner was of the opinion that both light and darkness had a positive value. He states that in the Deluge pictures Turner wished to express his criticism of Goethe for neglecting to establish "the equality of light and darkness as values in art and nature."[16] As proof of this, he repeats Turner's rejoinder from the marginal notes to Goethe's rhetorical question, "If the eye be sunny [alone] it could not know darkness," Turner's response was, "were the eye not sunny, how could we perceive light?"[17] Gage believes that *Shade and Darkness* "is the visual embodiment" of Turner's "rejoinder to Goethe."[18] That Turner's response acknowledges his own conviction that the eye must also be sensitive to darkness is surely correct. However, it does not necessarily follow from this that his conviction is specifically embodied in *Shade and Darkness* or that the two Deluge pictures demonstrate his belief in the "equality of light and darkness as values in art and nature, which [Gage states] Turner felt Goethe had unduly neglected."[19] Though it is reasonable to say that Turner entertained the belief that light and darkness, as discrete principles, can be considered equal, in a practical sense this is not so. While, practically, they are interdependent,

this interdependence does not imply equality. Turner was convinced that light, which is positive, holds dominion over darkness, which is negative.

Though Turner emphasizes light in one painting and darkness in the other, in order to establish their essential contrast, these pictures also involve the dynamic interaction of light and darkness. *Light and Colour* displays, as has been observed, a spectral brilliance and a limited (though necessary) use of shade; light pervades an earth that is still largely submerged. For Turner, as shall be argued, this was essentially a spiritual world. *Shade and Darkness* is not primarily concerned with light, and yet light functions in it as an active force. When Turner answered Goethe's statement that darkness is the absence of light with the rather obscure reply that "nothing about shadow or Shade as Shade and Shadow Pictorially or Optically,"[20] he was referring to the efficacy of light, to the necessary intervention of light in darkness.

This is demonstrated in *Shade and Darkness*, where Turner depicts primarily the dark material realm, whose inhabitants were designated by God for destruction. It is in this domain that light and shade (necessary for the depiction of form) most effectively function. The title is helpful, I believe, in determining some of the artist's meanings. By coupling the words "Shade" and "Darkness" in that particular order, Turner wished not only to establish the direction of the process involved as the light of day is withdrawn but also to make the point that the creation of shade requires the presence of light. Further, as mentioned, he was of the opinion that in nature the perception of complete darkness seldom, if ever, occurs; if and when it does, colour is extinguished. This might help to explain why Turner expressed dissatisfaction with Goethe's statement that darkness is the absence of light. His response (to repeat, "nothing about shadow or Shade as Shade and Shadow Pictorially or Optically") seems to suggest that in this picture he wished to reestablish, through the intervention of light in darkness, a unifying range of chromatic values between the polarities of full light and complete darkness. The fact that shade and shadows are attributable only to the action of light, which seems to be what Turner is demonstrating in *Shade and Darkness*, and that light is the cause of colour, as he indicates in the companion picture *Light and Colour*, is surely an affirmation of his

belief in the primacy of light; he seems to have believed that light, like God, is omnipotent.

R.D. Gray was the first to suggest Turner was criticizing Goethe's contention that colour is the creation of a mixture of darkness and light by alluding in *Light and Colour* to the Newtonian principle that colour is the product of light alone.[21] Gage concurs with Gray's belief that Turner was alluding to this Newtonian principle but denies that in doing so the artist was criticizing Goethe's account of the creation of colour from light and darkness.[22] Gray was surely correct in observing that the Deluge pictures illustrate the Newtonian principle that colour is the product of light. Though this cannot be clearly inferred from Turner's notations in his copy of the *Theory of Colours*, there is compelling evidence that he was convinced that colour creation depends on the refraction of white light, as Newton had postulated. As has been demonstrated, there are references to this idea in his Royal Academy lecture notes.[23] Allusions to colour creation according to Newton, however, are also associated with the Deluge pictures themselves. In addition to the large rainbow-hued bubble that contains the composition of *Light and Colour*, there are the picture's poetic lines, which refer to prismatic bubbles "emulous of light"; both suggest colour creation by means of light.[24] Further, by linking "light" with "colour," in that sequence, in the title of the picture, Turner also implies that colour is created from light.

There is yet more persuasive evidence in *Light and Colour* that Turner is suggesting colour creation according to Newton. If, as is generally agreed, this painting does contain allusions to Goethe's theory (since it is mentioned in this picture's title), one might reasonably assume that the large bubble and its rainbow hues are part of that theory. However, Goethe's reasons for the appearance of colour on bubbles are not readily determined, and he fails to explain the cause of the rainbow.[25] Since Newton discussed bubbles and the rainbow in his *Opticks* and clearly explained the cause of their colour, it is reasonable to assume that Turner is illustrating colour production according to him.[26] Still, it would be incorrect to say that *Light and Colour* does not refer to Goethe's precepts. The prominent curving sweep of brushwork on the periphery of this colourful bubble illustrates Goethe's observation that colours on bubbles rotate.[27]

Gage's remark that in supporting Newton Turner was not criticizing Goethe's theory of colour creation in *Light and Colour* must be examined. Though Gage states that in his marginal notes Turner was "little concerned ... with the anti-Newtonian basis of Goethe's ideas,"[28] he was, nonetheless, concerned with it. That Turner did not make more evident his reaction to Goethe's anti-Newtonianism in his copy of the *Theory of Colours* could be explained by the relatively oblique manner in which Goethe expressed his opposition in this, the didactic part of the treatise. It would not readily have attracted Turner's strong polemical response. However, the Deluge pictures themselves appear to furnish convincing evidence of such a response. It seems likely that, as with his earlier companion pictures *Watteau Study* (fig. 68) and *Lord Percy* (fig. 69), his Deluge pictures not only illustrate theoretical concepts but also involve a critical assessment of them. Since Turner did not illustrate Goethe's fundamental principle of colour creation in a painting purportedly (according to the picture's title) illustrating Goethe's theory, surely this must imply a criticism of Goethe's principle.[29]

In his Deluge pictures Turner appears to have been interested in Goethe's observations of natural phenomena, specifically his observations of the sky. Goethe was, however, not merely describing what he saw but providing illustrations of colour creation. In his theory Goethe considered that transient colours are produced in "certain material mediums" that result from mixing darkness and light. When he discusses dioptrical colours of the first class he describes the medium of atmosphere (a "material medium") as being characterized by degrees of transparency.[30] Light and darkness can interact there and produce "simple and remarkable phenomena."[31] He then describes the particular conditions in nature that result in the creation of the two prime colours – yellow (which he considered to be the result of darkening light) and blue (which he claimed results from the lightening of darkness).[32]

Concerning yellow, Goethe noted, "The highest degree of light, such as that of the sun ... is dazzling and colourless [white] ... This light, however, seen through a medium but very slightly thickened appears to us as yellow. If the density of such a medium be increased, or if its volume becomes greater, we shall see the light

gradually assume a yellow-red [orange] hue, which at last deepens to a ruby-colour."[33] In considering the creation of blue, he noted that "If ... darkness is seen through a semi-transparent medium, which is itself illuminated by a light striking on it, a blue colour appears: it becomes lighter and paler as the density of the medium increases, but on the contrary appears darker and deeper the more transparent the medium becomes: in the least degree of dimness short of absolute transparence, always supposing a perfectly colourless medium, this deep blue approaches the most beautiful violet."[34]

In presenting the particular conditions under which these two prime colours appear, Goethe does not always explain the process clearly. A useful clarification, however, has already been discussed.[35] Yellow, the opposite and near-complement of blue is created as the result of placing the white light source behind a semitransparent medium. The white light is transmitted through the medium to produce a yellow. In this particular example, what Goethe does not state is that the medium contains a degree of darkness that affects the nature of the colour; the greater the density of the medium, the greater the amount of darkness it contains and the greater the impact of it on the colour. The consequence of this is that if white light passes through a medium of a certain density, yellow is created; if this light passes through a medium of greater density, the yellow changes to a yellow-red (orange). If the medium is thickened further, the light becomes red.

Goethe's reasons for the creation of blue are equally vague in their presentation. Because of this, it is once more necessary to outline the method employed. Instead of beginning with white light behind a semi-transparent medium, one begins with darkness behind the medium. Darkness penetrates through the medium and when it emerges, mixes with a small amount of white light reflected from the surface of this medium. In doing so, it produces blue. By thinning the medium, more darkness penetrates through it to mix with the small amount of white light to create a "most beautiful" violet. Further thinning eventually results in the creation of black or absolute darkness.[36]

Because of the abstractness of theory, Goethe believed that it should not crowd out or obscure the empirical evidence on which it is based.[37] For that reason, he describes for a second time, and

in greater detail, the creation of the phenomena of the "atmospheric colours," yellow and blue; this recapitulation and elaboration makes his principles and processes somewhat easier to grasp:

The sun seen through a certain degree of vapour appears with a yellow disk; the centre is often dazzling yellow when the edges are already red. The orb seen through a thick yellow mist appears ruby-red (as was the case in 1794, even in the north); the same appearance is still more decided, owing to the state of the atmosphere, when the scirocco [sic] prevails in southern climates: the clouds generally surrounding the sun in the latter case are of the same colour, which is reflected again on all objects. The red hues of morning and evening are owing to the same cause. The sun is announced by a red light, in shining through a greater mass of vapours. The higher he rises, the yellower and brighter the light becomes.[38]

Regarding the blue in the sky he writes: "If the darkness of infinite space is seen through atmospheric vapours illumined by the day-light, the blue colour appears. On high mountains the sky appears by day intensely blue, owing to the few thin vapours that float before the endless dark space: as soon as we descend in the valley, the blue becomes lighter; till at last, in certain regions, and in consequence of increasing vapours, it altogether changes to a very pale blue."[39]

As has been mentioned elsewhere, it was likely an empathetic quickness of mind that led Turner to recognize these descriptions and explanations of colour in the sky (its yellow and red effects produced at sunrise and its blue colour in daylight) as significant indicators of the fundamental importance of nature to Goethe.[40] Still, recognizing and comprehending are frequently different processes. There is no particularly compelling evidence to indicate that Turner understood that these descriptions of natural phenomena were illustrations of the creation of colour by means of the intermixture of darkness and light.[41] Nonetheless, Goethe's descriptions appear to have determined certain effects in his two paintings: the dominance in *Light and Colour* of warm colours, especially yellow and red, which are indicative of a rising sun, and the appearance in *Shade and Darkness* of cooler colours, especially the striking accent of blue in the evening sky. This blue

colour is complemented by the smallish patch of lighter blue that identifies the ark situated in the middle distance.

Deep tones make *Shade and Darkness* a decidedly gloomy picture. It shows a sky in which areas of brooding black and purplish-grey cloud ominously overhang a particularly dark landscape and are presented against a backdrop that includes, as has been observed, a portion of bright blue sky. In the central distance a brilliant shaft of moonlight, an almost spiritual light, flashes down on the swelling flood waters and especially on the bluish-coloured ark, toward which a long column of paired beasts proceeds. In the shadowy left foreground a primitive shelter partially protects the bodies of two sleeping humans. Above this dusky landscape a line of intensely black birds threads its way across the menacing sky.

By contrast, the companion picture, *Light and Colour*, is awash with a rich blend of colours of swirling prismatic brilliance – light from the sun that has recently risen above the horizon and the receding waters of the Flood. In the upper central portion of the picture the small, fragile-looking figure of Moses is ensconced on a cloud-wreathed mountaintop writing the book of Genesis. Immediately below him is the brazen serpent hanging from a pole. Below this are the retreating flood waters, on the surface of which bob human bodies, some of whose heads are enclosed in shining bubbles. One big rainbow-hued bubble, mentioned previously, is the "window" through which the picture's subject matter is viewed. For all their complexity of subject matter and vagueness of imagery – or perhaps because of them – these pictures possess a remarkably powerful effect.

While Turner disagreed with Goethe about colour creation, he was clearly receptive to what Goethe had to say about the contrasting and complementary attributes and tendencies of his two prime colours, even though he seems not to have been in full agreement with him. The verses that Turner attached to *Shade and Darkness* and *Light and Colour* allude to the attributes of yellow and blue that are mainly, though not entirely, listed in the twin columns of Goethe's table of polarities.[42] One column lists the attributes and tendencies of yellow, the positive colour; the second lists the attributes and tendencies of blue, considered the negative colour. This table aided Turner in developing his pictures' moods. It will be remembered that the accent of blue in *Shade and*

Darkness is the one vivid colour among many sombre hues. The atmosphere is dark and foreboding, signalling the approach of both night and calamity. The poetic lines from his "Fallacies of Hope," associated with this picture, help to convey the mood:

> The moon put forth her sign of woe unheeded;
> But disobedience slept; the dark'ning Deluge closed around,
> And the last token came: the giant framework floated,
> The roused birds forsook their nightly shelters screaming
> And the beasts waded to the ark.

The poetic phrase "disobedience slept" refers to the two sleeping figures in the left foreground that appear to personify the material fallen world and allude to death.[43] This gloomy phrase also embodies the negative and passive qualities that Goethe associated with blue.[44] The line "The roused birds forsook their nightly shelters screaming" suggests feelings of anxiety and restlessness that Goethe had also assigned to blue.[45]

The lines attached to the yellow-accented companion picture, *Light and Colour*, also from his "Fallacies of Hope," are of especial importance, since they seem to assist in determining the meanings of both paintings. Because Goethe considered yellow (the closest colour to white light) active, positive, and suggestive of gaiety,[46] it would initially appear that *Light and Colour's* swirling epiphany of brilliant sunlight and aerial hues presents a lively, positive mood and thus contributes a suitable contrast to the negative, dark and brooding atmosphere of *Shade and Darkness*. Yet the poetry associated with *Light and Colour* makes it eminently clear that the shimmering imagery of this picture is neither cheerful nor optimistic.[47]

> The ark stood firm on Ararat; th' returning sun
> Exhaled earth's humid bubbles, and emulous of light,
> Reflected her lost forms, each in prismatic guise
> Hope's harbinger, ephemeral as the summer fly
> Which rises, flits, expands and dies.

These lines allude to a light-filled (morning) world of change that eventually leads to despair and death, very much in the spirit of

the verse attached to one of Turner's early exhibited works.[48] It is perhaps because yellow is mutable and, according to Goethe, "active" and associated with the transience of morning light that Turner gave it a negative connotation.

By mentioning "Hope's harbinger" in his poetic lines attached to this painting, Turner was not referring primarily to bubbles but rather to their "prismatic guise," which had suggested to him the rainbow, traditionally a symbol of hope. However, both bubble and rainbow are "ephemeral as the summer fly / Which rises, flits, expands and dies," and so hope is fleeting.[49] Yet the brief existence of the fly, a reference to life that ends where it begins, is also a powerful allusion to the dynamic cycle of nature. This natural cycle, an emblem of unity and universal harmony, is a symbol of permanence in change: the individual fly will perish, but its progeny and future generations will sustain nature's renewing, cyclical process, to which, indeed, the circular movement in the Deluge pictures' compositions (especially *Light and Colour*) may possibly allude.

This cycle of nature also embraces individual and collective human life and thereby accommodates aspects of the Deluge pictures' biblical theme. For example, in *Light and Colour* the poetical reference to the death of the fly and the depiction of the figures whose heads are contained in bubbles, symbolizing the transience of human life, remind the reader/viewer that death and decay, and thus temporality, are the legacy of the fallen Adam, whose redemption God had carefully planned and which promised humankind deliverance from the ruin of the Fall.

But the meanings of the Deluge pictures elaborated by narrative metaphors of biblical history are still more profound and mysterious. Their subject figures forth, as has been noted, the theme of sin and redemption. Near the compositional centre of *Shade and Darkness* is the ark of Noah, and near the centre of *Light and Colour* is the Brazen Serpent, both symbolic prefigurations of salvation. Also, the apocalyptic character of these pictures, like that of the slightly later *Angel Standing in the Sun*, confers on them palpable overtones of the day of judgment; indeed, "The deluge was a shadow of the day of judgment."[50] Themes of death and revival and of fall and redemption, which recur in the Bible, seem to have had especial interest for Turner. And these ideas are embodied

specifically in the stories of Noah and Moses, who were considered as types of Christ and are the Deluge pictures' protagonists.[51]

However, it would not be true to say that these dynamically complex and allusive pictures involve only two protagonists. A third is God. Notably in *Light and Colour*, Turner suggests the spiritual in the natural. God's presence is alluded to in that picture in the brilliant morning sunlight. In popular religious texts light was associated with God.[52] And as observed previously, Turner had used this solar metaphor before; for example, in his vignette the *Mustering of the Warrior Angels* (engraved 1835). Subsequent to painting *Light and Colour*, he employed it in *The Angel Standing in the Sun*. And on his deathbed he is reputed to have uttered the words, "The sun is God."[53]

In the Bible, God intervened in the affairs of Noah and Moses. This intervention is suggested in *Light and Colour*. Moses is presented on the mountaintop writing the book of Genesis, which was inspired by God; this same image seems also to refer indirectly to Moses on Mount Sinai recording the Ten Commandments dictated to him by God.[54] Below the figure of Moses and above the waters of the receding Flood, on the peak of a lower mountain, Turner has depicted the Brazen Serpent raised on a pole (foreshadowing the Crucifixion)[55] that was cast by Moses on the instruction of God. It was created to save Moses' people who, having angered the Lord with their complaints, were fatally bitten by poisonous snakes but who, having repented (by gazing at the Brazen Serpent), were miraculously cured. These events allude to the redemption of humankind and may also refer to God's covenant, of which the rainbow (suggested by the prismatic effect on the large bubble) was the visible sign.[56]

There is a further episode involving God and Moses to which Turner likely alludes in *Light and Colour*. It is perhaps one of this picture's most intriguing images: the dramatic image of human bodies floating on the surface of the receding flood waters. Though this occurrence is palpably intended to represent the consequence of the Flood, it appears to be accorded further significance, since it also suggests the story of the passage of the Israelites through the Red Sea: "six hundred thousand men, beside women and children ... 'were all baptized by Moses in the sea,' by passing through the place of the element [the Red Sea], which

afterwards refused the same passage to the Egyptians, who, attempting it, were drowned."[57] The particular allusion in Turner's picture seems to be to the drowned soldiers of Pharaoh's army, who personified evil. Both events, the Deluge and the Red Sea episode, were part of God's scheme of redemption, assuring humankind of deliverance from the Fall. This salvation through the agency of water served as a preparation for, or prefiguration of, baptismal purification, an *imitatio Christi*, when the sins of humanity are washed away and life begins anew.[58]

The overlapping and interrelating of themes in these pictures involve the association of two lights: spiritual light and material light. It has been established that Turner believed that material light is the source of nature's colour; he considered it a dominant, positive force, since its presence causes shade and colour and its absence results in darkness. His advocacy of the Newtonian principle that colour is contained in white light reflects a point of view that extended back to his early investigation of particular ways in which nature's dazzling, changing light effects could be captured in paint.

Though both his watercolour *Norham Castle* (c. 1823; discussed in chap. 11) (fig. 114) and his much later painting *Light and Colour* seem to indicate that colours are dynamic and derive from white light, their colour effects differ, and these differences are instructive. In *Norham Castle* Turner effectively demonstrates that light and colour inhabit shadow. The shaded portions of the castle, and most especially those round its broken edges and openings, significantly radiate prismatic colour. Closely allied in value, minute dots of the primaries and secondaries contained in these shaded areas are intended to indicate the subtle, momentary sparkling of light in shade.

In *Light and Colour*, however, the temporal effect is different. It has been extended. Turner has, with remarkably expressive power, created patches of strong red and yellow in the sky associated with adjacent, though different, zones of atmosphere, in order to allude to the swelling brilliance of the rising sun that displays first red, and then yellow. Also, by means of his broad brushwork he has suggested, as noted, the migration of colours over the surface of the large bubble that Goethe had described.[59] In this picture, then, Turner has presented the viewer not with an

instant but rather with transitional effects that suggest the *process* of light and colour discussed by Goethe.[60] This process, in the case of sunlight in this picture, is also an allusion to the changing but unending night/day cycle. Turner, like Goethe, attempted to comprehend and express nature's dynamism, which is part of the universe's inherent harmony.

Turner and Goethe seem to have concurred in the general belief that light is an active, positive force and that darkness is passive and negative. They also shared an interest in the causes of colour and its changing nature. Though Turner rejected Goethe's ideas of colour creation and supported those of Newton, he nonetheless appears to have agreed with Goethe's idea of colour change. As noted above, while the large bubble in *Light and Colour* illustrates colour creation according to Newton, the curving brushwork on its surface suggests, paradoxically, the rotating nature of colour on bubbles that Goethe had identified. Also, in both *Shade and Darkness* and *Light and Colour* Turner, with brilliant readiness of mind, illustrates the transitional nature of colour in the sky that Goethe described. This was astutely pointed out by Frederick Burwick when he remarked that in the Deluge pictures Turner illustrates the blue-black of approaching night (or, more correctly, from Turner's perspective, the ebbing of daylight!) characteristic of the sky effect in *Shade and Darkness*, which functions in dioptric polarity to the red-yellow associated with the rising sun in *Light and Colour*.[61]

Though many of the pictorial colour effects in *Light and Colour* are based on Turner's understanding of optics and acute observations of nature, they have been given fresh meaning as a result of what Goethe had described and discussed in his *Theory of Colours*. Eastlake had stated in the introduction to his edition that the contents of the treatise could be useful to artists. Turner seems to have been less convinced of this than Eastlake. Still, Goethe was a poet with a poetical vision, and Turner was certainly attracted to what he had to say. His theory, Turner claimed, was unspecific enough to allow the creative artist freedom of interpretation: "Goethe," he observed, "leaves us ample room for practice even with all his theory."[62] Certainly, Turner did not always agree with, and indeed, did not always appear to grasp, Goethe's ideas. However, he seems to have concluded that in the hands of an art-

ist of genius, the theory could be given artistic significance. In the ramified content of the Deluge pictures, he has brilliantly demonstrated this. In these two works of deep originality, he seems to have engaged the full expressiveness of pictorial colour within a theoretical and historical framework. Since he explored metaphorical and symbolic potentialities of colour – some ideas based on what Goethe had written, others that were his own – he would have concluded that in these two paintings he had introduced colour effects related to light that satisfied the exalted demands of high art; specifically, those of the historical landscape.

Epilogue

R USKIN REMARKED THAT Turner's genius was "exceptional, both in its kind and in its height: and although his elementary modes of work are beyond dispute authoritative and the best that can be given for example and exercise, the general tenor of his design is entirely beyond the acceptance of common knowledge, and even of safe sympathy. For in his extreme sadness, and in the morbid tones of mind out of which it arose, he is one with Byron and Goethe; and is no more to be held representative of general English landscape art than Childe Harold or Faust are exponents of the total love of Nature expressed in English or German literature."[1]

Turner was uncommon. The formidable nature of his talent made him so. This exploration of major examples of his art demonstrates the striking uniqueness of his creative vision. It shows his perceptions to have been acute and his culture wide. Many of these pictures broke through the constraints and privileges of traditional painting and vigorously challenged conventional artistic ideas. This is especially true of the historical subjects painted after his first visit to Italy and the literary illustrations. They communicate meanings that do not depend on the restrictive or exclusive vocabularies that define established categories of landscape representation. In challenging conventional ideas his art, though it shadows forth a highly personal world of remarkable depth and richness, became, on many levels, less accessible.

History, as has been shown, is, in many respects, central in Turner's art, and because of this it has been possible to reveal more completely the complex structure and unusual texture of his mind. He identified closely with a world that had disappeared or was slipping away. Hence the elegiac treatment of some of his pictorial subjects. Still, he made an effort in his art to preserve and strengthen history's continuities: he was convinced that the past could illuminate the present. Conversely, he believed that the present could provide insights into the past. Also he thought that both past and present could furnish trustworthy intimations of the future.

Turner's historical landscapes often allude to design and direction imposed either from below or from above. The Fates who control and thwart the aspirations of humankind are often alluded to in the themes of his paintings and the poetical tags that accompany them. Indeed, Ruskin wrote of Turner that the thread of Atropos (the Fate who cuts the thread of life) can be traced "throughout all his works and life."[2] Turner was also attracted by the Christian theme that life is controlled by forces beyond the power of humanity. The fall of humankind from grace, with its consequent mutability, sinfulness, and the need for redemption, helped establish the cycle of creation and dissolution, a dynamic that underlies and shapes the subjects of a number of his pictures.

Turner's vision of history was exalted and spacious, in part because of its complex content and expansively allusive nature. Enriched by a spectrum of ideas gleaned from past or recent events, from typology, technology, and science, and from myths and legends, both public and private, his historical landscapes and literary illustrations were invested with new life and meditated meaning and were elevated to the heady realm of poetry.

Unlike most of his artist contemporaries, Turner was prepared to respond to the impact of technology on his society and to consider pictorially ideas that science could provide. Science, like technology, was part of Turner's changing world, and by the eighteenth century, scientists had begun to consider nature dynamic, not static, animate not passive. Though it would appear that Turner in many respects resisted change, paradoxically it was nature's dynamic character that fascinated him; it deepened his understanding and urged on him a more acute appreciation of nature's fleeting qualities and of the brevity of human life.

One could argue that Turner believed man to be not simply an individual who passes through history, "who experiences history, who meets history. No, man is nothing but history, for he is, so to speak, not an active being but someone to whom things happen."[3] Turner fervently hoped that something would happen to him; that he would receive the recognition that he believed was his due. He was persuaded that as an exceptional artist with a

poetical vision he had earned his place in the sun. It was reported that he confided to his old friend and patron, Walter Fawkes, that he was the "Great Lion of the Day,"[4] this was perhaps his candid acknowledgment of a daunting, original talent that he believed should be commemorated. One of the most touching allusions to his desire to be remembered is diffidently expressed in verses that he scribbled in one of his many sketchbooks:

Some tokens of a life, not wholey passed
In selfish strivings or ignoble sloth
Haply these shall be found when I am gone
Wh[ich] may dispose thy candour to discern
Some merit in my zeal & let my words
Out live the maker.[5]

Appendix

The following excerpt (156–65) is from the H.H. Langton (expurgated) typescript copy of the Sir Daniel Wilson Journal (B65–0014). I am grateful to the University of Toronto for permission to publish this excerpt. The entry is dated 25 May 1889:

I was young and wholly inexperienced in the world's ways. I had left the old home with five pounds in my pocket, and all the world before me where to choose my place of work, and Providence my guide; as with experiences to be smiled at now. The mail brought welcome letters from her who was already the lodestar of my life. The chances of being able to set up a home of my own seemed remote enough. But after unsuccessful attempts in various directions I introduced myself to Alderman Moon – then foremost among art publishers, and by and by Sir Francis Grahame Moon, Lord Mayor of London. His place of business was a small old-fashioned nook behind the Old Exchange which was burnt down while I was leading [a] bachelor life in London. In the clearance that followed for the new building and the widening of adjoining thoroughfares Moon's old nook in Threadneedle Street vanished. In the privately printed memoir of William Miller – a quarto that would have benefited by condensation – is a letter of W.M.'s addressed to "The Great Art publisher" on the 22nd of eighth month 1839, in which that liberal patron of art is most wisely bound down in very specific terms of 650 guineas as the payment for the engraving of Turner's "Modern Italy" on a scale of 24 inches by 17. But W.M. stood in the fore front of engravers, and had to be sued, not to sue. I presented myself to the Alderman hat in hand, as a young adventurer, with my reputation to win, soliciting his aid to help me to the opportunity. I found him a wonderfully oily, fair-spoken gentleman, delighted to patronize rising talent, as long as he saw a reasonable prospect of coining his patronage into gold! He invited me to dine with him at Finsbury Square, a most patronizing act of condescension. We discussed

Turner and high art, fame, fortune, and futurity; and it was finally agreed that he was to secure the copyright of one of Turner's pictures [p. 157] which I was to engrave on the largest scale for £100, and if successful it was to be followed by another at £500. Had I been rich in the world's wisdom I should have insisted on reducing the terms to writing. But the money element was of small account with me then, not that I was trouble[d] with any excess of it! I was eager to be allowed an opportunity to try my prentice hand; and that secured I had no fear for the future. The "Moon" in later years figured in "Punch" and other comic sheets as foremost among the City luminaries. He had succeeded to the shop and business of the more famous Alderman Boydell in the quaint, crooked, and narrow old London thoroughfare which vanished half a century ago. Fortune smiled on him. He achieved wealth, a knighthood and Whittington's civic chair. I read in later years in the Athenaeum of the death of his son and heir by his own hand. He was not held in honour by the artists whom he patronized, and occasionally with ostentatious display. But he was a shrewd man of business, knew what would sell, could diagnose the aesthetic susceptibilities of art patrons, feel the pulse of the public, flatter the weakness of a sanguine aspirant for fame, and with the help of his own moonshine turn all into gold.

Under the guidance of this civic Apollo I drove in a cab to the dingy old mansion, 47 Queen Anne St West, to have my first introduction to the great painter, and if possible obtain permission to engrave one of his pictures. I had been a devout worshipper of him before the "Oxford Graduate" undertook to be his prophet. But I was also familiar with the stories of his eccentric vagaries, and his parsimonious greed. Had I known his better qualities, as I learned afterwards to appreciate them, I would have gone directly to the painter; and probably fared better. His old housekeeper, a queer bundle of wrappages, opened the door and after some parleying ushered us into a room on the ground floor. The shutters were only partially open, and the window-panes, obscured with dirt, admitted very imperfectly the light of a gloomy November day. [p. 158] After what seemed a long delay the door was abruptly opened by an old, slovenly dressed, slouching little man, as remote from the ideal of artist or poet as could well be conceived. Yet even then I noted the wonderful flash of his keen grey eyes, which redeemed the otherwise vulgar and sensual look. They were very odd eyes, very partially opened, and shining through the two little chinks below his eyebrows in a very cunning and irate fashion. The alderman had been condescendingly patronizing me

in a very ostentatious fashion, to which, as became a humble suppliant, I meekly submitted. But so soon as the painter's eyes were fixed on him all this vanished. Turner's style of address was abrupt, if not insolent. He was dealing with one of a class who made money out of him, and would over-reach him if they could. So he abruptly addressed Moon: "Well, what do you want?," pretty much in the style that one would use to a begging im-poster, and the Alderman's patronizing airs vanished. The interview, however, was not unexpected. Turner was only revenging himself for old experiences when he had to go, hat in hand, to such patrons. I trembled for my chances of success, but his man-ner to me was more gracious, and after inspecting some specimens of my handiwork he responded with an amiable grunt. I was introduced into the gallery cumbered with the treasures of art that now fill the Turner galleries at Trafalgar Square, and he indicated the picture he chose to let me have. It was not the one I would have chosen, but it was triumph enough to get one of his choice. My youthful ambition was in fair way of realization. With all the enthusiasm of a young dreamer I stole into St. Paul's, and at the close of the service knelt at the altar rail and prayed for success in what seemed to me then a great undertaking. And to a youth dependent on his own pen and pencil for bread, a work that involved the labour of many months was no trifling undertaking.

The door of the strange house in Queen Anne Street was no longer closed to me. I paid repeated visits there, found that the great painter could [p. 159] be kind and even genial to an enthusiastic youth, while grimly ridiculing his enthusiasm. I was privileged to enter the "Inaccessi-ble gallery" where, in dust and damp, were piled against the wall some of the choice pictures seen by me for the first time after they became the the property of the nation.

As to "The embarkation of Regulus" on which I was allowed to try my prentice hand, it is one of a class bluntly characterized by Ruskin as "nonsense pictures," and when in later years the great art critic com-mended my translation of the picture, he added: "But it is labour thrown away; for the picture is one of Turner's grand mistakes, an artifice, not a study." As a piece of sunlight, however, it is a wonderful study. It lights up my room as though I had learned in those days the art of extracting sun-beams from cucumbers.

The "Regulus" which Turner entrusted to me was first exhibited at the British Institution in 1837, and did not meet with a purchaser; nor is it one that – even were I a wealthy man – I would select for myself. It is

one his "Claude" compositions; though, as I found, nothing could in-cense him more than to hint at any trace of Claude in his pictures. It is an artificial vista of architecture and shipping, arranged after the fashion of the side scenes, on the stage; but redeemed by many apt minor details, and above all by the marvellous glow of sunshine. In the "Memorials of Hope Park" the privately printed memoir of William Miller and his kin, is a letter from the eminent engraver, Pye. Mr John Pye wrote to w.M. invit-ing him to engrave a plate from the pictures in the National Gallery of "the picture by Claude (perhaps the most perfectly beautiful specimen of that Master) of which the accompanying is a memorandum." The memo-random sketch accordingly shows the pillars of an impossible ruin mar-shalled in stage fashion at one side; a pillared facade meeting [matching] it at the other; a tower with an archway beyond; and the blazing sun with its bright illuminated path over the waters. If it were designated the Claude receipt for landscape composition [p. 160] – as it well might be – then Turner's "Regulus" is undoubtedly fashioned after the same pre-scription, though much less artificial and improbable. But both painters went direct to nature for the mastery of sunshine and atmospheric effect. After criticism has done its worst, the beauty of the National Gallery Claude as a grand triumph in the representation of sunlight charms ev-ery lover of true art, and makes him indifferent to the theatrical disposi-tion of the scenic display. It is greatly to be regretted that w.M. was unable to undertake the engraving, and so to have fulfilled in another and more durable form the ambition of Turner to marshall his own best works in rivalry with those of Claude. But in one respect at least the artist of Lorraine has Time on his side. His pictures are solidly painted, with enduring pigments. Turner would seemingly make any sacrifice to get the effect he aimed at. He had, moreover, worked so much and on so large a scale in watercolours that he was prone to resort to the same pro-cesses when painting in oils. The "Regulus" is hung too high to admit of any close inspection; but judging from its general effect, I fancy it is still much in the same condition as when I was familiar with every touch on the canvas. But should it ever pass into the hands of an unwary picture cleaner, my engraving may acquire a value as the memorial of a lost pic-ture. There was a story current among the artists of my early days of Wal-lis having obtained one of Turner's pictures to engrave, and rashly setting to work with sponge and water he washed the clothes off the principle group of figures and otherwise reduced the picture to a condition that compelled him to return it to the painter, and put an end to his chance

of ever engraving another "Turner"! The story has every probability in its favour. My own experience was that in making a slight attempt with the wet corner of a silk handkerchief to remove a spot of dirt, I made the discovery that if my operations were extended the whole clouds and tinting of the sky, with much else, would vanish, as they are all painted over an oil ground in mere size colours. These had obviously [p. 161] darkened, so that allowance had to be made for this in finishing the engraving.

The great African city which somehow deeply imprinted itself on Turner's imagination, is symbolized by palatial architectural piles, and shipping of archaic form and rigging crowd the harbour. As to Regulus, the small figure in Roman toga descending the grand flight of steps of the palace on the right, he is not likely to be noticed in the original picture – is indeed out of sight as it now hangs. In the final touches as the engraving drew to a close, Turner gave more prominence to it in the touched proof. In a group of sailors on the left in the foreground, the barrel of nails is introduced in a much more prominent fashion, in allusion to the cruel fate of the Roman Consul on his return; while – according to the motto composed by Turner for another of this class of pictures, his "Decline of the Carthaginian Empire" : –

While o'er the western wave the ensanguined sun
In gathering haze a stormy signal spread,
And set portentous.

He was indeed a true poet in the rendering of the ideal of his subject through the medium of his art, making sky and cloud, sunshine and gloom, harmonize with the theme and embody a story that needed no interpreting motto. But as for his attempts in the peot's [sic] art with pen instead of pencil, and an inkbottle superseding the palette, they are the most singular demonstrations of a poet "wanting the facility of verse," and in truth any command of language.

The Claude-like composition of the "Regulus" so impressed my mind that soon after my first visit to the Gallery in Queen Anne Street West, I devoted a day to the study of the Claude engravings in the print room of the British Museum; and on the whole regarding it as a commendable mark of zeal. I mentioned it to Turner on my next visit. To my surprise he assailed me in the wildest manner. Much good Claude would do me! What did I mean? Did I intend to copy his painting? What did I know of Claude? etc. etc. I was alarmed lest [p. 162] he should withdraw the coveted painting, just as my ambitions were on the eve of realization; and after soothing his ire to the best of my ability, I took good care never again to mention the name of Claude in his hearing. But henceforth I fully appreciated his sense of rivalry with the great French landscape painter, and was in no degree surprised when, in making the splendid bequest of his gallery of paintings to the nation, he conditioned that one of his "Carthage" pictures, and a beautiful sunrise, should be hung between Claude's two great pictures "The Seaport" and "The Mill."

The gruff onslaught on me for imagining that any help could be got, in the translation of his work, by a study of Claude, led to another and equally characteristic scene. He demanded of me what were to be the proportions of my reduction of his painting, and scornfully resented the idea that that depended on those of his own canvas. So I undertook to submit to him my reduced drawing. In my subsequent interview to settle the proportions of the engraving I ventured to take with me an artist friend, James Giles; and a letter of his written at a long subsequent date, describing this as the only time he ever saw the great painter, recalls to my memory some forgotten incidents of the interview. The original picture was unusually high for its length; though this seems to have been a shape favoured by him. The proportions of his famous "Slave Ship" in the Boston Gallery are such; and on looking at it I feel that it would be improved by covering up a portion of the sea in the forefront. But Turner had ideas of his own about the proper proportions of an engraving, and was prone to demand the impossible feat of realizing his ideal without varying from the actual proportions of the original. There was no disguising from oneself that, however marvellous the intellectual powers of the great poet-painter in his own special line of art, he had in his later years given himself up largely to sensual indulgence. The fine gold was woefully tarnished and overlaid with dross and slime. J.G. [p. 163] describes the strange, slovenly, uncouth figure, of which the foregoing sketch (from the Methodist Magazine) is a flattering presentation. He had a besotted look, partly due to the fact that he was suffering from a bad cold. Shabby in dress, with dirty linen, a large coloured handkerchief tied like a poultice round his neck, and into which his chin was sunk, the figure was completed by an old slouched hat drawn over his eyes. I had by this time become so familiar with the strange excentric artist that I was less impressed with his grotesque contrast to the ideal formed in the mind of any admiring student of his works. I was now more at my ease with him, knowing his gruff ways, and that "his bark was waur than his bite," as the

old Scotch proverb has it. So I inquired as to his health, and accepted the bluff response, "Oh, very bad." I had brought a memorandum of the dimensions of the picture with the reduced drawing, which he at once declared could not be correct. "I tell you it is the right shape"; and when I evaded the contest on this point and indicated the desired change, the response was: "It can't be done; I tell you it can't be done." I had by this time come to know his ways. There was no use meeting his absurdest misstatements with a direct contradiction, but after an amusing wrangle in which his irritability exhausted itself, he ended, "Well, if it must be, leave your drawing with me and I'll do it. But I tell you its right in the picture. Your drawing must be wrong. There's some mistake." When I saw him shortly after he had my drawing before him. I made no reference to our previous conversation. Had I ventured to hint that the proportions of my drawings were the same as his picture, the old wrangle would have been renewed, and he would probably have insisted on the production of his ideal proportions without deviating a hairs breadth from the actual picture. But having thus given free vent to his humour he took my drawing in hand and did all that I desired. In the picture as actually engraved it is not only reduced in height by taking off a piece of the sky, and also I think off the foreground, but it is [p. 164] lengthened on both sides, though chiefly on the left. There Turner drew in additional masts and rigging; and told me to be sure to return the drawing to him when I made the transfer for my etching. The actual dimensions are 22 ¼ by 15. Miller's engraving of the "Grand Canal, Venice" is 22 ¾ by 14 ⅞. For the one I got £100., for the other W.M. received $500. [sic] – certainly not too large a price for the laborious industry prolonged through many months which resulted in an engraving of which Ruskin says: "There is no better representation of Turner's work by line engraving. The sky especially is exquisite." The painting was sold ultimately for 7000 guineas.

As my months of patient labour drew to a close Turner's hints and touches on my proofs were very valuable. The engraver's art is not a mere copying. The painter has all the advantages of colour, and aims at reproducing Nature in her own garb and atmosphere. But the engraver's work is equivalent to that of the translator of a poem into another language. His is a translation in which the equivalents of colour have to be rendered by texture, and light and shade; to produce by mere variations of one black tint the effect achieved by gorgeous colours of a Turner. It is a severe test to the painter, but tried by it the far surpasses Claude. He never lost his command of atmospheric effect. The most extravagant vagaries of his latest stage of flaring colour, when reduced by the process of the engraver to their true equivalents of light and shade, revealed the power of the great master of chairoscuro [sic] – "the Prince of the power of the air," as one of his old critics aptly styled him. When my ambitious undertaking was finished, Turner expressed himself, in his gruff way, as pleased: – "Better than I expected of you" were his parting words; and so I saw my last of the strangely gifted artist. As for Moon, he gave me a note at three months' date for my poor little hundred pounds. It was the first of my [p. 165] experiences in "paper," and I did not know what to make of the mysterious substitute for my hard-earned shekels. As for the promised new plate at a remunerative price, the hope of which had buoyed me up through many a long day's work, he shilly-shallied, and when pressed to fulfil his bargain, could not remember that he had ever made such a promise. As for me, I went down to Scotland where my ever kind uncle cashed my note for me. I produced my "Regulus" as a proof that I had "won my spurs," claimed my own Maggie for my bride, and ere long turned to letters. Had Moon kept good faith with me it might have altered the whole subsequent course of my life. No thanks to him that I then caught the tide which taken at the height led on to fortune.

The sketch of the strangely gifted excentric genius with whom I was thus brought for a brief period into intimate relations, has beguiled me into a reverie, and reillumined an early, half-forgotten page in my life. As for the "Moon" transaction, and the liberal dealings of that patron of art, I noted long ago, in the Athenaeum of March 14, 1874, when Messrs Christie, Manson and Woods sold the fourth portion of engravings from the works of Turner, first on the list and at the highest price were "'Ancient Carthage' engraved by D. Wilson: artist's proof £12, another £12; proof before letters, £10, another £11." So that four proofs from the plate realized at that sale very nearly half of the whole sum paid to me for engraving my first and last Turner.

Notes

PREFACE

1 Gage, *Collected Correspondence*.

CHAPTER ONE

1 Klingender, *Art and the Industrial Revolution*, 12.
2 Opie, in Barry, Opie, and Fuseli, *Lectures on Painting*, 276.
3 Thornbury, *Turner*, 309.
4 Finberg, *Turner*, 232.
5 Finberg, *Turner's Sketches*, 96.
6 Ibid., 126.
7 Gould, *Time's Arrow, Time's Cycle*, 10. I am grateful to Dr Mark Antliff for bringing this lively and perceptive study to my attention.

CHAPTER TWO

1 Gage, *Turner: "A Wonderful Range of Mind,"* 31.
2 Reynolds, in his *Discourses*, considered the Italians superior to other painters, especially the Dutch, because of the latter's specificity and lack of concern for idealization, or in other words, for "general" nature. Though he was not without admiration for Rembrandt, he believed that the artist should avoid the specific effects often associated with Dutch art, which were, in his mind, linked with the enjoyment of human beings in their "lowest state," who have "no pleasures but those of sense, and no wants but those of appetite." As society "is divided into different ranks, and some appointed to labour for the support of others, those whom their superiority sets free from labour, begin to look for intellectual entertainments." This taste for the elevated "general" nature then, was considered associated with the privileged classes and possessed a moral value (Reynolds, *Discourses* 9 (1780): 169–70; see also Hemingway, *Landscape Imagery*, 90). Turner, born of a later generation than Reynolds, particularly admired the art of the Low Countries and sometimes emulated their styles and subject matter in his paintings.
3 It was in 1798 that quotations from poetry were first permitted to accompany exhibited pictures at the Royal Academy. Of the ten works that Turner exhibited in that year, five carried tags from the poetry of his favourite poets. One work displayed lines from Milton's *Paradise Lost*; four exhibited lines from Thomson's *Seasons*. Although Turner was to associate poetic lines with his paintings until the end of his career, their function changed over time. For this reason he made different choices and even modified poetic lines that he chose, or composed them to suit his exacting poetical requirements. The verses that

he attached to his oil paintings and watercolours exhibited at the Royal Academy in 1798 are metaphorically descriptive; poetry and paintings reciprocate or echo similar sublime dramatic effects. By the next year, the lines he chose were from the works of new poets, and fresh poetic perspectives were added, endowing some of his landscapes, in consequence, with richer meanings. Verses by Milton and Thomson were now joined by those from Mallet and Dr Langhorne. Lines chosen for his watercolour *Morning, from Dr Langhorne's Vision of Fancy* possess an allegorical dimension, establishing an association between nature and humankind that anticipates in tone those pessimistic poetic lines from his own so-called manuscript poem "Fallacies of Hope." Langhorne's lines associate hope and joy of youth with morning light. Oblivious to the changes that time brings, youth fails to observe "the dark cloud gathering o'er the sky" or to notice how soon "the vernal grove decays." "Mirror of life thy glories thus depart." In the same exhibition was his watercolour *Warkworth Castle, Northumberland – Thunder Storm Approaching at Sun-Set*, to which was attached poetic lines from Thomson's *Seasons*. The lines chosen also allude to a link between humankind and the diurnal sequence – a theme that would play an important role in his later historical canvasses. In 1800, the poetic lines chosen add a further dimension; they furnish historical allusions. This is true of his oil painting, *Dolbadern Castle, North Wales* and his watercolour, *Caernarvon Castle, North Wales*. In one of his Royal Academy lectures he remarked that "we cannot make good Painters without some aid from Poesy" (British Library [henceforth BL] Add. MS 46151, BB, fol. 22v).

4 His future patron, Walter Ramsden Fawkes of Farnley Hall, Yorkshire, was an early purchaser of many of his alpine watercolours that resulted from this trip. Turner would get to know Switzerland better in 1836, and especially in the early 1840s, when he made several trips there.

5 See Finley, "Turner's 'Landscape Sublime,'" esp. 164. The powerful austerity of form in Turner's alpine watercolours attracted the young John Sell Cotman, who sketched in pencil Turner's *Passage of Mount St Gothard* of 1804 (Abbot Hall Art Gallery, Kendal). If Cotman made a sketch of this work while it was hanging in Turner's newly constructed gallery in Harley Street, he must have done so surreptitiously, since Turner allowed no sketching there. Cotman's sketch, which is in the British Museum, is entitled *Via Mala* and is illustrated in Holcomb's *John Sell Cotman*, 31.

6 Tate Gallery, Turner Bequest (henceforth TB) LXXXI, 58–9. See Finberg, *A Complete Inventory*.

7 See, for example, TB LXXII, 30.

8 Ibid., 28a.

9 Ibid., 54.

10 See notations in TB LXXI and LXXII. The Venetian school had an especial appeal for Turner, partly as a result of his growing interest in the Venetian method and probable awareness of the glazing techniques of British artists, among them the eminent painters Reynolds and Gainsborough. The effects achieved by Gainsborough, in particular in the paintings of his later maturity, would especially have attracted him. In these works, particularly in his portraits of women, Gainsborough often employed a thin, smooth layer of white as the underpainting of flesh tones that would receive full or near-full illumination. Over this he would apply feathery strokes, frequently of glazed pigment, that model and establish a translucent, luminous veil of colour. Gainsborough was

equally interested in heightening the luminosity of his late landscapes, favouring a strong back lighting.

11 TB LXXII, 51, 51a.

12 Ibid., 51; see J. Townshend, "Turner's Writings," 9.

13 TB LXXII, 23a.

14 Ibid., 30.

15 See Gage, *Colour in Turner*, 62.

16 TB LXXII, 27a. This glaze was designed to subdue and harmonize local colour. *St Peter Martyr* was destroyed in a fire at the church of ss. Giovanni e Paolo, Venice, in 1867.

17 See ibid., 28a.

18 Finberg, *Turner*, 41.

19 Ibid., 41n. See especially, the satirical article "The Venetian Secret," *Literary Gazette*, 19 Aug. 1826, 522–3. The following is an excerpt: "This miraculous discovery ... was no less than the long-sought *Venetian Secret*, by which every painter, old and young – from dull delineator of a duck-pond, to the daring designer of an epic – was to become at once a rival of Titian, having by her [Miss Purvis's] magic touch, heated the alembic of their imaginations to the accomplishments of these notable deeds of art – all bewitched into the persuasion that the whole mystery of these illustrious workers in paint was wrapped in a maiden's nostrum. Gillray, however whose presumption not even majesty could restrain, let fly some picked-pointed shafts at the artistical phalanx who got themselves embogged within her magic circle, in their too eager and purblind ramblings after her dazzling ignis fatuus. What colour that came out of her mire of pigments, we, not being present, venture not to proclaim; though Folly described them of as many colours as Joseph's vestment, or Mister Northcote's patchwork morning gown."

20 For reproduction of Gillray's print and discussion of it, see especially Wilton, *Turner in His Time*, 34; also, Gage, *Turner: "A Wonderful Range of Mind,"* 79–81.

21 Lindsay, *Turner*, 60.

22 His notes are largely the script of these lectures in different stages of completion, both "draft and copy, mostly undated except by watermark ... [and] much overlaid with additions and alterations in the process of frequent repetition" (see prefatory notes, BL Add. MS 46151). John Gage has transcribed some of the notes for Turner's lectures on light and colour (*Colour in Turner*, appendices).

23 The Redgraves observed that "His lectures on perspective ... were, from his naturally enigmatical and ambiguous style of delivery, almost unintelligible. Half of each lecture was addressed to the attendant behind him, who was constantly busied, under his muttered directions, in selecting from a huge portfolio drawings and diagrams to illustrate his teaching" (*A Century of British Painters*, 257).

24 See Ziff, "Backgrounds"; Gage, *Colour in Turner*, chap. 6 and appendices; Venning, "Turner's Annotated Books," and more recently, M. Davies, *Turner as Professor*.

25 He was to begin building his villa at Twickenham, based on his own designs, in 1812; see chapter 5.

26 Gage, *Colour in Turner*, 106.

27 He observed that while the abstraction of perspective that treatises provide may be "a useful and well beaten road to science," it is "circuitously cautious for a painter's pursuit" (BL Add. MS 46151, D, fol. 4r). "Turner required only straightforward rules" (Davies, *Turner as Professor*, 38).

28 BL Add. MS 46151, I, fol. 9r.

29 Davies, *Turner as Professor*, 17. In one of his lectures Turner observed that "one blunder in the practice of art teaches more than a hundred treatises on the same subject" (BL Add. MS 46151, BB, fol. 44v).

30 The Redgraves noted (*A Century of British Painters*, 257–8) that "many of ... [the drawings] were truly beautiful, speaking intelligibly enough to the eye, if his language did not to the ear ... Thomas Stothard, the librarian to the Royal Academy, who was nearly deaf for some years before his death, was a constant attendant at Turner's lectures. A brother member, who judged of them rather from the dryness of the subject, and the certainty of what Turner's delivery would be, than from any attendance on his part, asked the librarian why he was so constant. 'Sir,' said he, 'there is much to *see* at Turner's lectures – much that I delight in seeing, though I cannot hear him.'"

31 See Gage, *Colour in Turner*, 108, 109.

32 BL Add. MS 46151, I, fol. 9r.

33 See Ziff, "Dignity of the Art," 45.

34 See, for example, Ziff, "Backgrounds," 139. We can reasonably assume that during the second decade of the nineteenth century Turner was aware of published criticisms levelled against members of the British cultural community, who were accused of a lack of support for historical pictures. The institution considered largely responsible for this was, paradoxically, the Royal Academy, whose mandate was to provide encouragement for this category of painting. A particularly significant and sustained published offensive against the Academy was launched in 1816 (and continued until 1820) when the important new quarterly journal, the *Annals of the Fine Arts* (edited by James Elmes), issued its first numbers. Members of the Royal Academy were apparently shocked and appalled by the *Annals'* stinging rebukes and seem privately to have denounced this publication. It is likely that Turner had read or, at least, knew of the *Annals*, not only because of its pointed criticisms against the Academy (especially concerning the Academy's neglect of history painting) but because Turner had probably been consulted on, or had offered a correction of, the published directory entry in which he appeared in the *Annals'* first "Annual Register of Artists," where he is entered initially as a "Landscape" painter (1: 434). It appears that he considered this designation either as imprecise or as erroneous, for in the next register and in the two subsequent ones, he is described as a painter of "Historical Landscape" (2: 580; 3: 685; 4: 654). This latter designation was not only more correct, it was more fitting for a Royal Academician who was also that institution's distinguished professor of perspective.

35 The influence of the *Discourses* on the lectures has long been acknowledged and, as has been rightly noted, "No aspect of Reynolds, whether it was his art, writings, or personality, failed to stimulate Turner's regard" (Ziff, "Backgrounds," 127.) It was during the first series of lectures in 1811 that Turner proposed that the Royal Academy establish a professorship of landscape.

36 BL Add. MS 46151, C, fol. 15r. These ideas concerning nature's basic shapes and forms were taken from Mark Akenside's didactic poem, *The Pleasures of the Imagination*. See, Gage, *Turner: "A Wonderful Range of Mind,"* 22; Shanes, *Turner's Human Landscape*, 254–7.

37 BL Add. MS 46151, H, fol. 4r.

38 See Burke, *The Analysis of Beauty*.

39 In his first series of lectures (1811) he displayed a diagram of the upper section of Raphael's *Transfiguration* in which the two-dimensional structure of the picture is analysed to show that it is composed of a series of interrelated triangles (TB CXII, 163).

40 TB CXII, 17. The allusions to optics here and elsewhere in Turner's notes are significant and reflect a general tendency in popular treatises and practical manuals of the later eighteenth and early nineteenth centuries to analyse the nature of colours – to consider them within a system, thereby making them more useful to artists. Passing references in these publications to physical and physiological optics and the invocation of names of celebrated scientists aided in bestowing on colour a fresh level of significance.

41 In a treatise published in 1805, its author considered this difficulty, remarking that "it appears that we have very few [material] colours which will in themselves express those of the Prismatic Spectrum; but that there requires a combination of different ones, to produce any thing like an imitation of them: and as the greater part of our colours are compounds, it proves in how very few cases we can have any great brilliancy of colouring ... The compound colours in the spectrum are composed of only two combined colours, therefore any pigment that can be imitated, two of the three primitives, the yellow, red, and blue, will clash with them ... but when three or four are combined, a degree of obscurity takes place, which ranks them in a lower order" (Gartside, *Essay on Light and Shade*, addenda, n.p.).

42 BL Add. MS 46151, H, fol. 25v. At the end of one version of the perspective lecture, Turner observed that theory "must ask for the confirmation of Practice[:] it is Practice tho' the most severe teacher [it] is the only Fine Instructor in each Department; and that is the Art obtained by Practice which can only be truly called Art" (ibid., T, fol. 23r).

43 Ibid., N, fol. 7r.

44 In a popular, though anonymous, eighteenth-century treatise, *The Art of Drawing and Painting in Water-Colours*, the author considered colours tonally, that is, in a scale from light to dark, contending that "Colours are to be distinguished in the following Manner; we must first take White, the next Yellow, the next Orange, and then proceed to the Red, after that the Purple, then to the Blue, and after that to the Black. Observe [the writer explained] White and Black are the Extremes of Colour." In placing white and black respectively at the top and bottom of the tonal scale of colours, the writer considered them not only as functioning as extremes in the tonal sequence, but as two "hues" in their own right (28). Gerard de Lairesse (1641–1711), the Flemish painter and theorist, considered white pigment the equivalent of light. Black, he maintained, stands for darkness (Lairesse, *The Art of Painting*, 156–7).

45 BL Add. MS 46151, H, fol. 36r.

46 Ibid., fol. 2v.

47 Ibid., fols. 4r–4v.

48 Ibid.

49 Ibid., O, fol. 4r; see Davies, *Turner as Professor*, 50.

50 BL Add. MS 46151, H, fols. 12r, 12v.

51 Ibid., A, fol. 16v.

52 Ibid.

53 Ibid.

54 The engraver of Turner's celebrated *Regulus*, Daniel Wilson, observed that "The engraver's art is not a mere copying. The painter has all the advantages of colour, and aims at reproducing Nature in her own garb and atmosphere. But the engraver's work is equivalent to that of the translator of a poem into another language." See the appendix, which presents Wilson's account of his engraving of *Regulus*; see especially typescript, 164. I am indebted to the late Dr Marinell Ash, who, well over a decade ago, directed me to this material. I have discussed the relationship between engraving and painting in chapter 2 of *Landscapes of Memory*; see also Gage, *Turner: "A Wonderful Range of Mind,"* 76.

55 In his "Backgrounds" lecture, Turner refers specifically to Rembrandt's *Rest on the Flight into Egypt*, which was in the collection of his patron Sir Richard Colt Hoare and appears to have influenced Turner's *Limekiln at Coalbrookdale* (c. 1797); see Butlin and Joll, *Turner*, cat. no. 22.

56 See Gage, *Colour in Turner*, 202–9 (BL Add. MS 46151, H).

57 Webb, *Inquiry into the Beauties of Painting*, 94.

58 Reynolds, *Discourses*, 14 (1788): 251.

59 BL Add. MS 46151, H, fol. 40r.

60 Ibid.

61 Ibid.

62 Ibid., fol. 33r.

63 Ibid., fol. 39r.

64 Reynolds, *Discourses*, 4 (1771): 61.

65 BL Add. MS 46151, H, fol. 36r.

66 Yellow was considered the lightest tone, red the middle tone, and blue the darkest.

67 BL Add. MS 46151, H, fol. 39r. Turner wrote that in the work of the Bolognese "colors are primitives of Light by contrast of Shade, not only of their own, but by the medium of half tone [in?] its Shadow by the admission of Reflexes [reflections]" (ibid.). In his "Backgrounds" lecture Turner analysed the approach of the Bolognese more fully; he spoke of the "one tone appropriate to the design of the Picture or the colour of the principal figure ... [which] often appears flat, meagre and frequently misapplied. The space could as well be supplied with something else where shadow and strength appear to have been only desirable" (Ziff, "Backgrounds," 140).

68 Reynolds, *Discourses*, 8 (1778): 157.

69 BL Add. MS 46151, H, fol. 37r; "The centre is occupied by a sky of pure white and blue ... The figures are wrought to the same high tone as the sky and each figure, single or grouped, relieved from the pure white cloth on the table by the several powers of primitive bright and full toned colours" (Ziff, "Backgrounds," 138).

70 BL Add. MS 46151, H, fol. 37r.

71 Ibid., N, fols. 7r, 7v.

72 This he first considered in his notes in the Louvre. He speaks of the "combination of color ... The union of the many [colours] to produce the General tone sometimes called Historic tone" (ibid., H, fol. 41r).

73 Ibid., N, fol. 7v.

74 Gage, *Colour in Turner*, 109.

75 BL Add. MS 46151, N, fol. 7v.

76 Ibid., fol. 8r.

77. Opie, in Barry, Opie, and Fuseli, *Lectures on Painting* 273. For the history of *ut pictura poesis*, see Lee, "Ut Pictura Poesis," 197–269.

78. This was a restriction frequently referred to by writers, including Reynolds. In the early eighteenth century the Earl of Shaftesbury explained that "every Master in Painting, when he has made choice of the determinate Date or Point in Time, according to which he wou'd represent his History, is afterwards debar'd the taking advantage from any other Action than what is immediately present, and belonging to that single Instant he describes." Although such art embraced that "immediately present" moment, Shaftesbury did allow for edifying references to the recent past and immediate future (Cooper, *Characteristicks*, 3: 353).

79. BL Add. MS 46151, N, fol. 8r.

80. Ibid., N, fols. 11r, 8r; I have been aided here by Gage's transcription; see *Colour in Turner*, 201.

81. BL Add. MS 46151, N, fol. 11r.

82. See Turner's attempt to overcome this difficulty in his late Deluge picture *Light and Colour*, discussed in chap. 12.

83. BL Add. MS 46151, N, fol. 8r; I have been aided here by Gage's transcription (*Colour in Turner*, 202).

84. BL Add. MS 46151, N, fol. 11r.

85. Ibid.

86. Gage, *Colour in Turner*, 113.

87. BL Add. MS 46151, Y, 1r.

88. Ibid., H, fol. 35r; see Gage, *Colour in Turner*, 111, 250n188.

89. BL Add. MS 46151, H, fol. 36r. Barbara Keyser, in discussing de Piles' reference to "coloris," or the activity of colouring, mentions his artistic requirement of "knowledge of the incidence of lights, the artifice of chiaroscuro, the sympathy and antipathy of particular colours, aerial perspective and the effect of the whole together" (*Cours de peinture*, 74n24; see Keyser, "Saving the Significance," 144–5).

90. Gage, "Turner's Academic Friendships," 67–8.

91. Reynolds, *Discourses*, 15 (1790): 267. In his Royal Academy lectures Turner also refers to the advantages of practice over theory, as noted in n29, above.

92. See Gage, "Turner's Academic Friendships," 677; see also Venning, "Turner's Annotated Books (II)," 42.

93. Butlin and Joll, *Turner*, cat. no. 100.

94. At about this time (c. 1810) Turner wrote poetic lines reflecting on the condition of the wronged poet (TB CXIV, 2a, 3; see Ziff, "An Unrecorded Poem by Turner," 16).

95. See Gage, *Colour in Turner*, 136.

96. Ziff, "Turner on Poetry and Painting," 207–8.

97. Gage, *Colour in Turner*, 136.

98. Finberg, *Turner*, 78.

99. Farington, *Diary*, 6: 2024 (3 May 1803).

100. Ibid., 7: 2710 (5 April 1806).

101. Ibid., 7: 2777 (3 June 1806).

102. Ibid., 8: 3093 (20 July 1807). Turner's extended, tongue-in-cheek title of *A Country Blacksmith* may have been meant to mock generally, in a good humoured way, the detailed, low subject matter of Dutch and Flemish genre painters, but more specifically, the paintings of Wilkie, which he admired and which his painting was intended to challenge.

103. Thornbury, *Turner*, 432.

104. This was first suggested by Owen, Brown, and Leighton in the catalogue "*Noble and Patriotic*," 166.

CHAPTER THREE

1. Reynolds, *Discourses*, 4 (1771): 58.

2. For example, Byron established resonating relationships between great marine battles of different eras, between the battle of Actium (31 BC), when the forces of Anthony and Cleopatra were beaten by Octavian's fleet, and the battle of Lepanto (1571), involving the Turks and Christians; these were also brought into association with the modern sea battle, the "fatal" Trafalgar (1805), where the British fleet emerged victorious over its French and Spanish foes (2.40). Byron also mentioned the vandalism of the barbarous Lord Elgin, whom he considered responsible for the vandalism of the Acropolis and who was, in his opinion, nothing but a "modern Pict" (2.12).

3. Quoted in Boase, *English Art*, 176.

4. Byron, *Childe Harold's Pilgrimage* (2.73).

5. The last volumes of *The Works of the British Poets* contain translations from the classical authors. See Wilton, *Turner's Verse Book*, 12–13.

6. Thornbury, *Turner*, 225.

7. The swan-neck prows appear in the original pen, ink, and wash sketch that dates from c. 1807 (TB XCVIII, 5).

8. Thornbury, *Turner*, 123.

9. He was also inspector of the cast collection at the Academy in 1820, 1829, and 1838; see Butlin, Gage, and Wilton, *Turner*, 1775–1851, 180–1.

10. The sense of place becomes especially strong in his landscapes executed after about 1796; see especially Finley, "Turner's 'Landscape Sublime.'"

11. Thornbury, *Turner*, 96; see below, chap. 5.

12. St Clair, *Lord Elgin and the Marbles*, 8–9.

13. Ibid., 56.

14. George, "Turner, Lawrence, Canova," 26, 30.

15. Holcomb, *Colman*, 12.

16. Haydon, *The Autobiography and Memoirs*, 1: 66–8.

17. Gage, *Collected Correspondence*, 17 (Turner to Earl of Elgin, 7 Aug. 1806).

18. Thornbury, *Turner*, 362.

19. Byron, *Childe Harold's Pilgrimage* (2.11).

20. Finberg, *Turner*, 222.

21. Gage, *Turner: "A Wonderful Range of Mind,"* 24.

22. Nicholson, *Turner's Classical Landscapes*, 131.

23. Gage, "Turner and the Greek Spirit," 16.

24. Gage, *Collected Correspondence*, 67n3. The subject, Evelyn Joll believes, was influenced by lines from Gally Knight's poem *Phrosyne: A Grecian Tale*, written in 1813, which "Turner must have known" (Butlin and Joll, *Turner*, cat. no. 134).

25. Thornbury, *Turner*, 434.

26. Butlin and Joll, *Turner*, cat. no. 133.

27. Gage, "Turner and the Greek Spirit," 18.

28. Ibid., 16.

29. This relief, in addition, embodies Turner's own dedicated belief that light is all-powerful, a theme that through most of his career interested him.

30 Ibid.

31 The rising sun in *Dido Building Carthage* is symbolic of the beginning of Carthage (RA 1815). In *The Temple of Jupiter Panellenius Restored* the rising sun may also serve as a metaphor for liberty, which is necessary for Greek culture to thrive.

32 Gage, "Turner and the Greek Spirit," 16.

33 Lindsay transcribed Turner's poem (TB 133, 1) on the Temple of Jupiter Panellenius, which he considered to reflect "natural process" (*Turner*, 142).

34 Gage, *Turner: "A Wonderful Range of Mind,"* 239.

35 *The Temple of Aphaia at Aegina, during Excavations*, c. 1825 (see Wilton, *J.M.W. Turner*, cat. no. 493); see also Gage, "Turner and the Greek Spirit," 18 and appendix. Cockerell and "Grecian" Williams were also acquainted; the former supplied materials for the latter's book *Select Views in Greece* (1829), a copy of which was in Turner's library (Gage, *Turner: "A Wonderful Range of Mind,"* 60).

36 The watercolours illustrated lines from British poets, represented by Byron, Scott, and Moore. There was also a frontispiece for this series; see Finley, *Landscapes of Memory*, 250n9.

37 *Rokeby* is not dated but was most likely painted in this year (1822).

38 Turner, some seven years earlier, had made a number of watercolours of these relics commemorating General Thomas Fairfax's role in the Civil War; see, for example, Wilton, *J.M.W. Turner*, cat. no. 582 (1815).

39 See Turner's *Fishmarket, Hastings, with Turk* (1824), noted and reproduced in Shanes, *Turner's Human Landscape*, 81, pl. 115.

40 Chains, an obvious symbol of oppression, appear on the ankles of slaves cast overboard in Turner's later *Slavers Throwing Overboard the Dead and Dying – Typhoon Coming On*, shown at the Royal Academy in 1840 (Museum of Fine Arts, Boston). This picture reflects continuing discussions on slavery in books and parliamentary speeches at that time. Its red sky, symbolic of blood and death, is a clear expression of the artist's deep abhorrence of slavery and man's inhumanity to man, to which the watercolour *The Acropolis, Athens* also alludes. For further discussions concerning liberty and its absence, see chap. 10.

41 Turner has not, however, accurately represented the Parthenon's octastyle portico.

42 This watercolour is in a private collection. The temple is now identified as the Temple of Poseidon.

43 From sketches made on his Greek visit (1816–18), Turner's friend Hugh William Williams – "Greek" Williams – painted a similarly dramatic watercolour of the temple, combining sunlight and storm and the wrecked remains of a ship washing up on the shore; see Macmillan, *Painting in Scotland*; pl. 73.

44 Butlin and Joll, *Turner*, cat. no. 373.

45 See Coolsen, "Phryne and the Orators," 9.

46 In 1817, for example, he devised a watercolour composition of Tivoli (see Wilton, *J.M.W. Turner*, cat. no. 495) and several watercolour designs of Mount Vesuvius (ibid., cat nos. 697–9). No. 697, *Mount Vesuvius in Eruption*, was in the collection of his patron Walter Fawkes. It was based on a drawing or drawings by Major James Cockburn (1778–1847) of the Royal Artillery (Elmes, *Annals of The Fine Arts*, London, 1817, 555); see Powell, *Turner in the South*, 81.

47 Ibid., 13, 14; see Gage, "Turner and Stourhead," 75–83.

48 Elmes, *Annals of the Fine Arts*, London, 1820, 421.

49 Highet, *The Classical Tradition*, 422.

50 Barbier, *Samuel Rogers and William Gilpin*, 16.

51 Hoare, *A Classical Tour*, 1: viii.

52 Sass, *A Journey to Rome and Naples*, 104.

53 Powell, *Turner in the South*, 9.

54 Brand, *Italy and the English Romantics*, 192–3.

55 BL Add. MS 46151, H, fols. 4r–4v. See also Gowing, *Turner: Imagination and Reality*, especially 19, 21; but more particularly, Stainton, *Turner's Venice*, 9.

56 BL Add. MS 46151, H, fols. 12r–12v.

57 *The Complete Works of William Hazlitt*, 4:7on. (*The Examiner*, 1816); see also Finberg, *Turner*, 241.

58 *Blackwood's Edinburgh Magazine*, September 1837, 335.

59 See Butlin and Joll, *Turner*, cat. no. 383.

60 See Finley, *Turner and George the Fourth*, 70–1.

61 Checkland, *The Rise of Industrial Society*, 159.

62 See also Butlin and Joll, *Turner*, cat. no. 360.

63 Mommsen's *History of Rome*, ix.

64 Ibid.

65 Butlin and Joll, *Turner*, cat. no. 228.

66 An early tribute by Turner to Raphael (whom Reynolds had also greatly admired) occurs in his *Fifth Plague of Egypt* (exh. RA 1802), in which the figure of Moses (with raised arms) is based on the figure of St Paul in *The Sermon of St Paul in Athens*, one of the tapestry cartoons that, subsequently, he also chose to refer to (as had Reynolds) in his Royal Academy lectures. Copies of the Raphael cartoons by Thornhill belonged to the Royal Academy and hung in the Great Room of Somerset House, where Turner delivered his lectures.

67 Finberg, *Turner*, 264.

68 Elmes, *Annals of the Fine Arts*, London, 1820, 421.

69 TB CLXXIX, 25a.

70 Ibid., 26.

71 Finley, "Rome from the Vatican,'" 63.

72 Ibid.

73 Thornbury, *Turner*, 455.

74 Monkhouse, *The Turner Gallery*, 3: n.p.

CHAPTER FOUR

1 Turner would much later return to the subject of Europa's abduction and, indeed, essentially to this composition, in a painting executed between about 1840 and 1850 (see painting, The Taft Museum, Cincinatti, Ohio [Butlin and Joll, *Turner*, cat. no. 514]).

2 The combination of peacock and classical cornice sinking into the mud occurs in his contemporary painting, the *Thames at Weybridge* (c. 1807–10; Butlin and Joll, *Turner*, cat no. 204), which is at Petworth. This painting became a late subject (1819) of a print (*Isis*) for the *Liber Studiorum* (Rawlinson, *Engraved Work*, 68).

3 The publication included various categories of landscape, such as the mountainous, historical, pastoral, marine, and architectural.

4 BL Add. MS 46151, I, fol. 10.

5 Ibid., H, fol. 27r. In another related passage referring to *St Peter Martyr*, he speaks of the oblique lines of its trees, "passing [rearing?] through to the top

of the Picture" (ibid, fol. 26r). Much later, he was pictorially to allude again to the composition of this painting, though less directly, in his dramatic *Vision of Medea* (see Finley, "Theatre of Light," 219, 222). Other artists before and after him were also attracted to Titian's picture. For example, Reynolds in his eleventh discourse considered its landscape "eminent." John Constable admired its background and considered it possibly "the foundation of all the styles of landscape in every school of Europe in the following [seventeenth] century." He also remarked that it depicted the "admirable union of history and landscape" (Leslie, *Memoirs of the Life of John Constable*, 293–4). Further, in his lectures on landscape painting delivered to the members of the Literary and Scientific Society of Hampstead and the Royal Institute of Great Britain in 1833 and 1836 respectively, he discussed this picture at length (ibid, 293–4, 301, 304–6, 314, 320).

6 According to Lindsay, both *Bacchus and Ariadne* and *Dawn of Christianity* may initially have been considered for octagonal frames. Lindsay suggests that "the octagon would better suit his [Turner's] purposes; the *Dawn* and *Bacchus* show pencil lines marking an octagonal space and *Dawn* was completed as a circle" (*Turner*, 204). Corners of the support of *Glaucus and Scylla* have been similarly marked off: (I am grateful to Dr W. Jackson of the Kimbell Art Museum, Fort Worth, for arranging for me to examine this picture without its frame.) The sketch compositions for *Dawn of Christianity* (*Flight into Egypt*) indicate that while working out ideas for his proposed picture he had decided that it should be presented in a circular frame (Evelyn Joll, Butlin and Joll, *Turner*, cat. no. 394). Joll (ibid, cat. no. 395) has observed that the writing in the lower left corner of *Glaucus and Scylla* (here, the corner has *not* been marked off) "is not certainly" by Turner. Having examined this inscription, I believe that the inscription concerns the preparation of the panel and appears to have been written by the preparator.

7 See chap. 10.

8 Joll (Butlin and Joll, *Turner*, cat. no. 394) identified the theme of "flight" in *Dawn of Christianity* (*Flight into Egypt*) and *Glaucus and Scylla*.

9 A sepia pen and ink wash drawing of this composition (TB CXVIII-P) was prepared c. 1813 (fig. 29). Engraved for the *Liber Studiorum*, it was never published.

10 *Glaucus and Scylla* was painted on a prepared wooden panel; for *Bacchus and Ariadne* and *Dawn of Christianity*, a specially prepared double canvas was used. See Martin Butlin's discussion of these double canvases in his article "Turner's Late Unfinished Oils," 43–5.

11 Butlin and Joll, *Turner*, cat. no. 382 (in this instance, see the first edition, 1977). In the early summer of 1982, I received permission from Martin Butlin at the Tate Gallery to examine *Bacchus and Ariadne* without its frame, because I suspected that it, like *Glaucus and Scylla*, it was at one time considered by Turner as the companion of *Dawn of Christianity*, then it, too, would have been shown in a frame with a circular inset. I was assisted in this examination by Martin Butlin and Lord Dunluce, to whom I am grateful, and my suspicion was confirmed. Turner seems to have finished this picture while it was framed and on the walls of the Royal Academy during Vanishing Days in 1840. This is indicated by the colour glazes that trace the shape of the frame's circular opening on the canvas.

12 Nicholson, "Turner's 'Apulia in Search of Appulus,'" 679.

13 Ibid, 680n.

14 Turner may have consulted both the painting and the engraving by William Woollett, made after it. It may not be coincidental that this picture and his earlier (c. 1806) Poussinesque *Garden of the Hesperides* (discussed in the next section, below), also shown at the British Institution, both present settings whose topography has been largely, though not entirely, appropriated from specific classical landscape designs.

15 Chubb, "Minerva Medica," 30.

16 Nicholson, *Turner's Classical Landscapes*, 227–8.

17 Ibid, 228.

18 Nicholson, "Turner's 'Apulia,'" 680.

19 Finberg, *Turner*, 195.

20 Leslie, *John Constable*, 327.

21 Hutchison, *History of the Royal Academy*, 67.

22 The sublime, according to Edmund Burke, required subdued colour: "colours such as are soft, or cheerful ... are unfit to produce grand images. An immense mountain covered with shining green turf, is nothing in this respect, to one dark and gloomy" (*A Philosophical Enquiry*, 81–2).

23 Ziff, "Backgrounds," 143. Turner may have been familiar with Reynolds' comments: "The favourite subjects of Poussin were Ancient Fables; and no painter was ever better qualified to paint such subjects, not only from his being eminently skilled in the knowledge of the ceremonies, customs and habits of the Ancients, but from his being so well acquainted with the different characters which those who invented them gave to their allegorical figures" (Reynolds, *Discourses*, 5 [1772]: 87–8).

24 The nymph Galatea was pursued by the Cyclops, Polyphemus, who had fallen passionately in love with her. However, she did not return his affection as she was in love with the beautiful youth Acis. The jealous Cyclops, enraged by Galatea's preference for Acis, tore a huge rock from a mountainside and crushed the youth with it; in consequence, the nymph transformed her beloved into a river that was named after him.

25 Wilkie, *Romantic Poets*, 92. The connection between the biblical Fall and the Judgment of Paris was also alluded to in Turner's slightly later mock-dramatic sketch *The Amateur Artist* (c. 1809; discussed in chap. 2, above). The drawing shows the amateur artist examining a painting on his easel depicting the Judgment of Paris. Another painting, visible to the left, is inscribed with the title, "Forbidden Fruit," showing the serpent in the Garden of Eden, buttressed on one side by Adam, on the other by Eve.

26 Butlin and Joll, *Turner*, cat. no. 57. As Gage rightly observes (*Colour in Turner*, 137), in the closing line there is a reminiscence of "that fatal moment in Book IX of *Paradise Lost*, when Eve

 her rash hand in evil hour
 Forth reaching to the fruit, she pluck'd, she eat:
 Earth felt the wound, and Nature from her seat
 Sighing through all her works gave signs of woe,
 That all was lost."

There are two versions of the "Ode to Discord" in the Verse Notebook. I here quote the version that appears in Butlin and Joll, *Turner*, cat. no. 57. The Notebook is now in the collection of Rosalind Malord Turner.

27 Powell, "Turner's 'Vision of Medea,'" 12.

28 Ibid., 15. The Fates – Clotho, Lachesis, and Atropos – provided mortals with good and bad fortune. Clotho spins the thread of life, Lachesis determines its length, and Atropos cuts it off. Their presence in Turner's picture, I previously believed, could be considered simply as an allusion to the action of fate. However, I have reconsidered and now believe that Turner was likely thinking of the Furies.

29 Medea, herself, would surely have qualified as one of these sinners!

30 Powell, "Turner's 'Vision of Medea,'" 15, 16.

31 Seneca, Medea: A Tragedy, 37.

32 Thornbury, Turner, 447.

33 Jason has the appearance of Hercules, who visits the Garden of the Hesperides, where he kills the dragon Ladon in order to secure the golden apples.

34 Athenaeum, 7 May 1831.

35 Gage, Turner: "A Wonderful Range of Mind," 98.

36 Turner made notes on this painting in the Louvre in 1802 and alluded to it in his Venus and Adonis (c. 1803–5). After the Napoleonic wars he saw it again, in 1819, in Venice. In his lectures at the Royal Academy Turner observed that this picture was noted for its "obliquity and waved lines" that suggest "feelings of force" (see discussion in n5, above); see also Lindsay, Turner, 163.

37 See chap. 5, n2.

38 See Butlin and Joll, Turner, cat. no. 302. David Hill (Turner on the Thames, 64, 167) has observed the presence of oil spatters on page 5 of the sketchbook, TB XCVIII, which dates from c. 1807. The pen, ink, and wash composition on this page is the initial design for Turner's Ulysses Deriding Polyphemus. David Hill has suggested that "it would be worth considering whether he [Turner] might not have started the painting at the time of this study" (ibid.). However, this observation does not seem to take into account the oil composition. See chap. 11, n53, for a further discussion.

39 Turner and Ruskin, 1: 54 ("Notes on the Turner Gallery at Marlborough House").

40 Homer, Odyssey 1. 267–8.

41 See studies and notations relating to the two in sketchbooks TB XCIII (c. 1805–7) and TB XCVIII (c. 1807).

42 For example, Apollo and his chariot are shown, probably influenced by the design of Poussin's Cephalus and Aurora (Gage, Colour in Turner, 132).

43 Thornbury, Turner, 445.

44 TB XCVIII, 5.

45 In a review of this picture the critic of The Athenaeum (13 May 1829) associated the flames and smoke enveloping the mountain with volcanic emissions: "How colossal and mysterious the form of the monster appears, as we view him withing under the agonies of the recently-inflicted torture, and obscured by the vapours of Ætna!" See also, 196.

46 Virgil, Aeneis, in Works, 215, 221.

47 See Reynolds, Discourses, 13 (1786): 237–8.

48 See, for example, New Ladies Magazine, 1786, 458, as quoted by Manwaring, Italian Landscape, 20, 23.

49 Virgil, dedication to Aeneis, in Works, 213.

50 Thornbury, Turner, 434.

51 TB XC, 21.

52 Turner appended the following lines to the picture's entry in the Royal Academy catalogue from the fourth book of Dryden's Aeneis: "When next the sun his rising light displays, / And gilds the world below with purple rays, / The Queen, Aeneas, and the Tyrian Court, / Shall to the shady woods for sylvan games [sic] resort."

53 Maurice, dedication to Richmond Hill.

54 Ibid., 32; see Finley, "Love and Duty," 380.

55 Maurice, Richmond Hill 55.

56 Ibid., 50.

57 TB CXXIX, 6a–7.

58 A later, comparable example is Watteau Study (RA 1831), in which Watteau is shown painting in Petworth House (see chap. 7). Turner discussed such fanciful arrangements in his Royal Academy lectures (see BL Add. MS 46151 N, fol. 14 r.). Comparable effects could be achieved by means of anachronisms, and these Turner explored in his Rome from the Vatican (RA 1820). They had been considered earlier, for example, in Prince Hoare's "Offices of Painting," where pictures of this type were referred to as "allusive" (The Artist, 2: 260, 264, 265, 266, 273, 274; see Finley, "Rome from the Vatican," 70).

59 Thornbury, Turner, 406.

60 Reynolds had recommended that the aspiring artist "should enter into a kind of competition" with an artist from the past. While Reynolds suggested that the artist should paint a similar subject, Turner, in this instance, considered the similarity in terms of composition. Reynolds also observed that by competing, the artist would make "a companion to any picture that you consider as a model ... This method of comparing your own efforts with those of some great master, is indeed a severe and mortifying task, to which none will submit but such as have great views, with fortitude sufficient to forego the gratifications of present vanity for future honour" (Discourses, 2 [1769]: 30–1). The affinity of Turner's two Carthage pictures with Claude's landscapes was probably strengthened by his recent paintings Dido and Aeneas and Apullia in Search of Appullus. This latter painting, as has been noted, was exhibited at the British Institution in 1814, based on the design of the Claude painting Landscape with Jacob, Laban and His daughters, owned by his patron, the Earl of Egremont.

61 See chap. 2, n72.

62 TB LXXII, 54. His luminous watercolours painted about this time also provide evidence of his growing interest in a "high" tone.

63 In his eighth discourse, Reynolds discussed the limits imposed by a central focus of light in painting that did not involve the sky. Turner had experimented with a central, unifying focus of light in predominantly dark landscapes palpably influenced by the effects in Rembrandt's work. This occurs, for example, in the early Limekiln at Coalbrookdale (c. 1797) and. about 1818, in The Field of Waterloo, in which the centrally located light source has an especially dramatic effect. See the discussion of this latter picture in chap. 6.

64 Rothenstein and Butlin pointed out that after Turner's early experiments using a white ground for sky and water in his Thames studies on canvas (c. 1807), the artist "began to explore the possibilities of attaining a high key in his finished oils by using a white ground throughout" (Butlin and Joll, Turner, cat. no. 113).

65 Opie, in Barry, Opie, and Fuseli, Lectures on Painting, 273. The idea of pictorial pairing was, of course, not new. For example, during the renaissance and

baroque periods contrasting and complementary pairs of pictures were not uncommon, and this practice continued. In the eighteenth century, paired pictures sometimes depicted vice and virtue, or contrasting human emotions, but also sequentially related subjects such as those representing different stages in particular human activities or human life, or conditions of civiliza-tions. Turner was almost certainly aware of the relationships established retro-spectively for the two Radnor Claudes that were engraved in 1772. One, *Seacoast with the Landing of Aeneas in Latium*, was engraved by J. Mason with the title "Landing of Aeneas, the Allegorical Morning of the Roman Empire"; the other, its so-called companion, *Pastoral Landscape with the Arch of Titus*, was engraved by W. Woollett and was intended to represent the allegorical evening of the Roman Empire (see Roethlisberger, *Claude Lorrain*, 1: 233 and Kitson, "Turner and Claude," 2–15).

66 Butlin and Joll, *Turner*, cat. no. 131.

67 Ruskin, *Modern Painters*, 1: 30.

68 Farington, *Diary*, 13: 4637 (4 June 1815); see also Butlin and Joll, *Turner*, cat. no. 131.

69 Gage indicated long ago that the comparison of the rise and fall of ancient empires and their similarity with current states of civilization were ideas that had currency during the late eighteenth and early nineteenth centuries. Gage pointed, for example, to Gibbon's monumental history, the *Decline and Fall of the Roman Empire* ("Turner and Stourhead," 75–8; see also Butlin and Joll, *Turner*, cat. no. 135).

70 There exist a number of studies of Claude-like seaport compositions sketched by Turner that possess similarities with these pictures, especially TB CCXX-VII(a), 15; see Nicholson, *Turner's Classical Landscapes*, 294.

71 Powell, "Turner's Vision of Medea," 17n15.

72 Metastasio, *Dido, A Serious Opera*, 61.

73 See appendix (typescript, 160), describing the stage-like qualities of Turner's seaport composition *Regulus*.

74 Ziff, "Turner's Last Four Paintings," 48. They were painted when Turner lived in Chelsea. Mrs Booth observed Turner painting them, as they were "set in a row and he went from one to the other, first painting on one, touching on the next, and so on, in rotation"; J.W. Archer, "Reminiscences," *Once a Week*, 1 February 1862, 166 (reprinted in *Turner Studies* 1, no. 1 [1981]: 36); Gage, *Turner: "A Wonderful Range of Mind,"* 251n102.

75 Intentionally or not, these pictures present yet a further way of challenging the poet's ability "to lead the mind on," by presenting a sequence of major events spanning Aeneas's Carthaginian sojourn.

76 The photograph was discovered by Eric Shanes; see *Turner Studies* 1, no. 1 (1982): 49. This picture was formerly in the Tate Gallery, London; also see Butlin and Joll, *Turner*, cat. no. 430.

77 Beye, *Epic Tradition*, 230. Turner had employed this epic device earlier, when considering Raphael and his mistress, the Fornarina, in *Rome from the Vatican*; see Finley, "Rome from the Vatican," 66.

78 Finley, "Love and Duty," 385.

79 Virgil, *Aeneis*, in *Works*, opp. 261. The engraved plates used in these early illus-trated editions of Dryden's *Aeneis* were adapted from those designed by Cleyn and engraved by Hollar for Ogilby's 1654 edition of Virgil's works, Jacob Ton-son, who was responsible for the changes to the plates, "In most cases ... had Aeneas's features altered – to those of King William!" (Stewart, "William III," 335).

80 Pitt, *The Aeneid*, 2: 348n.

81 In this configuration there is also, perhaps, an echo of the well-known theme of Hercules choosing between Pleasure and Virtue.

82 This theme, for example, underlies his *Medea* (1828; RA 1831).

83 Virgil, *Aeneis*, 366.

84 Ziff, "Turner's Last Four Paintings," 48.

85 Ibid., 51.

86 Gage, "Turner and Stourhead," 73.

87 *A Description of the House and Gardens at Stourhead*, 14.

88 Gage first suggested this possibility ("Turner and Stourhead," 73).

89 Ibid.

90 Turner may have included the priest Chryses because of his involvement with the Trojan War, a struggle to which the artist sometimes alluded in his pictures associated with Aeneas. Turner considered Chryses as a pictorial subject early in his career (c. 1805; see TB XCVIII, fols. 3a, 4). This priest became the sub-ject of a watercolour exhibited at the Royal Academy in 1811 that was accom-panied by lines from Pope's translation of Homer's *Iliad*. Gage identified the figure of Chryses in this picture ("Turner and Stourhead," 71–5).

91 Ibid., 73.

92 Ibid., 74.

93 Powell, *Turner in the South*, 156.

94 The red chalk drawing in Turner's sketchbook (TB CCLXXIX(b), 6; illustrated by Gage, *Turner: "A Wonderful Range of Mind,"* 37) is palpably unrelated to the figures in Turner's picture.

95 De Tressan, *A History of the Heathen Mythology*, 68.

CHAPTER FIVE

1 For a discussion of a similar attitude in the poetry of John Clare, see Barrell, *The Idea of Landscape*, esp. 120–2.

2 During the romantic period in literature and painting the artist was often considered as a solitary being who lived on the fringes of society or, indeed, who was considered to be an outcast. Turner certainly appears to have felt his apartness. Can it be coincidental that vagabondage and exile are important, albeit allusive, ideas in a number of Turner's pictures? He chose to represent, for example, Adam and Eve, Agrippina, Ulysses, Aeneas, Medea, Ovid, and Napoleon. Although not appearing in his paintings, one character that undoubtedly appealed to him was the wandering hero of Byron's *Childe Harold's Pilgrimage*.

3 See Finberg, *Turner*, chap. 11–13.

4 See, for example, Hill, *Turner on the Thames*, 122.

5 Ibid., 1.

6 Pye, *A Short View*, 39; poetic quotation from Thomson's *Spring*. See especially Mack, *The Garden and the City*, chap. 1.

7 Sir Henry Wooton, in his *Elements of Architecture*, refers to the Tuscan column as "a plain, massie, rurall Pillar, resembling some sturdy well-limbed labourer." In his Verse Book Turner composed a poem referring to this line from Wooton (see Wilton, *Turner's Verse Book*, 31).

8 Barry Venning has suggested that for Turner the demolition symbolized the neglect of Pope's genius; see his perceptive review of Wilton's *Turner's Verse Book*, 49.

9 Herrmann, "Landseer on Turner (Part 1)," 28, 29, 30. The composition may display a faint tribute to another landscape showing the Thames: Girtin's *White House at Chelsea* (1800), which Turner greatly admired. The importance of *White House at Chelsea* has been discussed by Gage (*Turner: "A Wonderful Range of Mind*," 125). The focus of Girtin's watercolour is a house, a striking, small near-rectangle of white anchored in the middle ground of the landscape.

10 This painting is considered in chap. 8.

11 Butlin and Joll, *Turner*, cat. no. 86.

12 Wilton, *Turner's Verse Book*, 71–2.

13 Butlin and Joll, *Turner*, cat. no. 86. This suggestion was made by Dr A. Holcomb.

14 It has been suggested that the negative tone of Turner's verse was probably influenced directly by Thomson's description of London in 'Winter' (Hemingway, *Landscape Imagery*, 238). Commerce was considered an agent of power and luxury that leads, ultimately, to a state's corruption and collapse. Similar reservations, specifically concerning the British "shopkeeper mentality," which places commerce before culture, is aired in contemporary verses in Turner's lecture notes on perspective: "Can commerce so engross her only thought / That Taste like Lead by weights, not thought be bought" (BL Add. MS 46151, BB, fol. IV; see Venning, "Turner's Annotated Books (III)," 35. This was later noted by Ziff, "An Unrecorded Poem by Turner," 16, 17.

15 John Denham, in *Cooper's Hill* (1642), associates the city with activity; the country, with passivity, retirement, and reflection; see Turner, *Politics of Landscape*, 55; see also Barrell, *Idea of Landscape*, especially, 21–2.

16 See Finley, "Love and Duty," 380.

17 Roestvig, *The Happy Man*, I: 287. Dr J.D. Stewart introduced me to this invaluable study many years ago: also see Solkin, *Richard Wilson*.

18 The lines are as follows:

Which way, Amanda, shall we bend our course?
The choice perplexes. Wherefore should we chuse?
All is the same with thee. Say, shall we wind
Along the streams? or walk the smiling mead?
Or court the forest-glades? or wander wild
Among the waving harvests? or ascend,
While radiant Summer opens all its pride,
Thy Hill, delightful Shene?

These lines from 'Summer' (2.1401–8), as has been observed (Butlin and Joll, *Turner*, cat. no. 140), further describe the prospect and places viewed from the summit; they include references to Twickenham and to Alexander Pope.

19 Thomson, *The Seasons*, 2.142–5 (Hemingway, *Landscape Imagery*, 219). The Thames itself was an established symbol of Britain's power whose praises had been sung by poets, including Dedham and Pope (ibid., 218).

20 See Stuckey, "Turner's Birthdays," 5.

21 Ziff, review of Gage, *Colour in Turner*, 126.

22 Whittingham, "What You Will (I)," 10. Turner knew this picture (purchased by his friend, the architect John Soane in 1802) by 1803 (ibid., 4).

23 Turner sketched this painting about 1818 (Ziff, review of Gage, *Colour in Turner*, 126).

24 See Whittingham, "What You Will (I)," 10.

25 It has been observed that most of the figures are adapted from Watteau's *Pelerinage à l'Ile de Cythère*, which was engraved and published in 1733; see the entry in the catalogue *Rococo*, Victoria and Albert Museum (c6), 43.

26 Ibid.

27 See Finley, "Rome from the Vatican," 59n18. If Turner's sketchbook (TB CXLI) containing the pencil sketch of *L'Ile Enchantée* and the *Richmond Hill* studies also contains an idea for his subsequent *Rome from the Vatican*, as has been proposed (see Whittingham, "What You Will (I)," 10), this would be in accord with the observation made years ago that one of the preliminary studies for *Rome from the Vatican* contains Watteauesque figures that inspired the composition of *Watteau Study* (RA 1831); see Finley, "*Ars Longa, Vita Brevis*," 246n25.

28 Behn, *Works* 6: 284–5.

29 Colton, "Merlin's Cave," 2–3. I am grateful to Dr J.D. Stewart for bringing this article to my attention.

30 See, for example, similar elegant Watteauesque groups of figures that occur in *Richmond Gardens. View of Hermitage* (engr. Gravelot and Du Bosc 1735) and *Richmond Gardens. View of Richmond Lodge* (engr. Chatelain from *Vitruvius Britannicus* 4, 1739); see Willis, *Charles Bridgeman*, pls. 109, 110a.

31 Finberg, *Turner*, 306.

32 Though it seems possible that Turner was initially inspired by Stothard's Watteauesque design, *Giornata Seconda*, which illustrated an 1825 edition of the *Decameron* (see Butlin and Joll, *Turner*, cat. no. 244), there are other similar designs that may have come to his attention. Very close to Turner's *Boccaccio* in composition and effect is Stothard's *Sans Souci*, Gage refers to the *Decameron* subjects and versions of *Sans Souci* (*Turner: "A Wonderful Range of Mind*," 147, 251). There is another Stothard design of the same general character with Watteauesque reclining couples that includes a prominent central fountain (it should not be noted that there is also a fountain playing in Turner's *Boccaccio*, though not centrally placed); Stothard's design illustrates Coleridge's *Garden of Boccaccio*, published in *The Keepsake* (1829), which, because of Turner's close association with the illustrator at that time, may have been known to him before it was published. This poem includes a reference to a tower, a prominent feature that functions as a topographical sign in Turner's picture:

I myself am there,
Sit on the ground-sward, and the banquet
"Tis I, that sweep that lute's love-echoing strings,
Or pause and listen to the tinkling bells
From the high tower, and think that there she dwells.
With old Boccaccio's soul I stand possest,
And breathe an air like life, that swells my chest.

(*The Keepsake*, London, 1829, 284)

33 Butlin and Joll, *Turner*, cat. no. 244.

34 Whittingham, "What You Will (I)," 24n182.
35 British Museum, *Catalogue of Political and Personal Satires* 10 (1949): 13854 (c. September 1820).

CHAPTER SIX

1 It has recently been shown that these lines from a poem in Turner's sketch-book were in fact composed by the dramatist and writer George Coleman J.; see Piggott, "Turner's Spithead Sketchbook," 12–13.
2 Boime, *Art in an Age of Bonapartism*, 133.
3 See, especially, Shanes, *Turner's Picturesque Views*.
4 Did Turner believe in the idea of progress? This is a difficult question to answer, but since progress is at odds with traditional ways of life that he valued, it seems unlikely that it was a concept he eagerly embraced. And yet, one should not necessarily assume consistency in his attitudes. He was, above all, strongly patriotic, and he may have believed that progress was one of the necessary attributes of a modern Britain (see chap. 8 for a discussion of n61, where the meaning of *View of London from Greenwich* is considered).
5 See chap. 9.
6 Scott, *Napoleon Buonaparte*, in *Miscellaneous Prose Works*, 9:311.
7 Ibid., 15:198–200.
8 I mistakenly believed that in his view of Fontainebleau Turner was representing the departure of Caulaincourt and Ney for Paris with the instrument of abdication (Finley, *Landscapes of Memory*, 199). He was, in fact representing – as has been rightly pointed out – Napoleon's departure from Fontainebleau (Krause, *Turner in Indianapolis*, 190).
9 Scott, *Napoleon Buonaparte*, in *Miscellaneous Prose Works*, 15:227.
10 Ibid., 228.
11 Turner's poetic lines appear in his discursive poem planned for, but never published in, the *Southern Coast*. The poem is found in TB CXXIII (c. 1811); see 90a. These lines were transcribed by Thornbury (*Turner*, 213) and recently, with corrections, by R.M. Turner (in Wilton, *Turner's Verse Book*, 172):

Regulus, whom every torture did await
Denyd himself admitance at the gate
Because of captive to proud Carthage power
But his firm soul would not the Romans lower.
Not wife or children dear, or self could hold
A Moment's parley love made him bold
Love of his country; for not au[gh]t beside
He loved but for that love he died.

12 Finley, "Theatre of Light," 224; see also appendix to this volume (typescript 161).
13 In 1837 Turner undertook the reworking of *Regulus* on the walls of the British Institution, which involved a strengthening of its light effects. Sir John Gilbert watched Turner at work: "He had a large palette, nothing in it but a huge lump of flake-white; he had two or three biggish hog tools to work with, and with these he was driving the white into all the hollows and every part of the surface. This was the only work he did, and it was the finishing stroke. The sun ... was the centre; from it were drawn – ruled – lines to mark the rays; these lines were rather strongly marked, I suppose to guide his eye" (Cust, "The Portraits of Turner," *Magazine of Art*, 1895, 248–9, as quoted in Butlin and Joll, *Turner*, cat. no. 294).

14 Wilson had apprenticed under one of Turner's favourite engravers, William Miller.
15 Ibid.
16 Ibid.
17 See appendix (typescript 161). Wilton noted the presence of Regulus in *J.M.W. Turner*, 221.
18 The influence of the theatre on Turner's art is notable, especially in the dramatic paintings and illustrations from the final years of the 1820s and also in some subsequent works.
19 Turner's *Regulus* does not openly depict violence, even though the theme itself is violent. It was not that Turner avoided its depiction; violence is, as observed previously, an essential aspect of his contemporaneous *Vision of Medea*. It was rather that he considered rage, frenzy, and murder to be inappropriate in this particular context. If violence in *Medea* suggests the extent of the heroine's sense of betrayal, of her fury and desire for revenge, the lack of it in *Regulus* is surely intended to feed and sustain a mood determined by the hero's reflection and calm, stoical acceptance of his fate. For this reason Turner's allusions in his picture to Regulus's future tortures are oblique. Still, the setting responds to its subject matter. As in the painting, *Medea*, the setting responds to its disturbing, even menacing. As in the painting, *Medea*, the setting responds to its subject matter. On the deck of the docked ship in the left foreground is the barrel that Wilson, the engraver, identified as the one studded with nails in which Regulus was confined (see appendix [typescript 161]). The harsh, remorseless brilliance of the sun effectively demonstrates Turner's similar analogical thinking and presents an experiment of remarkable artistic boldness. A relationship is established between the viewer, who assumes the role of Regulus, and the image of the sun, which becomes the radiant metaphor for Regulus's other agonizing ordeal – when he had his eyelids removed and was forced to stare into the sun until blinded (see Gage, *Colour in Turner*, 143). By alluding to these tortures, despite such pictorial restraint, and by evoking the sublime, Turner has overridden convention and claimed a more elevated status for his picture's historical theme. Probably he was recalling Edmund Burke's ideas in the latter's celebrated *Philosophical Enquiry into the Origin of Our Ideas of the Sublime and Beautiful*. Burke described and commented on the sublimity of pain and the novel observation that exposure of the eyes to the blinding brilliance of the sun was eminently sublime: "Such a light as that of the sun, immediately exerted on the eye ... overpowers the sense, [and] is a very great idea ... Extreme light, by overcoming the organ of sight, obliterates all objects, so as in its effect exactly to resemble [another sublime quality,] darkness" (Burke, *A Philosophical Enquiry*, 80).
20 In about 1798 Turner made a pencil sketch (TB XL, 67) inspired by a drawing by J.R. Cozens of *Hannibal Crossing the Alps*, which was probably a variant of the design of the lost oil painting; see Matteson, "Alpine Passage," 387.
21 Gage, *Colour in Turner*, 143.
22 The Salassians "suddenly rose from their ambuscade in the rear. These had ... been concealed in the woods, on the right of his march and near the point of

this pass, but rose from their ambuscade when he had gone by them, formed in the vale behind him, followed his rear out of sight, and attacked him at this instant. Another body of men appeared equally over the ridge of the mountain before him, at the same instant; and attacked his van ... Thus assailed in front and in rear at once, by a sudden burst of perfidy; had Hannibal been off his guard at the moment, the whole army of the Carthaginians must have been crushed by the blow; and Hannibal's march over the Alps has been considered in the history of man, as one of the wildest exertions of military extravagance. In front, the Salassi upon the crest of the mountain, moving parallel with elephants, the cavalry, and the baggage plied them with massive stones from the boulders above mentioned, and rolled down upon them the huge rocks noted before. But they brought their principal force, and made their principal assault, against the rear. Unless this was beaten, their perfidy would be incomplete" (Whitaker, *Course of Hannibal*, 1:263–4).

23 Poetic lines concerning fate first appear associated with landscape watercolour tours exhibited at the Royal Academy in 1799; lines from "Dr Langhorne's Visions of Fancy" accompany *Morning*, and lines from Thomson's *Seasons* accompany *Warkworth Castle, Northumberland* (see n3, chap. 2). Matteson ("Alpine Passage," 390) has pointed to Gisborne's poem *Walks in a Forest*, first published in 1794, as one possible source of inspiration for Turner's early drawing (c. 1798; TB XL, 67), which was, as mentioned in n20, influenced by the Cozens' Hannibal design. This poem describes Hannibal's alpine crossing and mentions specifically his glimpse of Italy, establishing a contrast between the sublime mountains and the beautiful Italian plain (ibid.), an aesthetic contrast that Turner would have appreciated; further, the poem is coloured by a "sense of tragic destiny," that confronted Hannibal (ibid.). Certainly, as Matteson notes, Gisborne's poetic lines bear "a striking resemblance in meter and imagery to the passage from the 'Fallacies of Hope' that Turner appended to the painting of 1812" (ibid.). We know that, at least at a later date, Turner was familiar with Gisborne's poem; see chap. 10.

24 Matteson ("Alpine Passage") convincingly suggests that Turner's early (c. 1798) composition on the theme of Hannibal (mentioned in n23, above) was inspired by Napoleon's invasion of Switzerland in that year (see 394–5).

25 Turner adapted the image for his design *Marengo*, prepared (c. 1827) for Samuel Rogers' poem *Italy* (1830); see Rawlinson, *The Engraved Work*, 43, 353. Also see Matteson, "Alpine Passage," 396.

26 Maccum, *View of Napoleon*, 45.

27 Ibid., 88.

28 Ibid., 95.

29 Ibid.

30 Turner was insistent that it be hung at eye level, probably so that the detail could be clearly seen, particularly its multiplicity of small figures; see Farington, *Diary*, 11: 4108 (11 April 1812).

31 Maccum, *View of Napoleon*, 133. Beethoven's removal of his dedication to Napoleon from his "Heroic" symphony on learning of his imperial plans is well known.

32 Ibid., 104.

33 This is from his ambitious poem intended for Cooke's *Picturesque Views on the Southern Coast*; see Lindsay, *Turner*, 137.

34 Turner may have anticipated the idea of a Napoleonic invasion of Britain as early as 1804 in *Boats Carrying Out Anchors and Cables to Dutch Men of War, in 1665*, by alluding to the lack of preparedness of the English against the Napoleonic threat. According to A.G.H. Bachrach, the painting may refer to an incident in the Anglo-Dutch wars in which, after the defeat of the Dutch fleet at Lowestoft in June 1665, the English had become complacent and were unprepared for the swift Dutch refit of their fleet. This led to Dutch victories culminating in their invasion of the Medway exactly two years later in June 1667; see Butlin and Joll, *Turner*, cat. no. 52.

35 Finley, *Turner and George the Fourth*, especially chap. 3. One of these events was the Provost's banquet, which took place on 24 August. It was a formal affair held in the great hall of Parliament House (the "Westminster Hall of the North"). Turner's friend the architect Charles Robert Cockerell had been able to secure Turner's admission to this event. He went there accompanied by fellow artist David Wilkie, who had indicated his strong desire to witness the ceremony in which the king received a silver basin containing rose water "for the purification of the royal hands" (13). In discussing, years ago, Turner's presence in Parliament House on this occasion, I concluded that there were no on-the-spot sketches of this event. However, since reexamining small sketched cards (approximately $3 \times 4 \frac{1}{2}$ in.) in the Turner Bequest (images I previously believed might have been associated with the coronation of July 1821), I have changed my opinion. I now believe that they depict the dinner in Parliament House. I have concluded this on the basis of the construction of the royal table (TB CCCXLIV, 445). These small cards would have been held comfortably in the palm of the hand, permitting Turner surreptitiously to record this particular event (see also TB CCCXLIV, 441 and TB CCCXLIV, 46).

36 *The Mission of Sir Walter Scott*, c. 1825, TB CLXVIII-B.

37 Scott arranged that the king himself should be dressed in tartan for the levee held at Holyrood. By covering himself in the Royal Stuart tartan, he was presenting himself as the living metaphor for the reconciliation of the two royal houses of Stuart and Brunswick. However, he was also indicating that he descended from King James VI of Scotland, and so legitimately could be called King of Scotland, or more precisely, King of Scots; see Finley, *Turner and George the Fourth*, 11–13; also see 7, 32–3.

38 Finberg, *Turner*, 142.

39 See Finley, "Turner's 'Landscape Sublime.'"

40 Farington, *Diary*, 7: 2777 (3 June 1806).

41 This review in the *Review of Publications of Art* for 1808 was very likely written by the critic John Landseer, as Butlin has noted (in Butlin and Joll, *Turner*, cat. no. 58). The emphasis is mine.

42 Hoare, "The Offices of Painting," in *The Artist*, 1: 17–19.

43 Thornbury, *Turner*, 429.

44 Shanes, *Turner's Human Landscape*, 90, 92.

45 Bachrach, "The Field of Waterloo," 9.

46 Ibid.

47 See Hemingway, *Landscape Imagery*, 31.

48 See Bachrach, "The Field of Waterloo," 9, 10.

49 This early painting seems to have represented a tilt forge; see McCoubrey, "The Hero," 8.

50 "Only in July 1847 was the final decision taken that it should remain ... It was finally taken down in 1883" (Alfrey, "Cult of Heroes," 35).

51 Ibid., 37.

52 TB CXIV, 2a–3.

53 Finley, *Landscapes of Memory*, 164–5.

54 Ibid., 221–2.

55 Ibid., 225–6.

56 Reynolds, *Discourses*, 14 (1788): 255.

57 See Ziff, "Backgrounds," 146–7.

58 See chap. 7.

59 Thornbury, *Turner*, 324. Perhaps the idea of black sails was inspired by ancient myth. Dr J.D. Stewart reminded me of the legend of the monster Minotaur who ate human victims. Minos, king of Crete, demanded from the Athenians an annual tribute of seven youths and seven maidens to feed the Minotaur. Theseus, son of the king of Athens, forswore to kill the Minotaur or to die in the attempt. He sailed as a victim with the other youths and maidens, despite the entreaties of his father, in a ship under black sails. Theseus promised his father that, should he return victorious, he would substitute white sails for black. Theseus was indeed victorious but on the return journey neglected to raise the white sails as he had promised. His father was so distressed on seeing the returning black sails, believing that his son had died, that he took his own life.

60 The elegiac atmosphere of this image, as Dr Stewart has suggested to me, may provide a specific link with certain aspects of Turner's earlier *Waterloo*.

61 Hazlitt, *Works*, 15:321.

62 Ashton, *Caricature and Satire on Napoleon*, 253–4. It seems reasonable to suggest that Turner may also have been aware of Benjamin Robert Haydon's lost *Napoleon Musing on St Helena* (c. 1830), where Napoleon is shown back turned with folded arms; see McCoubrey, "War and Peace," 6 (pl. 4).

63 As has been observed (ibid., 2), Wilkie's body had been refused burial for reasons of public health by the governor of Gibraltar, whose characteristic rock is gleaming through the mists in the left background.

64 Gage, *Collected Correspondence*, 161 ([22] February 1830); see McCoubrey, "War and Peace," 3.

65 Wallace, "Turner's Circular, Octagonal and Square Paintings," 53, 107–17. A diorama representing Napoleon's second funeral was on display at the *ci-devant* Bazaar in St James' Street, London, in April 1841, two months before Wilkie's demise; see *The Athenaeum*, 3 April 1841.

66 See Finley, "Turner's Illustration to *Napoleon*," 399n31; see also *Landscapes of Memory*, 259n75.

67 As well as containing biographical facts, the sketch, perhaps written by A. Ricourt (I am grateful to Lee Johnson for this suggestion), provides interesting material concerning Turner's art. For example, it contains the information that in 1834 Turner recorded the burning of the Houses of Parliament from a boat near Westminster Bridge. See the appendix in Finley, "Turner, the Apocalypse and History," 695–6.

68 See chap. 10.

69 The gift was in response to Constable's presentation of Reynolds's palette to the Royal Academy in 1830; see Butlin, Gage, and Wilton, *Turner, 1775–1851*, cat. no. B 50.

70 Gage, *Collected Correspondence*, 157 (W.L. Roper to Turner, 24 Dec. 1829).

71 Wilton, *Turner in His Time*, 163; Turner's directions for his charity were never carried out.

72 See especially Cumming, "The Greatest Studio Sale," 3–8.

CHAPTER SEVEN

1 See Stuckey, "Turner's Birthdays," 3–4.

2 Rogers, *Italian Journal*, 212; see Finley, "Rome from the Vatican," 62.

3 Writers of contemporary guides often remarked on the intermixture of old and new buildings in Rome. See for example, *Hakewill's Tour*, n.p., and Rogers' *Italian Journal*, 219.

4 Powell, *Turner in the South*, 116.

5 A year after Turner exhibited *Rome from the Vatican*, Joseph M. Gandy, Soane's pupil, "published an essay 'On the Philosophy of Architecture' in which he ascribed to the Ark, the 'divine origin' of architecture 'from the first dawn of its existence'" (Omer, "The Building of the Ark," 70).

6 Manwaring, *Italian Landscape*, 38.

7 Gage, *Colour in Turner*, 93.

8 "Raphael was less penetrated by a devout, than by an amorous principle. His design was less to stamp maternal affection with the seal of religion, than to consecrate the face he adored, his Holy Families, with one exception, are the apotheosis of his Fornarina" (Fuseli, in Barry, Opie, and Fuseli, *Lectures on Painting*, 456).

9 Turner, as has been noted (Gage, *Colour in Turner*, 243n94), sketched Titian's painting in the Borghese when in Rome in 1819 (TB CXCIII, 4) and made reference to it in several other paintings, including *The Bay of Baiae* (1823; Clore Gallery for the Turner Collection, London; see Powell, *Turner in the South*, 70).

10 Gage, *Colour in Turner*, 93.

11 It should be observed that the large blue and whitish pot in front of and to the left of Watteau in *Watteau Study* appears to have been influenced by the Chinese pots with covers in Egremont's collection.

12 Butlin and Joll, *Turner*, cat. no. 338.

13 Thornbury, *Turner*, 117.

14 Gage, *Collected Correspondence*, 161 (Turner to George Jones, [22] Feb. 1830).

15 It is perhaps significant that Turner chose the lines of a poet to illuminate the meanings of these theoretical pictures. His second and final pair of paintings illustrating theory, also by a poet, is *Shade and Darkness: Evening of the Deluge* and *Morning after the Deluge*. This pair is concerned with Goethe's colour theory. See, especially, chap. 12.

16 Du Fresnoy, *The Art of Painting*, 37. The two lines (445–6) and the other four (447–50) occur in the section "Of White and Black."

17 BL Add. MS 46151, H. 35r. One recalls how much Turner admired Thomas Girtin's watercolour *White House at Chelsea* (1800), with its small but strong accent of white. See Girtin and Loshak, *Girtin*, cat. no. 337; also see the probable allusion, as faint as it is, in *Pope's Villa at Twickenham* (chap. 5).

18 With the withdrawal of light, the deepest shadow would (in painting, drawing, and print) be represented pictorially by a value close to black. As one art theorist observed, "White and black ... are not deemed colour in themselves; however, they may, as materials [pigments], be so considered when on the palette. White and black are with the painter representatives of light and darkness"

19 Thornbury, *Turner*, 438.

20 Butlin and Joll, *Turner*, cat. no. 244.

21 The particular pose of Watteau was adapted from the guitar player in Watteau's *Les Charmes de la Vie* (Wallace Collection, London); see Finley, "*Ars Longa, Vita Brevis*," 246n25. For the influence of his own sketch, see n27, below.

22 See Butlin and Joll, *Turner*, cat. no. 338.

23 Turner's representation of St Peter in prison was influenced by Raphael's composition of the same subject in the Vatican's Stanza d'Eliodoro.

24 Turner had earlier painted Watteauesque figures in English settings – for example in *England: Richmond Hill* – but he also did so later, in 1828, in *Boccaccio Relating the Tale of the Birdcage*.

25 Early in his career, Turner knew of and had studied the *Oeuvre Gravé* of Watteau, published by Jean de Julienne (1727–35): he adapted, as has been noted, part of the engraved design of Watteau's *Acis et Galathe* for the landscape of his *Garden of the Hesperides* (exh. 1806); see chap. 4.

26 Finley, *Landscapes of Memory*, 170.

27 Raphael and the seated figures in one of the sketches for *Rome from the Vatican* (TB CLXXIX, 26), as noted previously, influenced the composition of figures in *Watteau Study* (see Finley, "*Ars Longa, Vita Brevis*," 246n25).

28 TB CXI, 66a; transcription by R.M. Turner, in Wilton, *Turner's Verse Book*, 105–6.

29 See Finley, *Landscapes of Memory*, chap. 4.

30 *The Art Union*, 1 (1839): 49. Only one of the frames was retained in the engravings.

31 See Finley, *Landscapes of Memory*, chap. 8.

32 There is no evidence in Turner's on-the-spot sketches or from an examination of the grounds that there was a sunken garden at Bemerside.

33 Scott, *Poetical Works*, 5:1.

34 The manuscript of "Sir Tristrem" (the Auchinleck manuscript) was, however, not in Scott's collection but in that of the Advocates' Library, Edinburgh.

35 Opie, in Barry, Opie, and Fuseli, *Lectures on Painting*, 276.

36 Artistic licence was deemed essential for "allusive" history painting, the most elevated category of art. In this category, pictures introduce historical allusions to events of other epochs in order to help realize the artist's poetical intentions. As Hoare put it, "the character and genius of an age, a government, or a hero are expressed, by the representation, not of actual events immediately belonging to either, but of congenial scenes and actions, drawn from examples of celebrity in the records of traditions of former times. This mode of graphic representation, I conceive, takes place decidedly within the threshold of Poetry, and forms a distinct branch of it" (*The Artist* 2, 260). Hoare observes that paintings by Raphael in the rooms of the Vatican, the narrative scenes, for example, display this poetical approach: "the Retreat of Attila, from the presence of Leo [I,] the Escape of St Peter from prison, and other subjects of this celebrated series of paintings [that] bear ... allusion to the actions of Leo the Tenth" (ibid, 264). Hoare states that "the poetical licence claimed by Raffaelle ... is similar to that adopted by the elegant muse of Virgil ... Aeneas is ... introduced into Carthage, a city built two or three centuries after his death, as ...

Leo X into events antecedent, by a term of no less duration, to [his] birth" (ibid., 265–6).

CHAPTER EIGHT

1 Klingender, *Art and the Industrial Revolution*, 37.

2 Mortier, "Illustration of Science and Technology," 34.

3 Burke, *A Philosophical Enquiry*, 57.

4 Young, *Annals of Agriculture*, 4: 166–8.

5 Wyndham, *Tour through Monmouthshire and Wales*, 25.

6 Elton, introduction to *Art and the Industrial Revolution*, n.p.

7 "The mill appeared as a symbol of social energies which were destroying the very 'course of Nature,'" (Thompson, *English Working Class*, 189).

8 He was to purchase fifty-three of these drawings at the Monro sale in 1833; see TB CCCLXXII; also, see Butlin and Joll, *Turner*, cat. no. 22.

9 *The Hero of a Hundred Fights* (RA 1847) was, as mentioned (chap. 6), painted over an early (c. 1800) industrial subject.

10 It was likely based on Rembrandt's *Flight into Egypt*, in the possession of his patron, Colt Hoare (Butlin and Joll, *Turner*, cat. no. 22).

11 Daniels observes that Whitaker deplored the results of industrialization in Leeds and its environs and suggests, persuasively, that this was the reason Turner's design was not published; see "Turner and Leeds," 12.

12 Ibid.

13 Ibid.

14 Ibid.

15 Ibid., 11.

16 The watercolour is in The Lady Lever Art Gallery, Port Sunlight.

17 Rodner, "Turner's *Dudley*," 32; see also Shanes, *Turner's Picturesque Views*, 43 (pl. 66).

18 Rodner, "Turner's *Dudley*," 32.

19 *Gentleman's Magazine*, October (1825): 311.

20 J.K. Shuttleworth (1832), as quoted by Briggs, *The Age of Improvement*, 61.

21 Carlyle, *Signs of the Times* (1829), in *A Carlyle Reader*, 34–6.

22 Dickens, *Hard Times* (1854) in *Works*, 17: 175–6; see also 17: 25, 72, 123, 129, 133, 173.

23 Wordsworth, *The Excursion*, in *Poetical Works*, 5: 339, 343.

24 BL Add. MS 51716, fols. 646–65 (15 Oct. 1835).

25 *Punch*, July 1841, 2.

26 See preface to Samuel Smiles, *George Stevenson*, New York, 1868. This biography was first published in 1857; also, Klingender, *Art and the Industrial Revolution*, 139.

27 An article entitled "The Age of Iron," which appeared in *The Athenaeum* (26 June 1841), presents some idea of the wealth of published material issuing from capital and provincial presses: "Our table trembles beneath a burthen of this new and voluminous literature ... It is hardly to be conceived that there is a department of life or of literature not already permeated by the genius of Iron, or a recluse so antiquated as not to experience a deep and soul-stirring interest in the practice and theory, the statistics and the legislation, the police and the polemics, the topography, chronology, &c. of railway bars and locomotive engines" (483).

NOTES TO PAGES 138–45

28 See Barman, *Early British Railways*, 25.

29 Opie, in Barry, Opie, and Fuseli, *Lectures on Painting*, 276.

30 Hamerton, *Turner*, 295.

31 It has been referred to by Gage as "an allegory of the forces of nature" (*Turner: "Rain, Steam, and Speed,"* 19).

32 Ruskin, *Notes on the Turner Gallery*, 55–6, 76. "Formerly he painted the Victory in her triumph, but now the Old Téméraire in her decay; formerly Napoleon at Marengo, now the Cemetery at Murano; formerly the Studies of Vandevelde, now the Burial of Wilkie" (ibid., 56).

33 Monkhouse, *The Turner Gallery*, 3: n.p.

34 See *The Art Union*, May 1839, 43.

35 See Egerton, *Turner: "The Fighting Téméraire,"* 11.

36 Turner seems occasionally to reverse the sequence, as with the frontispiece for his *Liber Studiorum*, where the most ancient architecture is in the middle ground.

37 Elliott, *Poetical Works*, 92.

38 Klingender, *Art and the Industrial Revolution*, 160.

39 Gage refers to the newspaper account describing the race between a locomotive and a thoroughbred; the latter run down (*Turner: "Rain, Steam, and Speed,"* 27). However, he is surely incorrect to suggest that in Turner's picture the hare will not be overtaken by the locomotive (ibid., 33). In Turner's picture the hare is nearly invisible to the eye when the painting is reproduced; for this reason the detail of the hare illustrated here is from the engraving.

40 Davies, *British School*, 99–100.

41 MacDermot, *Great Western Railway*, 1: 190.

42 Gage, *Turner: "Rain, Steam, and Speed,"* 11–13.

43 Turner had certainly discussed the railway (Finley, *Landscapes of Memory*, 103); he had quipped about railway travel (Lindsay, *Turner*, 185). He valued the saving of time that the railway made possible and, indeed, profited directly from this technology late in life when he sold a small plot of land at Twickenham to a railway company (Thornbury, *Turner*, 339).

44 Burke (*A Philosophical Enquiry*, 61) discusses the sublimity of Milton's description of Satan in *Paradise Lost*.

45 As quoted in Froude, *Life of Carlyle*, 384.

46 Dickens, *Dombey and Son*, in *Works*, 18: 323.

47 *Punch*, 1845, 9: 47.

48 Gage first identified Rembrandtesque qualities in this painting (*Turner: "Rain, Steam, and Speed,"* 57). Turner seems to have evoked similar qualities of work of this master in his early (c. 1797) industrial subject, *Limekiln at Coalbrookdale* (see Butlin and Joll, *Turner*, cat. no. 22).

49 Reviewers of *Rain, Steam, and Speed* were often complimentary in their response to it, though many observed that it lacked clarity. In June 1844 *The Art Union's* critic noted that "Few artists have studied nature more closely than Turner," but he observed that in such a picture as this, the spectator might wonder "with what profit"; and on this question there was "divided opinion." The writer concluded that "it is at least agreed on all hands that his enunciation of what he sees is often in a language of mysticism" (155). The *Athenaeum's* critic (11 May 1844) also alluded to the obscurity of this picture's imagery. The painting was referred to as a "vision ... strong in the plenitude of those rainbow tints which the Under-graduate [Ruskin] sets above the more temperate splendours of Claude, Cuyp, or Poussin, or any landscape painter, ancient or modern. When this humour is on the artist, it matters little whether it be 'a whale or an ouze' that he has taken in hand, or a locomotive and a viaduct, or one of the Fairy Morgana's cloud-cities, the scene being wholly forgotten in the treatment; and that those who cannot dream with him in all the fulness of his frenzy, had better turn away, lest they run into vituperation." When in 1845 the American James Lenox purchased (unseen), through C.R. Leslie, Turner's much earlier *Staffa: Fingal's Cave* (RA 1832; discussed in chap. 9), the buyer wrote to Leslie of its "indistinct" character (Leslie, *Autobiographical Recollections*, 206). When asked by Turner whether he had heard from Lenox, Leslie was compelled to report that he had and that Lenox had remarked on the picture's indistinctness. Turner considered that this possibly was due to an alteration of the varnish in consequence of the transatlantic voyage, and recommended possible ways to remedy the effect, concluding that "You may tell Mr Lenox that indistinctness is My Fault." See Holcomb, "'Indistinctness is My Fault': A Letter about Turner from C.R. Leslie to James Lenox," 557–8.

50 See Butlin and Joll, *Turner*, cat. no. 409. The intimate association between the viewer and nature established by Turner in his pictures is discussed in Finley, "Turner's 'Landscape Sublime.'" This association is strengthened in some of his late works, such as in *Snow Storm—Steam-Boat off a Harbour's Mouth Making Signals* (RA 1842), the inspiration for which was reputed to be the experience of Turner having lashed himself to the mast of the vessel for four hours (see the parallel with Claude-Joseph Vernet in Barbier, *Samuel Rogers and William Gilpin*, 74–5, and the discussion in Butlin and Joll, *Turner*, cat. no. 398). There is a similar story that was almost certainly concocted to chime with the contents of *Rain, Steam and Speed*: "Travelling by coach to catch a train at Exeter, Lady Simon sat opposite 'an elderly gentleman, short and stout, with a red face and a curious prominent nose.' They passed through 'a violent storm' that blotted 'out the sunshine and the blue sky and ... [hung] like a pall over the landscape.' The old gentleman seemed strangely excited at this, jumping up to open the window, craning his neck out, and finally calling to her to come and observe a curious effect of light. A train was coming in their direction, through the blackness, over one of Brunel's bridges, and seen through driving rain and whirling tempest, gave a peculiar impression of power, speed, and stress" (Stirling, *The Richmond Papers*, 54–5).

51 Ruskin considered *The Fighting Téméraire*, "the last of a group of pictures, painted at different times, but all illustrative of one haunting conception, of the central struggle at Trafalgar" (*Notes on the Turner Gallery*, 78).

52 Ibid., 79.

53 Egerton, *Turner: "The Fighting Téméraire,"* 78.

54 This was observed by Shanes, *Turner's Human Landscape*, 42.

55 Egerton, *Turner: "The Fighting Téméraire."*

56 Ibid., 81–2.

57 TB CXIV, 2a–3.

58 Both pictures, McConnel observed, were "Painted at my especial suggestion" (Treuherz, "The Turner Collector," 39).

59 Butlin and Joll, *Turner*, cat. no. 360.

60 TB CCVIII, v.

61 Whether or not Turner perceived progress as also destroying liberty is difficult to determine, though many Britons believed that it was. If Turner believed this in the 1830s, he appears not to have believed it earlier. Then he designed and was ready to accept commissions for works in which progress was to be celebrated. For instance, in about 1825 he prepared a watercolour, *View of London from Greenwich*, perhaps for a London series in which 300 years of London's history is commemorated (Shanes, "Turner's 'Unknown' London Series," 38). Whatever Turner felt about progress at this time, I do not believe that the meaning of this watercolour has been adequately understood. Though the formidable presence here of Thames shipping points to the city's economic importance as a port, Turner also suggests, at the same time, the progress of the nation. By including in his watercolour prominently positioned steamships on the river and reference to a plan of land reclamation in the left foreground, he alludes to the country's technical and engineering attainments. The practical successes of steam-driven conveyances were on the minds of Britons at this particular time. British engineering genius was clearly acknowledged with the opening in 1825 of the Stockton and Darlington Railway. The significance of steam in London's future as a modern trading centre, to which this watercolour seems to allude, is a theme that chimes with the substance of an article published in 1825: "steam-boats have superseded all the coasting packets in the kingdom. It has now been ascertained that it can be applied to the propelling and dragging of goods on a rail-road, at a far cheaper and more expeditious rate than can be accomplished by other means. In a country where every species of intelligence is diffused with such rapidity, the march of improvement cannot be permanently arrested" (*London Magazine*, n.s., no. I [Jan.–June 1825]: 36). By depicting in the foreground of his watercolour two hemispheres of the globe, one inscribed with the words "N[orth] Pole," the other with "New World," Turner is suggesting British enterprise through exploration, and he is probably alluding to early as well as more contemporary explorations. Among the most recent explorers he may have been thinking of were F.W. Beechey, Sir John Franklin, and W.E. Parry.

62 Hawes, "Turner's 'Fighting Téméraire,'" 41.
63 Thompson, *English Working Class*, 190.
64 Finley, "Turner and the Steam Revolution," 29.

CHAPTER NINE

1 These lines were attached by Turner to *The Fountain of Fallacy*, exhibited at the British Institution in 1839.
2 See chap. 1, n4.
3 Dennis L. Sepper states that *Vorstellungsarten* was intended to refer to "the ways of conceiving things, which he [Goethe] had characterized as an attempt to bring many objects into relationship that, strictly speaking, they did not have with one another" (*Goethe contra Newton*, 91).
4 Thornbury, *Turner*, 302.
5 See Hill, *Turner's Birds* and Lyles, *Turner and Natural History*.
6 See Matteson, "John Martin's 'The Deluge,'" 220–8. The author points to the remarkable popularity in Britain during the 1820s and 1830s of the Deluge theme in painting and poetry (ibid., 221).

7 In 1825, Williams wrote to the engraver William Miller about one of his watercolours that was in the process of being engraved, noting that "having had a conversation with Dr [afterwards Sir David] Brewster on the subject of the old moon in the new moon's arms, as represented in my view of part of the remains of the Temple of Minerva by moonlight, I wished to have a conference with you regarding it. From what he said, and indeed from my own observations since, it appears that the moon takes this appearance as if the new moon embraced the old, and does not appear to take the same line of circumference, but appears to belong to a *larger circle*. It is ocular deception; but as it appears so in nature, when the telescope is not used, it had better be represented truly" (Miller, *Memorials of Hope Park*, 119).

8 See Gage, *Collected Correspondence*, 244.

9 Constable stated that "painting ... should be pursued as an enquiry into the laws of nature. Why, then, may not landscapes be considered as a branch of natural philosophy, of which pictures are but the experiments?" (see his lecture 4, delivered to the Royal Institute of Great Britain [1836] as quoted in Leslie, *John Constable*, 323). As has been observed, Constable would see this as an indication that painting "was not merely a mechanical skill, but depended on principles and theoretical knowledge, rather than as a statement of the need for a disinterested observation of natural phenomena" (Hemingway, *Landscape Imagery*, 17). Science for Constable, whatever differences the term may have held for him, concerned natural "laws," which could aid him in *understanding* what, as an observer of a dynamic nature, he was examining and thereby assist him in establishing technical and stylistic strategies that would allow him pictorially to mimic natural appearances and effects. Sketching out-of-doors enabled him to implement these strategies, which were then introduced into his large studio paintings. Constable stated, "In such an age as this, painting should be *understood*, not looked on with blind wonder, nor considered only as a poetic aspiration, but as a pursuit, *legitimate, scientific, and mechanical*" (ibid., 273).

10 Thornbury, *Turner*, 310.

11 His interest in the science and theory of light, however, is expressed in the notes made for his Royal Academy lectures and the notations in the text of his copy of Goethe's "Theory of Colours"; for the latter, see especially chap. 12.

12 Finley, *Landscapes of Memory*, 224–5.

13 Rogers, *Italy, A Poem*, London, 1830.

14 The watercolour (19.3 × 14.0 cm) is in the collection of the Preston Hall Art Gallery, Stockton-on-Tees.

15 Gage, *Turner: "A Wonderful Range of Mind,"* 224.

16 As has been observed, "Hers is a rendition of Laplace in English, not a mere translation" (Patterson, *Mary Somerville*, 72).

17 Greene, *Geology in the Nineteenth Century*, 30. In this brief review of aspects of the early history of geology I am particularly indebted to material in the early chapters of Greene's book; see also Finley, "The Deluge Pictures," 543–5.

18 Ibid., 20, 22.

19 Ibid., 20, 22, 25, 30.

20 Ibid., 23, 31, 72.

21 Werner did not publish a theory of neptunism; see ibid., 41.

22 Ibid., 31, 41.

23 Ibid., 63–4, 69.

24 This debate was in fact localized (Edinburgh-based). It did not involve, as Lyell stated, Freiberg. Also this debate did not enlist arguments that were formulated or proposed by Werner; see ibid., 56.

25 Ibid., 26.

26 Ibid., 72.

27 Ibid. Lyell believed that geology could only be adequately understood when illuminated by the other independent scientific disciplines on which it was built; see ibid., 71.

28 Ibid., 73, 75.

29 In England these ideas were pursued by a young land surveyor, William Smith (1769–1839), who holds a distinguished position in the history of British geology as the author of the *Geological Map of England* (1815) and as an important figure in English stratigraphic geology. In 1790 Smith discovered that rocks were layered in a particular sequence and that these layers contained certain fossils that appeared indigenous to them. He concluded from this that rocks could be identified and dated by means of fossils peculiar to them. Such geological discoveries were of signal practical importance for mining and industry; see Phillips, *A Selection of Facts*, 4–5; Conybeare and Phillips, *Geology of England and Wales*, xlv; Fitton, *English Geology*, 4.

30 See especially Helsinger, "Turner and the Representation of England," 103–25.

31 TB CXI, 3a–4, 4a, 5. It is interesting to observe that about this time (1811–15) James Ward painted his renowned *Gordale Scar* (Tate Gallery, London) (fig. 91), which is a painting of great size, depicting a vast, spectacular gorge in Yorkshire – apparently as a challenge to Sir George Beaumont's assertion that it was unpaintable. As the picture was intended as a pictorial exercise in the sublime (illustrating concepts in Burke's *Philosophical Treatise*), Ward, to suggest the idea of "infinity" (in which "parts of some large object are so continued to an indefinite number, that the imagination meets no check" [ibid., 73]), emphasized the particular stratified character of the scar's towering, massive rocks, so as to overwhelm the viewer with their incalculable, immense age as well as to illustrate Burke's idea of "succession" (see Finley, "Turner's 'Landscape Sublime,'" 162).

32 To say that Burke's theory of the sublime "really opened the way to a union between art and geology," as Pointon does ("Geology and Landscape Painting," 86), is only partially correct, since Pointon's position appears to ignore the influence of Gilpin's practical picturesque applications of the sublime that are discussed in relation to rocky landscape in his popular travel guides. These guides provided tourists (as well as other travel writers) with an appreciation of unusual geological formations, such as those that had been encountered by visitors to Staffa.

33 In his perspective lectures Turner observed that "Art ... pervades through Nature even Geological formations" (B1. Add. MS 46151, s. fols. 9v–10r). He also mentioned the nature of the strata of Lulworth Cove in his descriptive poem on the south coast, which dates from his visit there in 1811; see TB CXXIII, fol. 58.

34 Macpherson's work, published in the early 1760s, was entitled *Fingal, an ancient Epic Poem, in Six Books*. It was based on research on Gaelic poetry and songs that Macpherson undertook during visits to the Highlands and Western Isles. He later combined this poem with others and published them. Though these poems were purported to have been translated from the ancient Gaelic, they were actually a combination of collected material and verses composed by Macpherson himself.

35 Rosenfeld, *Georgian Scene Painters*, 124, 177, 178–9.

36 Some of the columns – they are three feet in diameter – are seven-sided. In part of the decorative framework of his watercolour – Turner shows a six-sided crystal. In part this was not

37 Stoddart, *Remarks on Local Scenery*, 2: 307.

38 Lockhart, *Sir Walter Scott*, 197. Scott may have had with him Stoddart's *Remarks on Local Scenery*; see n40, below.

39 Scott, *A Voyage to the Hebrides*, 250.

40 Scott would probably have been familiar with Stoddart's *Remarks on Local Scenery*, since he owned a copy (see Cochrane, *Catalogue of the Library at Abbotsford*, 8). This book contains an engraved view of the interior of the Cave looking towards its entrance, similar, in vantage point to that adopted by Turner for his vignette (see Stoddard, *Remarks on Local Scenery*, 2: 306).

41 Scott, *Poetical Works*, 10: 149.

42 See Finley, *Landscapes of Memory*, 140.

43 Egerton, *Turner: "The Fighting Temeraire,"* 69–70.

44 Stoddart, *Remarks on Local Scenery*, 2: 306.

45 *Fraser's Magazine*, July (1832): 717.

46 Scott, *Poetical Works*, 10: 109–10.

47 Gage, *Turner: "A Wonderful Range of Mind,"* 220.

48 Scott, *Poetical Works*, 10: 315–16.

49 Macculloch, "Sketch of the Mineralogy of Sky," *Transactions of the Geological Society* 3 (1816): 23; Macculloch, "Supplement to the Mineralogy of Sky," *Transactions of the Geological Society* 4 (1817): 183; Macculloch, *The Highlands and Western Isles*, 3: 474.

50 Macculloch, "Sketch of the Mineralogy of Sky," 3: 265.

51 Macculloch, *The Highlands and Western Isles*, 3: 474.

52 The cave and the overhanging rock showing the the coils of the dragon emerging from the darkness may have been influenced by an engraving (illustrating Spenser's *Faerie Queene*) on the title page of volume 2 of Anderson's *Complete Edition of the Poets of Great Britain*, which was in Turner's possession. Turner was interested in geology even earlier. For example, in 1797 he made pencil sketches of stratified rocks during a tour of the north of England; at least one sketch depicts a subtle and unusual rock formation that would likely have been overlooked by someone not familiar with the specific qualities of geological formations. I am grateful to Dr David Hill for bringing this to my attention.

53 TB CXXIII, 149a; see also Wilton, *Turner's Verse Book*, 174.

54 See, for example, Finley, *Landscapes of Memory*, chap. 8.

55 See n29, above.

56 See n31, above, for reference to James Ward's *Gordale Scar*.

57 Porter, *The Making of Geology*, 142.

58 Rupke, *William Buckland*, 201. Buckland graphically characterized this relationship in his notes (University Museum, Oxford): "In our youth we have feasted with the heroes of the Iliad and the Enead. But we have no other document beyond the records of the poet to prove the reality of this feast at which, in imagination, we have been present. The chisel of the sculpturer and the pen

of the poet have recorded the adventures and the glories of the heroes of Thebes and Troy, and the antiquary still treads the ruins of the cities which their arms defended or destroyed. But the documents of geology record the warfare of ages antecedent to the creation of the human race, of which in their later days the geologist becomes the first and only historiographer. And the documents of this history are not sculptured imitations of marble, but they are the actual substance and bodies of the bones themselves, mineralized and converted to imperishable stone" (ibid., 60).

59 Reynolds, *Discourses*, 13 (1786): 238.

60 See chap. 4.

61 Ibid.

62 For references to how allusion can extend and enrich a painting's narrative content, see Hoare, *The Artist*, 2: 266.

63 Quoted by Hutchison, *The Royal Academy*, 85.

64 Ruskin, *Notes on the Turner Gallery*, 19.

65 "The excessive darkness of the stream ... [reminds] us of Cocytus" (Ruskin, *Modern Painters*, 5: 317). Cocytus, the river of lamentation, was one of the great rivers of the underworld.

66 Ruskin refers to the dragon as being "wrapped in flame and whirlwind" (ibid., 305).

67 Nicholson, *Classical Landscapes*, 78.

68 Ruskin, *Modern Painters*, 5: 313. Dr Adele Ernstrom (formerly, Holcomb) has kindly drawn my attention to Anna Jameson's *Sacred and Legendary Art* (1848), which she believes Ruskin may have read. Jameson speaks of the dragon that "might have been, as regards form, originally *a fact*; for wherever we have dragon legends, whether the scene be laid in Asia, Africa, or Europe, the imputed circumstances and the form are little varied. The dragon introduced into early painting and sculpture so invariably represent a gigantic winged crocodile, that it is presumed there must have been some common origin for the type chosen as if by common consent; and that this common type may have been some fossil remains of the Saurian species, or even far-off dim tradition of one of these tremendous reptiles surviving in Heaven knows what vast desolate morass or inland lake, and spreading horror and devastation along its shores" (*Sacred and Legendary Art*, 1: xxxvi–xxxvii). Reflecting on Jameson's remarks, Dr Ernstrom correctly observed (in a letter of 8 May 1994) the Enlightenment trends that explained the physiognomies of mythological beasts in terms of their relationships with extant or extinct creatures. She noted, specifically, that "the dragon understood as crocodile ... not only avoided great morphological disjunctions in the history of living creatures, but also dispatched the 'excesses' of myth as fabulous extrapolations from naturally explicable phenomena." I am most grateful to her for these valuable observations.

69 Parkinson, *Organic Remains*; see especially 3: 287.

70 *London Times*, 3 March 1806, 3; *Gentleman's Magazine*, March 1806, 274; also, ibid., January 1807, 7.

71 Ruskin, *Modern Painters*, 5: 399.

72 The connection between the Hesperian apple and the fruit of the tree of knowledge was alluded to by Turner in his sketch composition *The Amateur Artist*, dated c. 1809 (see chap. 2). This association was of interest to the romantics; for example, it was referred to by Keats in his poetic drama, "Otho the Great."; see Gotlieb, *Lost Angels*, 83–4.

73 "Dryden says that art reflecting upon nature endeavours to represent it as it was first created without fault" (BL Add. MS 46151, N, 4r).

74 Ruskin, *Modern Painters*, 5: 315.

75 Finley, "Heaven and Earth," 118. The contrast between prelapsarian and postlapsarian states, which the perfection and imperfection that Turner implies, suggests his recollection of *Paradise Lost*, a poem that seems to be central to his appreciation and understanding of the biblical Fall.

76 See chap. 4.

77 As has been indicated before, the critic of the *Athenaeum* (13 May 1829) associated the flames and smoke with volcanic emissions: "How colossal and mysterious the form of the monster appears, as we view him writhing under the agonies of the recently-inflicted torture, and obscured by the vapours of Ætna!"

78 *The Deluge* (c. 1805), Clore Gallery for the Turner Collection, London (493). Turner was to some extent influenced by Poussin's version of the subject that he had studied in the Louvre in 1802 (Butlin and Joll, *Turner*, cat. no. 55).

79 Müller-Tamm, "Turner, *Schatten und Dunkelheit*" 570.

80 Ibid.

81 See, for example, Powell, *Turner in the South*, 116n30; John Gage notes that Turner and Davy were in Rome in the winter of 1828–29 (*Turner: "A Wonderful Range of Mind,"* 254n44), though there appears to be no evidence that they actually met at this time.

82 Müller-Tamm, "Turner, *Schatten und Dunkelheit*" 570.

83 Ibid.

84 Siegfried and Dott, *Humphry Davy on Geology*, xxviii. The editors of these lectures further remark that "Davy did not force his geology to conform to scripture; he believed that the revealed truth of the sacred writings and the truth to be found in nature through scientific investigation formed a general harmony, rather than a detailed correspondence" (ibid., xlii). This position was maintained in Davy's late *Consolations in Travel*. For example, in the dialogue between Onuphrio (who belongs to the English aristocracy and whose prejudices are attached to his birth and rank) and The Unknown (Davy), the former, who has not been convinced by the latter's arguments concerning the nature of the early earth and the development of life, remarks, "you speak of a diluvian formation, which I conclude you would identify with that belonging to the catastrophe described in the sacred writings." In reply, The Unknown remarks, "I have made use of the term 'diluvian,' because it has been adopted by geologists, *but without meaning to identify the cause of the formations with the deluge described in the sacred writings*" (Davy, *Consolations in Travel*, 107–8). The emphasis is mine. See also Knight, *Humphry Davy*, 177.

85 Buckland, *Vindiciae Geologicae*, 24.

86 Buckland, *Geology and Mineralogy*, 1: 88.

87 See especially, Gage, *Collected Correspondence*, 262 (30 Nov. 1843). From this letter it is evident that Buckland and Turner had met or corresponded at an earlier date. See also, Gage, *Turner: "A Wonderful Range of Mind,"* 221–2.

88 Turner often referred in his paintings to continuity or to the loss of it; see, for example, his *Pope's Villa at Twickenham*, discussed in chap. 5, and *Rain, Steam and Speed* and *The Fighting Téméraire*, discussed in chap. 8.

89 Buckland, *Geology and Mineralogy*, 1: 88.

90 Rupke, *The Great Chain of History*, 172–3.

91 See Finley, "Heaven and Earth," 109–27.

92 Gage, *Turner: "A Wonderful Range of Mind,"* 221.

93 See Butlin, Luther, and Warrell, *Turner at Petworth*. The details of mollusks in the right foreground of Turner's *Interior at Petworth* (c. 1837) probably relate to his patron's scientific interests; see also Sidlauskas, "Creating Immortality," 59–65. I am grateful to John Hatch, who brought this article to my attention.

94 The plate is entitled "The Country of the Iguanodon." It is possible that Mantell and Turner met at Petworth, though I have found, as yet, no evidence that they did.

95 Ibid.

96 This type of skull seems first to have been noted by Baron Cuvier, who was also a pioneer in comparative anatomy; his assessments of vertebrate fossil remains were well known in Britain; see Parkinson, *Organic Remains*, 3: 283–4; also, Mantell, *Fossils of the South Downs*, 54, and *Geology of Sussex*, 63.

97 Ibid.

98 For an informative discussion of available illustrations, see Rudwick, *Scenes from Deep Time*.

99 See the discussion of the Deluge pictures in chap. 12.

100 Gage, *Turner: "A Wonderful Range of Mind,"* 222.

CHAPTER TEN

1 The biblical Fall signalled the severance of the original unity that had existed between humanity and nature in the golden age. Now, nature and human-kind are at odds. It was possible, however, to restore this relationship either through the creation of works of art or by means of scientific study and the understanding of nature (see especially Cunningham and Jardine, *Romanticism and the Sciences*, 3–4). Dr Trevor Levere very kindly brought this collection of essays to my attention.

2 The form of the vignette was considered to be "poetical." Within it "Fancy, unrestrained by time and place, indulges in the revelry of fairy fiction" (Landseer, *Lectures*, 115–16). Turner possessed a copy of these lectures; see Finley, *Landscapes of Memory*, 248.

3 Turner had contemplated this pictorial subject earlier (c. 1819); see sketch compositions, TB CLXXXVI, 34.

4 Jan Piggott has noted that Turner adopted the image of the holy family from his design, *Bethlehem* (W 1252; R 588) for Finden's *Landscape Illustrations to the Bible* (1836), though it seems unlikely that, as he believes, the snake was borrowed from Poussin's *Deluge* (see his perceptive review of Mordechai Omer's "Turner and the Bible", *Turner Society News* 76 (1997): 3). Milton refers to this symbol of evil as the "old Dragon" in his "On the Morning of Christ's Nativity" (Milton, *Poetical Works*, 6: 156).

5 In one of the preparatory sketch compositions for *Dawn of Christianity* (*Flight into Egypt*) (Clore Gallery for the Turner Collection, London, 5508), a pyramid is shown in the background. A few years before he painted *Dawn of Christianity*, Turner prepared a watercolour vignette of an Egyptian subject for Moore's *Epicurean* (1837) depicting a distant pyramid (TB CCLXXX, 118). However, in the sketch composition for *Dawn of Christianity* (*Flight into Egypt*) the pyramid seems to be presented in association with a bridge that is in front of it. This conjunction is similar to that of the pyramid and bridge that appears in his early *Fifth Plague of Egypt* (RA 1800, Indianapolis Museum of Art), and, as has been persuasively shown, the architectural features of this latter picture owe a debt to Piranesi (see Holcomb, "The Bridge in the Middle Distance," 47–8).

6 This idol appears to be a representation of Isis; another, to the left, is of Anubis. Turner made brief pictorial notations of Egyptian gods in an early sketchbook (see TB LXVI [c.1800–c.1802], 72–4), though apparently not these. I wish to acknowledge my debt to the Ulster Museum, Belfast, and especially to Mr Martyn Anglesea, who arranged for me, in 1982, to examine *Dawn of Christianity* out of its frame.

7 Gisborne, *Walks in a Forest*, 4–5.

8 Ibid, 2, 4.

9 Ibid, 4.

10 Ibid, 5, 6.

11 Rawlinson, *The Engraved Work*, 55: 598–604.

12 Tuve, *Images and Themes*, 39. I have to acknowledge my debt to Dr Ross Kilpatrick, who first suggested to me that Milton's poem may have been a source for this painting.

13 "Ode on the Morning of Christ's Nativity," in Milton, *Poetical Works*, 6: 156–7.

14 By the middle of the seventeenth century, the ambit of typology had expanded. It had begun to embrace pagan heroes and gods were perceived as pre-Christian types of Christ; see Korshin, *Typologies in England*, 5. I am grateful to Dr J.D. Stewart, who suggested that I examine this work.

15 Eric Shanes has independently suggested the possibility of this meaning on the basis of the setting sun in *Glaucus and Scylla* and the ruined bridge and rising sun in *Dawn of Christianity* (*Turner's Human Landscape*, 214–15). Pictorial references to the end of one era and the beginning of another were typical of Turner's mature way of thinking, and also of other romantics. For example, the German painter Caspar David Friedrich explored pictorially the transition from paganism to Christianity. (see Boersch-Supan, *Caspar David Friedrich*, 164). Soon after Turner exhibited these three pictures, he showed a pair of paintings that also present allegorical times of day: *Shade and Darkness, The Evening of the Deluge* and *Light and Colour, Morning after the Deluge*. These pictures were exhibited in 1843 (see chap. 12).

16 Gage, *Collected Correspondence*, 248 (Turner to Mrs Carrick Moore, 9 Dec. 1841).

17 *Illustrated London News*, 10 May (1845): 291.

18 Bindman, *William Blake*, 28; see Fuseli, in Barry, Opie, and Fuseli, *Lectures on Painting*, 412.

19 See, for example, the discussion of the *Mastering of the Warrior Angels* in chap. 9. The sun seems to be of particular significance in many of Turner's paintings representing Carthage. Could the artist have been aware of the belief that the chief deity of the Carthaginians was Baal, the Sun god? See Knight, *Ancient Art and Mythology*, 1–2.

20 The reference is to the first volume of Ruskin's *Modern Painters*, published anonymously in 1843; see Butlin and Joll, *Turner*, cat. no. 425.

21 The two lines from Rogers' poetry chosen for this picture were probably selected partly in amicable rivalry (as was often the case) with his old friend, the history painter George Jones, who used precisely these lines, one for each of the titles of two pictures exhibited at the Royal Academy in 1839; see the Royal Academy catalogue, nos. 597 and 634.

22 It has been noted that at the end of Rogers' poem *Columbus* there is a reference to God's Angel and to a vision of "tyranny vanquished," which, in alluding to the serpent in *The Angel Standing in the Sun*, also relates it to the underlying subject of its companion picture discussed below (see Smith, "Contemporary Politics," esp. 44). (ibid.). I am grateful to Dr Judith Dundas for bringing this article to my attention.

23 See Rawlinson, *The Engraved Work*: Milton's *Poetical Works* (1835), 55; Campbell's *Poetical Works* (1837), 58; Moore's *Epicurean* (1839), 59; see also Finley, "Turner, the Apocalypse and History: 'The Angel' and 'Undine,'" 686n7.

24 Burke observes that Milton described the sublime when he referred in *Paradise Lost* (3) to "the light and glory which flows from the divine presence" (*Philosophical Enquiry*, 80).

25 Lindsay (*The Man and His Art*, 153–4) has obviously paraphrased parts of my "Turner, the Apocalypse and History." Turner probably found inspiration for his painting in Milton. In *Paradise Lost* the archangel Michael, who expelled Adam and Eve from paradise, was associated with light and colour: Michael appeared in a colourful vest dyed by Iris, the goddess of the rainbow. Could Milton also have inspired the epic nature of Turner's theme? In this picture, the compositional cleavage of the universe into the material and spiritual realms resulting from the Fall may have been a recollection of *Paradise Lost* (9.9), where heaven is presented as being alienated from humanity.

26 One of Blake's watercolours, *The Body of Abel found by Adam and Eve*, was shown in his exhibition of 1809–10 (subsequently it was in John Linnell's collection, now in the Fogg Museum, Harvard University). This was also the subject of one of Blake's tempera paintings (c.1826; Tate Gallery, London).

27 Gessner, *The Death of Abel*, 139.

28 See the image of Death and the Soul, which appear respectively as a skeleton and a child, in Quarles, *Emblems, Divine and moral*, 277 (fig. 107). I am grateful to Dr Stewart who, years ago, brought this late edition to my attention.

29 Gessner, *The Death of Abel*, 149. The "soul," as will be shown, is an important ingredient of the story of Turner's companion picture, *Undine Giving the Ring to Masaniello*.

30 The imperfect world that Turner creates here is like that envisioned by Blake, or even Shelley (see Perkin, *The Quest for Permanence*, 126–7). Such a viewpoint may have been reinforced by contemporary conditions, by the corrosive consequences of industrialization. Social commentators of the 1830s and 1840s (a time of great social and economic distress) believed that there was great sinfulness in the world.

31 As Turner enjoyed the significance of dates, could it be coincidental that he exhibited his picture two hundred years after Masaniello's insurrection?

32 The "red cap of liberty" continued to have symbolic significance for some time after the French Revolution. See the following lines from the anonymously written play *Masaniello, The Fisherman King of Naples* (30): "his feet were bare and his head was merely covered with a cap whose Phrygian form and scarlet colour resembled the symbol of liberty." This was published in 1845.

33 In 1649 *The Tragedy of Masaniello* was published in London. In this play the (1631) eruption of Vesuvius became a metaphor for the energy released by Masaniello's revolt. The writer of the introduction also observed that this play would point to "the present condition of our [English] affairs." See Roworth, "The Evolution of History Painting," 230. This author also refers to the English medals that were struck, commemorating both Masaniello and Cromwell

34 *La Muette* was first performed in Paris in 1828. Because of its revolutionary content it became linked with the revolution of 1830. A few months after the revolution *La Muette* was performed in Brussels while Belgium was under Dutch rule. The opera's revolutionary theme so moved the audience that quite spontaneously they began to sing *L'amour sacré de la patrie*. By October of that year, Belgium declared itself independent.

35 *Foreign Quarterly Review* 4 (1829): 357, as quoted in Brand, *Italy and the English Romantics*, 19.

36 Kenny, *Masaniello: A Grand Opera*, 19.

37 Smith, "Contemporary Politics," 44. Smith, however, does not point to the parallel between the absolutism of Charles X and that of James II, which makes the comparison especially efficacious.

38 As an advocate of parliamentary reform, Turner, in 1834, had been invited to a dinner in Edinburgh in honour of Lord Grey, who, as prime minister (1830–34), had secured the passage of the Reform Bill (see Finley, *Landscapes of Memory*, 177–8).

39 Shanes, *Turner's Picturesque Views*, 38.

40 Ibid.; see pl. 53.

41 Ibid.

42 Gage, *Turner: "A Wonderful Range of Mind,"* 214.

43 Shanes, *Turner's Picturesque Views*, 38–9.

44 The following is an excerpt from a review of Perrot's ballet in the *Times* of 23 June 1843: "The innocent fisherman flings his net for a draught, and catches a greater prize than he expects, for a large shell rises with [the dancer] Cerito [the Ondine or sea sprite] in it, looking exceedingly languishing, and Matteo is lured to follow her among the rocks"; as quoted by Stuckey, "Turner, Masaniello and the Angel," 158.

45 See Ripa, *Iconologia*, 3: 1270. A further symbol of deceit is Vesuvius in eruption, which, as has been noted, occurs in the left background of this painting; see Finley, "Turner, the Apocalypse and History," 688–91, n19.

46 Ibid, 691; de la Motte-Fouqué, *Undine, A Romance*, 89–90; *Undine, A Romance* (anonymous), 112–13; Giraldon, *Les Beautés de l'Opera*, 9.

47 Howarth, *Louis-Philippe*, 291–3.

48 Letter of J.M.W. Turner to King Louis-Philippe, London, 26 April 1836; see Charavay, *Lettres Autographes* 2: 680 (1811). I am indebted to Dr B.K.B. Laughton, who kindly brought the reference to this letter to my attention. A thorough search has failed to uncover this document. See Finley, "Turner, the Apocalypse and History," 692n33.

49 Wilton, *Turner in his Time*, 229.

50 Finberg, *Turner*, 402–3, 405.

51 Helen Guiterman has published a letter from David Roberts to his daughter, sent from Brussels on Sunday 21 September 1845: "We left … on Wednesday afternoon Sleeping all night at Dover when the next morning who should stumble into the Coffee Room whilst we were at Breakfast but Turner, windbound on his way to Bologne for it blew a hurricane and had been for two days previous. He was as mysterious as usual and of course I did not ask him where he was bound for, although he pumped me" ("Roberts on Turner," 3).

52 Redgrave, *A Century of British Painters*, 253–4; Finberg, *Turner*, 410–11.

53 See Finley, "Turner, the Apocalypse and History," fig. 16, opp. 692.

54 Douglas, *Louis-Philippe*, 132.

55 Howarth, *Louis-Philippe*, 291–3.

56 According to W. Frith, Turner was working on *Undine* on one of the Varnishing Days before the opening of the Royal Academy exhibition of 1846 (*My Autobiography*, 1: 131–2); see Stuckey, "Turner, Masaniello and the Angel," 155. In 1846, Varnishing Days were held from Saturday 25 April to Thursday 30 April, excepting Sunday 26 April (see RA Council Minute Book 10 [1844–52], Royal Academy, Burlington House, London).

57 See, for example, the *Pictorial Times*, 25 April 1846.

58 Finley, "Turner, the Apocalypse and History," 695.

CHAPTER ELEVEN

1 Farington, *Diary*, 12: 4322 (29 Mar. 1813). Ten years later, Beaumont's dislike of the "white painters" seems to have encouraged David Wilkie to write to him that "The decline of all schools of colouring appears to be into whiteness, and into those corresponding tints of common-place chilliness that can only harmonize with white" (D. Wilkie to Sir George Beaumont, 14 Feb. 1823); in Burnet, *Practical Essays*, 195.

2 Finley, *Turner*, 195. Interest in using a white ground increased among painters, some of whom followed Turner and were called, as has been mentioned, the "white painters." At least one writer of an art manual recommended the use of a white ground at this time. In Craig's *Course of Lectures* the author, addressing the young artist, observed, "I have advised you before to paint your oil-pictures invariably on a white-ground; but, *in ... [landscape] it is even of more importance to do so than in any other [department]*" (273); emphasis added.

3 Newtonian science was responsible for the belief, firmly established in the later eighteenth century, that "tangible energies lav[e] the earth" (Stafford, *Voyage into Substance*, 188, 190).

4 BL Add. MS 46151, Y, fol. 1r.

5 Ibid., H, fol. 34r.

6 *Illustrated London News*, 20 May 1843.

7 Leslie, *John Constable*, 254.

8 See, for example, Gower, *Practical Treatise*, Garside, *Essay on Light and Shade*, Enfield, *Young Artist's Assistant*, Oram, *Colouring in Landscape Painting*.

9 Thornbury, *Turner*, 227.

10 BL Add. MS 46151, H, fol. 32r.

11 See Finley, *Landscapes of Memory*, chap. 3.

12 Thornbury, *Turner*, 138–9.

13 Brewster, "Observations on Vision through Coloured Glasses and on their Application to Telescopes, and to Microscopes of Great Magnitude," *Edinburgh Philosophical Journal* 6 (1822): 102–7.

14 Sherman observes that the spectrum was "apparently that described by Young and not that of Wollaston of 1802" (*Colour Vision*, 23).

15 Brewster, "Description of a Monochromatic Lamp for Microscopical Purposes, &c. with Remarks on the Absorption of the Prismatic Rays by Coloured Media," *Transactions of the Royal Society of Edinburgh* 9 (1823): 442.

16 Sherman, *Colour Vision*, 25.

17 Ibid., 26.

18 Ibid.

19 Brewster, "On a New Analysis of Solar Light," *Edinburgh Journal of Science*, n.s., 5 (1831): 197.

20 "Analysis of Scientific Books and Memoirs," *Edinburgh Journal of Science* 2 (1825): 347.

21 Thornbury, *Turner*, 138–9.

22 See Finley, "Turner's Colour and Optics," 357–66.

23 M. Muir, "Two Scottish Travel Artists, James Skene of Rubislaw, 1775–1864; David Roberts, 1796–1864," *Scottish Art Review* 10, no. 1 (1965): 9.

24 In 1824 Brewster wrote to Skene about the photometer and the illuminating power of gas (National Library of Scotland, henceforth NLS, MS 3813, fols. 77–9 [13 August 1824]). On the same day he wrote him a further letter suggesting that the "must now study Light-measuring[.] take a look at Page 655 of ye optics in Encyclopaedia" (NLS MS 3814, fol. 80). The Edinburgh Public Libraries possess Skene's *Scrap Book and Memoranda on Various Subjects* (1826), in which Skene noted, "To be wished for books Smith's Opticks 1737" (27).

25 *Proceedings of the Royal Society of Edinburgh* 5 (1866): 480.

26 Lockhart claimed that he, Skene, and Turner were together, apparently in 1831, on an excursion to Smailholm and Bemerside (Lockhart, Sir Walter Scott, 729). However, there is no record that either Lockhart or Skene was on this particular excursion. See Finley, *Landscapes of Memory*, chap. 5.

27 Finley, *Turner and George the Fourth*, 18.

28 "Painting can but approximate to all the niceties, combinations, and intricacies, of direct and reflected light, involving the contrasted obscurities of these objects [of nature], or parts of objects, least exposed to it, and modified by the almost imperceptible gradation of intensity as it recedes from the eye. When we add to this, the infinite interchange of tints, affecting every object in nature, which may be said altogether to elude common observation, and not easily detected, in all their niceties, by those most familiar with the study; we shall be less disposed to underrate the merits and difficulties of landscape painting" (263).

29 Ibid., 264.

30 Newton, *Opticks*, bk. 3, pt. 1.

31 Finley, "Turner's Colour and Opticks," 386.

32 TB CXCV, 177; see BL Add. MS 46151, H, fols. 12r–12v.

33 TB CXCV, 178 (No. 2, watermark 1824). Concerning the two diagrams, Turner stated in his lecture notes that "one may be considered as the material, the other that of lights by position only" (see BL Add. MS 46151, BB, 67r).

34 See Lindsay, *Turner*, 208.

35 Garside, *A New Theory of Colours*, pt. 1: 9, 10.

36 Gage first recognized the importance of light and darkness in these two diagrams; see *Colour in Turner*, 114–15.

37 The smaller size of the triangles of material colour suggests that he wished to observe that material colour is less efficacious than light colour.

38 Ibid., 115.

39 BL Add. MS 46151, BB, fol. 67r.

40 Farington, *Diary*, 14: 5120 (14 December 1817).

41 Though Turner often accented the primary colours in his watercolours and paintings, they are usually mainly intermixed with other hues. In his RA lecture

notes he alluded to a variable range of colours that should be employed in art, created by the primary and secondary hues and what he referred to as "multiples," which include "greys ... browns, neutrals ... [and] black" (Add. MS 46151, BB, fol. 67r). All these result in both simple and complex combinations of potentially harmonic relationships.

42 As quoted by Butlin and Joll, Turner, cat. no. 231.

43 H. Crabb Robinson, 7 May 1825, as quoted by Finberg, Turner, 289.

44 Turner indicated that one of his first tasks was to paint a companion piece for Lord Egremont's Claude. This may have been the Palestrina – Composition (see Butlin and Joll, Turner, cat. no. 295), though it was never acquired by Egremont (Gage, Collected Correspondence, 140 (Turner to C.L. Eastlake, August 1828).

45 Rigby, Journals and Correspondence, 135.

46 Finberg, Turner, 311.

47 See Robertson, Sir Charles Eastlake, (C.L. Eastlake to Maria Callcott, 26 Mar. 1829). 36. However, Joseph Severn, writing from Rome to Thomas Uwins on 8 March 1829, remarked that "Turner's works here were like the doings of a poet who had taken to the brush" (Uwins, Thomas Uwins, RA, 241). The pictures that Turner executed in Rome, Palestrina, Orvieto, Medea, and Regulus, were reworked later in England before they were publicly exhibited (at different times). Palestrina and Orvieto were shown at the Royal Academy in 1830; Medea, in 1831; and Regulus was exhibited at the British Institution in 1837.

48 Townsend, "The Changing Appearance of Turner's Paintings," 15.

49 Wickham, History of the Theatre, 181. Drury Lane installed gas in front of the stage, enhancing the magic of the performance. Leigh Hunt wrote in 1817 that the effect was "like the striking of daylight; and indeed it is in its resemblance to day that this beautiful light surpasses all others. It is as mild as it is splendid – white, regular and pervading" (quoted in Rosenfeld, Georgian Scene Painters, 167).

50 Bergman, quoted by Rosenfeld, Georgian Scene Painters, 167; emphasis added.

51 Though there is apparently no published response to the stage effects of gas in reviews of Medea in Corinth, there is to those of the opera Otello staged in the King's Theatre at the end of July 1828, immediately before Medea in Corinth was performed there. The critic of The Athenaeum (6 August) noted that the stage light was "brilliant and boldly thrown, – almost too dazzling, were it not for the relief afforded by the varieties of intensity, and the occasional patches of shade stealing in between its wildest and most startling flashes."

52 Wickham, History of the Theatre, 181.

53 The oil composition, almost certainly the preparatory study for the final painting, was perhaps undertaken before Turner's visit to Italy or possibly after his return to London from Rome (in early 1829). The study's topography is generally similar in design to the early sketchbook pen, ink, and wash composition of c. 1807, which Turner, most likely, would not have taken with him to Rome. In addition, the page on which this composition was created displays oil spatters, as has been observed (see chap. 4, n38), suggesting that the design of the oil study was probably derived directly from this source.

54 See discussion of Brewster's kaleidoscope in Gage, Colour in Turner, 122–3.

55 Ibid., 128.

56 Finberg, like Ruskin, considered Ulysses a central and crucial picture in Turner's development. Finberg perceived it as the final work of his "Romantic

period," though in colour it is "as bright and as extended as that of any of the later works." He noted that its forms were noticeably more distinct and less vaporous than those in the later works (Turner's Sketches and Drawings, 118–19).

57 See Gartside, A New Theory of Colours. The term "blots," introduced in the full title of this work, was derived, we may reasonably assume, from the language of Alexander Cozens.

58 Thomas Tredgold, "On the Principles of Beauty in Colouring," Philosophical Magazine 49 (1817): 265.

59 Knight, The Landscape, 69. Turner may also have been influenced by ideas presented in Knight's Analytical Inquiry, where the author speaks of the sense of sight "aided and corrected by ... [the sense] of touch." Until aided by the latter, "all the objects are only different rays of light variously reflected from their surfaces; and their visible projection is merely gradation and opposition of light and shadow; which, in round and undulating bodies, are intermixed gradually; and, in those of angular forms, abruptly. It is, therefore, only by habit and experience that we form analogies between the perception of vision and that of touch, and thus learn to discover projection by the eye: for, naturally, the eye sees only superficial dimension; as clearly appears in painting and all other optical deceptions, which produce the appearance of projection or thickness upon a flat surface" (59).

60 These discussions began quite early in perspective treatises published in England; for example, in Lamy's Perspective Made Easie, 5, 6; and in Taylor's, Linear Perspective, 1–2. Both treatises were in Turner's library. Turner referred to them in his Royal Academy lectures; for example, see BL Add. MS 46151, H, fols. 16v, 19r (Lamy) and ibid., E, fol. 8r; ibid., N, fols. 4v, 5r (Taylor).

61 See also, for example, BL Add. MS 46151, BB, fols. 45r, 45v; ibid., E, fol. 2r.

62 Ibid. The remainder of this passage is significant: "but as colour is not perceptible without light [.] figure [he apparently still means 'shape'] may be said to be material and inseparable from our Ideas of those various forms which are immediately the Object of our investigation, and that those forms, however they are conveyed to the mind should be distinctly delineated upon a plane surface."

63 See Eastlake, "Philosophy of the Fine Arts," 383; see also Keyser, "Victorian Chromatics," 197.

64 See, particularly, the public reaction to the pictures he exhibited in Rome.

65 Stewart, The Human Mind, 1: 492–3. I am grateful to Dr Judith Dundas for this reference.

66 See Gage, Colour in Turner, 185.

67 I shall refer henceforth to the facsimile of Eastlake's edition (1840), in Goethe, Color Theory, xxxi; reference will be to Theory of Colours.

68 The Farbenlehre, when originally published, was not favourably received in Britain. When Eastlake's edition appeared, it did not fare better. In his review of the publication in the Edinburgh Review, Brewster, in many respects the disciple of Newton, was scathing; he not only attacked Goethe's theory but Eastlake's decision to publish it: "In matters of taste we would cheerfully defer to the opinion of so distinguished an Academician [Eastlake]; but when he maintains that the experiments and views of Goethe are more applicable to the theory and practice of painting than the doctrines of Newton and his followers, we must consider him as placing the principles of his art in direct alliance with error ... [Goethe's] experiments are ridiculous – his assumptions are misera-

ble subterfuges, under which he escapes from truths within his reach – his details are without knowledge" (*Edinburgh Review* 72 [October 1840]: 131; quoted in Robertson, *Sir Charles Eastlake*, 54–5). Whether Turner was aware of this review or not, Eastlake's translation prompted him to undertake and exhibit his two celebrated Deluge pictures (chap. 12) that are directly concerned with Goethe's theory.

69 Sepper, "Science of Seeing," 190.

70 Cunningham and Jardine, in their introduction to *Romanticism and the Sciences*, note the romantics' "strong reaction against mechanical natural philosophy." Remarking on Goethe's attack on Newton's theory of colour, they repeat Charles Lamb's famous toast to "Newton's health, and confusion to mathematics," and they quote lines from Keats' *Lamia* that refer to Newton's scientific explanation of the phenomenon of the rainbow, which destroyed its poetry (3).

71 Sepper, "Science of seeing," 191.

72 Newton also suggested that there were five primary colour-producing rays. However, by suggesting seven colours he tried to establish an analogy between light colours and the seven tones of the diatonic scale, and in that number there was, therefore, the implication of a harmonic relationship.

73 Goethe, *Theory of Colours*, §160.

74 Wells, "Goethe's Scientific Method," 80; also, see his *Goethe and the Development of Science*, 81.

75 Ibid.

CHAPTER TWELVE

1 Mather, *The Gospel of the Old Testament*, 1: 106.

2 They may have been inspired by John Martin's paired pictures of the same subject exhibited at the Royal Academy in 1841 (Gage, *Colour in Turner*, 186). These pictures from the Tate Gallery, London, were stolen from the Frankfort exhibition *Goethe und die Kunst* (1994). At the time of writing, they had not been recovered.

3 Goethe referred to some of the British authorities whose works he had consulted during his own optical studies. The names mentioned are Bancroft, Sowerby, Reid, and Brewster. "I endeavoured to make myself acquainted with what had been done on the subject in England, and sought to make their works, and ways of thinking, clear and distinct to my mind" ("Tages-und-Jahres Hefte" [1817], as quoted by Sarah Austin, *Characteristics of Goethe*, 1: 134). Turner was already familiar with the theoretical writings of Thomas Malton Sr, George Field, and others, whose approaches to light and colour had elements in common with that of Goethe; see Gage, *Colour in Turner*, 54, 182–4.

4 Ibid. 173–80; see also Gage, "Goethe's Theory of Colours," 34–52. Turner's annotated copy of Eastlake's translation is now in the possession of Rosalind Mallord Turner.

5 See chap. 9, n.3.

6 Goethe, *Theory of Colours*, §§915–20. Frederick Burwick observes that "Not wishing to be accused of 'Schwärmerei,' he [Goethe] treated but briefly that allegorical, symbolic, and mystical use of colour" (*Damnation of Newton*, 50).

7 Goethe, *Theory of Colours*, §705.

8 Goethe believed that colours could be created either by mixture or intensification (augmentation). Blue intensifies to violet; yellow to red. Red and violet

mix to produce purple; yellow and blue to create green; see Wells, "Goethe's Scientific Method," 80, 87.

9 Gage, *Colour in Turner*, 179–80.

10 Evidence suggests that Turner, from a relatively early period of his career, believed in the supremacy of light. His *Apollo and Python*, exhibited at the RA in 1811, and the relief in his *Temple of Jupiter Panellenius Restored* (RA 1816; see chap. 3) may be seen as allegorical renderings of this conviction.

11 Goethe, *Theory of Colours*, §744.

12 BL Add. MS 46151, H, fols. 4r–4v. Gage has observed that in his marginal notes Turner attempted to reconcile the fact that light rays travel in parallel lines with the concept of "divergent" rays, which Goethe supported (Gage, *Colour in Turner*, 178–9); see also Gage, "Goethe's Theory of Colours"). Is it possible that Turner was familiar with the phenomenon of "inflexion" (diffraction) described by Newton? If he was, it might explain the presence of "divergent" rays of colour in his watercolour *Norham Castle*, c. 1823 (see chap. 11 above and discussion in Finley, "Turner: An Early Experiment with Colour Theory," 365–6; "Turner's Colour and Optics," 385–90; and especially, "Pigment into Light," 54).

13 See Gage, "Goethe's Theory of Colours," 35 (xxxix).

14 Ibid., §247; emphasis added.

15 Finley, "Pigment into Light," 52.

16 Gage, *Colour in Turner*, 178.

17 Ibid., 185–6.

18 Ibid., 186.

19 Ibid., 185; see Finley, "The Deluge Pictures," 541.

20 Gage, "Goethe's Theory of Colours," 47 (§744).

21 See Gray, "Turner and Goethe's Colour Theory," 114.

22 Gage, *Colour in Turner*, 185.

23 Turner observed, "light is … color and shadow the privation of it by the removal of the rays of color" (BL Add. MS 46151, H, fol. 35r).

24 Gray, "Goethe's Colour Theory," 115; for the above see passages in Finley, "The Deluge Pictures," 540.

25 Wells, "Goethe's Scientific Method," 87.

26 Newton, *Opticks*, bk. 1, pt. 2, prop. 5, theor. 4; exp. 14; prop. 9, prob. 4; bk. 2, pt. 1, obs. 17–19.

27 Goethe, *Theory of Colours*, §§ 463, 464; see Finley, "The Deluge Pictures," 540–1.

28 Gage, *Colour in Turner*, 185.

29 See Gray, "Goethe's Colour Theory," 114; Finley, "The Deluge Pictures," 541.

30 "Colours are called dioptrical when a colourless medium is necessary to produce them; the medium must be such that light and darkness can act through it either on the eye or on opposite surfaces. It is thus required that the mediums should be transparent, or at least capable, to a certain degree, of transmitting light" (Goethe, *Theory of Colours*, § 143).

31 Ibid., § 149.

32 Ibid., § 502.

33 Ibid., § 150; see also under augmentation of colour, § 517.

34 Ibid., § 151. Eastlake, as a painter especially interested in the Venetian technique, observed that comparable effects could be produced through glazing. For example, these effects could be created by a "light warm colour … passed

in a semi-transparent state over a dark one, [which] produces a cold, bluish hue, while the operation reversed, produces extreme warmth." See ibid., 268, note L. Turner himself understood such techniques, as he too was knowledgeable in the methods of the Venetians. There is no indication that these particular technical effects occur in the Deluge pictures or if they did, that they played a role in illustrating Goethe's theory. See also under augmentation of colour, ibid., § 517.

35 See chap. 11.
36 Ibid.
37 Goethe, *Theory of Colours*, § 175; see also Sepper, "Science of Seeing," 193.
38 Goethe, *Theory of Colours*, § 154.
39 Ibid., § 155.
40 Finley, "Pigment into Light,'" 51.
41 Ibid.
42 Goethe, *Theory of Colours*, § 696.
43 Is it possible that these figures are the lovers Semin and Semira, discussed in Gessner's *Deluge*? They were the last remaining inhabitants of this darkening world who awaited their watery fate. Gessner's *Deluge* was published in the third volume of a three-volume English edition (1802) of *The Works of Salomon Gessner*, illustrated by Thomas Stothard; see Matteson, "John Martin's 'The Deluge,'" 221.
44 Goethe, *Theory of Colours*, § 696.
45 Ibid., § 777.
46 Ibid., §§ 696, 766.
47 Butlin and Joll, *Turner*, cat. no. 405.
48 See chap. 2, n3, for a brief discussion of the poetic lines attached to *Morning, from Dr Langhorne's Visions of Fancy* (RA 1799).
49 See Gage, *Colour in Turner*, 186.
50 Mather, *The Gospel of the Old Testament*, 1: 106.
51 In these pictures, however, Noah does not appear, though he is very much part of Turner's narrative. See the account of Noah in Mather, ibid., 1: 100,107,128.
52 See, especially, the extensive section, "The Word of God Compared to Light" in Keach, *Scripture Metaphors*, 510–55. Goethe, like Turner, believed that light possessed a spiritual aspect.
53 See also chap. 10, n19.
54 Butlin and Joll, *Turner*, cat. no. 405.
55 See Gage, *Colour in Turner*, 187.
56 Mather, *The Gospel of the Old Testament*, 1: 107; see also Gage, *Colour in Turner*, 186.
57 Mather, *The Gospel of the Old Testament*, 1: 193.
58 Ibid. See also Keach, *Scripture Metaphors*, 232; M'Ewen, *Grace and Truth*, 27; Slade, *Doctrine of Types*, 16; Taylor, *Moses and Aaron*, 236–8. Water represented or alluded to as clouds, thickened atmosphere, flood, or the Red Sea is an important ingredient of the natural system of evaporation and condensation and a means of producing colour from white light. In Turner's picture this hydrological cycle also functions as a metaphor for the cycle of life. The work attributed to the Greek philosopher Ocellus Lucanus, *On the Nature of the Universe*, contains a passage referring to the celestial region, which, because it "is perpetually moved [active], governs." The sublunary region, which "is always

passive is governed ... The one [the celestial region] ... is divine, and possessed reason and intellect, but the other [the sublunary region] is generated, and is irrational and mutable." The author refers to "cities and families" that "continue only for a short time; the progeny of which, and the mortal nature of matter of which they consist, contain in themselves the cause of dissolution, for they derive their substance from a mutable and perpetually passive nature. For the destruction of things which are generated, is the salvation of the matter from which they are generated." The translator and annotator, Thomas Taylor, alluding to the sublunary region, then quotes poetic lines from Pope's *Essay on Man*: "All forms that perish other forms supply; / By turns they catch the vital breath and die; / Like bubbles on the sea of matter born, / They rise, they break, and to that sea return" (28).

59 Goethe, *Theory of Colours*, §§ 463, 464.
60 Goethe noted that "no colour can be considered as stationary" (ibid., § 772).
61 Burwick, *The Damnation of Newton*, 41.
62 Gage, "'Goethe's Theory of Colours,'" 51 (§ 914).

EPILOGUE

1 Ruskin, *Turner and Ruskin*, 2: 258 ('The Art and Pleasures of England').
2 Ruskin, *Modern Painters*, 5: 343–4.
3 Bultmann, *History and Eschatology*, 10.
4 Thornbury, *Turner*, 239.
5 TB CXI, 66a.

Selective Bibliography

MANUSCRIPT SOURCES

British Library, London, especially for J.M.W. Turner's notes for his Royal Academy lectures

Edinburgh Public Libraries (Central Branch): possesses "James Skene's Scrap Book and Memoranda on Various Subjects"

National Library of Scotland, Edinburgh, Robert Cadell Papers

Robarts Library, University of Toronto, Toronto, H.H. Langton copy of the Sir Daniel Wilson Journal.

Royal Academy, Burlington House, London, RA Council Minute Books

Tate Gallery, London, J.M.W. Turner's sketchbooks (see Finberg, *A Complete Inventory of the Drawings of the Turner Bequest*.)

PRINTED MATERIAL

Alfrey, N. "Turner and the Cult of Heroes." *Turner Studies* 8, no. 2 (1988): 33–44

Anderson, Robert. *A Complete Edition of the Poets of Great Britain.* 14 vols. London 1793; 1792–5.

Andrews, Malcolm. *The Search for the Picturesque: Landscape Aesthetics and Tourism in Britain, 1760–1800.* Aldershot, England: Scolar Press 1989.

Ashton, J. *English Caricature and Satire on Napoleon I.* London 1884.

Austin, S. *Characteristics of Goethe.* 3 vols. London 1833.

Bachrach, A.G.H. "Turner, Ruisdael and the Dutch." *Turner Studies* I, no. 1 (1981): 19–30.

— "The Field of Waterloo and Beyond." *Turner Studies* I, no. 2 (1981): 4–14.

Banier, Abbé. *The Mythology and Fables of the Ancients Explain'd from History.* 4 vols. London 1739.

Barbier, Carl P. *Samuel Rogers and William Gilpin.* Oxford: University Press 1959.

— *William Gilpin, His Drawings, Teaching and Theory of the Picturesque.* Oxford: Clarendon Press 1963.

Barman, C. *Early British Railways.* Harmondsworth, England: Penguin 1950.

Barrell, John, ed. *Painting and the Politics of Culture: New Essays on British Art 1700–1850.* Oxford: Oxford University Press 1992.

— *The Idea of Landscape and the Sense of Place 1730–1840: An Approach to the Poetry of John Clare.* Cambridge: Cambridge University Press 1972.

Barry, James, John Opie, and Henry Fuseli. *Lectures on Painting by the Royal Academicians, Barry, Opie, and Fuseli.* Ed. Ralph Wornum. London 1848.

Behn, Aphra. *The Works of Mrs Aphra Behn.* 6 vols. Ed. Montague Summers. London: Heinemann/Bullen 1915.

Bergman, Nils Gösta. *Lighting in the Theatre.* Totawa, NJ: Rowman and Littlefield 1977.

Berningham, Ann. *Landscape and Ideology: The English Rustic Tradition 1740–1860.* Berkeley, CA: University of California Press 1986.

Beye, C.R. *The Iliad, the Odyssey, and the Epic Tradition.* London: Macmillan 1968.

Bindman, David. *William Blake: His Art and Times.* London: Thames and Hudson 1982.

Boase, T.S.R. *English Art: 1800–1870.* Oxford: Clarendon Press 1959.

Boersch-Supan, Helmut. *Caspar David Friedrich.* Trans. Sarah Twohig. London: Thames and Hudson 1974.

Boime, A. *Art in an Age of Bonapartism, 1800–1815: A Social History of Modern Art.* Chicago: University of Chicago Press 1990.

Boulton, S. "'Church under a Cloud': Constable and Salisbury." *Turner Studies* 3, no. 2 (1984): 29–44.

Brand, C.P. *Italy and the English Romantics: The Italianate Fashion in Early Nineteenth-Century England.* Cambridge: University Press 1957.

Brewster, Sir David. *Treatise on Optics.* London 1831.

Briggs, Asa. *The Age of Improvement.* London: Longmans, Green 1959.

— *The Power of Steam.* London: Michael Joseph 1982.

British Museum. *Catalogue of Prints and Drawings. Division 1. Political and Personal Satires.* [Vols. 1–4, by Frederic George Stephens. Vols. 5–11, by Mary Dorothy George. Vol. 1–3, ed. George W. Reid.] 11 vols. [London] 1870–1954.

Brown, D.B. *Turner and Byron.* London: Tate Gallery 1992.

Bryant, Jacob. *A New System, or, an Analysis of Ancient Mythology.* 3 vols. London 1774.

Buckland, William. *Vindiciae Geologicae; or the Connexion of Geology with Religion Explained.* London 1820.

— *Geology and Mineralogy Considered with Reference to Natural Theology.* 2 vols. London 1836.

Bulmann, D.R. *History and Eschatology.* Edinburgh: University Press 1957.

Burke, E. *A Philosophical Enquiry into the Origin of Our Ideas of the Sublime and Beautiful.* Ed. J.T. Boulton. London: Routledge and Kegan Paul 1958.

Burke, J., ed. *The Analysis of Beauty.* Oxford: Clarendon Press 1955.

Burnet, John. *Practical Hints on Colour in Painting.* London 1827.

— *Practical Essays on Various Branches of the Fine Arts.* London 1848.

Burwick, Frederick. *The Damnation of Newton: Goethe's Colour Theory and Romantic Perception.* New York: Walter de Gruyter 1986.

Butlin, Martin, John Gage, and Andrew Wilton. *Turner, 1775–1851.* London: Tate Gallery 1975.

— *William Blake.* London: Tate Gallery 1978.

— "Turner's Late Unfinished Oils." *Turner Studies* I, no. 2 (1981): 43–5.

Butlin, Martin, and Evelyn Joll. *The Paintings of J.M.W. Turner.* Rev. ed. 2 vols. New Haven, CT: Yale University Press 1984.

Butlin, Martin, Mollie Luther, and I. Warrell. *Turner at Petworth: Patron and Painter.* London: Tate Gallery 1989.

Carlyle, Thomas. *A Carlyle Reader: Selections from the Writings of Thomas Carlyle.* Ed. G.B. Tennyson. Cambridge: University Press 1984.

Charavay, Étienne. *Lettres autographes composant la Collection de M Alfred Bovet décrites par Étienne Charavay*. Paris: [1887].

Checkland S.G. *The Rise of Industrial Society in England 1815–1885. Social and Economic History of England*. Ed. Asa Briggs. London: Longmans 1964.

Chubb, W. "Minerva Medica and The Tall Tree." *Turner Studies* I, no. 2 (1981): 26–35.

Clapham, Sir John Harold. *An Economic History of Modern Britain*. Vol. 1, *The Early Railway Age 1820–50*. Cambridge: University Press 1926.

Clark, H.F. "Eighteenth Century Elysiums. The Role of Association in the Landscape Movement." *Journal of the Warburg and Courtauld Institutes* 6 (1943): 165–89.

Clarke, M., and N. Penny, eds. *The Arrogant Connoisseur: Richard Payne Knight 1751–1824*. Manchester, England: Manchester University Press 1982.

Cochrane, J.G., ed. *Catalogue of the Library at Abbotsford*. Edinburgh: 1838.

Colton, Judith. "Merlin's Cave and Queen Caroline: Garden Art as Political Propaganda." *Eighteenth-Century Studies* 10, no. 1 (1976): 1–20.

Conybeare, W.D., and W. Phillips. *Outlines of the Geology of England and Wales*. Pt. 1, London 1822.

Coolsen, T.S. "Phryne and the Orators: Decadence and Art in Ancient Greece and Modern Britain." *Turner Studies* 7, no. 1 (1987): 2–10.

Cooper, Anthony Ashley, third Earl of Shaftesbury. *Characteristicks of Men, Manners, Opinions, Times*. 3 vols. London 1714.

Copley, S., and P. Garside, eds. *The Politics of the Picturesque: Literature, Landscape and Aesthetics since 1770*. Cambridge: Cambridge University Press 1994.

Craig, W.M. *A Course of Lectures on Drawing Painting and Engraving*. London 1821.

Cumming, Robert. "The Greatest Studio Sale That Christie's Never Held?" *Turner Studies* 6, no. 2 (1986): 3–8.

Cunningham, A., and N. Jardine, eds. *Romanticism and the Sciences*. Cambridge: Cambridge University Press 1990.

Daniels, S. "The Implications of Industry: Turner and Leeds." *Turner Studies* 6, no. 1 (1986): 10–17.

Davies, Martin. *The British School*. 2nd ed. London: National Gallery 1959.

Davies, Maurice. *Turner as Professor: The Artist and Linear Perspective*. London: Tate Gallery 1992.

Davy, Sir Humphry. *Consolations in Travel; or The Last Days of a Philosopher*. London: 1889.

de la Motte-Fouqué, F.F. *Undine, A Romance*. Tr. George Soane. London 1818.

de Piles, Roger. *Cours de peinture par principes*. [1709] Paris: 1791.

A Description of the House and Gardens at Stourhead [revised by Sir R.C. Hoare]. Bath 1818.

Dickens, Charles. *The Works of Charles Dickens*. National edition. Ed. B.W. Matz. 40 vols. London: Chapman and Hall 1906–8.

Douglas, Alfred. *The Life and Times of Louis-Philippe: Ex-King of the French*. London [1848].

Du Fresnoy, C.A. *The Art of Painting of Charles Alphonse Du Fresnoy*. Translated into English verse by William Mason, MA, with annotations by Sir Joshua Reynolds, Knt, President of the Royal Academy. York, England: 1783.

Dyos, H.J., and Michael Wolff, eds. *The Victorian City: Images and Realities*. London: Routledge, Kegan Paul 1973.

Eastlake, Sir Charles Lock. *Contributions to the Literature of the Fine Arts*. London 1848.

Egerton, J. *Wright of Derby*. New York: Metropolitan Museum of Art 1990.

– *Turner: "The Fighting Temeraire." Making & Meaning*. London: National Gallery Publications 1995.

Eliade, Mircea. *The Myth of the Eternal Return*. London: Routledge, Kegan Paul 1955.

Elliott, Ebenezer. *The Poetical Works of Ebenezer Elliott, the Corn-Law Rhymer*. Edinburgh: 1840.

Elmes, James, ed. *The Annals of the Fine Arts*. 5 vols. London 1817–20.

Elton, Arthur. *Art and the Industrial Revolution*. Manchester, England: City Art Gallery 1968.

Enfield, W. *Young Artist's Assistant, or Elements of the Fine Arts*. 6th ed. London n.d. [early 19th century].

Everett, Nigel. *The Tory View of Landscape*. The Paul Mellon Center for Studies in British Art. New Haven, CT: Yale University Press 1994.

Faber, George Stanley. *The Origin of Pagan Idolatry Ascertained from Historical Testimony and Circumstantial Evidence*. London 1816.

Farington, Joseph. *The Diary of Joseph Farington*. Ed. K. Garlick, A.D. Macintyre, and K. Cave. Paul Mellon Center for Studies in British Art. 16 vols. New Haven, CT: Yale University Press 1978–84.

Field, George. *Chromatics or, An Essay on the Analogy and Harmony of Colours*. London 1817.

– *Outlines of Analogical Philosophy*. London 1839.

Finberg, A.J. *A Complete Inventory of the Drawings of the Turner Bequest*. 2 vols. London: HMSO 1909.

– *The Life of J.M.W. Turner, RA* 2nd ed. Revised, with a supplement, by Hilda F. Finberg. Oxford: Clarendon Press 1961.

– *Turner's Sketches and Drawings*. New ed. Introd. L. Gowing. New York: Schocken Books 1968.

Finley, G. "Turner: An Early Experiment with Colour Theory." *Journal of the Warburg and Courtauld Institutes* 30 (1967): 357–66.

– "Turner's Colour and Optics: A 'New Route' in 1822." "Two Turner Studies." *Journal of the Warburg and Courtauld Institutes* 36 (1973): 285–90.

– "Turner's Illustrations to 'Napoleon.'" "Two Turner Studies." *Journal of the Warburg and Courtauld Institutes* 36 (1973): 390–6.

– "The Encapsulated Landscape: An Aspect of Gilpin's Picturesque." *City & Society in the Eighteenth Century*. Ed. P. Fritz and D. Williams. Publications of the McMaster University Association for Eighteenth Century Studies. Toronto: Hakkert 1973, 193–213.

– "J.M.W. Turner's Proposal for a 'Royal Progress.'" *The Burlington Magazine* 117 (1975): 27–35.

– "The Genesis of Turner's 'Landscape Sublime.'" *Zeitschrift für Kunstgeschichte* 42, no. 2/3 (1979): 145–65.

– "Turner, the Apocalypse and History: The 'Angel' and 'Undine.'" *The Burlington Magazine* 121 (1979): 685–96.

– *Landscapes of Memory: Turner as Illustrator to Scott*. Los Angeles, CA: University of California Press 1980.

– *Turner and George the Fourth in Edinburgh, 1822*. Edinburgh: Tate Gallery/Edinburgh University Press 1981.

– "Ars Longa, Vita Brevis: The 'Watteau Study' and 'Lord Percy' by J.M.W. Turner." *Journal of the Warburg and Courtauld Institutes* 44 (1981): 241–7.

– "J.M.W. Turner's 'Rome, from the Vatican': A Palimpsest of History?" *Zeitschrift für Kunstgeschichte* 49, no. 1 (1986): 55–72.
– "Turner and the Steam Revolution." *Gazette des Beaux-Arts* 112, (July–August 1988): 19–30.
– "Love and Duty: J.M.W. Turner and the Aeneas Legend." *Zeitschrift für Kunstgeschichte* 55, no. 3 (1990): 376–90.
– "Pigment into Light: Turner, and Goethe's 'Theory of Colours.'" *European Romantic Review* 2, no. 1 (1991): 39–60. Reprinted in *Imagination in English and German Romanticism and the Fine Arts*. Ed. Frederick Burwick and Jürgen Klein. Amsterdam: Rodopi 1996, 357–76.
– "The Theatre of Light: J.M.W. Turner's 'Vision of Medea' and 'Regulus.'" *Gazette des Beaux-Arts* 119 (May–June 1992): 217–26.
– "Heaven and Earth: J.M.W. Turner's Artistic Response to Astronomy and Geology." *Muse and Reason: The Relation of Arts and Sciences 1650–1850*, ed. Boris Castel, J.A. Leith, and A.W. Riley, Royal Society of Canada, Kingston, ON: Queen's Quarterly 1994, 109–27.
– "J.M.W. Turner and the Legacy of Greece." *Gazette des Beaux-Arts* 126 (November 1995): 187–94.
– "The Deluge Pictures: Reflections on Goethe, J.M.W. Turner and Early Nineteenth-Century Science." *Zeitschrift für Kunstgeschichte* 60, no. 4 (1997): 530–48.

Fitton, W.H. *Notes on the History of English Geology*. London 1833.
Frith, W. *My Autobiography and Reminiscences*. 3 vols. London [1887–88].
Froude, J.A. *A Life of Carlyle*. Ed. John Clubbe. London: John Murray 1979.
Gage, John. *Colour in Turner: Poetry and Truth*. London: Studio Vista 1969.
– "Turner's Academic Friendships: C.L. Eastlake." *The Burlington Magazine* 110 (1968): 677–85.
– *Turner: 'Rain, Steam, and Speed'; The Great Western Railway.'* Art in Context. Ed. J. Fleming and H. Honour. New York: Viking Press 1972.
– "Turner and Stourhead: The Making of a Classicist?" *The Art Quarterly* 37, no. 1 (1974): 59–87.
– ed. *Collected Correspondence of J.M.W. Turner*. Oxford: Clarendon Press 1980.
– "Turner and the Greek Spirit." *Turner Studies* 1, no. 2 (1981): 14–23.
– "Turner's Annotated Books: 'Goethe's Theory of Colours.'" *Turner Studies* 4, no. 2 (1984): 34–52.
– *J.M.W Turner: "A Wonderful Range of Mind."* New Haven, CT: Yale University Press 1987.
– "Color in Western Art: An Issue?" *Art Bulletin* 72 (1990): 518–41.
– *Colour and Culture: Practice and Meaning from Antiquity to Abstraction*. London: Thames and Hudson 1993.
Gartside, M. *An Essay on Light and Shade*. London 1805.
– *An Essay on a New Theory of Colours and on Composition in General. Illustrated by Coloured Blots*. 2nd ed. London 1808.
Geddes, A. *Memoirs of the Late Andrew Geddes, Esq., ARA*. London 1844.
George, H. "Turner in Europe in 1833." *Turner Studies* 4, no. 1 (1984): 2–21.
– "Turner, Lawrence, Canova and Venetian Art: Three Preciously Unpublished Letters." *Apollo* 144 (1996): 25–32.
Gessner, Salomon. *The Death of Abel*. Oxford 1814.
Gilpin, William. *Three Essays: On Picturesque Travel; and On Sketching Landscape*. London 1792.

– *Observations on the River Wye, and Several Parts of South Wales, &c. Relative Chiefly to Picturesque Beauty; Made in the Summer of the Year 1770*. London 1782.
– *Observations ... on Several Parts of England; Particularly the Mountains, and Lakes of Cumberland, and Westmoreland*. 2 vols. London 1786.
– *Observations, Relative to Picturesque Beauty, Made in the Year 1776, on Several Parts of Great Britain; Particularly the Highlands of Scotland*. 2 vols. London 1789.
– *Observations on the Western Parts of England, Relative Chiefly to Picturesque Beauty*. London 1798.
– *Remarks on Forest Scenery, and Other Woodland Views (Relative Chiefly to Picturesque Beauty), Illustrated by the Scenes of New Forest in Hampshire*. 3 vols. London 1791.
Giraldon, J.B. *Les Beautés de l'opéra, ou Chefs-d'oeuvre lyriques, illustrés par les premiers artistes de Paris et de Londres sous la direction de Giraldon*. Paris 1845.
Girtin, Thomas, and David Loshak. *The Art of Thomas Girtin*. London: Adam and Charles Black 1954.
Gisborne, Thomas. *Walks in a Forest*. London 1814.
Goethe, J.W. von. *Theory of Colours*. Tr. C.L. Eastlake; facsimile (1840). In J.W. von Goethe, "Color Theory." Arranged and edited by Rupprecht Matthaei. American ed., tr. and ed. Herbert Aach. New York: Van Nostrand Reinhold 1971.
Golt, J. "Beauty and Meaning on Richmond Hill: New Light on Turner's Masterpiece of 1819." *Turner Studies* 7, no. 2 (1987): 9–20.
Gottlieb, Erika. *Lost Angels of a Ruined Paradise: Themes of Cosmic Strife in Romantic Tragedy*. Victoria, BC: Sono Nis Press 1981.
Gould, Stephen Jay. *Time's Arrow, Time's Cycle: Myth and Metaphor in the Discovery of Geological Time*. The Jerusalem-Harvard Lectures. Cambridge: Harvard University Press 1987.
Gower, G. *Practical Treatise on Painting in Oil-Colours*. London 1795.
Gowing, L. *Turner: Imagination and Reality*. New York: Museum of Modern Art 1966.
Gray, R.D. "J.M.W. Turner and Goethe's Colour Theory." *German Studies Presented to Walter Bruford*. London: Harrap 1962, 112–16.
Greene, M.T. *Geology in the Nineteenth Century: Changing Views of a Changing World*. Cornell History of Science Series. Ithaca, NY: Cornell University Press 1982.
Guiterman, H. "'The Great Painter': Roberts on Turner." *Turner Studies* 9, no. 1 (1989): 2–9.
Hamerton, P.J. *The Life of J.M.W. Turner, RA*. London 1879.
Hamilton, Jean. *The Sketching Society: 1799–1851*. London: Victoria and Albert Museum 1971.
Harris, Moses. *Natural System of Colours*. London 1811.
Harrison, J.F.C. *Early Victorian Britain 1832–51*. London: Fontana 1988.
– *The Second Coming: Popular Millenarianism 1780–1850*. London: Routledge and Kegan Paul 1979.
Haskell, F., and N. Penny. *Taste and the Antique: The lure of Classical Sculpture, 1500–1900*. New Haven, CT: Yale University Press 1981.
Hawes, Louis. "Turner's 'Fighting Téméraire.'" *Art Quarterly* 35 (1972): 23–48.
Haydon, B.R. *Correspondence and Table-Talk*. London 1876.
– *The Autobiography and Memoirs of Benjamin Robert Haydon (1786–1846)*. Ed. Tom Taylor. 2 vols. London: Peter Davies 1926.
– *Neglected Genius: The Diaries of Benjamin Robert Haydon, 1808–1846*. Ed. J. Jolliffe. London: Hutchinson 1990.
Hazlitt, W. *The Complete Works of William Hazlitt*. Ed. P.P. Howe. 21 vols. London: J.M. Dent 1930–34.

Helsinger, Elizabeth. "Turner and the Representation of England." In *Landscape and Power*, ed. W.J.T. Mitchell. Chicago and London: University of Chicago Press 1994, 103–25.

Hemingway, Andrew. *Landscape Imagery and Urban Culture in Early Nineteenth-Century Britain.* Cambridge: Cambridge University Press 1992.

Herrmann, L. "John Landseer on Turner: Reviews of Exhibits in 1808, 1839 and 1840 (Part 1)." *Turner Studies* 7, no. 1 (1987): 26–33.

Highet, G. *The Classical Tradition: Greek and Roman Influences on Western Literature.* Oxford: University Press 1978.

Hill, D. *Turner on the Thames: River Journeys in the Year 1805.* New Haven, CT: Yale University Press 1993.

– *Turner's Birds: Bird Studies from Farnley Hall.* Oxford: Phaidon 1988.

Hoare, Prince. *The Artist: A Collection of Essays.* 2 vols. London 1810.

Hoare, R.C. *A Classical Tour through Italy and Sicily.* 2nd ed. 2 vols. London 1819.

Holcomb, A. M. "'Indistinctness Is My Fault': A Letter about Turner from C.R. Leslie to James Lenox." *The Burlington Magazine* 114 (1972): 557–8.

– "The Bridge in the Middle Distance: Symbolic Elements in Romantic Landscape." *Art Quarterly* 27 (1974): 31–58.

– *John Sell Cotman.* London: British Museum 1978.

Homer. *The Odyssey of Homer, Translated from the Greek by Alexander Pope, Esq. In Two Volumes.* Edinburgh 1769.

Howarth, T.E.B. *Citizen King. The Life and Times of Louis-Philippe, King of the French.* London: Eyre and Spottiswoode 1961.

Hunnisett, B. *Steel-Engraved Book Illustration in England.* London: Scolar Press 1980.

Hussey, Christopher. *The Picturesque: Studies in a Point of View.* London and New York: Putnam 1927.

Hutchison, S.C. *The History of the Royal Academy, 1768–1968.* London: Chapman and Hall 1968.

Irwin, David, and Francina Irwin. *Scottish Painters at Home and Abroad, 1700–1900.* London: Faber 1975.

James, J.T. *The Italian Schools of Painting.* London 1820.

Jameson, Anna. *Sacred and Legendary Art.* 2 vols. London 1848.

Keach, Benjamin. *A Key to open Scripture metaphors, in four books. To which are prefixed arguments to prove the divine authority of the Holy Scriptures … Together with types of the Old Testament.* London 1779.

Kemp, Martin. *The Science of Art: Optical Themes in Western Art from Brunelleschi to Seurat.* New Haven, CT: Yale University Press 1990.

Kenny, James. *Masaniello: A Grand Opera. In Three Acts, As Performed at the Theatre Royal, Drury Lane.* London 1831.

Keyser, B.W. "Victorian Chromatics." PHD diss., University of Toronto 1992.

– "Saving the Significance." *Museum Management and Curatorship* 13 (1994): 130–59.

Kitson, M. "Turner and Claude." *Turner Studies* 2, no. 2 (1983): 2–15.

Kitson Clark, G. *The Making of Victorian England.* London: Methuen 1962.

Klingender, F.D. *Art and the Industrial Revolution.* Ed. and rev. Arthur Elton. London: Evelyn, Adams and Mackay 1968.

Knight, David. *Humphry Davy: Science & Power.* Blackwell Science Biographies. Ed. David Knight. Oxford: Blackwell 1992.

Knight, R. P. *The Landscape.* London 1794.

– *Analytical Inquiry into the Principles of Taste.* London 1805.

– *An Inquiry into the Symbolical Language of Ancient Art and Mythology.* London 1818.

Korshin, J. *Typology in England 1650–1850.* Princeton, NJ: University Press 1982.

Krause, M. F. *Turner in Indianapolis.* Indianapolis, IN: Indianapolis Museum of Art 1997.

Lairesse, Gerard de. *The Art of Painting.* Tr. J.F. Fritsch, Painter. London 1738.

Lamy, Bernard. *Perspective made Easie: Or, the ART of Representing all manner of OBJECTS as they appear to the EYE, translated … by an Officer of Her Majestie's Ordnance.* London 1710.

Landseer, John. *Lectures on the Art of Engraving.* London 1807.

Laudan, Rachel. *From Mineralogy to Geology: The Foundation of a Science, 1650–1830.* Science and its Conceptual Foundations. Ed. David L. Hull. Chicago: University of Chicago Press 1987.

Lee, Rensselaer W. "*Ut Pictura Poesis*: Humanistic Theory of Painting." *Art Bulletin* 22 (1940): 197–269.

Leslie, C.R. *Memoirs of the Life of John Constable.* [Text is that of the 1845 ed.]. London: Phaidon Press 1951.

– *Autobiographical Recollections.* London 1860.

Levere, T.H. "Coleridge and the Sciences." In *Romanticism and the Sciences*, ed. A. Cunningham and N. Jardine. Cambridge: Cambridge University Press 1990, 295–306.

Lindsay, J. *J.M.W. Turner: His Life and Work.* London: Cory, Adams and Mackay 1966.

– *Turner: The Man and His Art.* New York: F. Watts 1985.

– ed. *The Sunset Ship: The Poems of J.M.W. Turner.* London: Scorpion Press/Evelyn 1966.

Lockhart, J.G. *Memoirs of the Life of Sir Walter Scott, Bart.* Edinburgh 1845.

Lucanus, Ocellus. *On the Nature of the Universe.* Tr. Thomas Taylor. London 1831.

Lyles, A. *Turner and Natural History: The Farnley Project.* London: Tate Gallery 1988.

McCoubrey, J. "War and Peace in 1842: Turner, Haydon and Wilkie." *Turner Studies* 4, no. 2 (1984): 2–7.

– "The Hero of a Hundred Fights: Turner, Schiller and Wellington." *Turner Studies* 10, no. 2 (1990): 7–11.

Maculloch, J. *The Highlands and Western Isles of Scotland.* 4 vols. London 1824.

Maccunn, F.J. *The Contemporary English View of Napoleon.* London: G. Bell 1914.

MacDermot, E. T. *History of the Great Western Railway.* 3 vols. London 1927.

M'Ewen, William. *Grace and Truth, or the Glory and Fulness of the Redeemer Displayed; In an Attempt to Illustrate and Enforce the Most Remarkable Types, Figures, and Allegories of the Old Testament.* London 1840.

Mack, Maynard. *The Garden and the City: Retirement and Politics in the Later Poetry of Pope, 1731–1743.* Toronto: University of Toronto Press 1969.

Macmillan, Duncan. *Painting in Scotland: The Golden Age (1707–1843).* Edinburgh: University of Edinburgh Press and Tate Gallery 1986.

Mantell, Gideon. *The Fossils of the South Downs.* London 1822.

– *Illustrations of the Geology of Sussex.* London 1827.

Manwaring, E.W. *Italian Landscape in Eighteenth Century England.* London: Frank Cass 1965.

Marks, A. "Rivalry at the Royal Academy: Wilkie, Turner and Bird." *Studies in Romanticism* 20 (1981): 333–62.

Masaniello, the Fisherman King of Naples. Strand [London] 1845.

Mather, Samuel. *The Gospel of the Old Testament: An Explanation of the Types and Figures by Which Christ Was Exhibited under the Legal Dispensation.* Rewritten by C[aroline] Fry. 2 vols. London 1834.

Matteson, L.R. "The Poetics and Politics of Alpine Passage: Turner's Snow Storm: Hannibal and His Army Crossing the Alps." *Art Bulletin* 62 (1980): 385–98.

– "John Martin's 'The Deluge': A Study in Romantic Catastrophe." *Pantheon* 39 (1981): 220–8.

Maurice, Thomas. *Richmond Hill; A Descriptive and Historical Poem*. London, 1807.

Metastasio, P.A.D.B. *Dido, A Serious Opera, in Two Acts, The Music by Saverio Mercadante, As Represented at the King's Theatre, Haymarket, July 5, 1827 etc*. London 1827.

Miller, William F. *Memorials of Hope Park: Comprising Some Particulars in the Life of Our Dear Father, William Miller*. London 1886.

Milton, John. *The Poetical Works of John Milton*. Ed. Sir Egerton Brydges. 6 vols. London 1837.

– *The Poems of John Milton*. Longman Annotated English Poets. Ed. John Carey and Alastair Fowler. London: Longman 1968.

Mommsen, T. *History of Rome*. Introd. E.A. Freeman. 4 vols. London 1868.

Monk, Samuel H. *The Sublime: A Study of Critical Theories in Eighteenth Century England*. New York: Modern Language Association 1935.

Monkhouse, W. Cosmo. *The Turner Gallery*. 3 vols. London: Virtue and Company n.d.

Mortier, Roland. "Illustration of Science and Technology and Artistic Perception in Eighteenth Century France." *Muse and Reason: The Relation of Arts and Sciences 1650–1850*, ed. Boris Castel, J.A. Leith, and A.W. Riley. Kingston, ON: Queen's Quarterly 1994, 27–42.

Müller-Tamm, Juta. "Joseph William Mallord Turner, Schatten und Dunkelheit – Der Abend der Sintflut [and] Licht und Farbe (Goethes Theorie) – Der Morgen nach der Sintflut – Moses schreibt das Buch der Genesis." In *Goethe und die Kunst*, ed. Sabine Schulze. Stuttgart: Hatje 1994, 566–70.

Newton, Isaac. *Opticks, or a Treatise on the Reflections, Refractions, Inflections & Colours of Light*. 4th ed. London 1730.

Nicholson, K. *Turner's Classical Landscapes: Myth and Meaning*. Princeton, NJ: Princeton University Press 1990.

– "Turner's 'Apullia in Search of Appulus' and the Dialectics of Landscape Tradition." *The Burlington Magazine* 122 (1980): 679–86.

Omer, M. "Turner and 'The Building of the Ark' from Raphael's Third Vault of the Loggia." *The Burlington Magazine* 117 (1975): 694–702.

Oram, William. *Precepts and Observations on the Art of Colouring in Landscape Painting*. London 1810.

Owen, Felicity, David B. Brown, and John Leighton. *"Noble and Patriotic"; The Beaumont Gift 1828*. London: National Gallery 1988.

Paris. Grand Palais. *J.M.W. Turner 1983–4*. French text by N. Alfrey, J. Gage, E. Joll, A. Wilton, and J. Ziff.

Parkinson, J. *Organic Remains of a Former World. An Examination of the Mineralized Remains of the Vegetables and Animals of the Antediluvian World; Generally Termed Extraneous Fossils*, 3 vols. London 1804–11.

Patrides, J.C.A. *Milton and the Christian Tradition*. Oxford: Clarendon Press 1966.

Patterson, E.C. *Mary Somerville and the Cultivation of Science, 1815–1840*. International Archives of the History of Ideas. Boston: Martinus Nijhoff 1983.

Perkin, David. *The Quest for Permanence*. Cambridge, MA: Harvard University Press 1959.

Phillips, Hugh. *The Thames about 1750*. London: Collins 1951.

Phillips, W. *A Selection of Facts from the Best Authorities Arranged so as to Form an Outline of the Geology of England and Wales, with an Introductory Compendium of the General Principles of That Science, and Comparative Views of the Structure of Foreign Countries*. London 1818.

Piggott, J. "A Lyric in Turner's Spithead Sketchbook Identified." *Turner Society News* 74 (1996): 12–13.

Pitt, Christopher. *The Aeneid*. 4 vols. London 1778.

– Review of "Turner and the Bible at Boston." *Turner Society News* 76 (1997): 3–60.

Pointon, Marcia. "Geology and Landscape Painting in Nineteenth-Century England." *Images of the Earth: Essays in the History of Environmental Sciences*, ed. L.J. Jordanova and R. Porter. Chalfont St Giles: British Society for the History of Science 1978, 84–116.

Porter, R. *The Making of Geology: Earth Science in Britain 1660–1815*. Cambridge: Cambridge University Press 1977.

Powell, C. "Infuriate in the Wreck of Hope': Turner's 'Vision of Medea.'" *Turner Studies* 2, no. 1 (1982): 12–18.

Pye, Henrietta. *A Short View of the Principal Seats and Gardens in and about Twickenham*. London 1767.

Quarles, Francis. *Emblems, Divine and Moral*. Ed. S.W. Singer. London 1845.

Rawlinson, W.G. *The Engraved Work of J.M.W. Turner, RA*. 2 vols. London: Macmillan 1908–13.

The Rebellion of Naples or the Tragedy of Massaniello … written by a Gentleman who was an eye-witness where this was really acted upon that bloody stage, the streets of Naples, 1647. London 1649.

Redgrave, Richard, and Samuel Redgrave. *A Century of British Painters*. New edition. London: Phaidon Press 1947.

Reynolds, Sir Joshua. *Discourses on Art*. Ed. Robert R. Wark. Paul Mellon Center for Studies in British Art. New Haven, CT: Yale University Press 1981.

Rigby, Elizabeth [Lady Eastlake]. *Journals and Correspondence*. Ed. C.E. Smith. London 1895.

Riley, Henry T. *The Metamorphoses of Ovid*, 3 vols. London 1851.

Ripa, Cesare. *Iconologia*, 3 vols. Perugia 1765.

Ritchie, Leith, and Alaric A. Watts. *Liber Fluviorum; or River Scenery of France … with Descriptive Letter-press by Leith Ritchie and a Biographical Sketch by Alaric A. Watts*. London 1853.

Robertson, David. *Sir Charles Eastlake and the Victorian Art World*. Princeton, NJ: Princeton University Press 1978.

Robinson, Sidney K. *Inquiry into the Picturesque*. Chicago: University of Chicago Press 1991.

Rodner, W.S. "Turner's Dudley: Continuity, Change and Adaptability in the Industrial Black Country." *Turner Studies* 8, no. 1 (1988): 32–40.

Roethlisberger, M. *Claude Lorrain*. 2 vols. Yale Publications in the History of Art, 13. New Haven, CT: Yale University Press 1961.

Roestvig, Maren-Sofie. *The Happy Man: Studies in the Metamorphoses of a Classical Ideal*. Oslo Studies in English. 2 vols. Bergen: Norwegian Universities Press 1962–71.

Rogers, Samuel. *The Italian Journal of Samuel Rogers*. Ed. J.R. Hale. London: Faber and Faber 1956.

Rosenfeld, Sybil. *Georgian Scene Painters and Scene Painting*. Cambridge: Cambridge University Press 1981.

Roworth, W.W. "The Evolution of History Painting: Masaniello's Revolt and Other Disasters in Seventeenth-Century Naples." *Art Bulletin* 75, no. 2 (1993): 219–34.

Rudwick, Martin J.S. *Scenes from Deep Time: Early Pictorial Representations of the Prehistoric World.* Chicago: University of Chicago Press 1992.

Rupke, N.A. *The Great Chain of History: William Buckland and the English School of Geology (1814–1849).* Oxford: Clarendon Press 1983.

Ruskin, John. *Notes on The Turner Gallery at Marlborough House.* 2nd ed. London 1857.

– *Turner and Ruskin: An exposition of the Works of Turner from the Writings of Ruskin.* Ed. with a biographical note by Frederick Wedmore. 2 vols. London: George Allen 1900.

– *Modern Painters.* "The New Universal Library." 5 vols. London: George Routledge / E.P. Dutton [1907].

St Clair, William. *Lord Elgin and the Marbles.* New York: Oxford University Press 1967.

Sass, Henry. *A Journey to Rome and Naples.* London 1818.

Scott, Sir Walter. *Poetical Works.* Ed. J.G.L[ockhart]. 12 vols. Edinburgh 1833–4.

– *Life of Napoleon Buonaparte.* In vol. 9 of *Miscellaneous Prose Works.* Edinburgh 1834–36.

– *The Lord of the Isles and A Voyage to the Hebrides by Sir Walter Scott.* Ed. George Eyre-Todd. Glasgow: David MacBrayne 1913.

Seneca, L.A. *Medea: A Tragedy by Seneca.* Chester 1776.

Sepper, D. L. "Goethe, Colour and the Science of Seeing." In *Romanticism and the Sciences,* ed. A. Cunningham and N. Jardine. Cambridge: Cambridge University Press 1990, 189–98.

– *Goethe contra Newton: Polemics and the Project for a New Science of Colour.* Cambridge: Cambridge University Press 1988.

Seyffert, O. *Dictionary of Classical Antiquities.* Ed. H. Nettleship and J.E. Sandys. New York: Meridian 1957.

Shanes, Eric. *Turner's Human Landscape.* London: Heinemann 1990.

– "Turner's 'Unknown' London Series." *Turner Studies* 1, no. 2, (1981): 36–42.

– *Turner's Picturesque Views in England and Wales 1825–1828.* London: Chatto & Windus 1979.

Sherman, Paul D. *Colour Vision in the Nineteenth Century: The Young-Helmholtz-Maxwell Theory.* Bristol, England: Adam Hilger 1981.

Sidlauskas, S. "Creating Immortality: Turner, Soane, and the Great Chain of Being." *Art Journal* 52, no. 2 (1993): 59–65.

Skene, James. "Painting." *Edinburgh Encyclopaedia* 16(1) (1823): 257–70.

Slade, Henry Raper. *Essay on the Doctrine of Types, and Its Influence in the Interpretation of the New Testament.* London 1830.

Smiles, Samuel. *The Life of George Stevenson.* New York: 1868.

Smith, Sheila M. "Contemporary Politics and 'The Eternal World' in Turner's *Undine* and *The Angel Standing in the Sun.*" *Turner Studies* 6, no. 1 (1986): 40–50.

Solkin, David H. *Richard Wilson: The Landscape of Reaction.* London: Tate Gallery 1982.

Sowerby, James. *A New Elucidation of Colour.* London 1809.

Stafford, Barbara. *Voyage into Substance: Art, Science, Nature, and the Illustrated Travel Account 1760–1840.* Cambridge, MA: MIT Press 1984.

Stainton, Lindsay. *Turner's Venice.* London: British Museum Publications 1985.

Stewart, Dugald. *Elements of the Philosophy of the Human Mind.* 2 vols. London 1814.

Stewart, J.D. "William III and Sir Godfrey Kneller." *Journal of the Warburg and Courtauld Institutes* 33 (1970): 330–6.

Stoddart, J. *Remarks on Local Scenery and Manners in Scotland during the Years 1799 and 1800.* 2 vols. London 1801.

Stuckey, Charles F. "Turner, Masaniello and the Angel." *Jahrbuch der Berliner Museen* 18 (1976): 155–75.

– "Turner's Birthdays." *Turner Society News* 21 (1981): 2–8.

Sussman, Herbert L. *Victorians and the Machine: The Literary Response to Technology.* Cambridge, MA: Harvard University Press 1968.

Taylor, Brook. *Linear Perspective: or, A New Method of Representing Justly All Manner of Objects As They Appear to the Eye.* London 1715.

Taylor, Thomas. *Moses and Aaron, the Types and Shadows of Our Saviour in the Old Testament Opened and Explained.* London 1653.

Thompson, E.P. *The Making of the English Working Class.* London: Victor Gollancz 1963.

Thornbury, Walter. *The Life of J.M.W. Turner, RA.* 2nd ed. London 1877.

Townshend, Joyce H. "The Changing Appearance of Turner's Paintings." *Turner Studies* 10, no. 2 (1990): 12–24.

– "Turner's Writings on Chemistry and Artists Materials." *Turner Society News* 62 (1992): 6–10.

de Tressan, L'Abbé. *A History of the Heathen Mythology; or The Fables of the Ancients.* 2nd. ed. London 1806.

Treuherz, J. "The Turner Collector: Henry McConnel, Cotton Spinner." *Turner Studies* 6, no. 2 (1986): 37–42.

Turner, James. *The Politics of Landscape: Rural Scenery and Society in English Poetry 1630–1660.* Oxford: Blackwell 1979.

Tuve, Rosemund. *Images and Themes in Five Poems by Milton.* Cambridge, MA: Harvard University Press 1957.

Undine, A Romance. London [1830].

Uwins, Mrs[Sarah]. *A Memoir of Thomas Uwins, RA.* London 1858.

Venning, B. "Turner's Annotated Books: 'Opie's Lectures on Painting' and Shee's 'Elements of Art [1–3].'" *Turner Studies* 2, no. 1 (1982): 36–46; 2, no. 2 (1983): 40–9; 3, no. 1 (1983): 33–44.

– Review of *Painting and Poetry: Turner's Verse Book and his Work of 1804–1812,* by Andrew Wilton. *Turner Studies* 10, no. 2 (1990): 47–9.

Victoria and Albert Museum. *Rococo: Art and Design in Hogarth's England.* London 1984.

Virgil. *The Works of Virgil: Containing His "Pastorals," "Georgics," and "Aeneis."* Translated into English Verse by Mr [John] Dryden. 2nd ed. London 1698.

Wallace, M.B. "Turner's Circular, Octagonal and Square Paintings 1840–1846." *Arts Magazine* 55 (1979): 107–17.

Warrell, Ian. *Turner: The Fourth Decade, Watercolours 1820–1830.* London: Tate Gallery 1991.

Webb, Daniel. *Inquiry into the Beauties of Painting.* 2nd ed. London 1761.

Wells, G.A. "Goethe's Scientific Method and Aims in the Light of His Studies in Physical Optics." *Publications of the English Goethe Society* 38 (1968): 69–113.

– *Goethe and the Development of Science, 1750–1900. Science in History.* Ed. G.L.E. Turner. The Netherlands: Alphen aan den Rijn 1978.

Whitaker, John. *The Course of Hannibal over the Alps Ascertained.* 2 vols. London 1794.

Whitley, W.T. *Art in England, 1800–1820.* Cambridge: Cambridge University Press 1928.

– *Art in England, 1821–1837*. Cambridge: Cambridge University Press 1830.

Whittingham, Selby. "What You Will; or Some Notes Regarding the Influence of Watteau on Turner and Other British Artists [1–2]." *Turner Studies* 5, no. 1 (1985): 2–24; 5, no. 2 (1985): 28–48.

Wickham, G. *A History of the Theatre*. Oxford: Phaidon 1985.

Wilkie, Brian. *Romantic Poets and Epic Traditions*. Madison/Milwaukee, WI: University of Wisconsin Press 1965.

Willis, Peter. *Charles Bridgeman and the English Landscape Garden*. London: Zwemmer 1977.

Wilton, A. *The Life and Work of J.M.W. Turner*. London: Academy Editions 1979.

– *Turner and the Sublime*. London: British Museum Publications 1980.

– *Turner in His Time*. London: Thames and Hudson 1987.

– *Painting and Poetry: Turner's Verse Book and His Work of 1804–1812*. London: Tate Gallery 1990.

Wordsworth, William. *The Excursion, Being a Portion of "The Recluse"* (1814). Vol. 5 In *Poetical Works*, ed. William Knight. 11 vols. Edinburgh 1882–89.

Wyndham, Henry. *Tour through Monmouthshire and Wales*. 2nd ed. Salisbury 1781.

Young, Arthur. *Annals of Agriculture and Other Useful Arts*. 46 vols. London 1784–1815.

Youngblood, P. "The Painter as Architect: Turner and Sandycombe Lodge." *Turner Studies* 2, no. 1 (1982): 20–35.

Ziff, J. "Turner and Poussin." *The Burlington Magazine* 105 (1963): 315–21.

– "Backgrounds: Introduction of Architecture and Landscape.' A Lecture by J.M.W. Turner." *Journal of the Warburg and Courtauld Institutes* 26 (1963): 124–47.

– "J.M.W. Turner on Poetry and Painting." *Studies in Romanticism* 3, no. 4 (summer 1964): 193–215.

– Review of *Colour in Turner*, by John Gage. *Art Bulletin* 52 (1971): 125–6.

– "Turner, the Ancients, and the Dignity of the Art." *Turner Studies* 3, no. 2 (1984): 45–52.

– "J.M.W. Turner's Last Four Paintings." *Turner Studies* 4, no. 1 (1984): 47–51.

– "The Art Glides On with Swelling Sail': An Unrecorded Poem by Turner." *Turner Studies* 11, no. 1 (1991): 16–18.

Index